160

OXFORD NO4

John
Mahoney
70

Dennis
Mahoney
80

Asenath
White
ton
160

J. H.

240

Dennis
Mahoney
40

Cornelias
Schneider
74.14

M J
Rourke

D
Mahoney

John
Mahoney
80

Patrick
Rourke
80

160

Mary
Mahoney
80

M J
Rourke
80

Dennis
Mahoney
80

Dan'l
O'Connor
40

M J
Patrick
Rourke
80

Micheal
Maher
220

Robert
Mahoney
200

15

14

13

John
Kennedy
80

James
Stratton
160

James
Kennedy
80

Dan
O'Connor
40

M J
Kutcher
60

M J
Kutcher
60

Jas.
White
80

Wm
Clear
80

E.T.

F R Kutcher
20

F R Kutcher
20

Albert
Kadera

A P
Rohret
160

James
Stratton
80

M J
Rourke
20

Jas.

Dan
O'Connor
40

F R Kitchen
84

Elizabeth
Rourke
80

Wm
Clear
80

River

Kennedy
141

Kennedy

Patrick
Rourke
80

E I
162 39

John E.
Scanlon

Wm
Clear
120

Jno Henry
to
Henry 34 31

River

OXFORD NO4

Wm
Haman
80

John
Kennedy
112

Jas
Kitchen
125

Patrick 58
Rourke
80

Patrick
Rourke
80

Road

Thos
Rourke

Eliza
Rourke
40

G A
Hamilton

22

23

24

154

PAC.
C.I.

SCH

F
Clear
20

Wm
Clear
20

John
40

James
Mooney
160

James
Barry Jr.
160

James
Barry
105

Fred
Immel
80

Robert
Edwards
80

Edwards
18

Alice
Edwards

G A
Hamilton
37

Alice
Edwards
etal

Caroline
Immel
80

Hamilton
93 27

Alex
Grace

27

26

25

Jas
Barry
Jr.
160

Barry Jr
40

William
Summer
hays 120

Jas
Barry Jr.

G. M.
Cleaman
40

C
Ahern
40

J. W.
Ward
80

J. W.
Ward
40

J. W.
Ward
40

Mathias
Ackerman
120

Angeline
Venter

G. M.
Cleaman
40

C
Ahern
40

SCH

OXFORD NO4

E R
Eliott
80

E R
Eliott

J. W.
Ward

Geo 40
Ackerman

George
Ackerman
80

IN THE STORYTELLING TRADITION OF STUDS TERKEL and the photographic spirit of Mike Disfarmer, *The Oxford Project* tells the extraordinary true tale of a seemingly ordinary Midwestern town through the pictures and words of its residents. Equal parts art, American history, cultural anthropology, and human narrative—*The Oxford Project* is at once personal and universal, surprising and predictable, simple and profound.

The Project began almost twenty-five years ago, when Peter Feldstein undertook the remarkable task of photographing nearly every resident of his town, Oxford, Iowa (pop. 676). The collection of photographs that resulted is a fascinating glimpse into the ethos and character of small-town life. In those stark, full-body images Feldstein managed to capture not only the visage of rural America, but a sense of its underlying spirit.

Two decades later Feldstein did it again, re-photographing as many of the original residents as he could locate. But this time, his neighbors didn't just pose, they *talked*. With astonishing honesty, the people of Oxford shared their memories, fantasies, failures, secrets, and fears with Feldstein and writer Stephen G. Bloom, who compiled their words into the poignant, short, first-person narratives that accompany their portraits. Each one is a reminder that the most compelling and unusual stories are always the truest.

Hundreds of Oxford residents come to life in these pages. Time leaps back and forth, instantly elapsing twenty years. Meet, among others, the donut baker who went from having to be weighed on a livestock scale to losing over 150 pounds with the encouragement of the entire town; the Pentecostal minister who gave up buck-skinning to found his own church and now awaits the rapture in 2028; the World War II veteran who survived the Battle of the Bulge, but still suffers terribly from post-traumatic stress disorder; his son, a recipient of the Purple Heart for his service in Vietnam, who shares his father's affliction.

Considered side-by-side, these portraits reveal the inevitable transformations of aging: wider waistlines, wrinkled skin, eyeglasses, and laugh lines. Babies and children have become parents themselves. The courses of lives have been irrevocably altered by deaths, births, marriages, infidelities, and divorces. Some have lost God, others have found Him. Equally fascinating are those for whom time has stood still; whose original and present day portraits appear eerily identical.

In a place like Oxford—where strangers are recognized by the sound of an unfamiliar engine idle—not only does everyone know everyone else, but also everyone else's brothers, sisters, parents, lovers, dreams, defeats, and favorite pot luck recipes. This intricate web of human connections among neighbors, friends, and family, is the mainstay of small-town American life—unforgettably captured here in Feldstein's candid black-and-white photography and Bloom's rhythmic storytelling.

THE OXFORD

PHOTOGRAPHS BY PETER FELDST

WELCOME BOOKS NEW

PROJECT

EIN TEXT BY STEPHEN G. BLOOM

YORK & SAN FRANCISCO

To Josephine and my brother Donald
—P. F.

To Iris and Michael
—S. G. B.

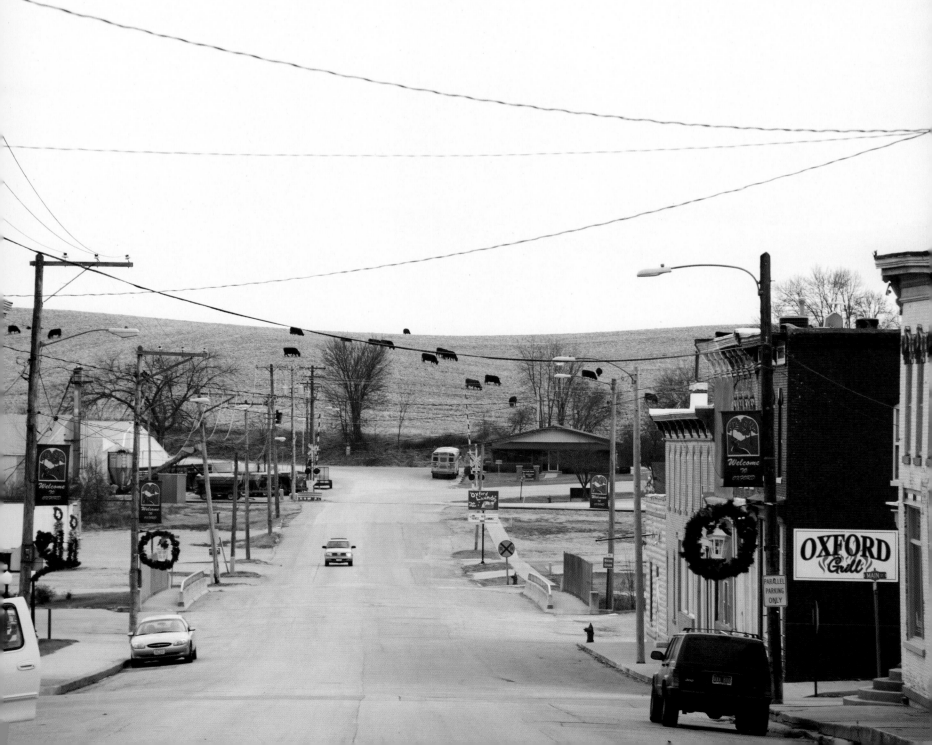

CONTENTS

PREFACE

GERALD STERN

TO STUMBLE UPON A SMALL TOWN LIKE OXFORD IS ONE THING—to be able to consider its whole population face by face, at your own leisure, is something else entirely. Think of how fascinated we are by group photographs and family portraits taken fifty years ago, how we pore over the clothes, the features, and the stances. What a field day it will be for the anthropologist, studying the thousand details of these lives so nicely exposed by Peter Feldstein's camera.

Oxford's population in 1984 was Irish-Catholic and Bohemian on the one hand, and Methodist on the other. There appear to be two African-Americans, both children. There is one Jew, Peter tells me. Only one person is dressed up, a little girl. Only a few men are in jackets and ties, but that is their work costume, not their usual dress. The attitude is casual and comfortable. Several men and boys are wearing hats, with peaks to keep out the summer sun. Some wear narrow-brimmed straws. A great many are wearing their Legion hats. Most women are wearing pants. T-shirts abound. There are overalls, but less than I would have thought. Some are in shorts and sandals; some are in shorts and halters. One is holding a guitar. Some are holding children. Many are holding dogs. One is holding a lion; one a raccoon. Most are smiling.

All stand facing the camera.

There are some canes, some suspenders. Some of the costumes are outrageous. No one is in rags. Several babies are in baskets, one in a wagon. The overwhelming majority is wearing sneakers. A few are a bit overweight. A few have beards.

What strikes me is the variety in age, size, costume, attitude, and posture. There are dozens of occupations: waitresses, cooks, businessmen, university personnel, government workers, house-painters, clerks, mail-carriers, secretaries, nurses, factory workers, bookkeepers, truck-drivers, veterinarians, teachers, backhoe operators, doctors, housewives, garage repairmen, roofers, chiropractors, farmers, bank tellers, Avon reps, prison guards, ministers, lawyers, college students, beauticians, carpenters, bank officers, sheriff deputies, railroad workers, tire changers, substitute teachers, cabinet makers, retirees, principals, bar owners, cashiers, masons, carpet installers, photographers.

Peter is the only one I know who has ever photographed an entire city. How the idea came to him I have no idea, but the execution was simple. Everyone was treated alike, and there was no direction. In and out. Six hundred and seventy times. The drama of the shooting determined the aesthetic. It was a lovely notion. With a tarp, two quartz lights, and a basic camera, Peter recorded their dreams, their fears—their spirit.

He is one of them.

April, 1984

Dear Neighbor,

During the month of May I am going to be working on a project
to photograh everyone in Oxford. Then I will print approximately
70 - 4x5 inch portraits on each piece of photographic mural paper.
We will then exhibit these in different locations downtown.

I will be contacting you during these next couple weeks to answer
any questions you may have and to set up appointments. The sessions
will take about 5 minutes and of most importance is that you feel
comfortable. We would like you to dress "as you are", not as you
might look in your Sunday best.

I would also like to mention that this project is being partially
sponsored by the Iowa Arts Council, with a great deal of cooperation
from Don Saxton and the City of Oxford.

Thank you, and I hope to see you soon,
Sincerely,

Peter Feldstein
628-4197

P.S. I'm hoping that this letter gets to all of you. Should you
know of anyone not contacted, please feel free to give them my
phone number and to encourage them to contact me. Thanks

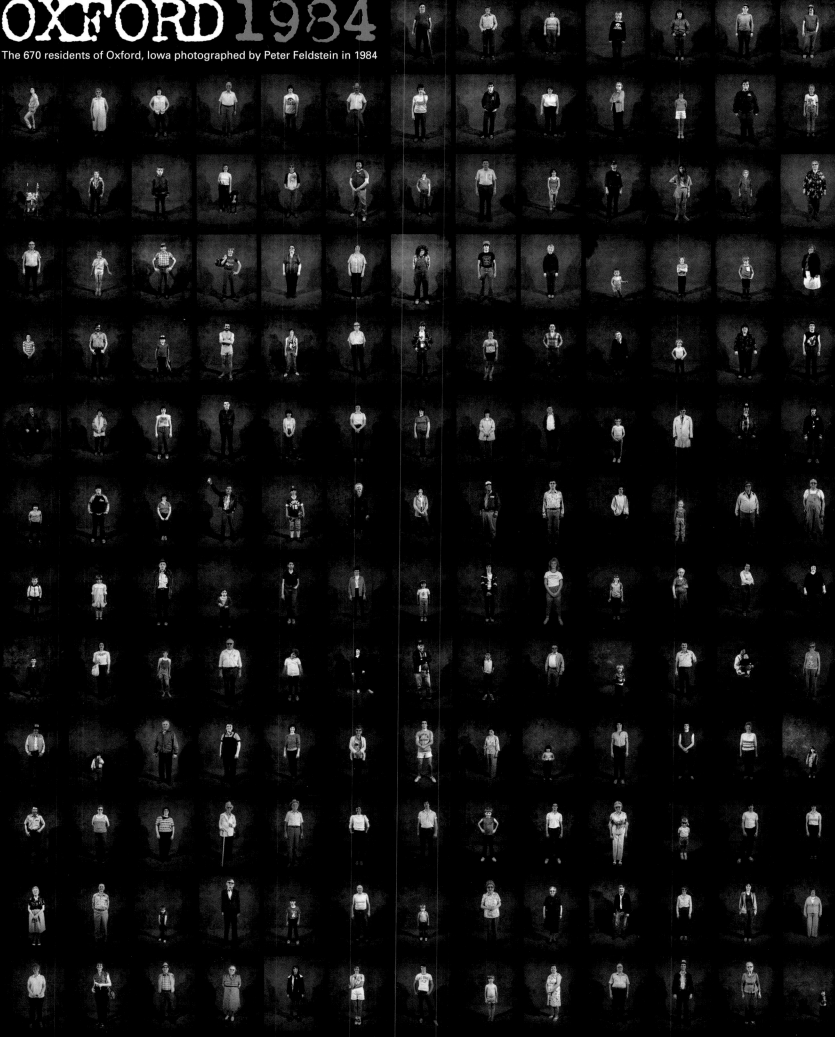

OXFORD 1984

The 670 residents of Oxford, Iowa photographed by Peter Feldstein in 1984

OXFORD AT A GLANCE:

THEN

Population: 693

Race: Caucasian (681); African-American (8); Other (4)

Median Age: 29.3

Residents 19 or under: 219

Residents 65 or older: 92

Families: 185

Households: 256

Marital status: Single (117); Married (331);
Separated (5); Divorced (18); Widowed (46)

Residents' place of birth:
United States (687)
Iowa (623)

Ancestry:
German (177); English (64); Irish (24); Swedish (2);
Norwegian (2); Other (38)

Income:
Median household: $16,842
Median family: $19,050
Per capita: $6,620

Housing units: 265

Median value of housing: $33,500

Median rent: $232

Poverty status: 8 families

Registered voters: 427
Democrats: 205 (48%)
Republicans: 67 (16%)
No party: 155 (36%)

Veterans: 73

NOW

Population: 705

Race: Caucasian (694); Asian-American (5); American
Indian (1); African-American (1)

Median Age: 35.9

Residents 19 or under: 218

Residents 65 or older: 82

Families: 190

Households: 279

Marital status: Single (149); Married (299);
Separated (9); Divorced (35); Widowed (45)

Residents' place of birth:
United States (657)
Iowa (585)

Ancestry:
German (198); Irish (139); Czech (62); English (52);
Swedish (16); Norwegian (11); Other (43)

Income:
Median household: $37,292
Median family: $48,750
Per capita: $18,335

Housing units: 286

Median value of housing: $86,300

Median rent: $438

Poverty status: 6 families

Registered voters: 501
Democrats: 228 (46%)
Republicans: 97 (19%)
No party: 176 (35%)

Veterans: 56

THE OXFORD PROJECT: WHO WE ARE

STEPHEN G. BLOOM

ONE BREEZY MAY MORNING IN 1984, photographer Peter Feldstein walked up and down every street in Oxford, Iowa, slipping flyers under doors, inviting residents to have their photographs taken. Using a fat red marker and a big piece of cardboard, he made a sign that read "Free Pictures," and taped the sign to a storefront window on Augusta Avenue, Oxford's main street. Inside, Peter covered the plate-glass windows with aluminum foil and brown kraft paper to keep out the sunlight, hung a wrinkled construction tarp as a backdrop, and turned on two 1000-watt quartz lights. Then he waited.

Six hundred and seventy-six people lived in Oxford, and Peter wanted to photograph every single one of them.

That first day, almost twenty-five years ago, no one showed up. For the next several days, Peter's only takers were kids on

their way home from school, probably happy for an excuse not to do their homework. Then, a curious, retired couple wandered by, and became the first adults Peter photographed. In the weeks that followed, fewer than a dozen people poked their heads in the storefront. At the end of every afternoon, Peter printed contact sheets of the few photographs he'd taken, and placed them in a notebook on a table outside so passers-by could flip through the pages.

On Memorial Day, Peter got his first break. That morning, Al Scheetz stopped in to have his picture taken on his way to march in the American Legion parade. He returned a few hours later with four-dozen Legionnaires and their families. The project took off from there.

Peter never posed anyone or asked them to dress up. He took one shot per person. Few did anything out of the ordinary—except those like Clarence Schropp, who wore his wife's wig, and Calvin Colony who brought along his three-hundred-pound pet lion, Samantha. Most came as they were—nothing more, nothing less. Pat Henkelman showed up carrying a sack of groceries.

By late summer, Peter had photographed six hundred and seventy Oxford residents.

If you ask Peter why he wanted to photograph his neighbors in the rural town of Oxford, he'll tell you it was a social experiment, a way to give equal, democratic billing to every single resident—rich or poor, young or old, respected or reviled. Peter's intention was to take straightforward pictures with no pretense, to make an honest record. He was inspired by the humble post-Depression portraits of Mike Disfarmer who photographed the townspeople of Heber Springs, Arkansas, as well as by the work of Doug Huebler, a conceptual artist whose idea was to photograph every person in the world. The pictures of Dorothea Lange and Walker Evans also figured heavily among his influences.

That spring Peter had an exhibition of the photographs in Oxford's American Legion Hall. A few hundred people stopped by; the show was covered by some of the local papers. Father James Lawrence of St. Mary's Church, the last resident to pose for Peter, told a reporter: "He sure stirred up a lot of talk. There are a lot of nice people in this town. Some of them are a little embarrassed,

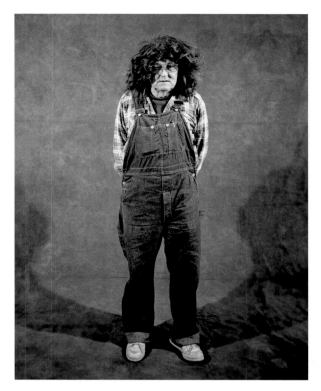

Clarence Schropp arrived to have his
photograph taken in his wife's wig.

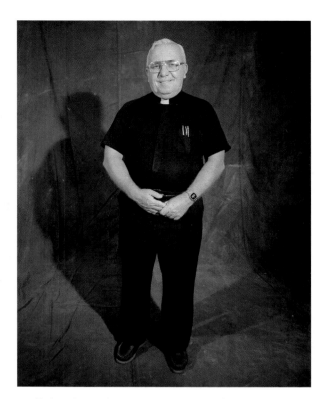

Father James Lawrence was the last Oxford resident
to be photographed in 1984.

but I think they really like it." After the show, Peter put the negatives away in an old set of metal file drawers, and went on with his life as a professor of art at the University of Iowa. And that was pretty much that.

Until 2005.

That's when Peter decided to set up his camera again to take photographs of as many of the original residents as he could find. More than a hundred had died, and probably as many had moved away. But the vast majority still lived in Oxford. Including Peter. For this go-around, he followed the same protocol as in 1984, with two notable exceptions: He asked people to stand in front of a blank plaster wall across the street from the original storefront; and he invited me to join him in the project to tell Oxford's stories.

After photographing the first handful of residents, Peter and I looked at the new portraits alongside the old, and we were stunned. Almost all had posed in an identical manner despite the more than two-decade interval. Mary Ann Carter, co-owner of the local Ford dealership, still tilted her head just a little to the left, her hands cupped neatly at her side. Retired carpenter Jim Jiras still wore a seed cap and carried two pens in his shirt pocket.

Over the course of the next two years, with Peter sitting in, I interviewed one hundred Oxford residents, one at a time. Armed with several pens and a pad on a clipboard—I never used a tape recorder—I asked few questions and mostly listened, allowing people to talk freely. Initially, I was surprised that people were so forthcoming. After all, they knew Peter, but I was a stranger. More than I would have expected broke down in tears and confessed life stories seldom acknowledged. Many talked about

relationships gone bad. Several revealed they were victims of domestic abuse or had weathered infidelities. A few exaggerated facts, boasting about events that I doubt ever occurred. A number of people confided great regrets and profound sorrows. Often their words came out slowly and methodically, other times they poured forth in jags and torrents. The language of not just a few was pure poetry.

After each interview, I typed up my notes and compressed each text into its final shortened form—"shrink wrapping" is how I describe the process, squeezing out the excess air—and we'd show what I had written to the person. Despite the private nature of our conversations, rarely did anyone choose to retract his or her words. I'd like to think Oxford people spoke so openly because there's comfort in talking about what burdens us. Or perhaps it was just the first time anyone outside of their families had asked.

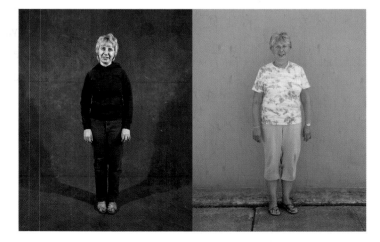

Pictured here in 1984 and 2005, Mary Ann Carter was among
the first to be re-photographed by Feldstein.

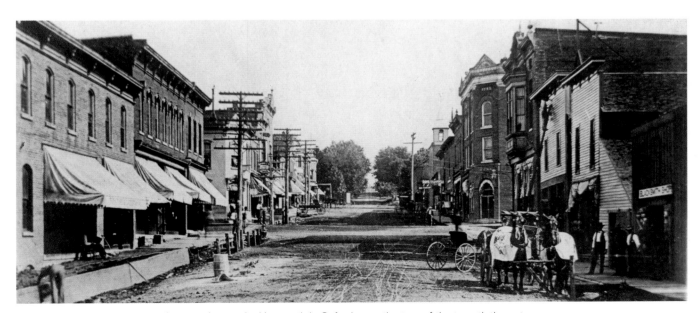

Pat Henkelman → with TV in background —

Cleaned homes in town. 4 Kids
Husband is deceased. 76 years old.
get up at 5 a.m.
Steve stops for breakfast every morning. He wants
creamy wheat or oatmeal, so that's what I
make for him. Say my morning prayers, take a
bath and eat breakfast.

A portion of Stephen G. Bloom's handwritten notes from his interview with Pat Henkelman.

Whatever their reasons, they wanted to share their stories. The more Peter and I listened, the more we realized we'd become confessors to an unheard and invisible America.

FOUNDED IN 1856, Oxford was a mail stop, first for stagecoaches, then for trains. In a contest to name the town, a little boy, Fred Cotter, drew slips of paper from a hat, and when "Oxford" was picked—to the pleasure of Mrs. W.H. Cotter, who had submitted the name because she had grown up in New York's Oxford Township—it stuck. By 1880, Oxford boasted eight hundred and ninety-one residents, five general stores, three hardware stores, two drug stores, three hat stores, two newspapers, three hotels, three churches, two undertakers, three physicians, four blacksmiths, and even an opera house. During Prohibition, the town was home to six rowdy saloons that somehow the local sheriff's office managed to overlook. Oxford's biggest claim to fame took place on September 18, 1948, when President Harry Truman passed through Oxford by train and stopped to give a five-minute speech.

By the time Interstate 80 was built and connected Oxford with Iowa City in the early 1960s, much of Main Street was closed down. Oxford is only sixteen miles from of the University of Iowa, a lively place (particularly for Iowa and especially on Saturdays after a Hawkeye football game), but it might as well be five hundred miles. Stroll down Augusta Avenue today, and chances are you won't see another person or even a passing pick-up.

This is not an uncommon small-town story. Much of rural America is dying. The median age is on the rise, as new generations seek metropolitan alternatives. Yet, step off the empty streets and inside the modest houses that line Oxford's Wilson or Nemora streets and you will still find a vital assortment of families and individuals, old timers and even a few newcomers, that continue to make their homes there.

Despite its withered exterior, Oxford, and the countless towns like it across the United States, continue to hold fiercely to their roots. They remain, in many ways, like large protective families, insulated and untouched by the energy and vulgarity of urban

Augusta Avenue looking north in Oxford, near the turn of the twentieth century.

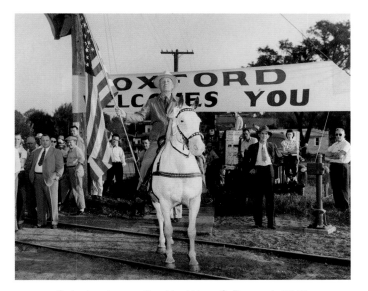

Oxford welcomes President Harry S. Truman in 1948.

commonly refers to a device that raises and lowers grain, not people. These are the kinds of characteristics and customs that have always defined rural communities, and they continue to endure.

THE PASSAGE OF TIME TAKES ITS TOLL. Life transforms us. In addition to inexorable signs of aging, our appearances change because of large and small tragedies. Hiccups to our health and happiness make an impact. Iowa's harsh winters and scorching summers do, too. Electric smiles have ripened into middle-aged frowns. Full heads of hair are now thin and gray. But in these time-lapse photographs, there are also Oxford men and women who have blossomed, just coming into their own. Some sparkle with possibility and exuberance.

Peter's portraits of the residents of Oxford and their own deeply felt words combine to create a national portrait of overlooked triumphs and travails. In the faces and voices of these strangers, we grow to understand ourselves better. They remind us of who we dreamed we would become, and who we turned out to be.

America. Oxford's still the kind of place where drivers don't put on their turn signals because everyone knows where everyone else is going. Almost everyone's phone number starts with the same prefix (828). Dinner and supper are two different meals. Everybody knows what a mudroom is—and has one. The word elevator more

OXFORD TRUISMS

Every small town has its own quirks, traditions, and conventions. Oxford is no exception.

The names Grabin, Jiras, Hennes, and Portwood are as common in Oxford as Garcia, Lee, Chen, and Cohen are in big cities. Almost everyone in town seems related because, if you go back far enough, they are—either by birth, marriage, or both.

Naming all your children with the same first letter is not uncommon.

Living more than ten miles away from where you grew up makes you exceptional.

Backdoors are how you almost always enter a house.

Religion is fundamental—whether it's Catholicism, Mormonism, Lutheranism, Evangelical Christianity, or Buddhism. But going to a house of worship is optional.

Bar fights are not a weekly occurrence, but neither are they an infrequent activity.

Alcohol and alcoholism figure in many residents' lives, and to a lesser degree, so does mental illness.

Collecting is a popular pastime—from lamps and figurines to tractors and engines.

Food is of great significance, as are recipes. Kolatches (Czech pastries) and Red Waldorf cake are popular desserts. Meat (meatloaf, steak, pork chops) and potatoes are king. Sliced deer meat cooked in cream-of-mushroom soup, square meal hamburger, and biscuit dough squares are also favorites.

Everyone has the same no-fail pie crust recipe, but no one can remember where it came from.

Driving a semi is a dream held by not just a few men in town. Pickups and cars tell a lot about the driver, as well as about the women who admire them.

Hats are essential.

Pliers and pocketknives are necessary tools; many men won't leave home without them.

Travel is O.K., but living in the big city brings all kinds of headaches, and is not recommended. Alaska is a dream vacation destination.

Deer may be pleasant to look at, and their racks (antlers) treasured, but deer can also be deadly. Almost everyone has hit a deer with a pickup or car at least once.

Farming is a dangerous livelihood. Losing digits and limbs is a risk that goes with the job.

Mushrooming, deer hunting, fishing, gardening, scrap booking, and playing bingo and euchre are popular ways to pass the time (and meet suitors, single or married.)

Oxford residents have *lots* of pets—dogs, cats, goats, hens, raccoons, rabbits, lions, ponies, horses, burrows, and peacocks.

Having children is important, although marriage is not a prerequisite to parenthood.

A person's life can drastically change by stopping off for a drink at a local bar.

If you're not an Oxford native, you'll never be a local, even if you live there for fifty years.

Few residents have been to college. Many say it's their biggest regret in life.

When someone dies in Oxford, big funerals are expected, as are casseroles.

"I'm satisfied here. Never thought of moving. My roots are too deep. I like the small-town atmosphere."

—Mayor Don Saxton

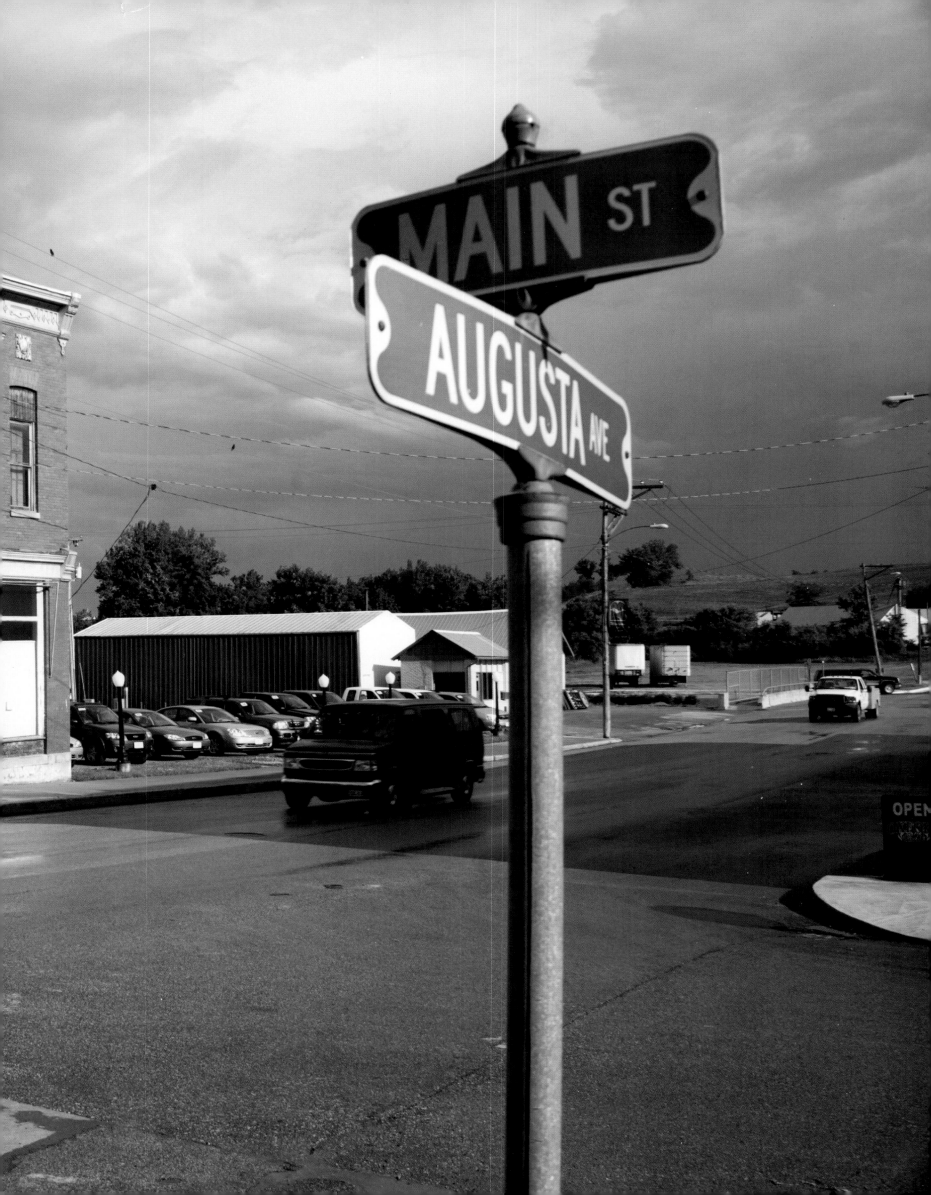

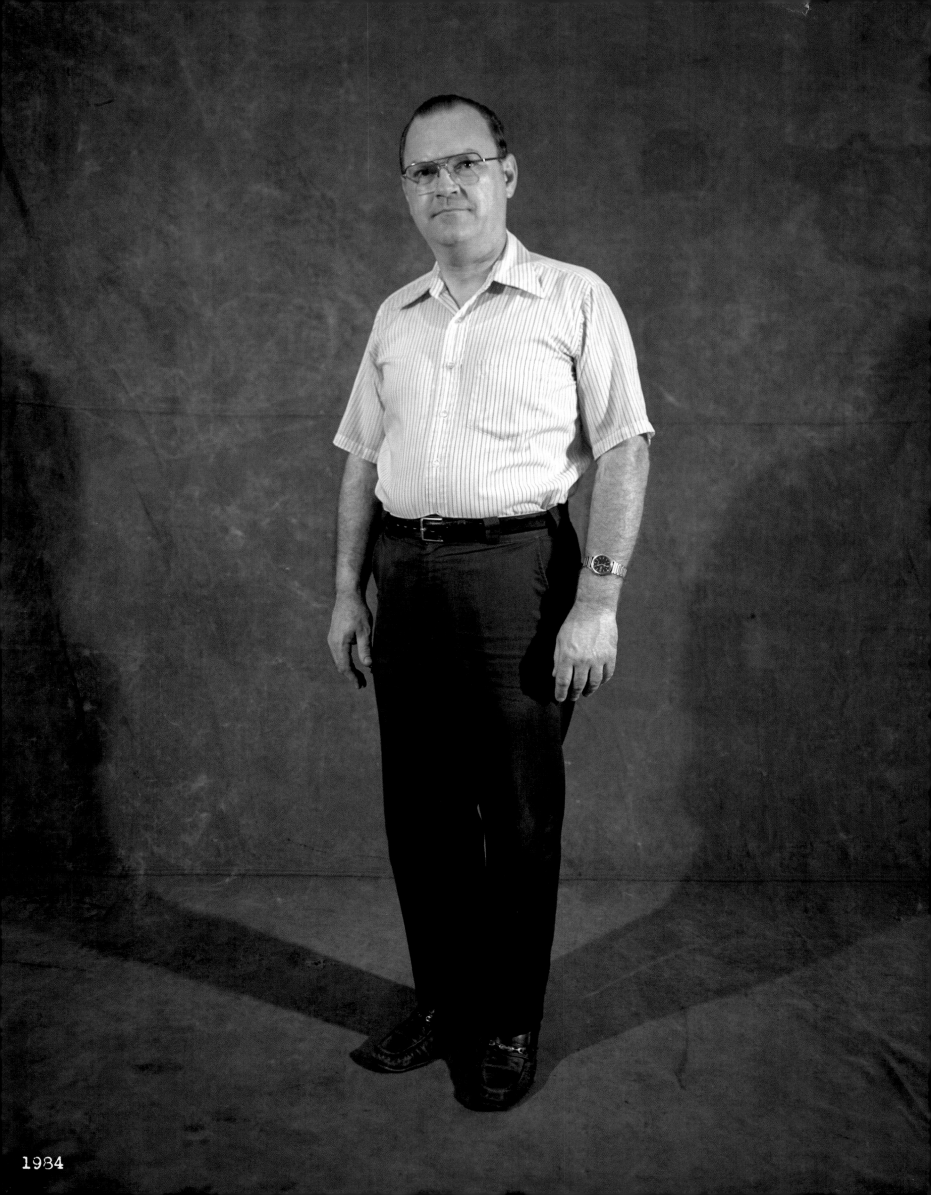

1984

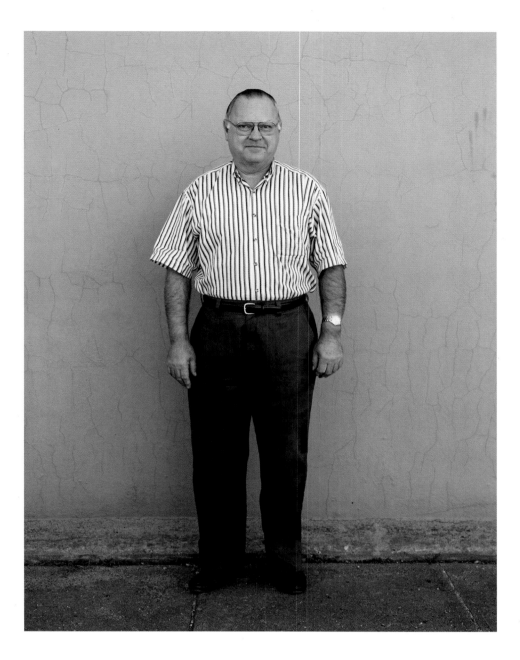

DON SAXTON

MY LIFE REALLY HASN'T CHANGED. Maybe I've put on weight, but not much. Ten pounds, tops. I haven't lost much hair. My health is still good. I still go to church every Saturday night, and I still sing in the church choir.

I'm retired from teaching high school typing, business, and accounting. Sometimes I substitute, but I really don't like that. When you retire you ought to mean it. There are people who say they're bored. I believe them, but I feel sorry for 'em.

I'm satisfied here. Never thought of moving. My roots are too deep. I've been mayor since 1974. I like the small-town atmosphere. For as long as I can remember, I've been having coffee and donuts with the same men at five-thirty every morning. I've been to lots of the larger cities once or twice—Dallas, Miami Beach, Chicago, New York—but I'm always glad to get back.

I collect antique cars. I have a '26 Model T, a '31 Model A, two '51 Chevrolets, a '54 Chevrolet fire truck that was in service for the city of Oxford for forty-four years, three Oldsmobiles ('60, '72, and '74), two Buicks ('50 and '66), and three tractors (two '53 Old Reds and a '54 Farmall).

There was a time in Oxford when we had two farm implement dealerships, a drugstore, a hardware store, a general merchandise store, three grocery stores, three gas stations, a welding shop, a Chevrolet dealer, a Ford dealer, a bank, three cafes, a weekly newspaper, a physician, a dentist, and a hotel.

All that's gone now.

DON SAXTON (b.1939)

"I make donuts at the Depot. I'm up to eleven dozen a day—chocolate cake, long johns, cream-filled bismarcks, cinnamon rolls, raspberry-filled croissants, apple turnovers, donut holes, and crullers."

—Kathy Tandy

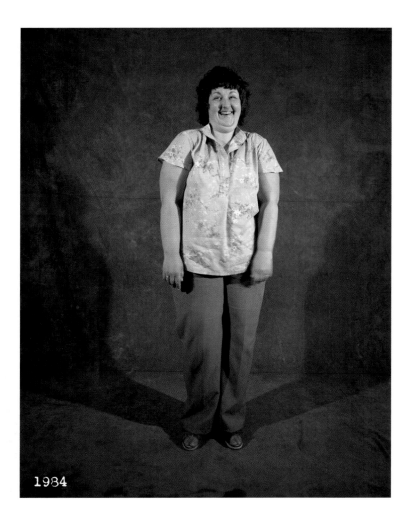

1984

"Everyone in town has always known me as the 'Big Girl.' The worst I ever got was 432 pounds. Bob Cochran had to weigh me on the livestock scale down at the Sale Barn."

KATHY TANDY

I MAKE DONUTS AT THE DEPOT. I'm up to eleven dozen a day—chocolate cake, long johns, cream-filled bismarcks, cinnamon rolls, raspberry-filled croissants, apple turnovers, dounut holes, and crullers.

I also cook lunch. Today I grilled twenty-six rib eyes. Meat loaf or chicken-fried steak is the most popular. We serve it with party potatoes—they're mashed potatoes mixed with cream cheese, sour cream, and butter.

On a big night, Gomer and I might go to Applebee's, Country Kitchen, or Wendy's. Gomer's a meat-and-potatoes kind of guy. Gomer can drink twelve cans of Pepsi a day. But he's a recovering alcoholic, so I'm not complaining.

Everyone in town has always known me as the "Big Girl." The worst I ever got was 432 pounds. Bob Cochran had to weigh me on the livestock scale down at the Sale Barn.

I couldn't walk around the house. I couldn't fit into a seat at the movie theatre. I never went to a restaurant because I thought I'd break the chair. If I was lucky, they'd show me to a booth, but then I'd be afraid I wouldn't be able to fit in. I'd go into someone's house and die from embarrassment when the floorboards creaked. I couldn't take a bath because I couldn't get out of the tub. The body odor problems were awful. You get up and walk to the other side of the room and you break into a sweat.

People can be cruel, but everyone in Oxford's been supportive. They've sent me cards, even flowers. As I started losing weight, they'd call and say, "You look great! Keep it up!"

I've tried them all—Atkins, South Beach, Slim-Fast, Weight Watchers. Now all I do is try to eat sensibly. Last time I weighed myself, I was 260 pounds. I want to get down to 220.

Gomer doesn't like to travel, but that's not gonna stop me. In a month, I'm leaving for Germany, Austria, and Amsterdam with a girlfriend. Gomer can get along fine without me. He doesn't like to sleep alone. He says that's what he misses most.

KATHY TANDY (b. 1952)

26

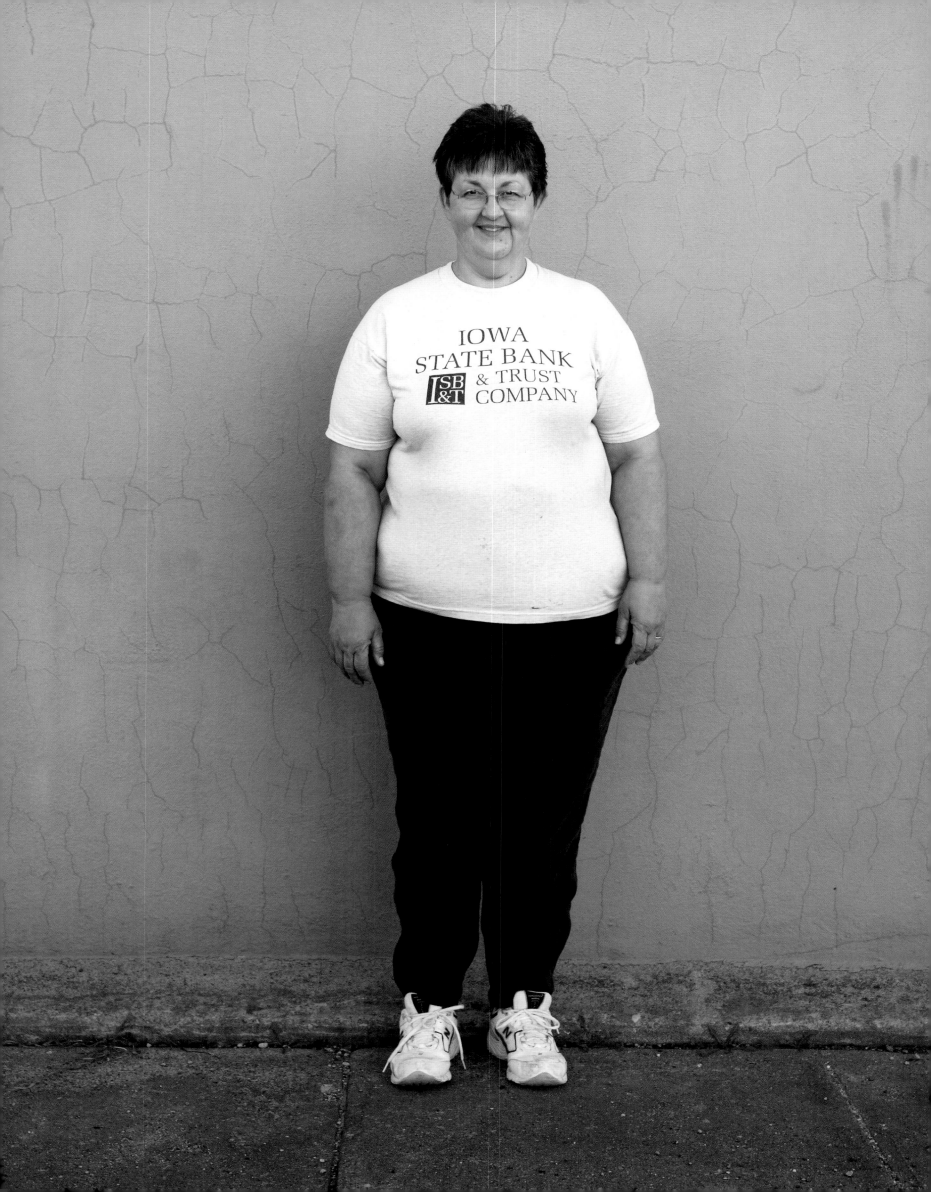

1984

"When your family is as longstanding as mine, everyone knows you. I've always been Gomer's boy or Ray's grandson." —Bob Tandy

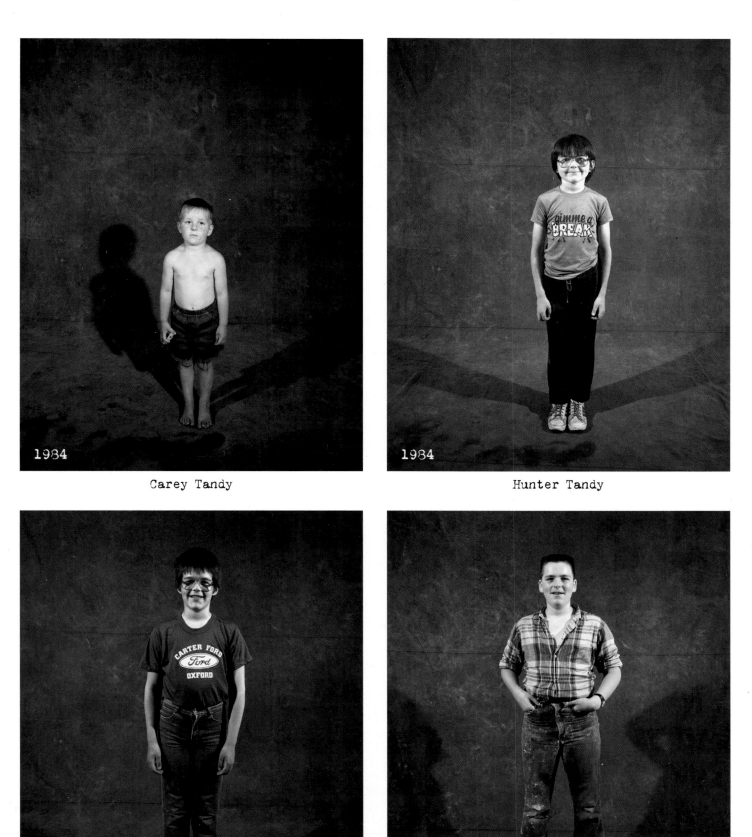

Carey Tandy

Hunter Tandy

Bill Tandy

Bob Tandy

OPPOSITE: Kathy Tandy's husband GOMER TANDY (b.1946)

ABOVE AND INSIDE GATEFOLD: Kathy and Gomer's sons CAREY TANDY (b.1980), HUNTER TANDY (b.1975), BOB TANDY (b.1971), and BILL TANDY (b.1972)

HUNTER TANDY

TWO MONTHS AGO, I moved to Ida Grove to run a remodel and repair shop. That's what I'll probably be doing in ten or twenty years.

When I was a kid, I said I'd like to be buried in an eighteen-wheeler when I died. I still do. I always wanted to be a truck driver like my father.

Ashton Kutcher is my second cousin. Ashton and his wife Demi Moore came and visited me sixteen or eighteen days ago. They surprised me. Ashton called and asked where I was living and then they just showed up. They stayed at the Super 8.

Ashton and I played a round of golf, and she stayed at the motel. When we got back, we all sat around and shot the shit. Demi is pretty cool. She's really levelheaded, a real nice person. I told Ashton, "You are one lucky son of a bitch!"

She's kinda like the rest of us.

BOB TANDY

I'M THE BLACK SHEEP OF THE FAMILY. I read everything I could get my hands on. I went from science fiction to military history to superhero stuff. I loved Edgar Rice Burroughs. I must have read Louis L' Amour's *The Walking Drum* fifty times.

I still get a lot of grief for having a college degree. My family is proud on one hand, but it's really not talked about because it makes me different from my brothers and the extended clan.

I wanted to get out of Oxford in the worst way. I didn't fit in. When your family is as longstanding as mine—we've been here since the 1850s—everyone knows you. I've always been Gomer's boy or Ray's grandson. The difference is that now I'm proud of that fact.

Our first child, Britton Elise, died as an infant almost three years ago. The doctors believed she died of placental abruption, which is a Latin term for Bad Fucking Luck. For six days my daughter lived in the hospital. She got to meet all of her cousins, aunts, uncles, grandparents, and two great-grandmas. There'd be eight, ten people singing to her. We took her outside. I wanted her to feel the breeze, and hear the birds and other children playing. She's buried next to my grandmother, and at her feet are my great-great-grandparents and a great-great-grandaunt and uncle.

That's Oxford. People have family feuds. They bitch. But when the shit hits the fan, people who on Wednesday were pissing and moaning, they'll be helping each other get through whatever you need them for. Then by Friday, they'll be calling each other assholes again.

Charisma and I now have a year-and-half-old daughter. Her name is Isabella Noel, which means Beautiful Gift. Are we better parents after losing Brit? Absolutely. Smelling the smells, tasting the tastes, knowing it could be gone—it changes you. Life is a pretty thin string.

"I always wanted to be a truck driver like my father." —Hunter Tandy

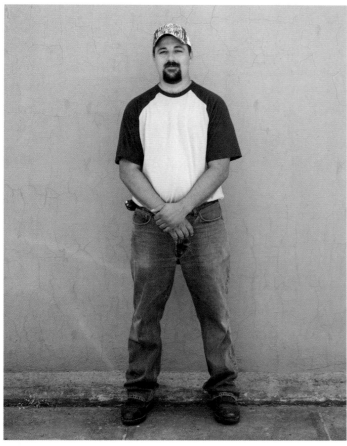

Carey Tandy

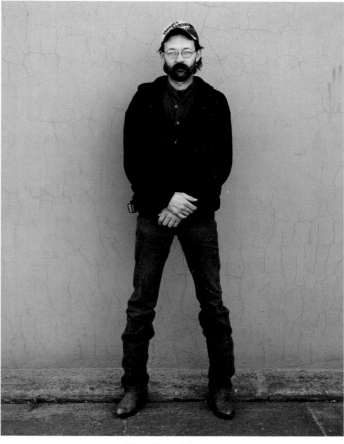

Hunter Tandy

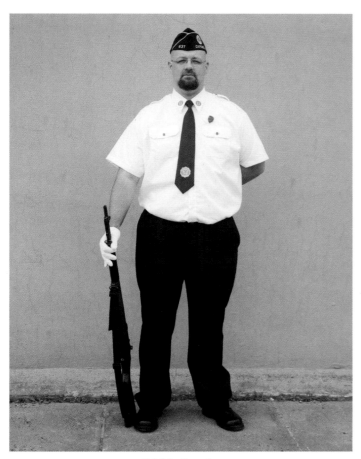

Bill Tandy

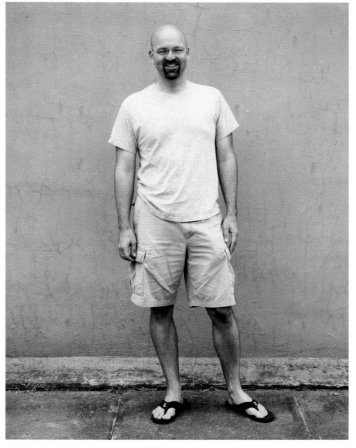

Bob Tandy

"I think about my dad every day. I remember
feeling his beard against my face. I remember
his hands—they were soft and warm."

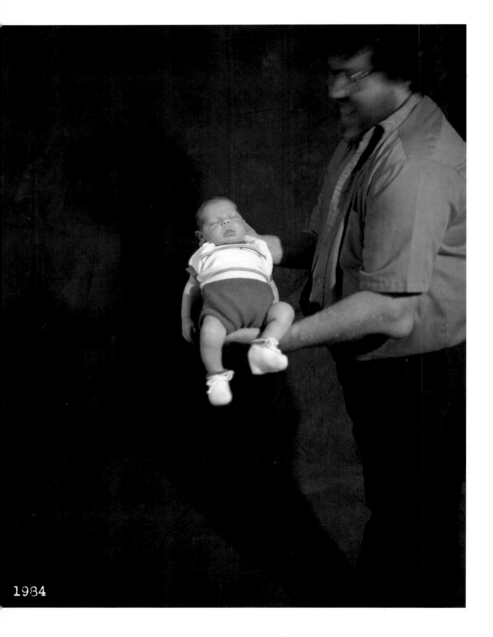

1984

BEN STOKER

WHEN I WAS TEN, MY DAD DIED. He had renal failure.
He used to take me to his office on Saturdays, and in the
afternoon we'd catch a Kernels game. Pretty much I think
about my dad every day. I remember feeling his beard
against my face. I remember his hands—they were soft
and warm.

Two years ago when I was nineteen, my mother died
of cancer. She was my guiding light.

I was very angry with God. He came and took my
father and then he took the other person I loved most in
the world. I'd be a liar if I said everything is all right. I know
I'll spend an eternity with both my parents. Two sayings
come back to me: "He's not going to put you through
something you can't handle," and "What doesn't kill you,
makes you stronger."

I have dreams, mostly of my mother. I dream that my
family is in Disney World and we're going from ride to ride,
but my mother's the only one not talking.

I started at Luther College two months after my
mother died. It was too soon. I turned into a party animal.
I needed to fix my life, so I came back to Oxford. I used
to want to study pre-med, but lately I've been thinking of
becoming a teacher. My mother was a teacher.

I want to have a family. I could care less if I make a
mark on the world. I just want to be the best father I
can be.

A lot of people don't like small towns because they're
so tight-knit. But that's what makes this place so great. You
know who's sleeping with whom, but when your mother
dies, you also know there'll be twenty-eight people at your
door with casseroles.

ABOVE AND OPPOSITE: **BEN STOKER** (b.1984), held by his father in 1984
FOLLOWING PAGES: Ben's parents **DARNELL STOKER** (1953–2004) and **DAVE STOKER** (1949–1994)

32

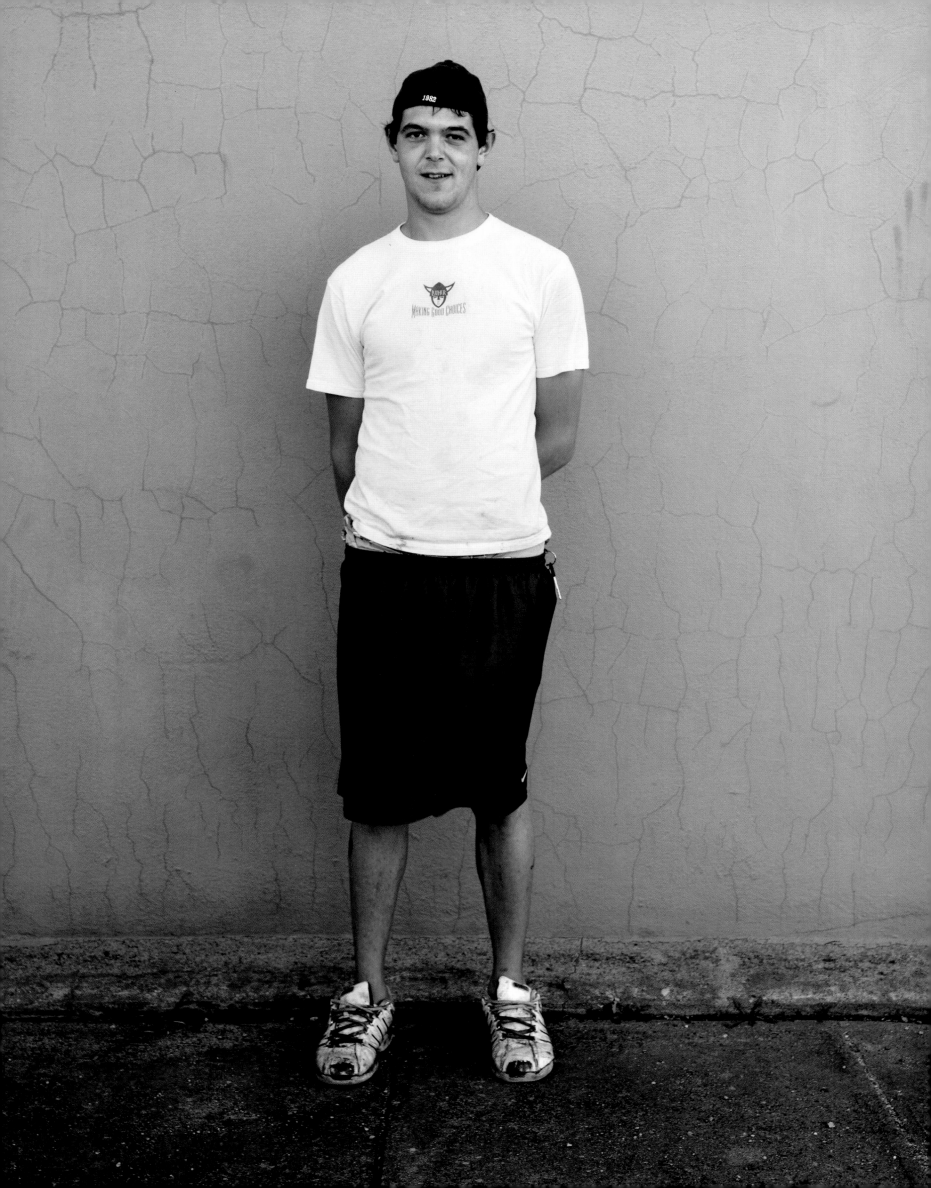

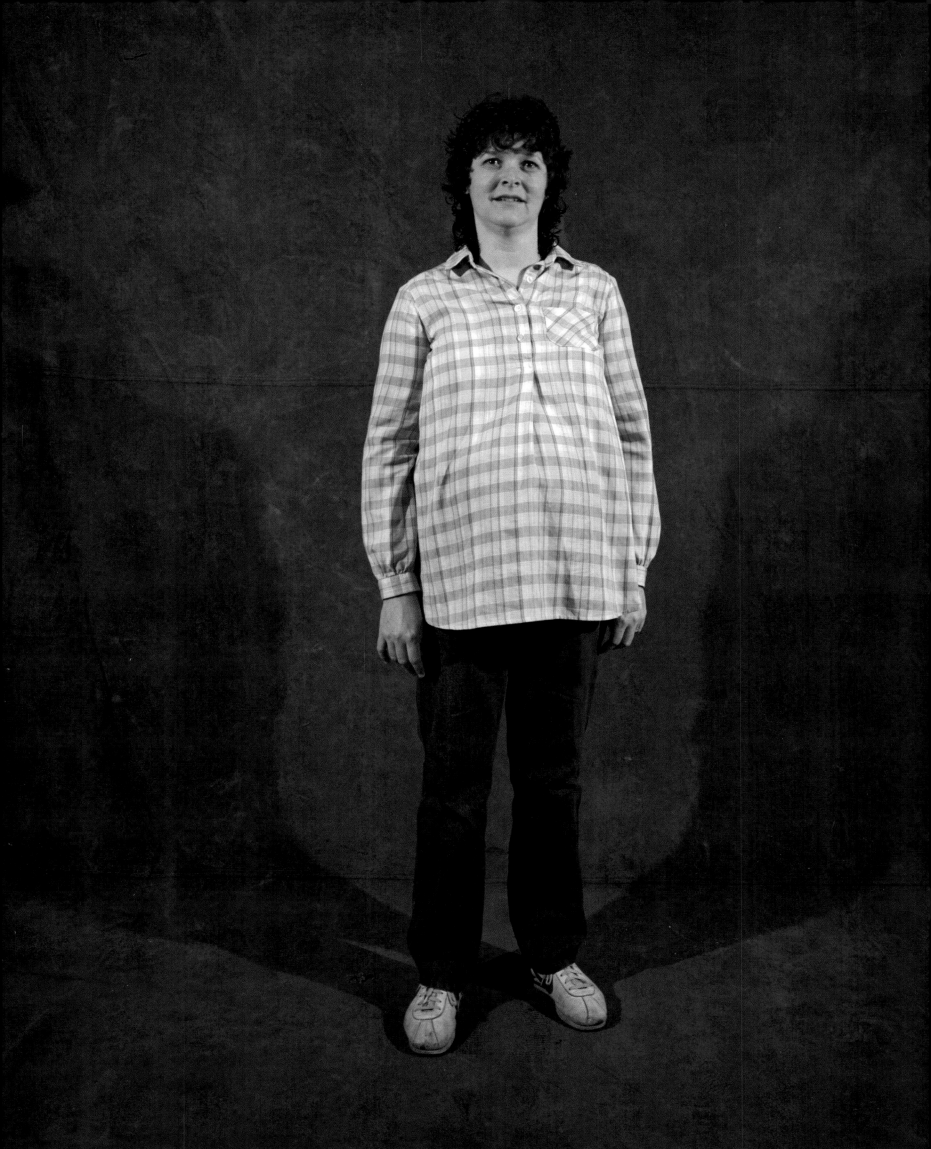

1984

DARNELL STOKER

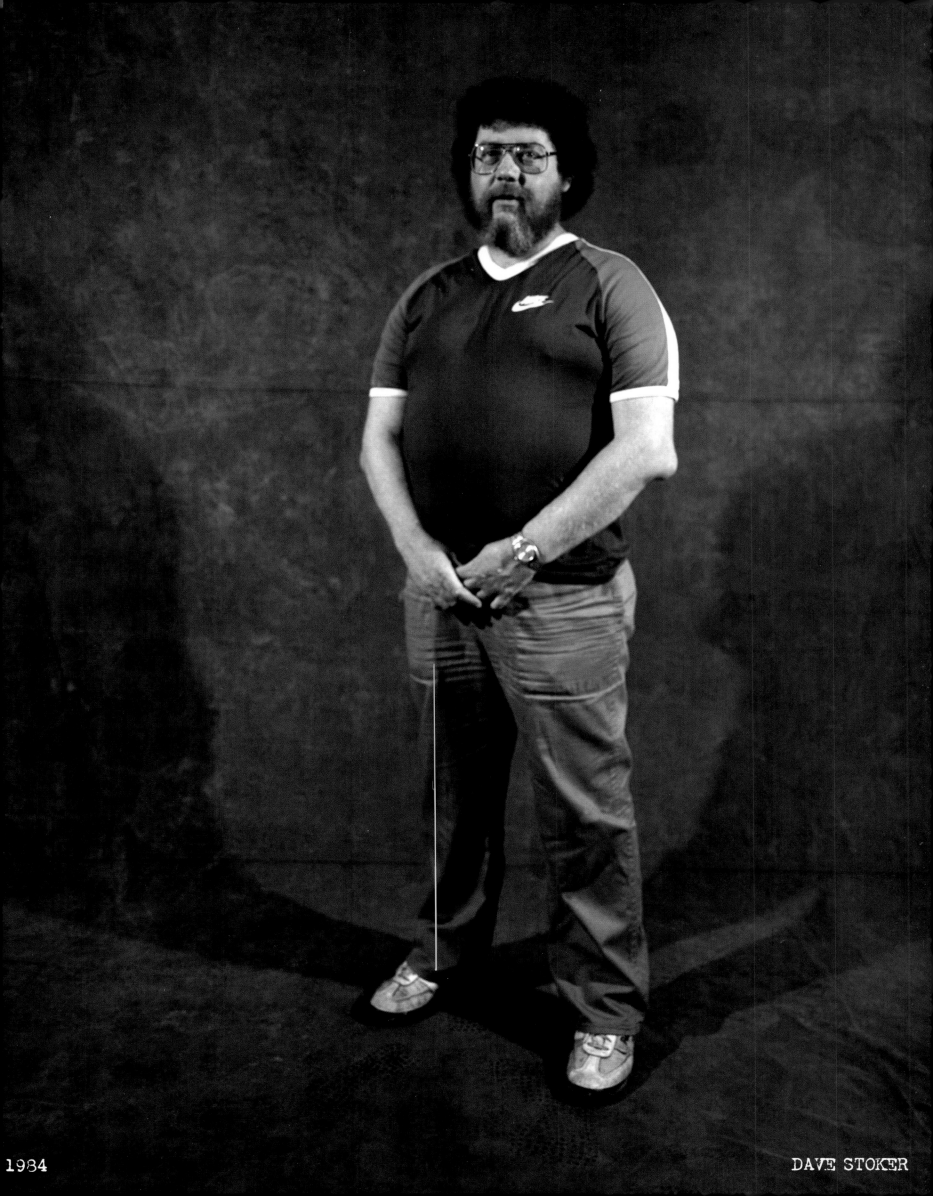

1984

DAVE STOKER

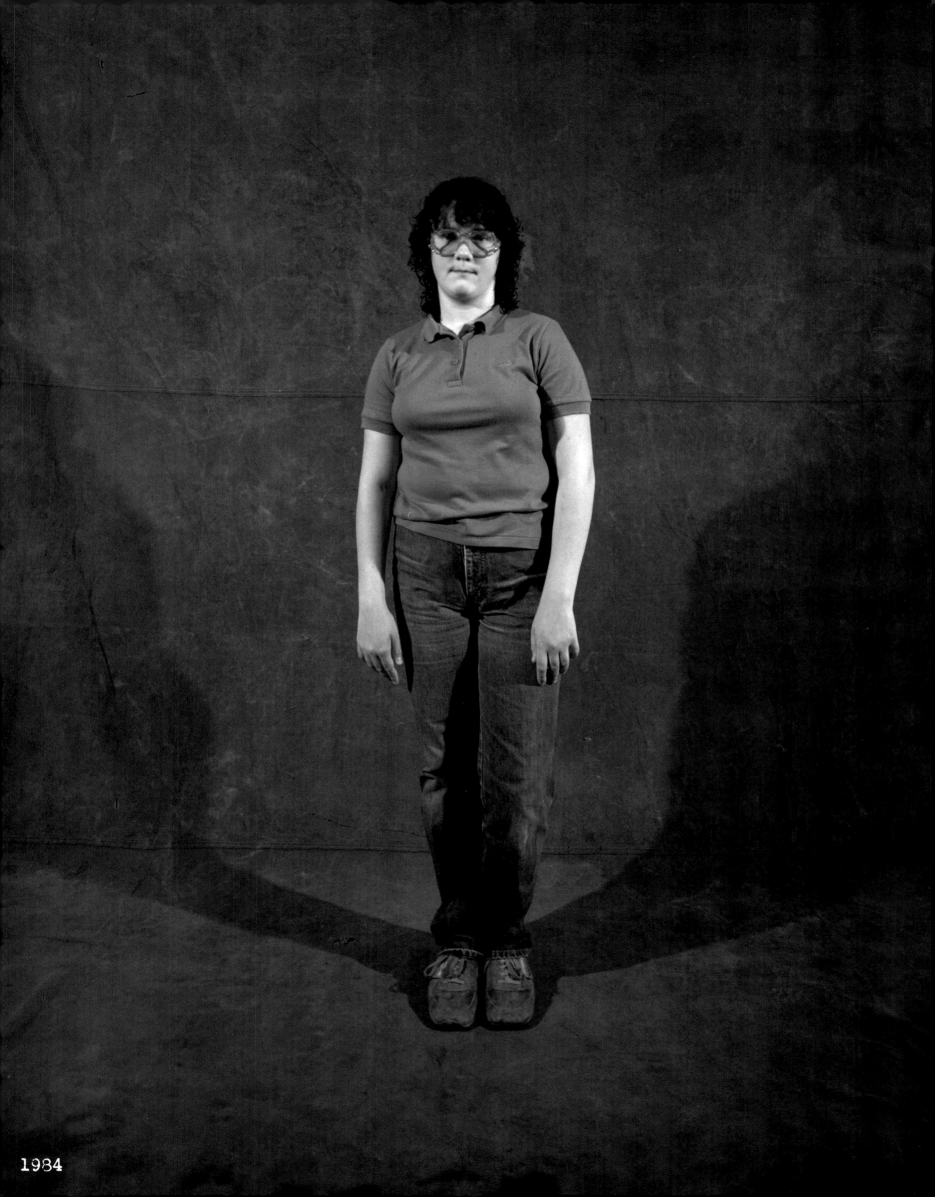

1984

"Whenever I come back home, a sadness comes over me. I don't belong and I never belonged."

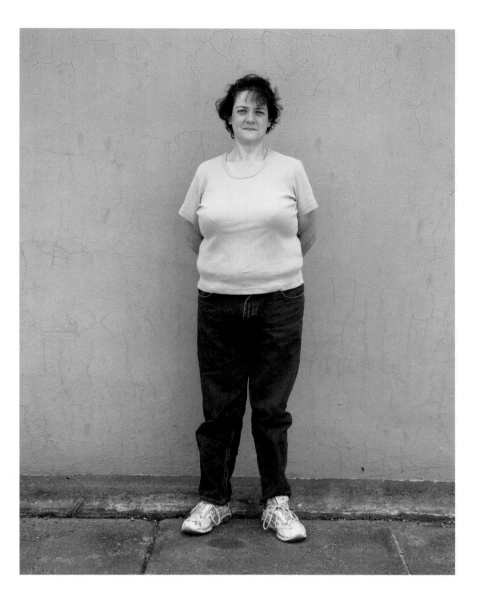

ROBIN ELLEN STOKER

KIDS USED TO CALL ME THE "FAT GIRL" OR "BRAIN." I was very shy. Eating was a source of comfort and a way to hide. I started wearing a bra in the second or third grade.

I met Karen when I worked at a theatre in Amana. A week later, we went on our first date. When I told my mom, I think she cried, but in front of me, all she said was that she was disappointed. Mom told my brother Ben, "You need to hate the sin, not the sinner."

My grandfather Darrel and I don't talk. In the last year or so, it's been a little better. Whenever I come back home, a sadness comes over me. I don't belong and I never belonged. It's too bad because I think I'm pretty cool, and I think I have a lot to offer.

I'm guessing that my top weight was 350 or 360. To fit in my car, I'd have to move the seat back so far that I couldn't reach the pedals. When I'd be in a women's bathroom, I couldn't navigate the door to get out of the stall.

I had gastric bypass surgery last year, and since the operation I've lost 120 pounds. I feel great.

Karen and I want to start a family in two or three years. We already have a donor. It's a boy I dated through college. Karen's going to carry the baby.

Karen and I have been together for eight years. I tell her all the time, "I love your big, sexy brain."

Ben Stoker's sister **ROBIN ELLEN STOKER** (b.1973)

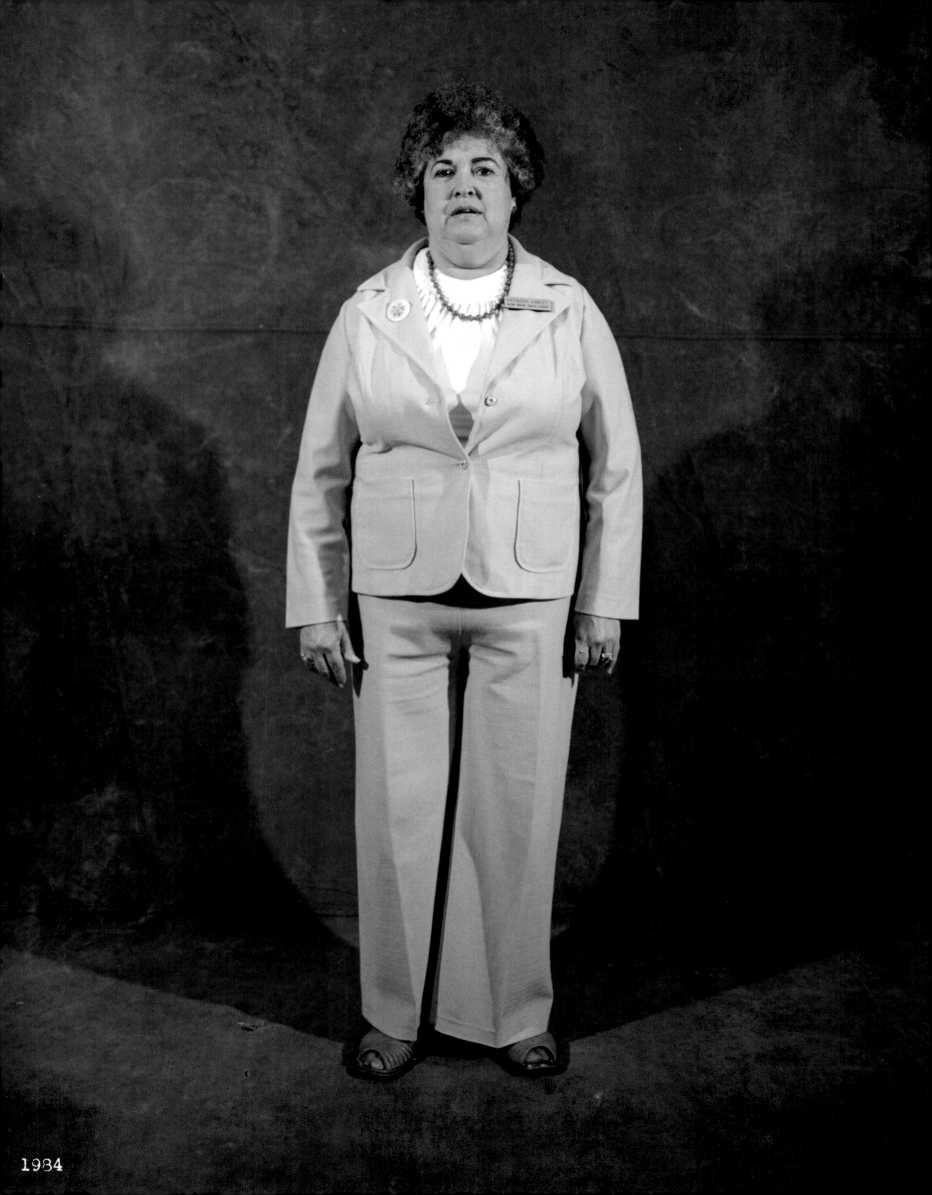

1984

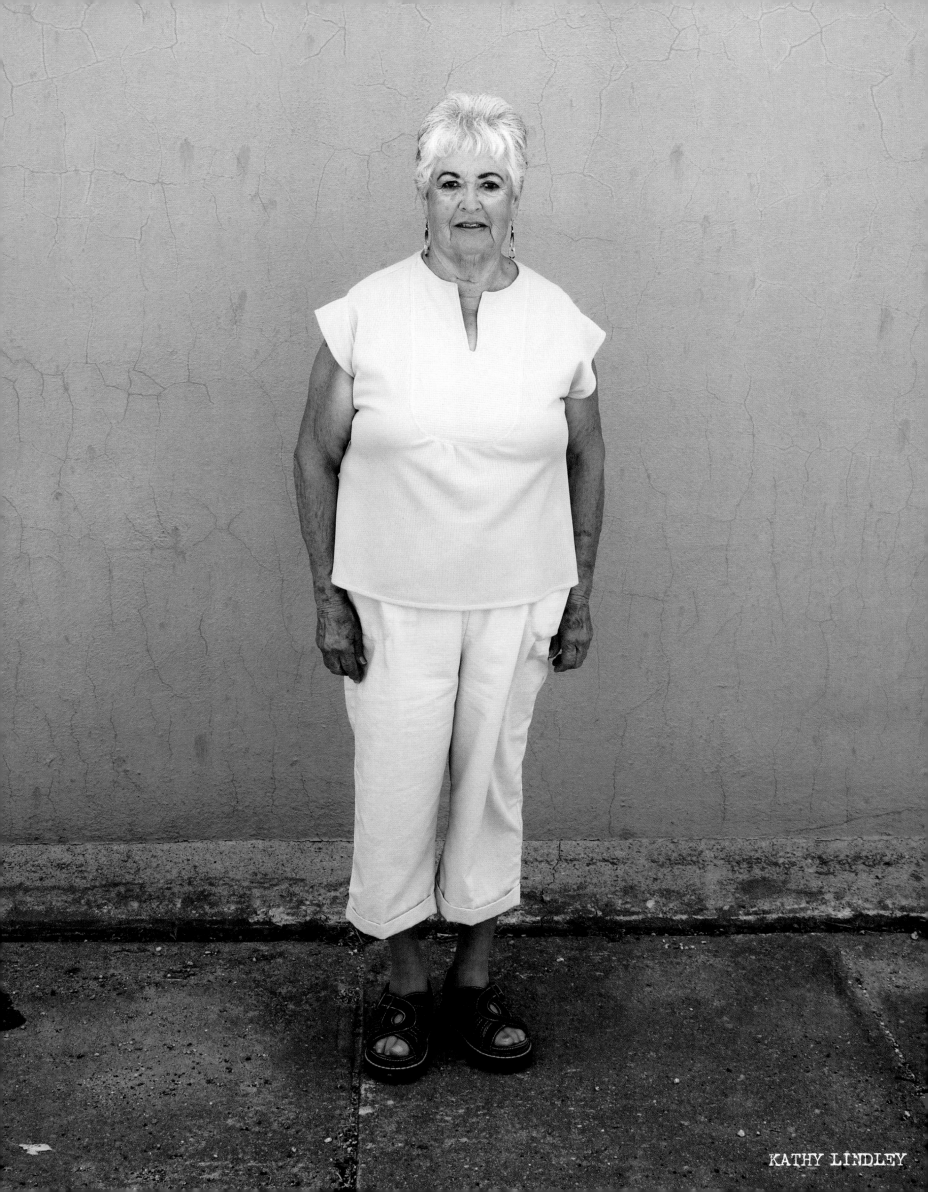

KATHY LINDLEY

"We lost one of our daughters to cancer two years ago.
I still talk to Darnell every day. The last thing she
said before she died was, 'I love you, Dad.'"

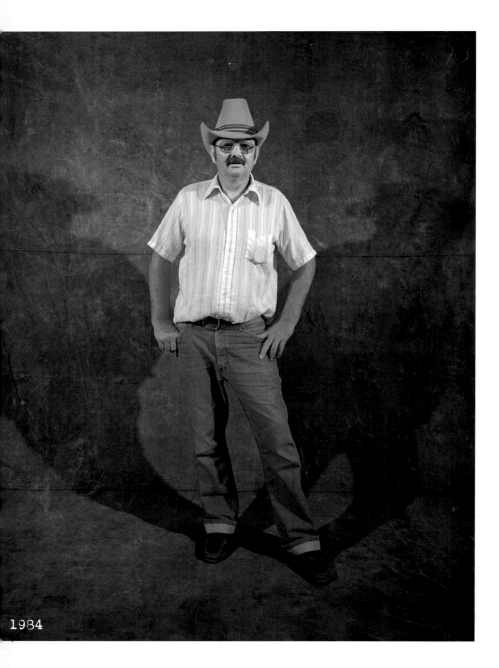

1984

DARREL LINDLEY

I SHOOT 'EM, BLEED 'EM, THEN SKIN 'EM. I do hogs, cattle, goats, buffalo, and sheep. I use a .22 Magnum. After I shoot 'em, I cut their throats. Hogs, I stick 'em underneath in their brisket.

Tomorrow I'm going to do four hogs. That'll take me four hours. Hogs I get twenty-four dollars apiece. Cattle is fifty dollars, plus the hide. There was a time when I'd work five or six days a week. I had customers in seven counties. I used to do five to six thousand head a year.

One thing I do, if there are kids around, is I cut out the eye (it's a little smaller than a golf ball), and I swish it around my mouth. The kids can't believe that. Then I give the eyeballs to the health teacher at the school so the kids can dissect it.

We lost one of our daughters to cancer two years ago. I still talk to Darnell every day. She had a great sense of humor. Always did, even as a little girl. The loss of a child is about as bad as it gets. The last thing Darnell said before she died was, "I love you, Dad."

The invasion of Iraq was very foolish. We never should've gone there. A just war is one thing, but this war isn't just. Bush isn't honest. He's an idiot and a coward.

I don't have a lot of disappointments. I wish I had charged people more, maybe then I'd have more money now.

ABOVE AND OPPOSITE: **DARREL LINDLEY** (b.1933) PRECEDING PAGES: Darrel's wife **KATHY LINDLEY** (b.1933)

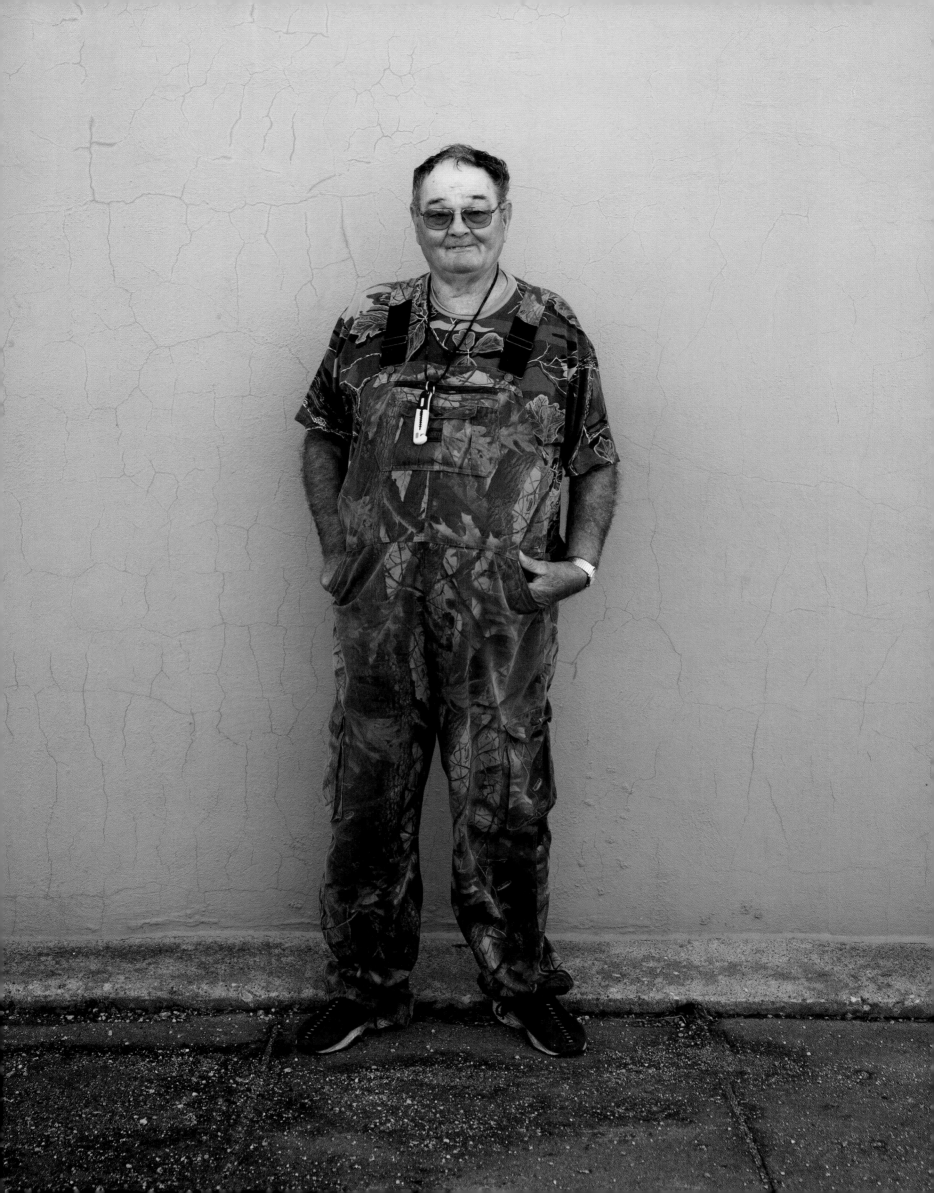

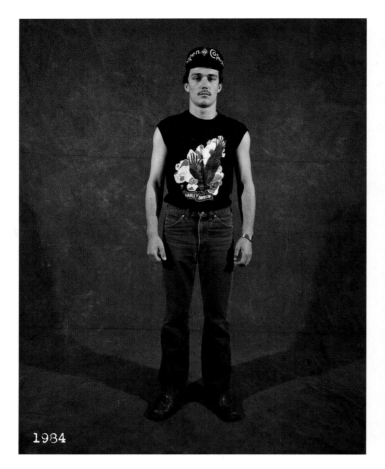

1984

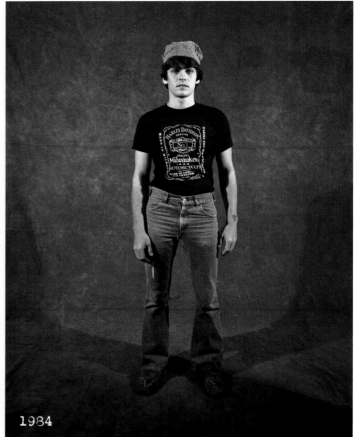

1984

Jerry Lindley

"You can trust everyone in this town—
from Highway 6 to the Interstate."

BOB LINDLEY

KATHY AND DARREL ADOPTED US when Jerry was three and I was eight months old. Our natural mother gave us away. She's still around, but I don't care to find her. Our biological father committed suicide six or seven years ago by nonstop drinking.

Jerry's always been angry at the world. He left school when he was in the eighth grade and got into drugs big time. He busted up a couple of teachers. Once he stole a guy's truck, got in a car accident, and killed someone. He's got a rap sheet as long as your arm.

One of the reasons I joined the military was to prove that I wasn't my brother. I went from Kuwait City into Iraq on the Highway to Hell and ran smack into the Republican Guard. I went over there with the guys I grew up with. We took care of each other. When you don't know if you're gonna be alive in two minutes, at least if you go, you know it'll be with your buddies around you.

I'm a Christian. If your life is helpful to others and you believe in the Upper Power, then you're O.K. I used to help Darrel out, going to homes butchering with him. We became a part of a whole lot of families' lives. We butchered for people who didn't have money, but that didn't make no difference. They still gotta eat.

Jerry's changed in the last couple of years. He don't do drugs and he don't drink. He's got a job and he's married now. Once you look through the tough guy, he's really a helluva of a nice person.

I like Oxford. You can trust everyone in this town—from Highway 6 to the Interstate. But one thing about Oxford is that if you're an outsider, you don't wanna cause any trouble. You mess with Oxford, you're gonna have problems.

My wife was my high school sweetheart. We've had some rough times. But it's important that my kids have a mom and a dad, and that we're the ones who raise them.

ABOVE: Darrel and Kathy Lindley's adopted sons, brothers **BOB LINDLEY** (b.1966) and **JERRY LINDLEY** (b.1963) OPPOSITE: **BOB LINDLEY**

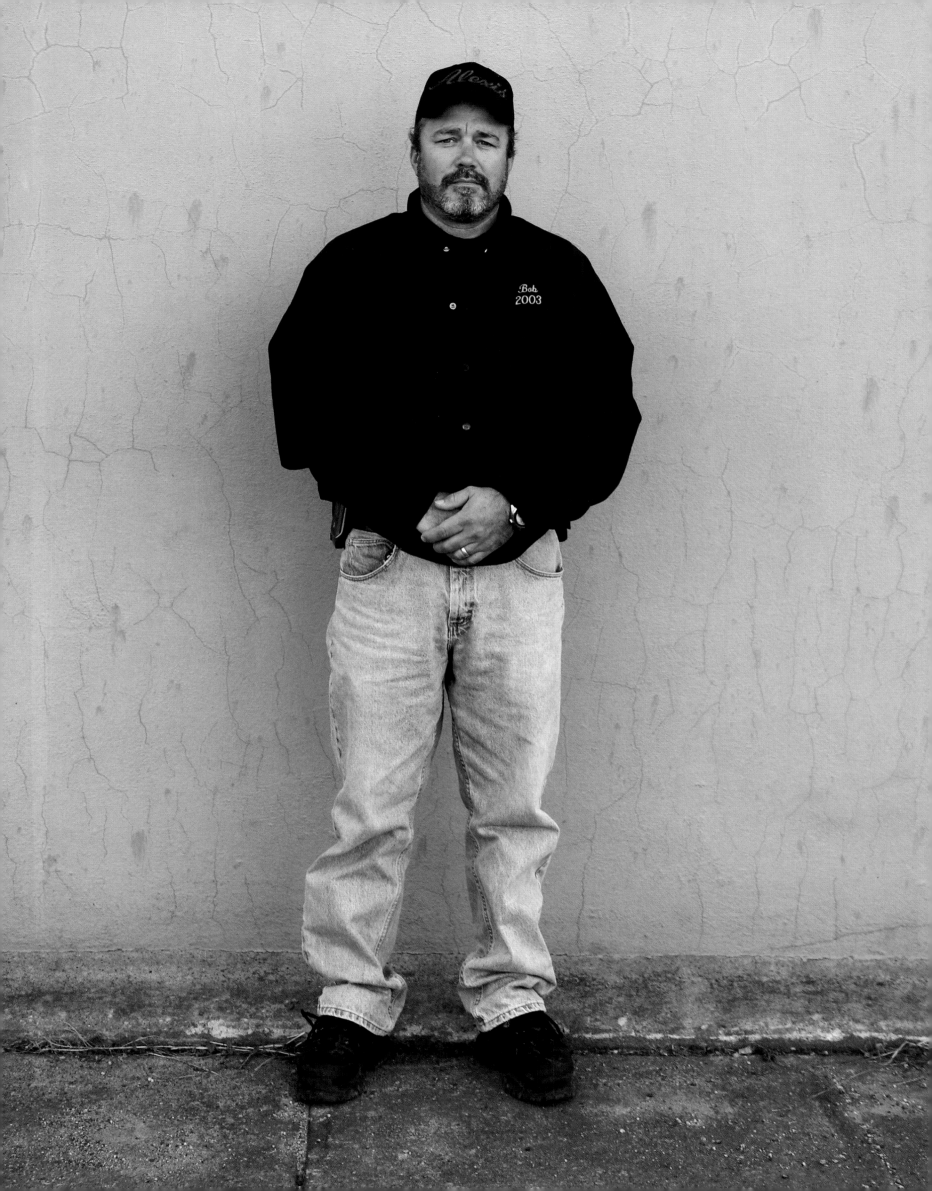

"We moved to Oxford in 1969. I was kinda leery. But a bigger house in a smaller town sounded awfully good."

—Linda Dolezal

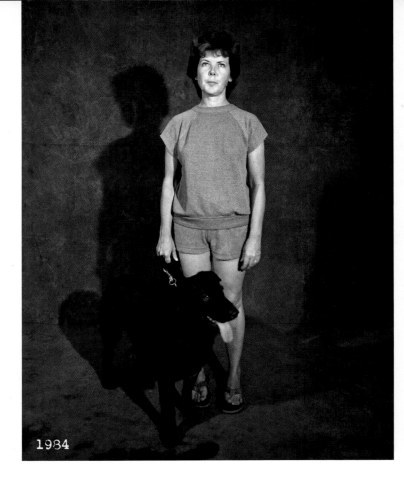

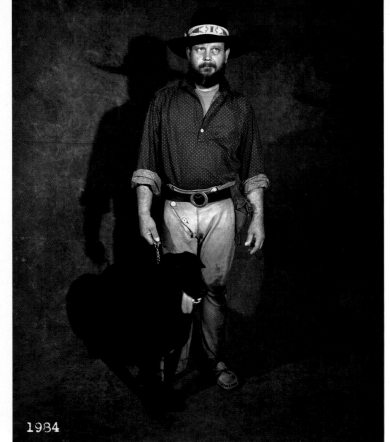

Jim Dolezal

LINDA DOLEZAL

JIM AND I MET ON A HAYRACK RIDE when I was thirteen and he was sixteen. We got married three years later. By the time I was seventeen, I had two children. That's all we ever wanted to do—get married and have a family.

We moved to Oxford in 1969. I was kinda leery. But a bigger house in a smaller town sounded awfully good. My mother brought her mobile home and moved it onto the lot next to our house.

One summer we got a pony. Our daughter wanted her to sleep in the house, so every night she'd walk the pony right down the stairs to the basement.

I became a grandmother when I was forty. I would have liked to have gone to college, but I was a stay-at-home mom. Our kids and grandchildren are everything to us.

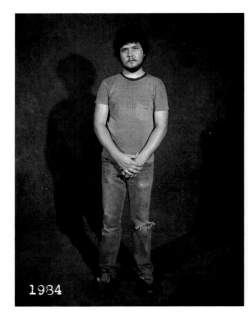

Mark Dolezal

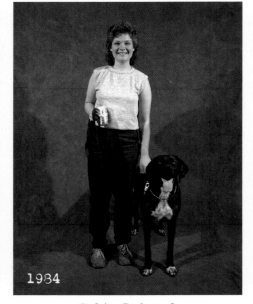

Julie Dolezal

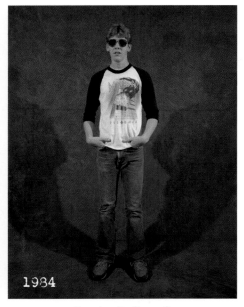

Jamie Dolezal

TOP LEFT AND OPPOSITE PAGE: LINDA DOLEZAL (b.1945) TOP RIGHT: Linda's husband JIM DOLEZAL (b.1942)
BOTTOM: Jim and Linda's children MARK DOLEZAL (b.1961), JULIE DOLEZAL (b.1962), and JAMIE DOLEZAL (b.1967)

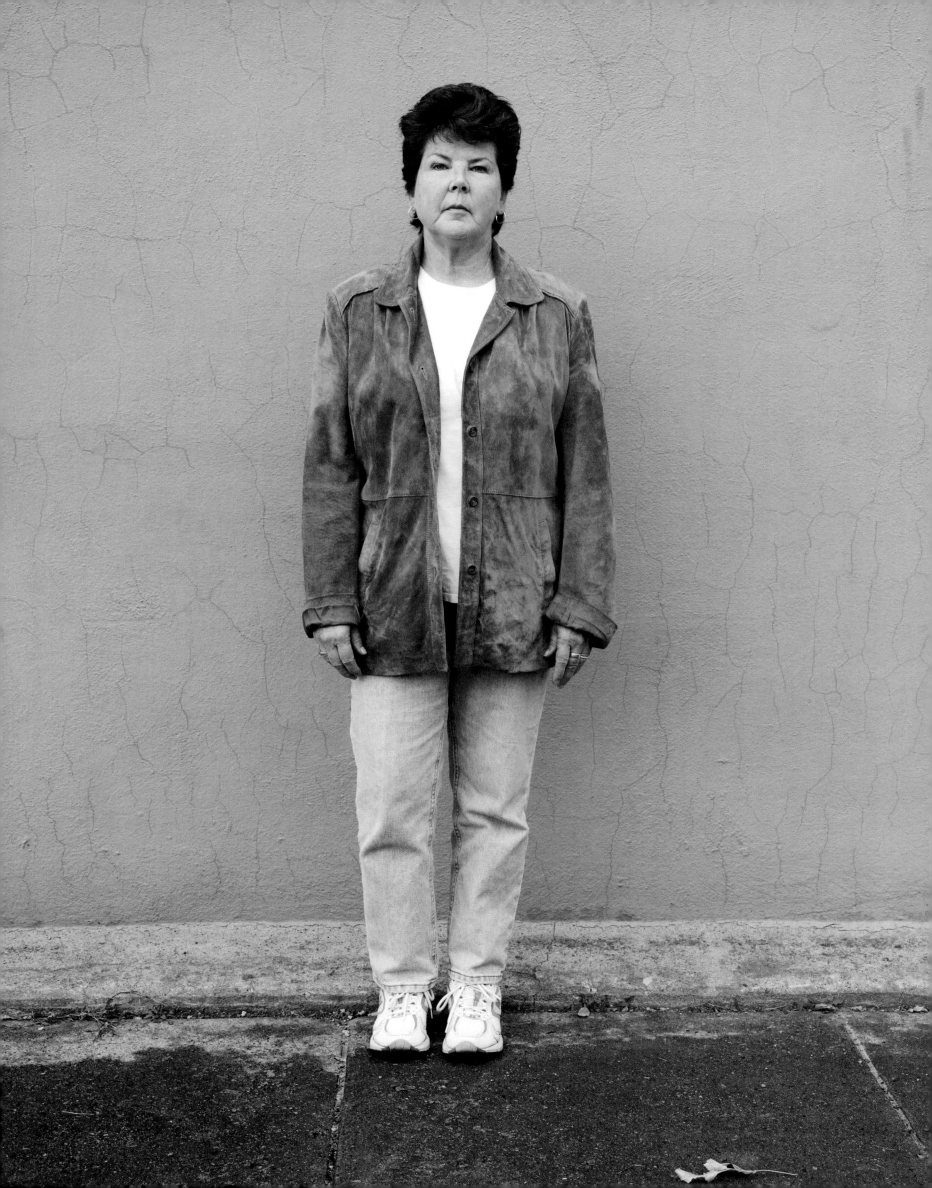

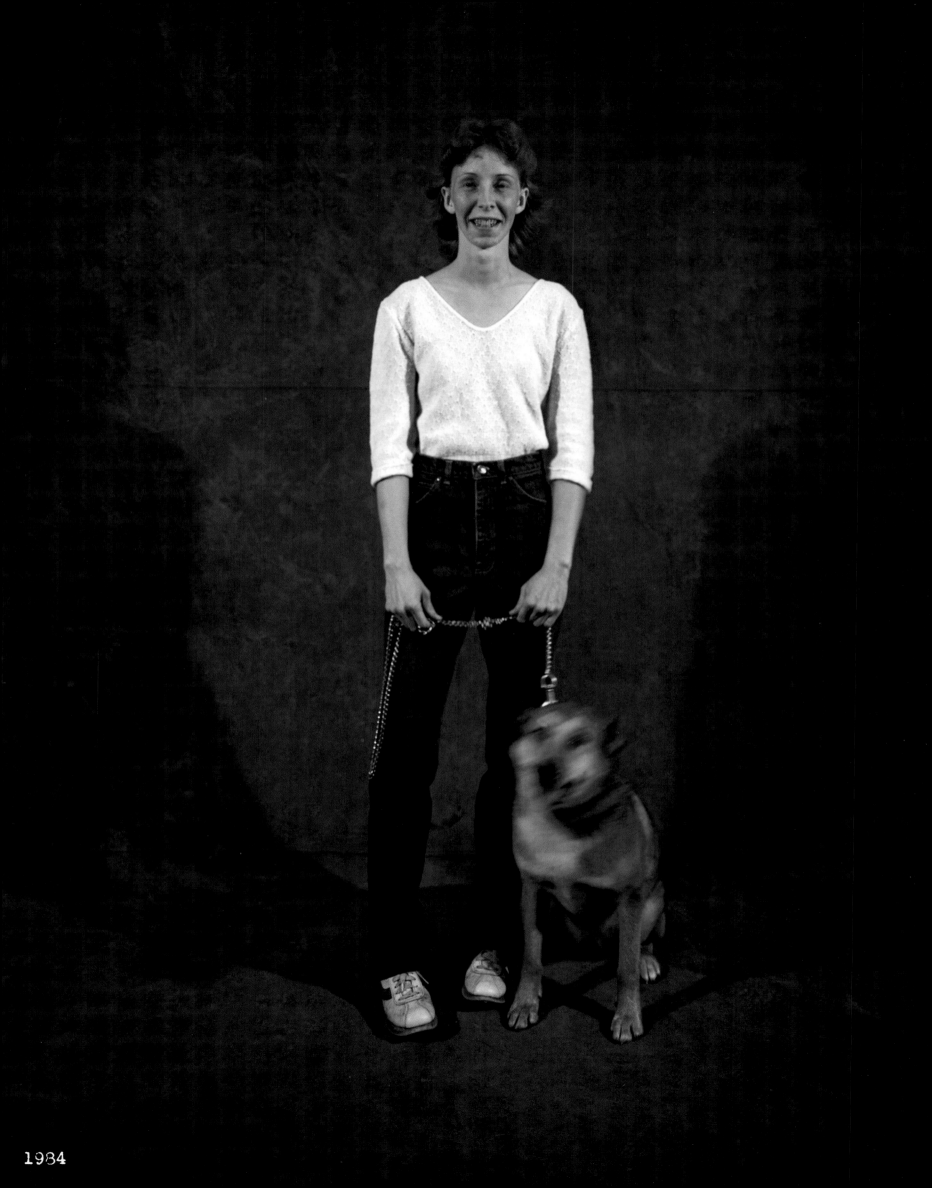

1984

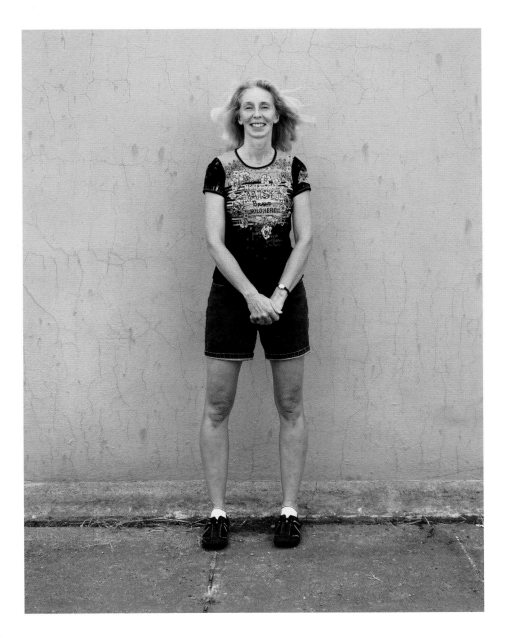

"When I moved to Oxford I was twenty-three. I wouldn't say people opened their arms to welcome me."

KIVA SHOGREN

MY MOM SAYS SHE GOT MY NAME from a movie, but she can't remember which one. Kiva's a Hopi Indian name, but it's also the name of a crater on the moon.

I found Goldie one day in Colorado. I was driving on a bridge and she was trying to get across. I hollered at her and she jumped right in my car and gave me a big slobbering kiss.

I moved to Oxford when I was twenty-three, and lived above the hardware store with Goldie and two cats (Bear and Stormy). No one warmed up to me. I think they thought I was a little strange. I was always on display and I felt vulnerable. People spread rumors about me. I wouldn't say they opened their arms to welcome me.

Then I got a job at Blooming Prairie, a natural food distributor that's run as a collective. There were hippies, gay people, lesbians, all selling organic food. I'm still there.

I met my husband at a bar in Iowa City. He was Catholic and I started going to church. I got baptized, which was important to me. We had two children. But his routine was more important than mine, and he left after eight years.

I was lonely, and one day I was walking my dog in town and I met Tim. He was working on his car. We got married and have another daughter.

KIVA SHOGREN (b.1961), with her dog Goldie

"One night under a full blue moon my mother went to a park and delivered me by herself."

1984

BARBARA BOYLE

SAGE AND ZEUS ARE GREAT PYRENEES. They'd been abused and dumped. It took four weeks to catch them. I used another Great Pyrenees as bait. I laid flat on my back with treats in both hands.

To this day, I can't get them into a pickup truck. If I try, they go crazy. They're terrified of men, especially men in seed caps. Reggie is the alpha dog. He'll back Sage and Zeus into a corner. I'm not a little dog person, but Reggie is the funniest dog I know. He makes me laugh every day.

My mother was sixteen when I was born. She hid her pregnancy by wearing baggy clothes. One night under a full blue moon, she went to a park and delivered me by herself.

Fifteen months later, my grandfather tricked her into signing adoption papers. When my adoptive family took me away, my aunts told me they remember me screaming.

The family that adopted me was wonderful, but I always had questions. Forever I wanted to know where my red curly hair came from. When I was fifty, I met an adoption searcher, and with her help, I found my family.

A couple of years ago, I got to meet all my relatives. I was so scared, I brought Reggie with me. But it turned out wonderfully and still feels like a miracle. My half-brother Billy was there. He and I both have red curly hair. We look like twins!

BARBARA BOYLE (b.1950), with her dogs Sage, Reggie, and Zeus

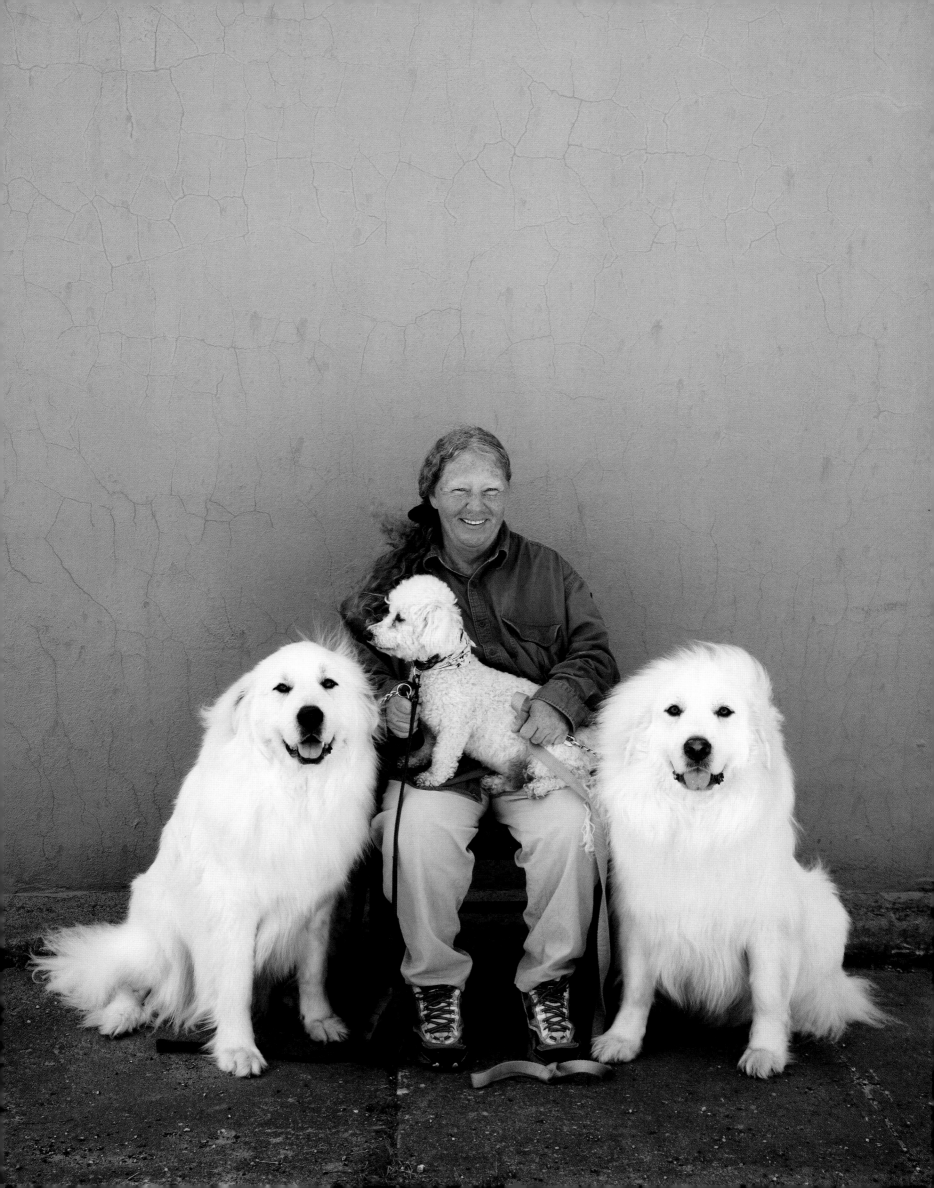

1984

"My mom pinned a note
to my shirt that said,
'Please take care of her.
We can't any longer.'"

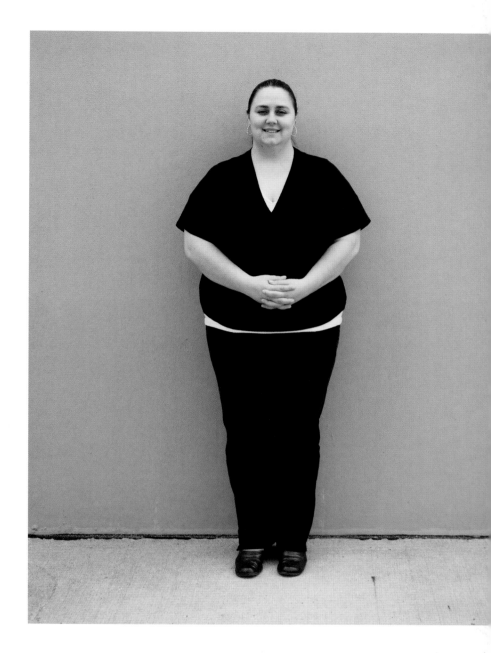

BRIANNE LECKNESS

MY MOM LEFT ME AT A CHURCH when I was three.
She used to travel with the carnival, and the carnival ended
up going broke in Iowa. When my mom and my stepfather
had a hard day, they'd take it out on me. So she left me
at this church with our dog Freddy. She pinned a note
to my shirt that said, "Please take care of her. We can't
any longer."

Freddy ran away and I got scared. I started crying. A
couple heard me and called the police. They sent me to
a foster home, which I hated. When I was four or five, I
moved to Blanche's place in Oxford. My favorite movie was
Annie. I watched that over and over with Blanche.

When I was nine, Blanche said to me, "I really can't be
your mom any longer." In my next family, the mother would
put my hair up. But I was a tomboy and it drove them mad.
I went to three or four other foster homes after that.

When I was thirteen, I was adopted by a very religious
family. They gave me my new name. They home-schooled
me; they said all history comes from the Bible. They
wouldn't let me cut my hair, no make-up or TV. I came home
one day and they had taken away all my jeans and replaced
them with skirts. They shredded my MC Hammer tapes.
They told me my marriage would be arranged. At sixteen,
the county sent me to another foster home.

On my eighteenth birthday, my mother blew into town.
She wanted us to go on *The Montel Williams Show* and
say how she really never wanted to give me up. She asked
me to move in with her in Florida and start a new life. That
didn't work out, so I came back to Des Moines, where I've
been for six years.

I met a guy from Honduras and he didn't speak a lick
of English. I got pregnant, then we broke up. After that, I
really got into partying. I'd stay out till three or four in the
morning. I liked drinking. I met another guy at a bar, and I
got pregnant again. Now I live with the fathers of both my
children and another guy.

Nothing for me has been normal, so why should now
be normal?

BRIANNE LECKNESS (b.1980), birth name Bobby Jo Kirkwood, with her dog

1984

"We used to take in newborn babies, but I quit because it was too hard to let them go."

BLANCHE SMITH

I FIRST HEARD ABOUT FOSTER PARENTING when I was a waitress at the Red Garter. I always liked babysitting, so I thought I'd give it a try.

We started forty-one years ago, and we've had five hundred children live with us. I had one girl for fourteen years, and others for just a couple of weeks. We used to take in newborn babies, but I quit because it was too hard to let them go.

One girl I got when she was three—her mother was running with the carnival, and she left the girl and a dog on the church steps. A lot of them are victims of sexual abuse—I had one who was just four years old and she'd already been abused twice.

The worst is when they come in with lice. I've had to shave girls' legs and armpits because no one taught them how.

You turn their values around. For some, it works. For others, it don't.

Brianne Leckness' foster mother **BLANCHE SMITH** (b.1944)

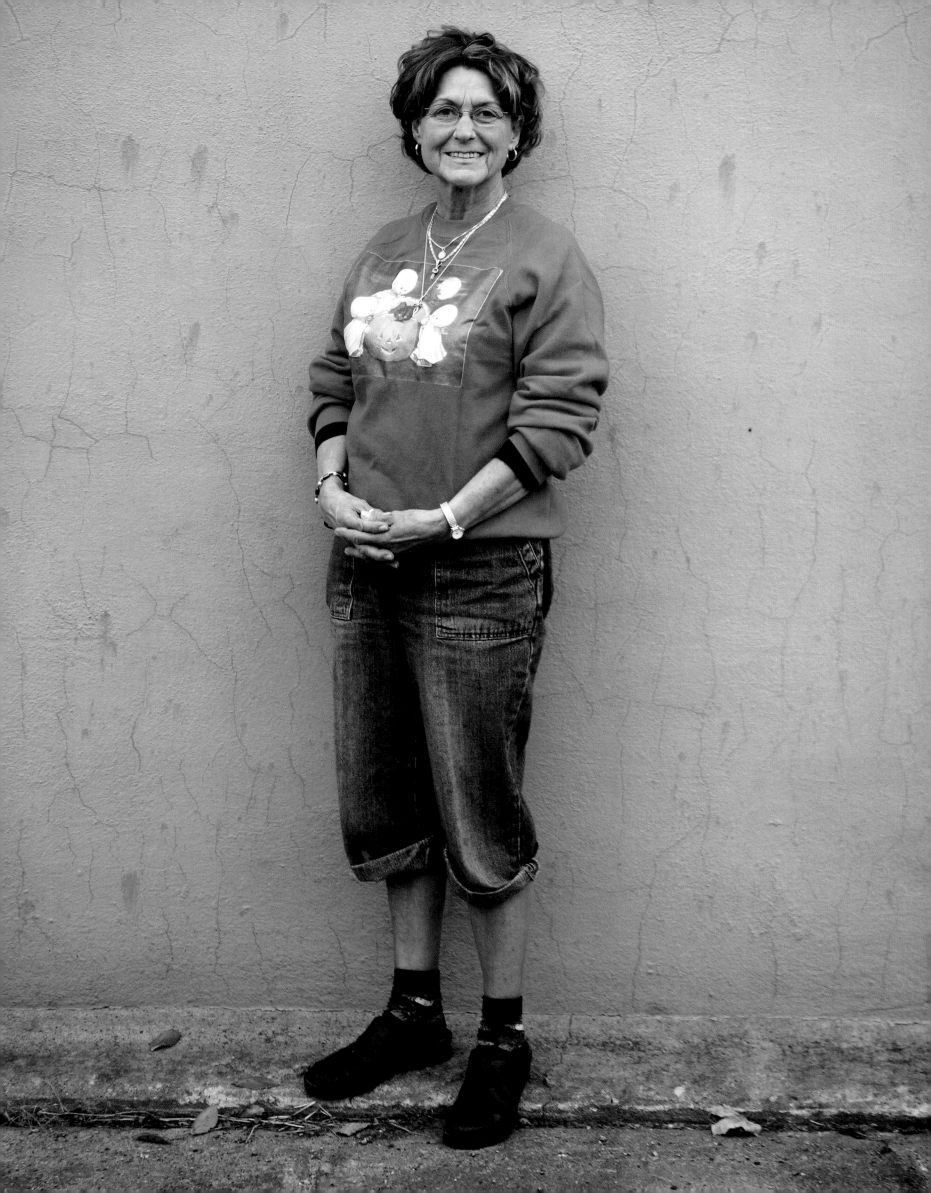

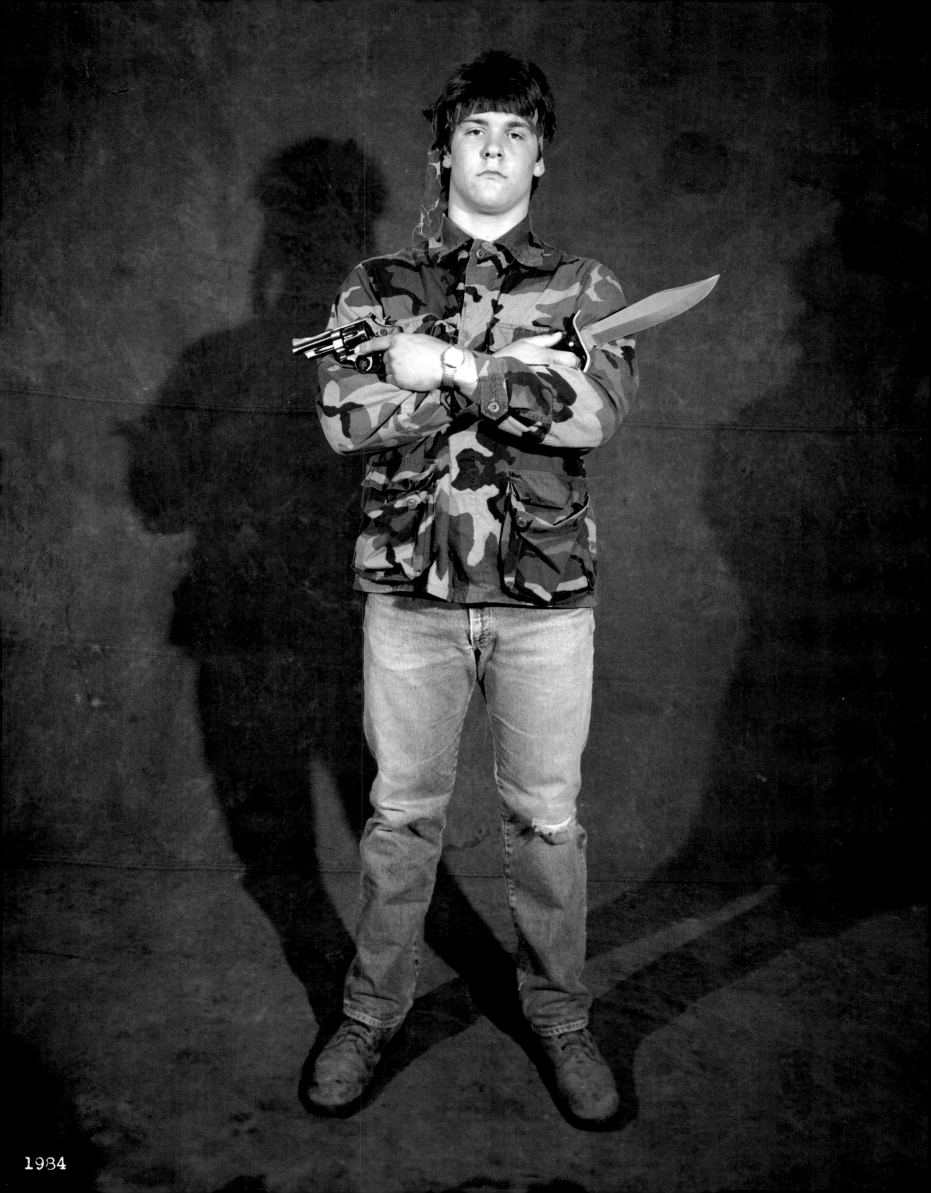

1984

> "We'd go to the river
> bottom and shoot
> cans, tree branches,
> anything. I dreamt about
> maybe being an Army
> sharpshooter."

SHAWN SMITH

IN MY RIGHT HAND, I had a mail order Jim Bowie knife (which I waited six months for), and in my left hand I had a little pistol. We'd go to the river bottom and shoot cans, tree branches, anything. I dreamt about maybe being an Army sharpshooter.

I played defensive end and running back in high school. After we beat West Branch, I got letters pouring in, from Western Michigan, Upper Iowa, Central College, Buena Vista, Wartburg. But I couldn't see signing up for more school.

My first job was baling hale and feeding hogs. I was twelve and I got a dollar an hour. All I had to do was work a hundred hours and I'd have a hundred dollars. Can you imagine how much money that was?

Over the years, my mom probably cared for five hundred foster kids, mostly girls. I pitched in. There were times when I'd be holding two crying babies, one in each hand.

I meet my wife at a dance in Swisher. The next day we went bowling, then started dating. I wanted kids right away.

These days, my older one will give me a couple of weekends a year to go muzzle loading. We go to Southern Iowa, rent a motel room, watch football, and shoot white-tail deer.

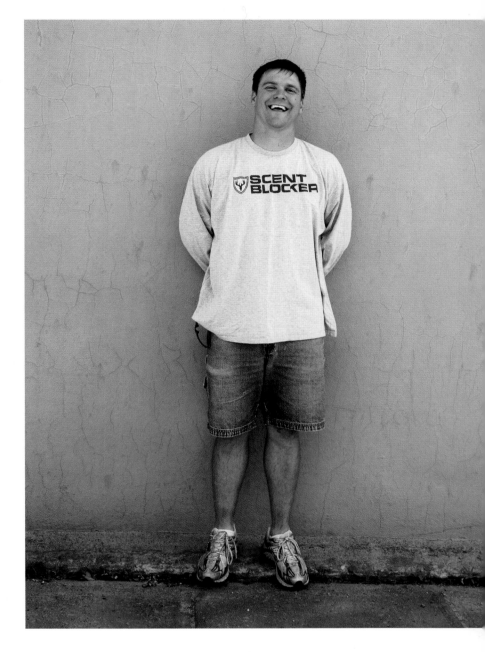

I work at Whirlpool-Amana. I supervise fourteen people making microwave ovens. I like it. You give 'em a good eight hours and the rest of the day is yours. I hate the phrase, "Everything happens for a reason." You work hard, and *you* make things happen.

All a guy needs is to get married, have a house, guns, a fishing boat, and a bow and arrows.

Blanche Smith's son **SHAWN SMITH** (b.1967)

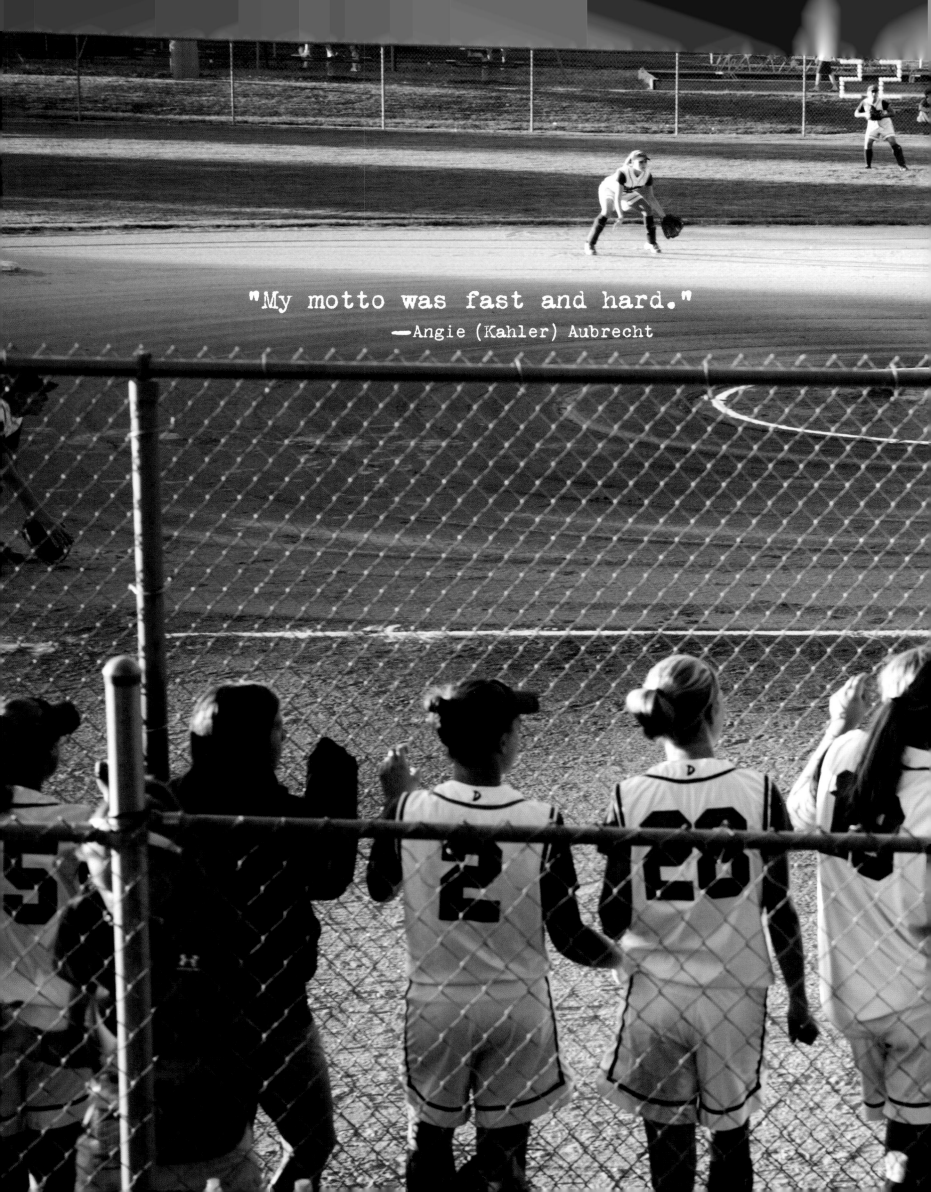

"My motto was fast and hard."
—Angie (Kahler) Aubrecht

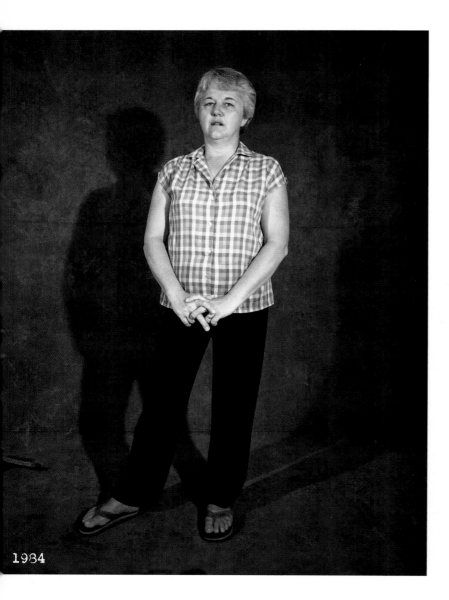

1984

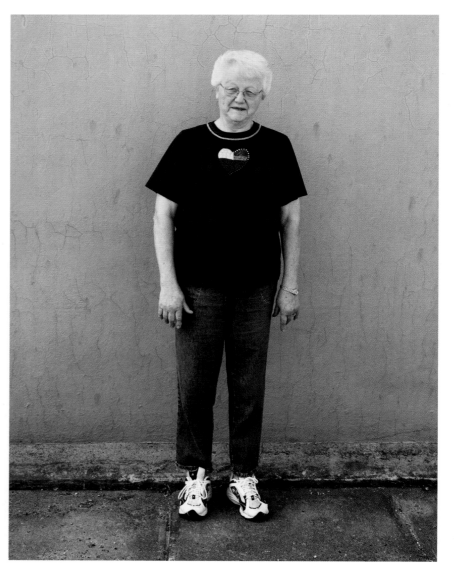

"I have a no-fail piecrust."

JOANNE KAHLER

THERE WERE NINE OF US. I milked cows, baled hay, hauled manure. I went to a one-room schoolhouse. Dorothy Punke was the teacher I remember the most. You put your hands on your desk and she'd wallop you with a ruler. We didn't dare sass.

Jack and I ran away to Hannibal to get married when I was eighteen. My father didn't like that. He said I was too young. But we'll be married fifty-two years in October.

I used to be a waitress at the Sale Barn. I'd set Angie on the freezer and she'd sit there for my whole shift.

These days I'm a "transportation monitor" for sixth, seventh, and eighth graders. I'm the first they hired. The bus drivers can't handle the kids and drive the buses. I didn't think it would be so bad, but it's awful. One kid took out his cell phone and pointed it at me and snapped a picture. I took his phone and wouldn't give it back.

I have a no-fail piecrust. I thought Marguerite Stockman gave me the recipe, but she says she didn't. My favorites are chocolate ice cream pie, coconut cream pie, and a sugar-free apple pie. I use Golden Delicious apples, Healthy Choice apple juice, cinnamon, tapioca, dot it with butter, and put in a tablespoon of lemon juice. I cook it down in a saucepan first.

I love bingo. A bunch of us go to Eagles and sometimes to Tama. I won a thousand-dollar jackpot once. The buy-in is pretty high, a hundred and fifteen dollars. But you get eighteen cards.

JOANNE KAHLER (b.1937)

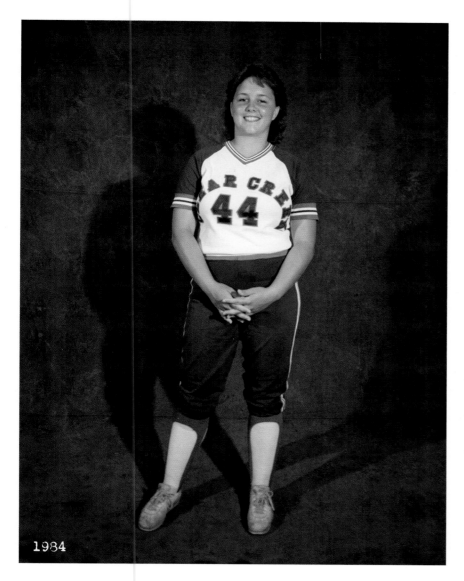

1984

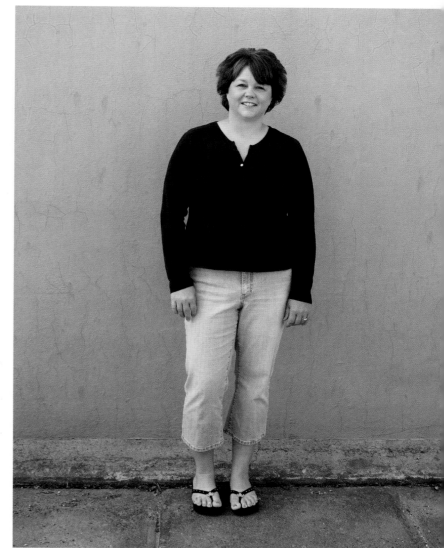

"I'm the sixth-winningest pitcher in Iowa history."

ANGIE (KAHLER) AUBRECHT

I STARTED PITCHING WHEN I WAS FIVE. I threw a pretty good curveball. It'd shoot straight at the batter, then swoop down. I had a change-up that threw off a lot of batters. I wasn't too fancy. My motto was fast and hard.

By the time I was in high school, I realized I couldn't go on to play college. I was in too much pain. I was taking Advil before and after games, and I always had ice packs on. My last game was when I was a senior. We lost that game. It would've taken us to State.

My record was 187 wins and 43 losses. I was inducted into the Iowa Softball Pitchers Hall of Fame. I'm the sixth-winningest pitcher in Iowa history.

These days, I work as a 911 dispatcher for the county. I get lots of drunk driver and domestic violence calls. You get calls from wives whose husbands are beating the crap out of them. One of my first calls was from a parent of a baby who wasn't breathing and died of SIDS.

When I was a pitcher, I was in control of the game. With 911, you have to take control of the call. If you don't, you're screwed.

I really live for this. I'm an adrenalin junkie. But you have to hide your emotions. You also need a strong bladder because the calls are constant.

In my spare time, I scrapbook. I scrapbook everything. I have a room in our house dedicated to scrapbooking. I'm about to scrapbook my first grandchild's birth.

Joanne's daughter **ANGIE (KAHLER) AUBRECHT** (b.1966)

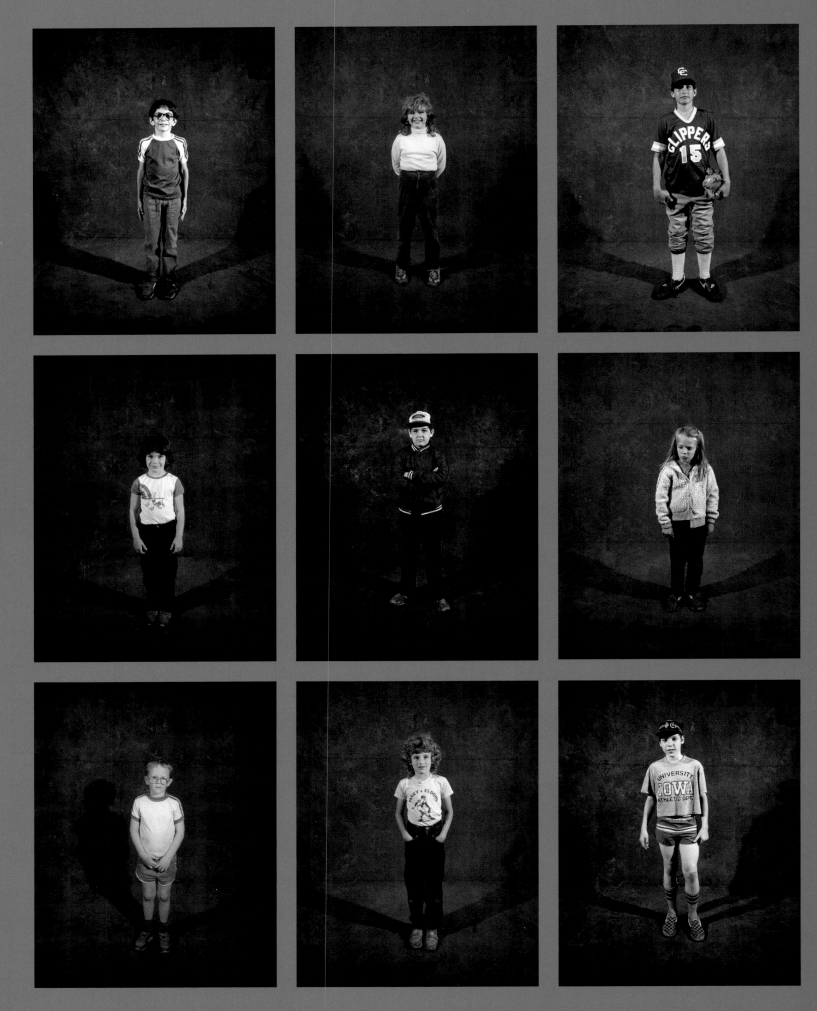

BOTH PAGES, TOP ROWS, LEFT TO RIGHT: DAVID KINNEY (b.1976), ROBIN PORTWOOD (b.1981), STEVE BECICKA (b.1969) MIDDLE ROWS: SARAH KINNEY (b.1978),
TIM PORTWOOD (b.1973), KATY HUEDEPOHL BOTTOM ROWS: TONY BRACK (b.1977), KIM (KUTCHER) KURKA (b.1977), KEVIN STOPKO (b.1971)

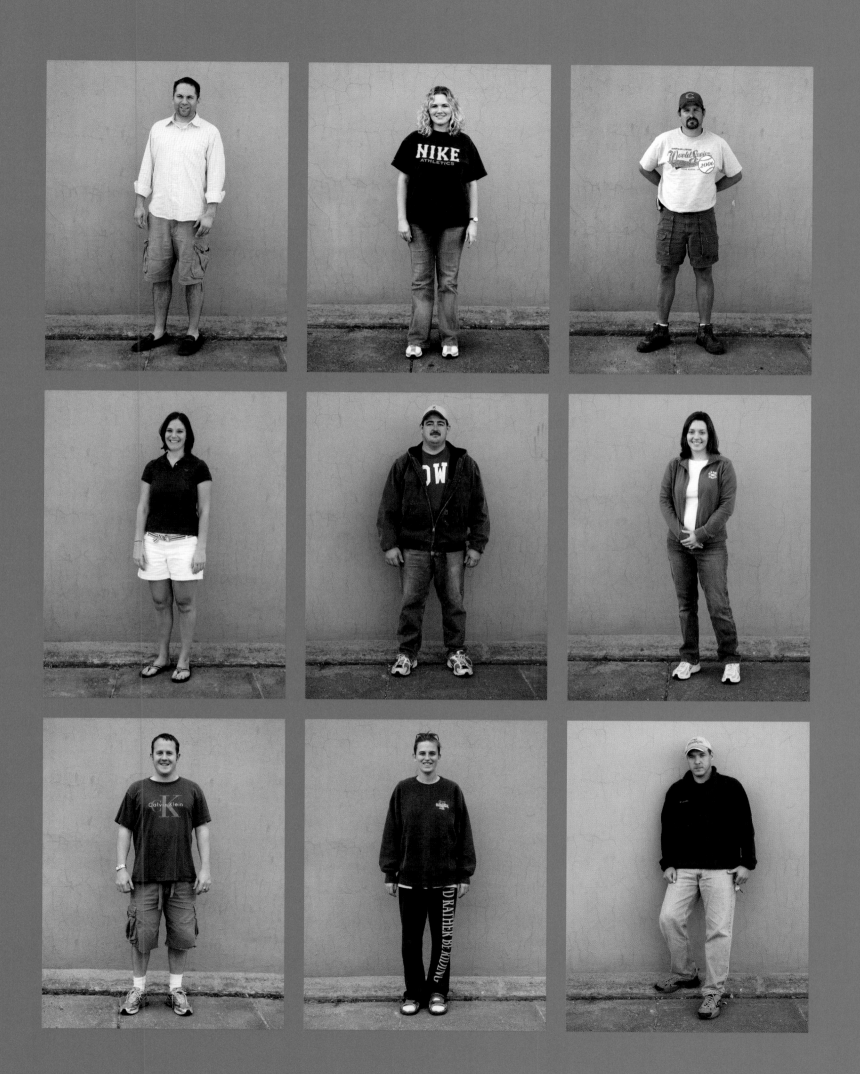

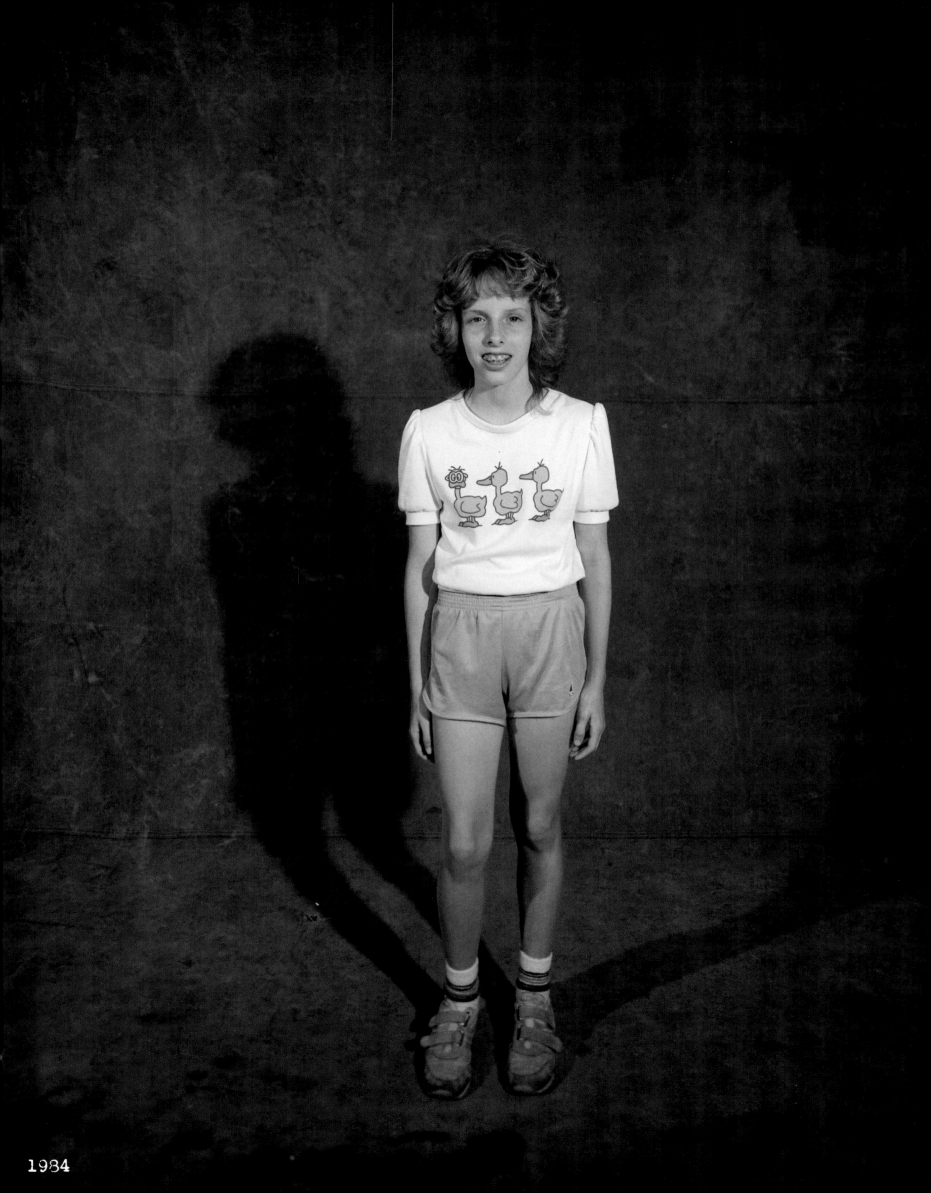

1984

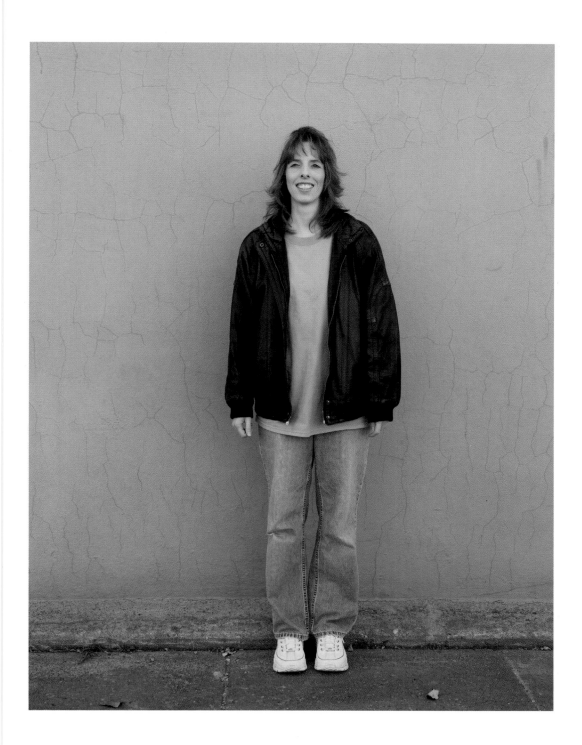

HOLLY (STOPKO) POESCHEL

I DID EVERYTHING THE BOYS DID. If they were covered with mud, I'd be covered with mud. We used to catch bullfrogs. We used to race our bikes all over town. The water tower was Base.

In high school, the popular kids picked on me. They called me Beaver. I had terrible buckteeth.

I've had all kinds of jobs. I've worked at Wal-Mart, Kmart, Hardee's, and Hy-Vee (as a sacker). I've also cleaned rooms at the Holiday Inn. For the last eleven years, I've been a custodian at the University hospital in Iowa City. That's where I met my husband.

One night after our shift, we were at the Nickelodeon and we started talking. The next thing you know, we have a trailer, two kids, two goldfish, a dog, and a cat.

I used to have panic attacks. They started when I was twenty-three. Your heart's beating at like 150 times a minute. I was down to 92 pounds. They got so bad, I got ulcers. I don't have much of a problem any longer. But I have to watch it when I get tired.

I enjoy going back to Oxford, but I'm glad we don't live there. It's nice to get away from everyone knowing everything about you.

HOLLY (STOPKO) POESCHEL (b.1972)

"I can still fit into my uniform.
My daughter Holly says that if anything
happens to me, she wants it."

—Bob Stopko

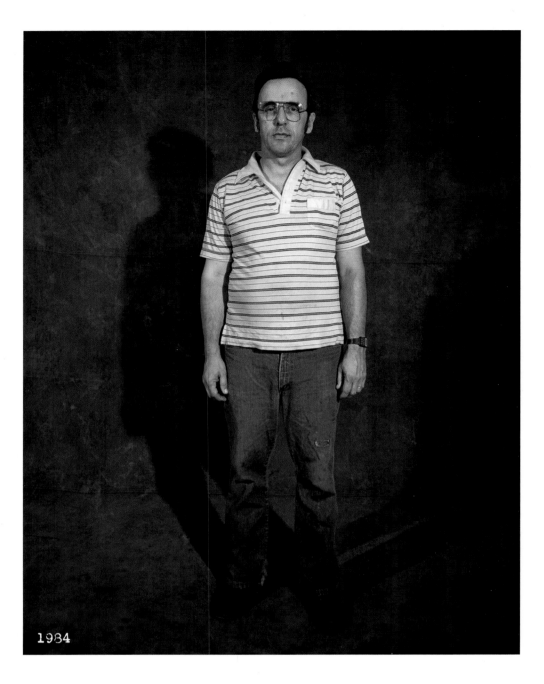

1934

BOB STOPKO

I ENLISTED WHEN I WAS SEVENTEEN. I served twenty-two years, ten days, eight hours, and ten minutes. I was a Pennsylvania coal miner's son. What did I have to look forward to?

I was stationed at Cu Chi. When the rockets came, if you weren't scared you'd be crazy. Some of my buddies got killed. One was a Jewish kid. He forgot something and went back to the barracks when the Vietcong started lobbing mortars.

The Vietnamese didn't give a shit who won the war. They had nothing before and they had nothing after.

I was sprayed with Agent Orange. They sprayed all around the bases. It took me twenty-five years to know.

I got cancer, teeth removed, diabetes, heart trouble, high blood pressure, my feet ache, the corneas in my eyes have been replaced.

They tell us the bad things about Iraq. They don't tell us the good things. He made a mistake by going in there, but if we pull out, we're gonna have more terrorists.

You get into some of these places and the people aren't civilized. They'd kill their own mothers. I think everyone should spend one tour in the military. They'd see what's going on, they'd grow up, and they'd get some discipline.

I can still fit into my uniform. My daughter Holly says that if anything happens to me, she wants it.

Holly Stopko's father **BOB STOPKO** (b.1935)

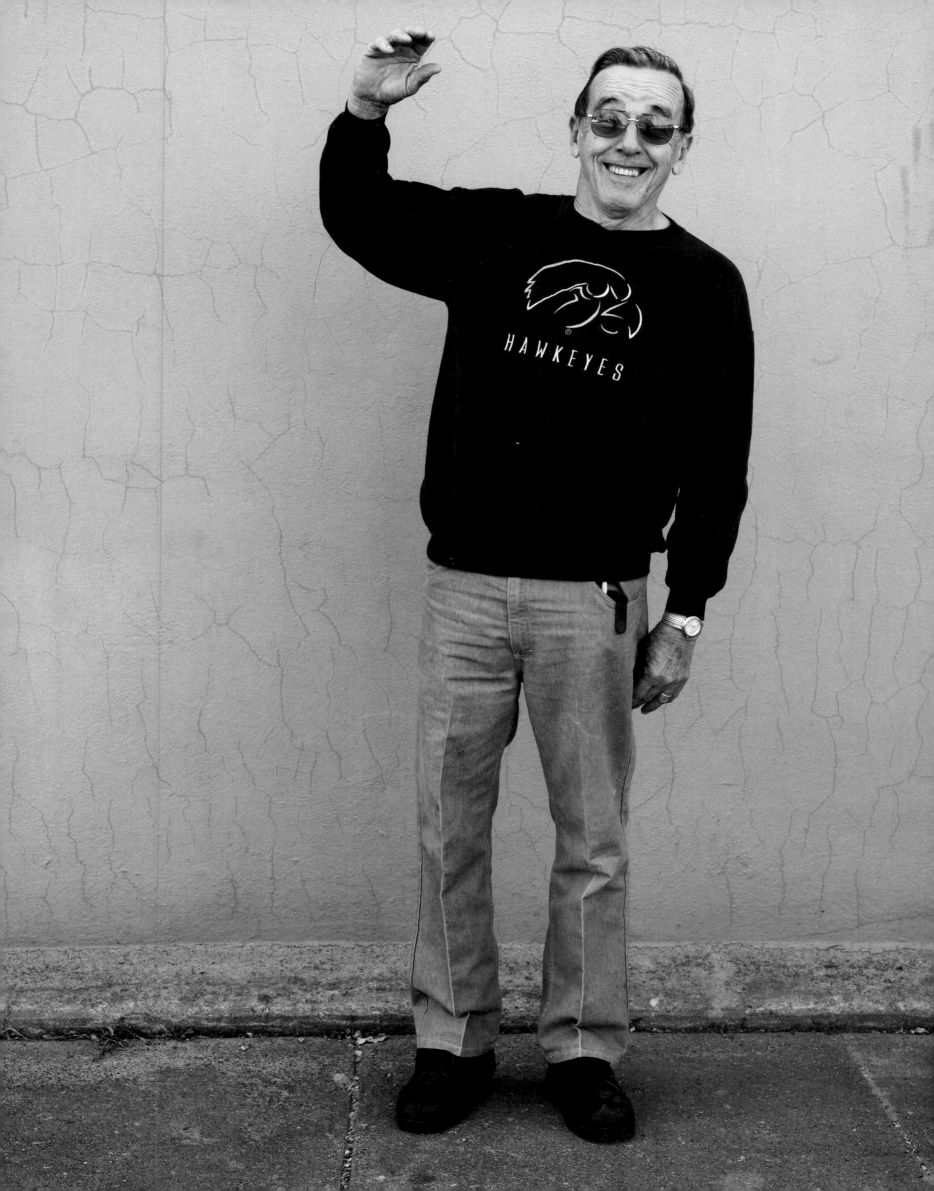

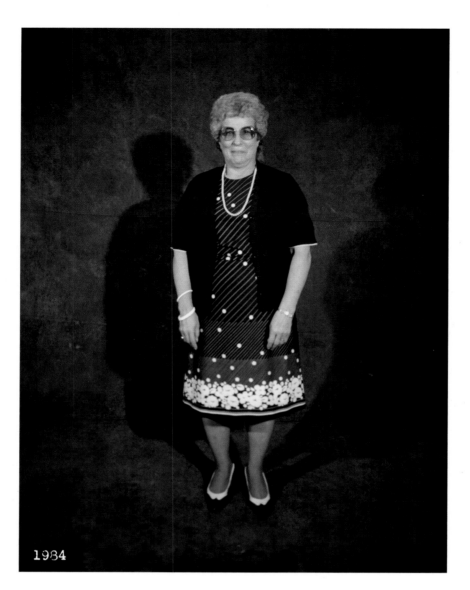

1934

"He never talks about what happened over there, but he came back different."

DORIS HOYT

OUR OLDEST SON, JIM JR., was wounded in Vietnam. We didn't hear from him for three months. When he got home, he came into the kitchen one morning yellow as a lemon. He started having seizures. He never talks about what happened over there, but he came back different.

Another son, Johnny, used to be a jeweler in Houston. He was diagnosed with HIV in the late eighties. When the kids were little, I wasn't home a lot (I had two jobs, sometimes three), and Johnny took over the responsibilities. He liked to bake and cook, and he liked nice clothes. I kinda felt it coming. I accept it, but his father can't.

Ten years ago, Johnny came to live with us. He just got out of the hospital. He was in a coma for twenty-two days and had double pneumonia. He lost forty pounds.

One of our sons, Tom, works for P&G. We almost lost him, too. He collided with a semi, and a hinge from his truck embedded itself in his head. Our youngest boy, Mike, was in construction, then drove a semi, but he wasn't home much, and his wife didn't like that, so he's back in construction. Our daughters, Theresa and Pat, married brothers.

We have eleven cats—Beige, Jazz, Feisty, Princess, Charley, Storm, Pistol, Sox, Housey, Gracie, and Flit. I hate it when people drop cats off at our steps, but we always take them in.

We've had happy times and sad times. It's like a sailboat in the ocean. Some days it's smooth. Other days it's rough.

ABOVE AND OPPOSITE: **DORIS HOYT** (b.1926) FOLLOWING PAGES: Doris' husband **JIM HOYT, SR.** (b.1925) and their son **JIM HOYT, JR.** (b.1949)

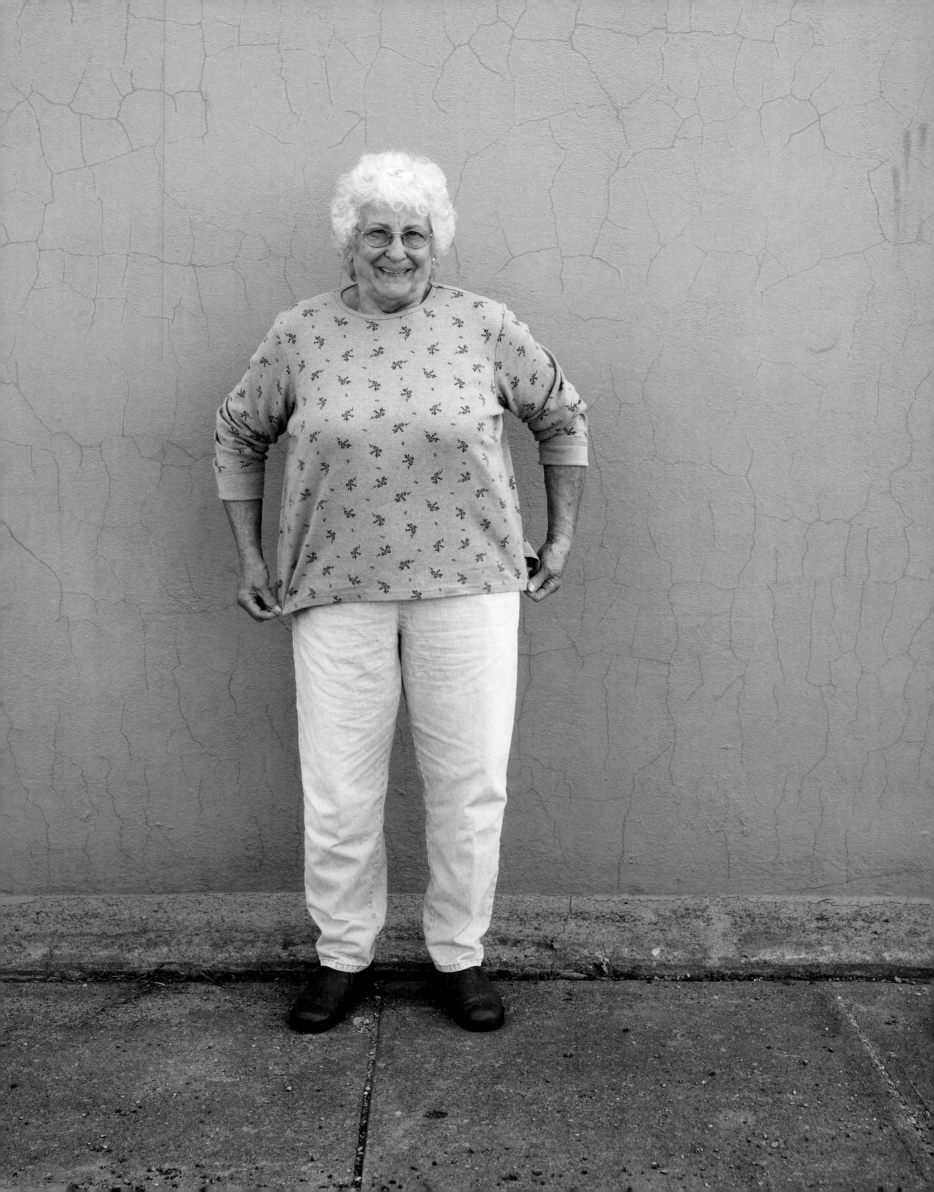

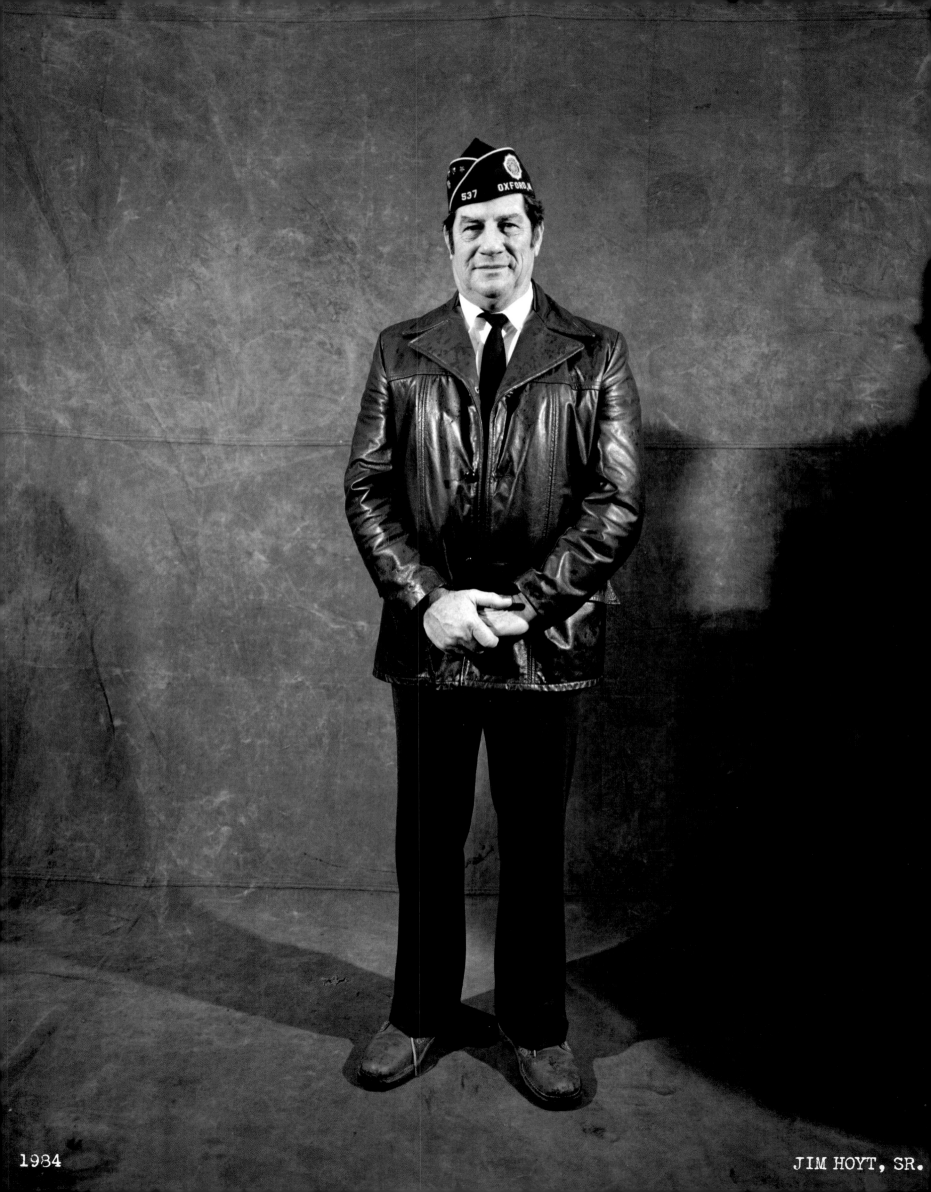

1984

JIM HOYT, SR.

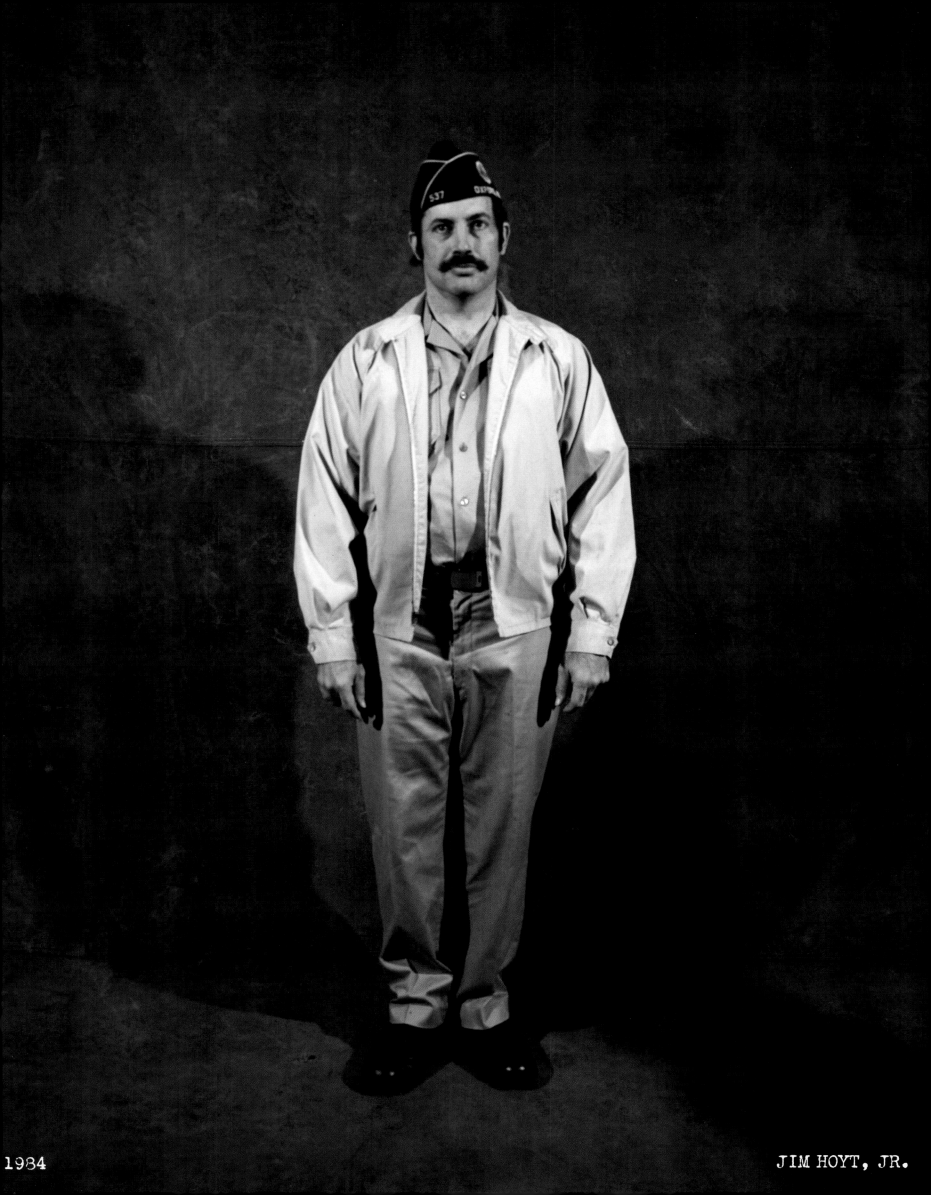

1984

JIM HOYT, JR.

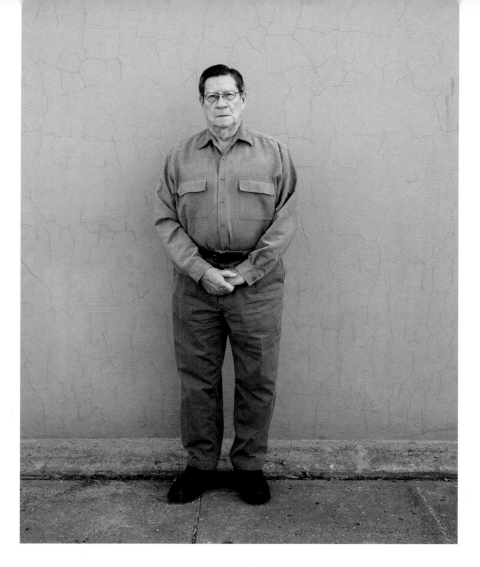

"I'm the last living of the first four American soldiers
who liberated Buchenwald concentration camp."

JIM HOYT, SR.

MY FATHER WORKED FOR THE RAILROAD and my
mother was a rural schoolteacher. I went from kindergarten
through twelfth grade in the same building. My biggest
achievement was winning the Johnson County Spelling
Bee in 1939. I was in the eighth grade and I still remember
the word I spelled correctly: *archive*.

After basic training I was sent overseas and went
through the Battle of the Bulge. I'm the last living of the
first four American soldiers who liberated Buchenwald
concentration camp.

There were thousands of bodies piled high. I saw
hearts that had been taken from live people in medical
experiments. They said a wife of one of the SS officers—
they called her the Bitch of Buchenwald—saw a tattoo she
liked on the arm of a prisoner, and had the skin made into a
lampshade. I saw that.

I received the Bronze Star, but when I got home, I didn't
have a job. I worked at a bank, then for Burroughs Adding
Machine, then in construction. I ended up a rural mail carrier.

I have post-traumatic stress disorder. My oldest
son, who was awarded the Purple Heart for service in
Vietnam, suffers from the same thing. Seeing these
things, it changes you. I was a kid. Des Moines had been
the furthest I'd ever been from home. I still have horrific
dreams. Usually someone needs help and I can't help
them. I'm in a situation where I'm trapped and I can't get
out. I go to a group therapy session every week at the VA.

For the fifty-year anniversary of the liberation of
Buchenwald, they asked me to return. They would've paid
for the whole works. But I said no. I didn't want to bring
back those memories.

Thinking back, I would have pushed to be a
psychologist—if for no other reason than to understand
myself better.

I met my wife Doris at a dance in Solon back in
1948. She's the love of my life. I don't know what I'd do
without her.

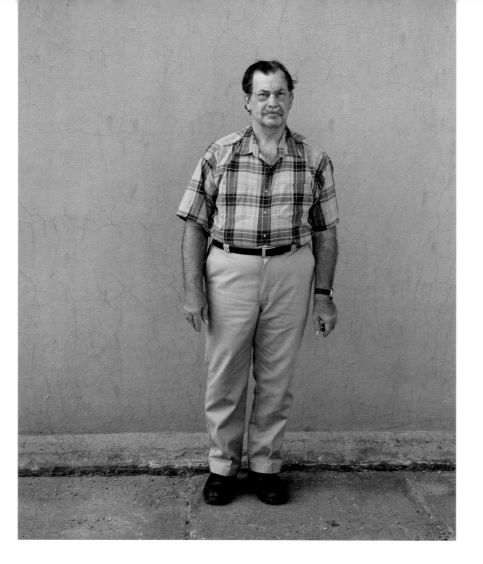

"I have post-traumatic stress disorder,
but I've never had nightmares."

JIM HOYT, JR.

I GOT DRAFTED IN AUGUST 1970. Our job was to plant anti-personnel mines outside the perimeter. We'd carry M203 grenade launchers. We'd go on search-and-destroy missions. You'd have to watch for booby traps. I never had to kill anyone the whole time I was over there.

They used Agent Orange to defoliate the jungle. They also used napalm. When someone got burnt by napalm, they'd look like a crispy critter. It was very unpleasant.

They had nasty-looking little green snakes with red eyes. You had to be careful when you slept. There were lots of scorpions and centipedes, too. The mosquitoes were terrible.

I got hit with a piece of shrapnel. It went into my thigh too deep to get out. It's still there.

I saw *The Bob Hope Show*, some of the Gold Diggers,

and Martha Raye. They had Donut Dollies at the base. They were nice, friendly women from the States. For R&R I went to Bangkok—they sure named that place right.

I came back and started doing bodywork. I seemed to be good at filling dents. But three months after I started, I came down with malaria. It's like the flu, but worse. You start sweating, then you get the chills. It attacks your brain.

I have post-traumatic stress disorder, but I've never had nightmares.

I'm a porter at JCPenney. I pick up trash, pick up hangers from the customer service area, clean up the restroom, clean the doors and mirrors. There are a lot of smudges.

I like to go target hunting now. It's something you don't have to feel too bad about.

OPPOSITE: **JIM HOYT, SR.** ABOVE: **JIM HOYT, JR.**

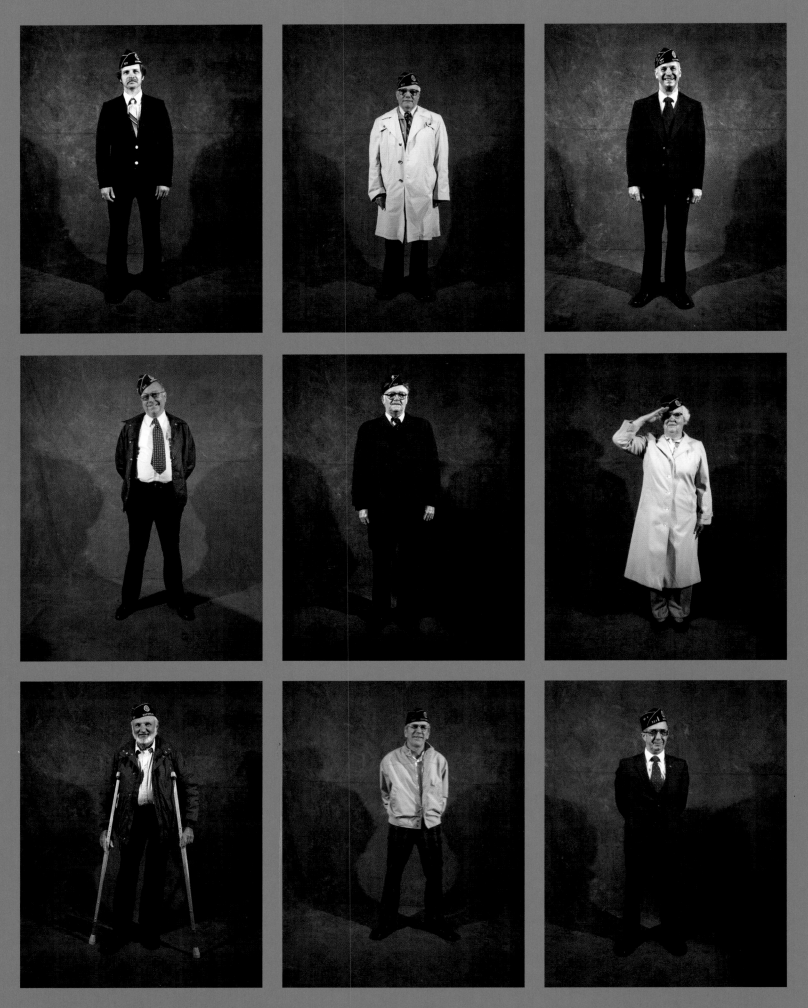

Oxford veterans in 1984. TOP ROW: DAN GORSH (b.1949), JEAN BRYANT (b.1917), AL SCHEETZ (b.1929) MIDDLE ROW: BOB MURPHY (b.1926),
DICK RUTH (1926–1988), GENEVIEVE McDANIEL (1918–2001) BOTTOM ROW: BILL SCHEETZ, DALE STECKLEY (1921–2004), DON CROW (1911–2007)

with. We took care of each other." —Bob Lindley

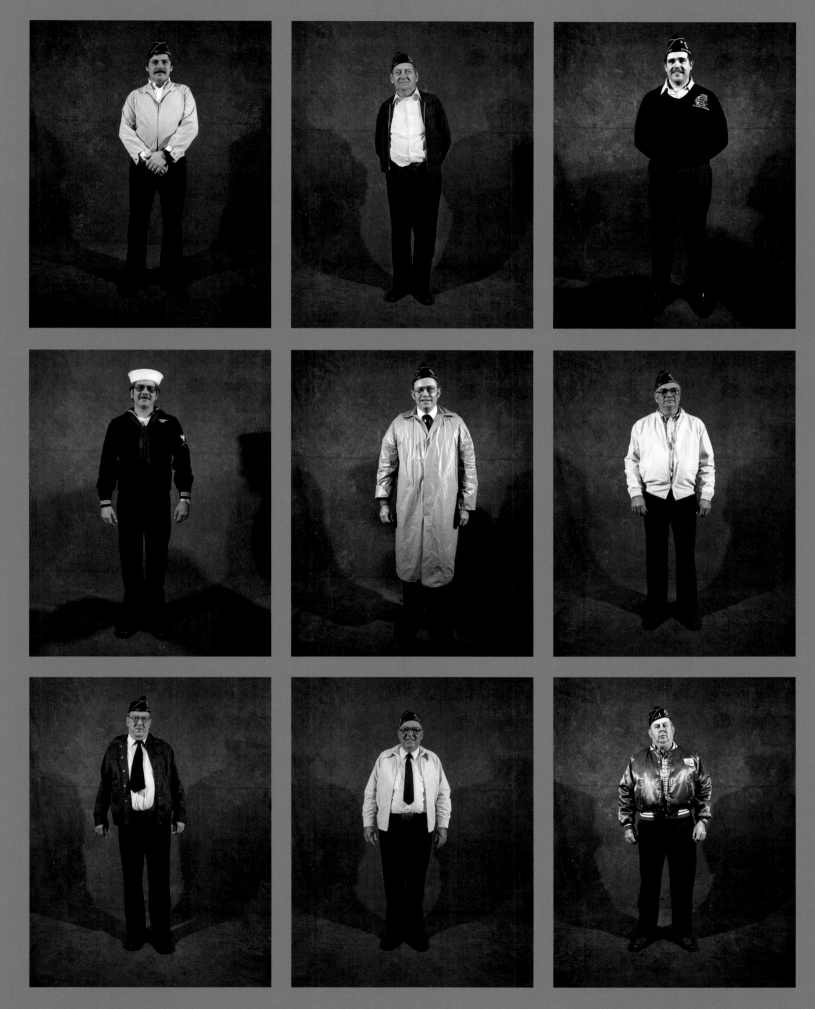

TOP ROW: **HARLAN YODER** (b.1948), **JACK McDONOUGH** (1918–1994), **RICHARD BRYANT** (b.1953) MIDDLE ROW: **MIKE SEDLACEK** (1951–1989),
RAY STRATTON (b.1930), **JIM ROHRET** (b.1931) BOTTOM ROW: **OLIE OLSON**, **ORVILLE YODER** (1920–2005), **LORIN "BUD" WOOD** (b.1926)

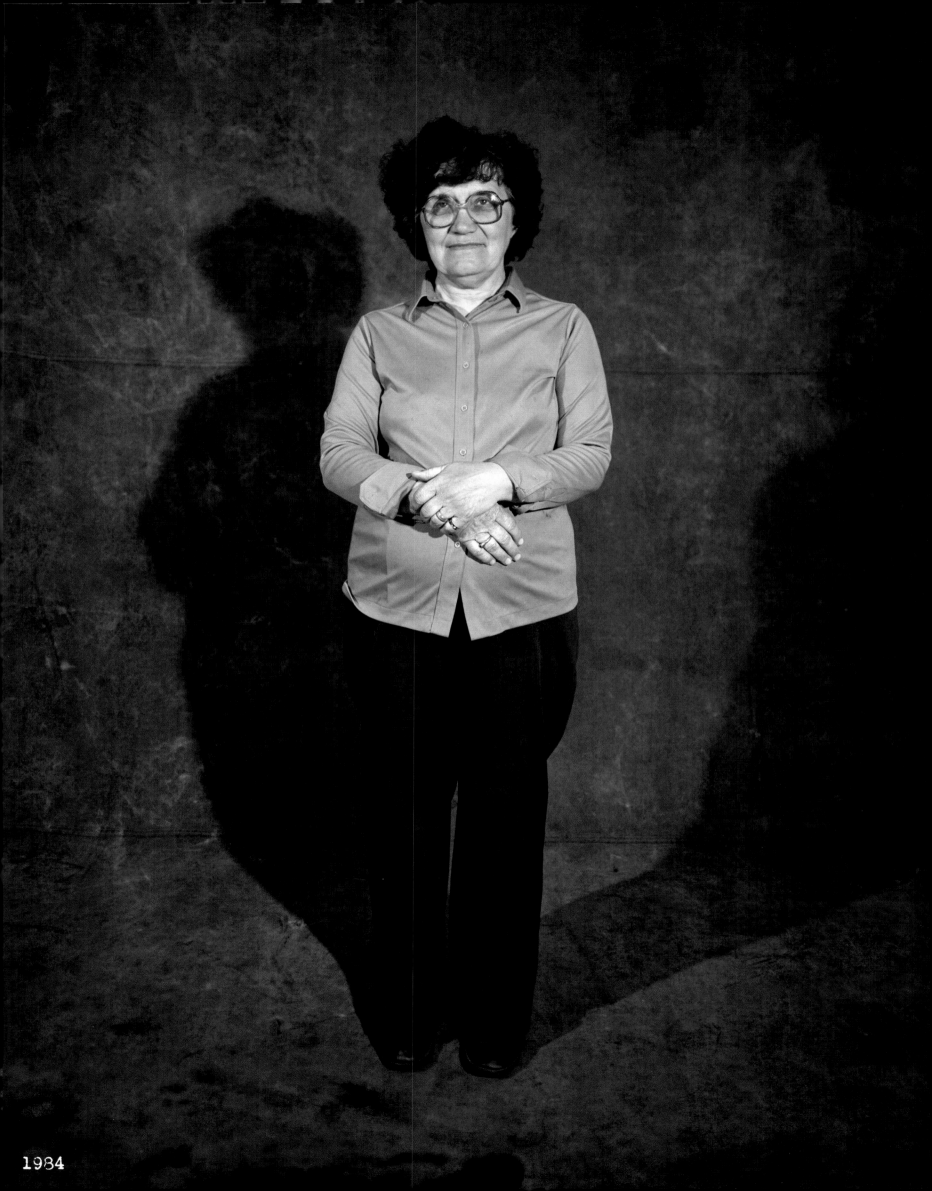

1984

"Five of our six children live within a block of us.
The sixth lives in Williamsburg, sixteen miles away."

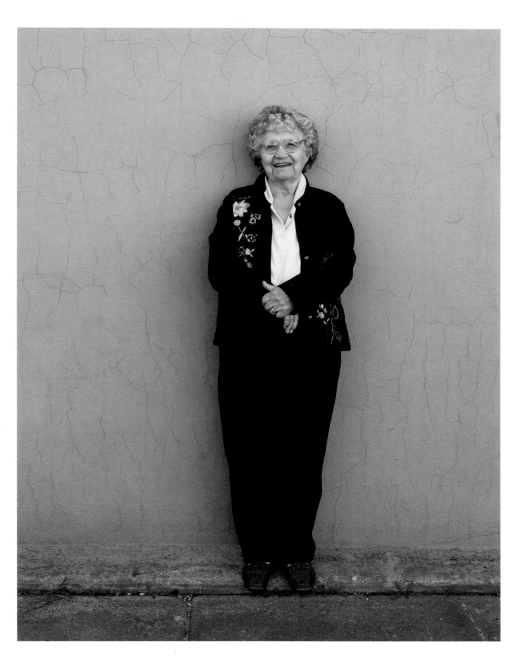

LINDA COX

I WAS DANCING AT THE USO in Cheyenne and a young man looked my way. I winked at him and he asked me to dance. We got to know each other, and when he was about to get shipped out, he bought me a diamond ring. We got married by a judge, but I didn't think it was right that Edward would be going overseas without a proper Catholic wedding. So we were married again by the Post's chaplain.

I was working at the Post's laundry when Edward's train went by. I wore dark glasses because I was crying so hard. I wrote him every day. He sent me a big bottle of French perfume, but by the time I got it, the seal was broken and all the perfume was gone.

Five of our six children live within a block of us. The sixth lives in Williamsburg, sixteen miles away.

My favorite recipes are sliced deer meat cooked in cream of mushroom soup, banana chiffon cake, Red Waldorf cake, square meal hamburger, and biscuit dough squares.

LINDA COX (b.1922)

> "I'm on oxygen now. I think it has something
> to do with all the bean and hog dust."

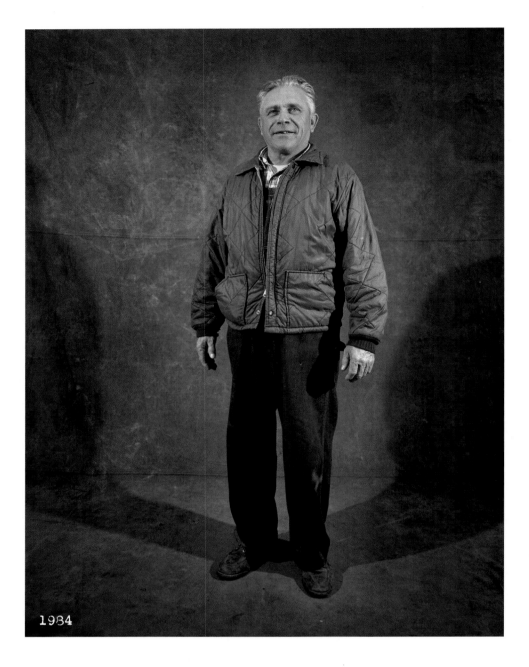

1934

ED COX

I USED TO LIKE TO GO COON HUNTING. My dad started me out when I was four. I taught my own boys how to coon hunt, too.

Farmers used to hire me to run their balers. I've hauled lime, rock, and sand. I also farmed. I grew corn, oats, and beans. I've done mechanic work, too. I once drove a semi. Nowadays, all I do is mow, rake, and bale hay. But I keep busy. I work my son's farm. He's got sixty-five head of sheep.

The wife and I have been married for sixty-one years. We argue once in a while, but you've got to have 'em every now and then.

We go to church every Sunday. We have six kids, and no one has left the church.

I'm on oxygen now. I think it has something to do with all the bean and hog dust. They say it's bad on your lungs.

Sometimes I go down to the Sale Barn and have a cup of coffee with some of the guys. I also like to have a beer at Old Roy's.

I guess I've done everything I've wanted to do.

Linda Cox's husband **ED COX** (b.1921)

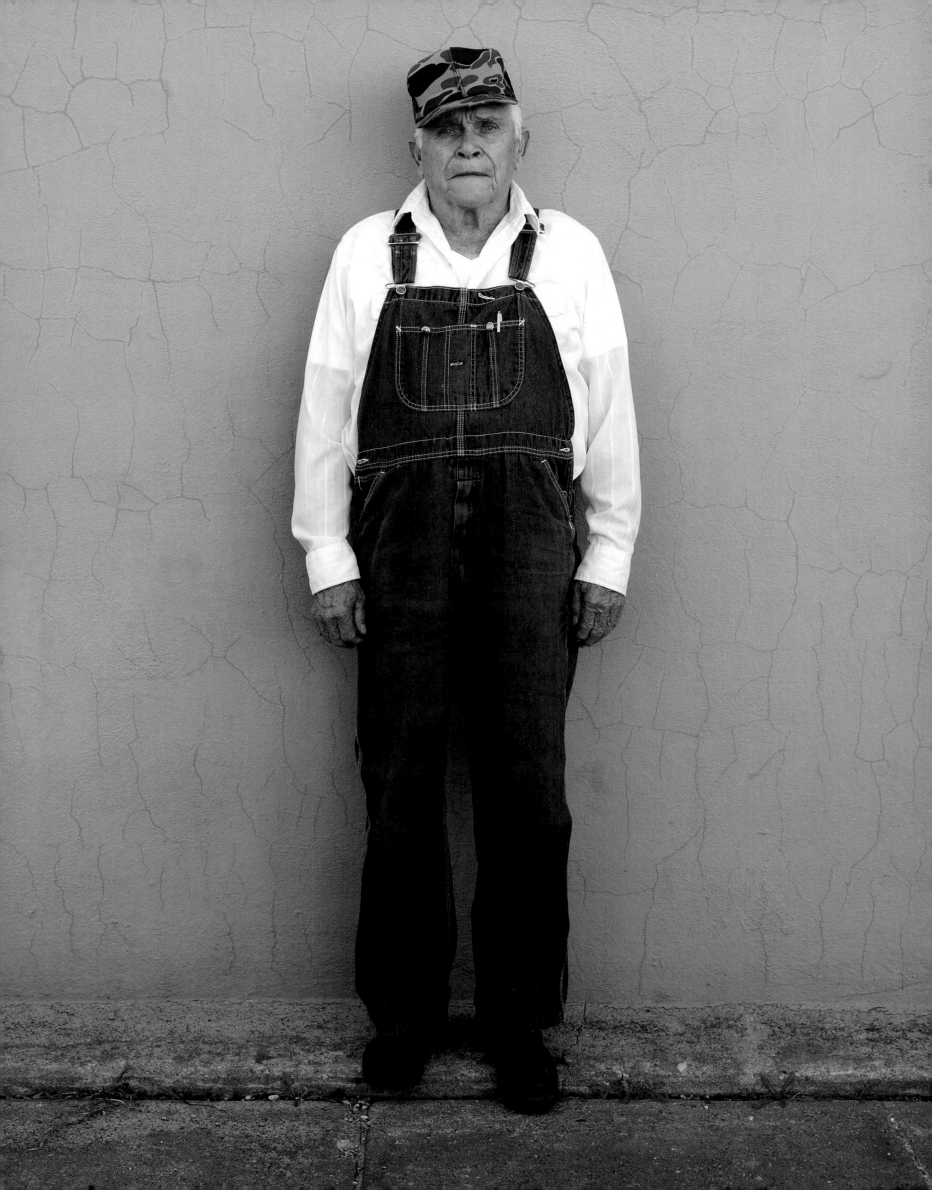

"Tim never showed up for our first date. He was playing euchre with my dad at the Sale Barn."

—Nancy (Cox) Kinney

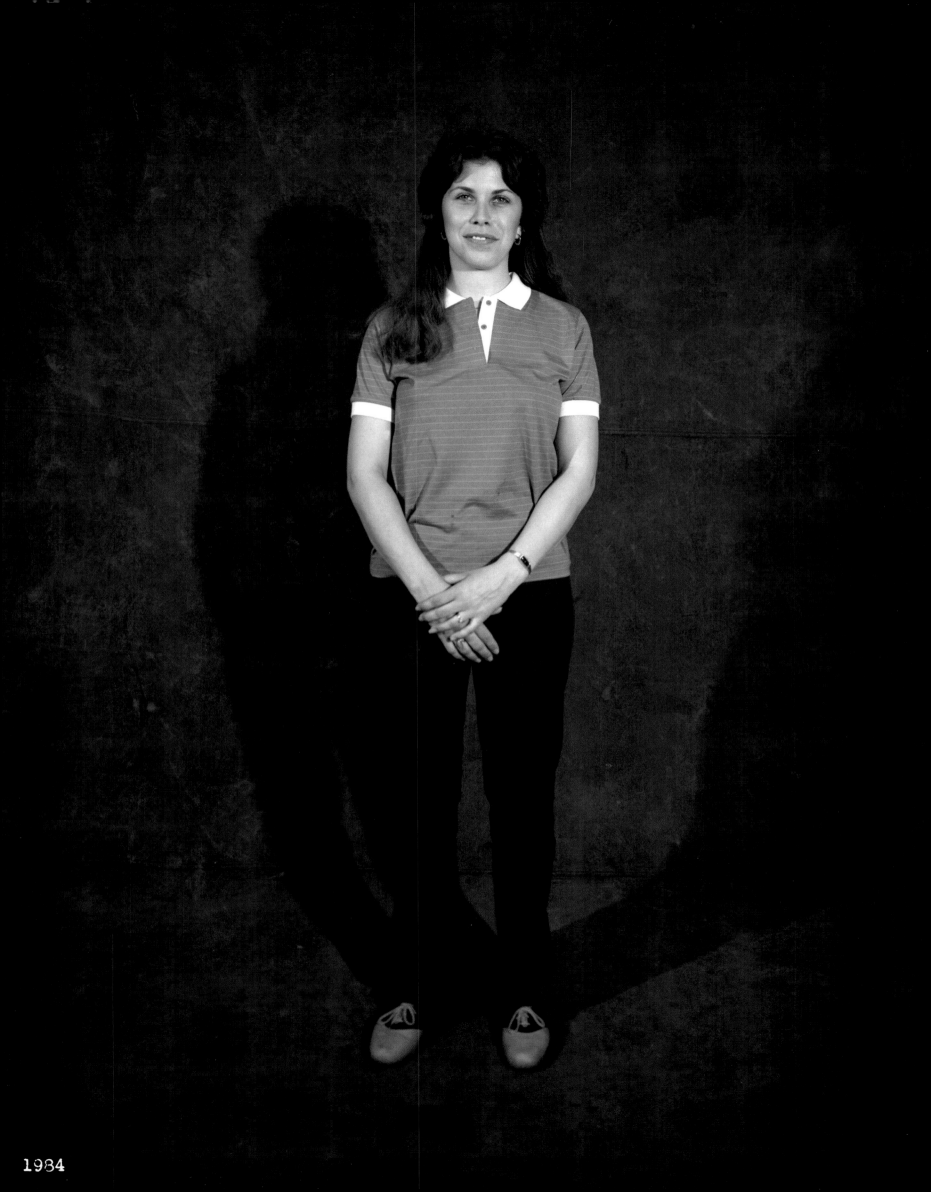

1984

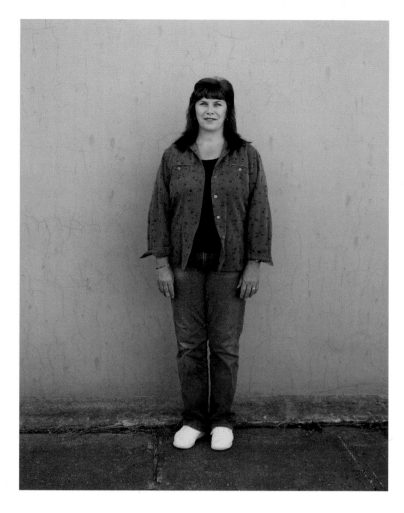

NANCY (COX) KINNEY

THE FIRST TIME I MET MY HUSBAND, my dad had hired him to break a horse. I caught the horse, Tim got on, and told me not to let go. But I did, and the horse broke for the pond. That was when I was fourteen and Tim was sixteen. I don't remember any fireworks. I do remember seeing him drive his blue truck around town. It had a Playboy sticker on the rear windshield.

A year later, Tim asked me out, but he never showed up for our first date. He was playing euchre with my dad at the Sale Barn.

We dated for nine years. There were a few off and ons. I was living with my girlfriend Donna, and he was living at home. Tim said he was tired of being boyfriend and girlfriend. We got married at St. Mary's. Five hundred people came. We went to Florida for the honeymoon.

I stayed working in housekeeping at the hospital for ten years. I quit in March of 1988 and in the fall, I got pregnant. Today we have two girls, Melissa and Mallory. They show their horses in 4-H. Their dream is to get to the State Fair.

My two brothers have macular degeneration, and so do I. We're legally blind. For me, it started in high school. My parents are carriers, but they don't have it.

Our backyard adjoins my parents' backyard. After high school I moved fifteen miles away to North Liberty, but I moved back to Oxford. I can walk to the bank, the Post Office, anywhere I want. I feel safe here.

I don't work any longer. I'm a Domestic Goddess.

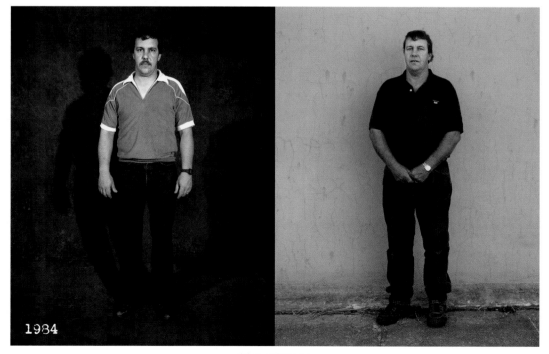

1984

Tim Kinney

OPPOSITE AND TOP: Ed and Linda Cox's daughter **NANCY (COX) KINNEY** (b.1959) BOTTOM: Nancy's husband **TIM KINNEY** (b.1957)

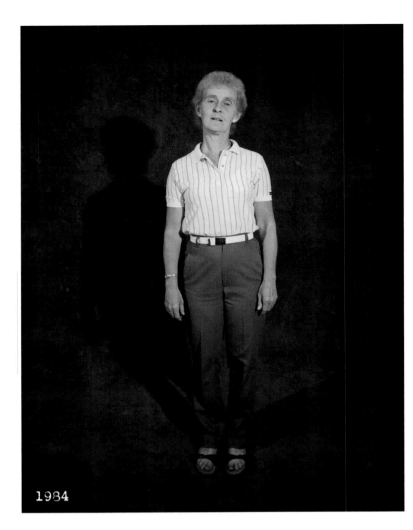

1934

"You can't gossip since everyone's related. If you talk too much, someone will say, 'Quit talking! Let's play cards!'"

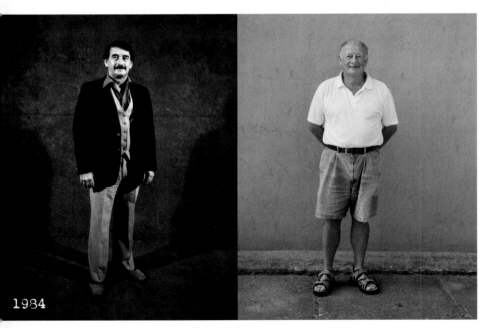

1934

Tom McAreavy

PAULINE McAREAVY

IN 1960 SOMEONE STARTED A EUCHRE CLUB. I used to play in the evenings, but after I retired we'd start at nine forty-five in the morning and play till nine at night. I'm one of the youngest in the group. You can't gossip since everyone's related. If you talk too much, someone will say, "Quit talking! Let's play cards!"

I met my husband at a wedding dance. But I knew who he was before that. He was a basketball player and I was a cheerleader, and he used to wink at me. I had a boyfriend in high school. He was a Sigma Chi. But when I met Tom I knew that was it.

Tom went to Korea and we became engaged before he shipped out. I still have every one of his letters wrapped with a pink ribbon. When he came back, we broke up. I threw the ring at him and he kept it. But we got married on September 1, 1956. My three sisters were bridesmaids. We went to Milwaukee for our honeymoon. We saw a Braves game and took a tour of a brewery.

By the time I was thirty-six, I had finished production. I produced from 1957 to 1969. I have six children. All of them have M names—Michael, Mary, Mart, Mindy, Morgan, and Matthew. I worked for thirty years as the school nurse.

I'm a Republican. I support President Bush and I admire him. I used to be a Democrat, though. Tom and I worked hard for Jimmy Carter and we were invited for his State of the Union message, then afterwards we danced in the White House. Jimmy, Rosalyn, and Amy shook our hands. Bill Clinton turned me off to the Democrats. Slick Willy. I look at him and realize they had this all planned.

TOP AND OPPOSITE: **PAULINE McAREAVY** (b.1933) BOTTOM: Pauline's husband **TOM McAREAVY** (b.1934)

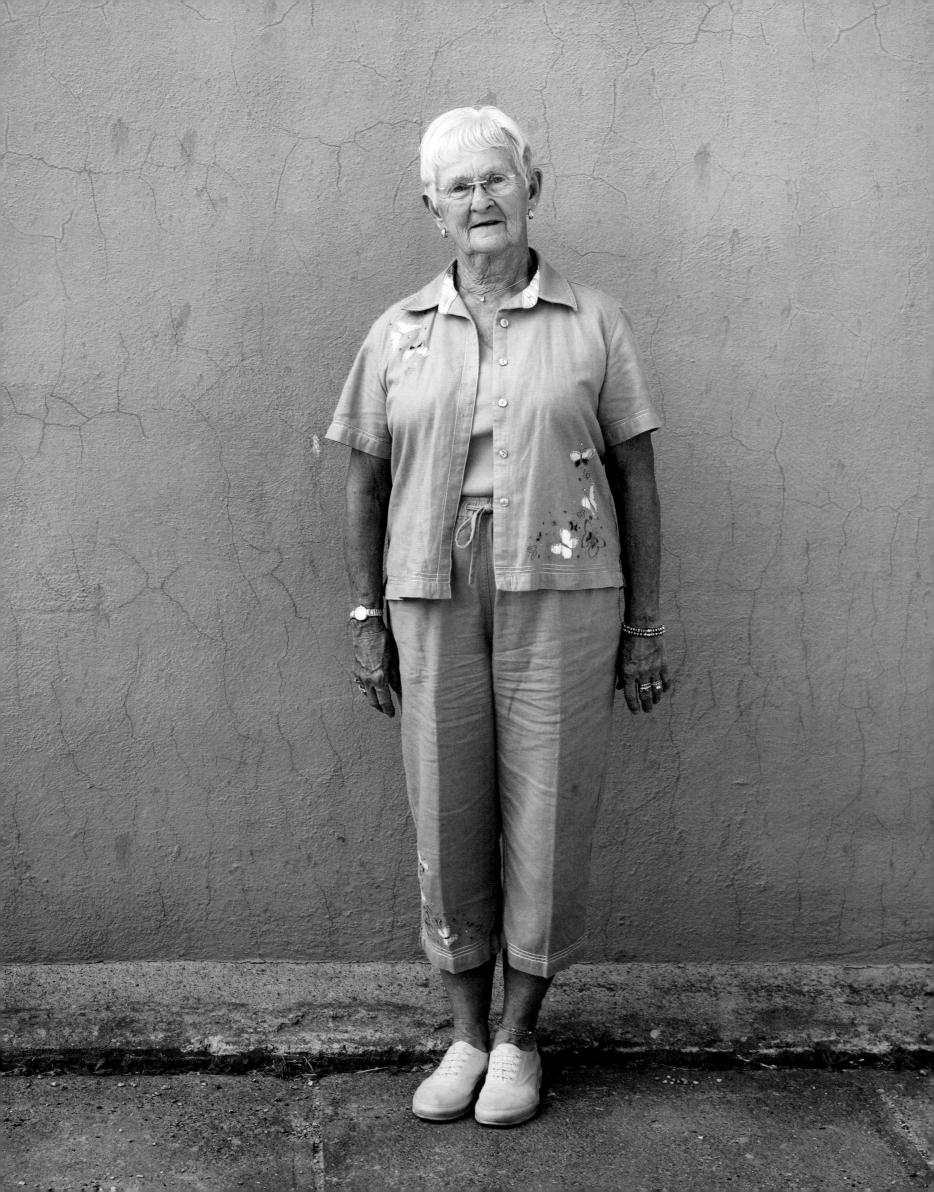

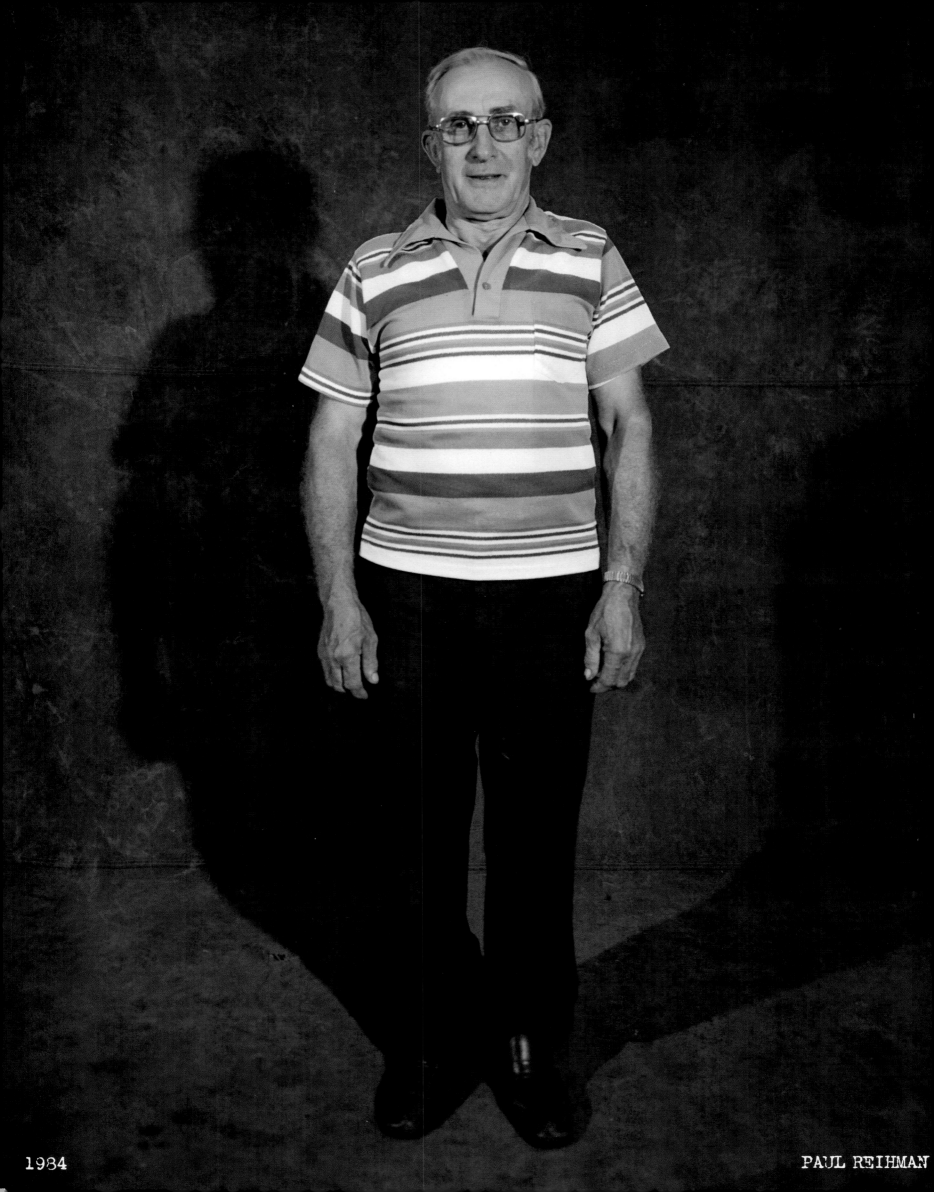

1984

PAUL REIHMAN

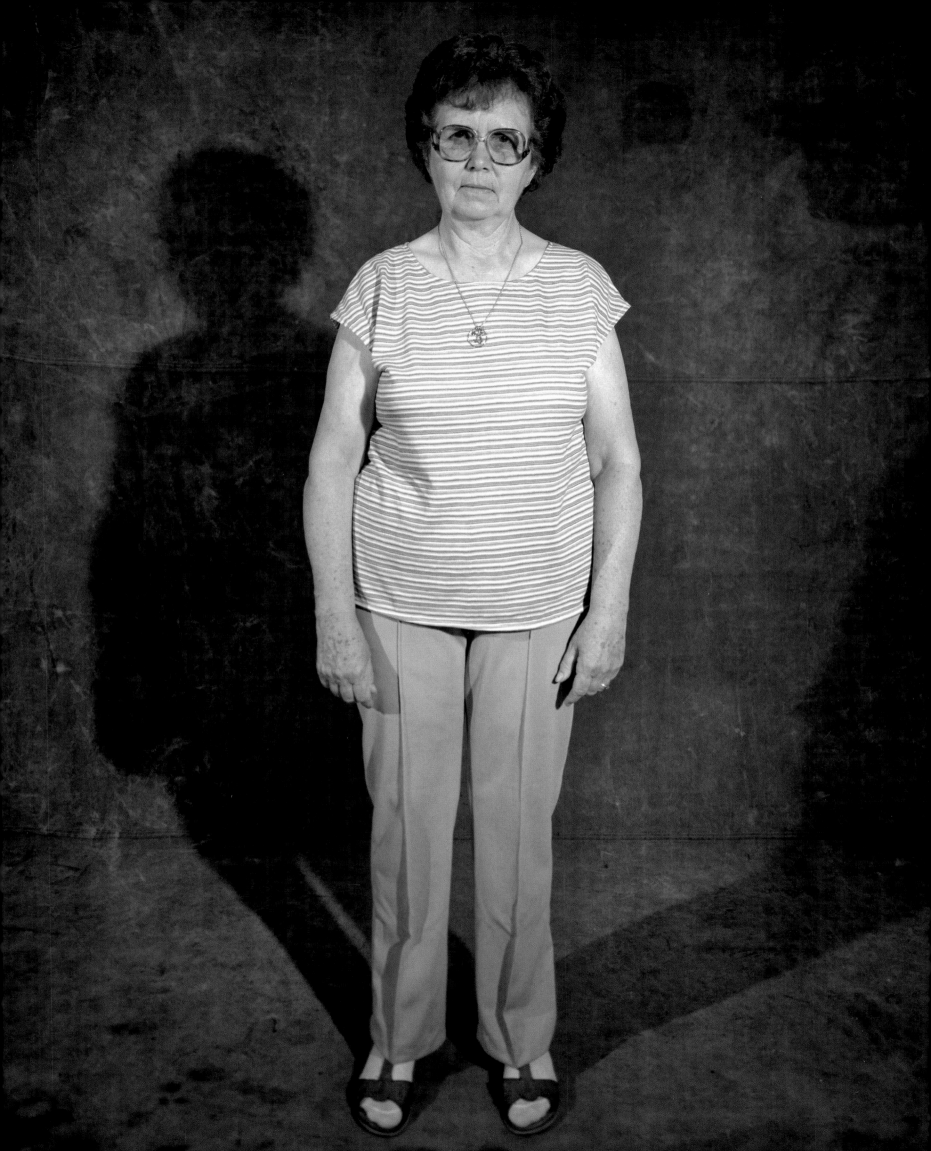

1984

VIOLET REIHMAN

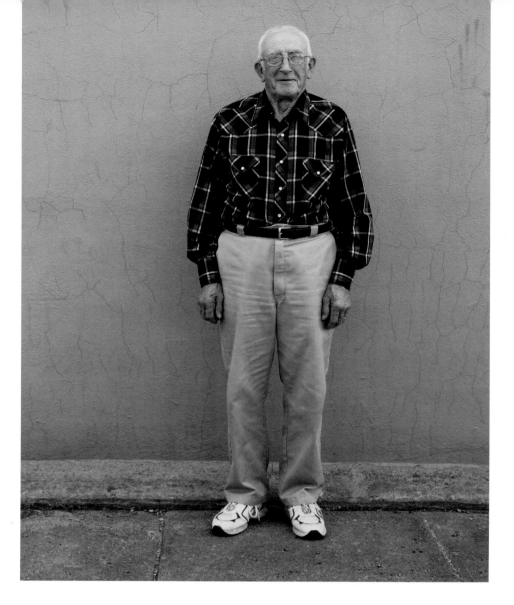

"We'll be married this fall sixty-three years.
I'm a happy guy every day. There's no other way."

PAUL REIHMAN

I WORKED AS A MECHANIC for thirty-five years for the Ford garage in town. Shorty Allison used to own it. Shorty sold to Reagan & Schultz (Schultz was a silent partner), then they sold to Lyle Salter, but he passed away one night real sudden and his wife sold to Carter.

I have five tractors: a John Deere H, John Deere B, John Deere MT, Farmall H, and an Allis Chambers B. I monkey around with them and ride them in parades.

I get up at six thirty. I don't eat much for breakfast, a bowl of All-Bran or Shredded Wheat and a half a glass of orange juice. I take care of my dog Trixie. She's a purebred Keeshond, bred in Belgium. I feed her and wash her. I also go to the Depot and meet friends—Brumley (he goes by Bullwinkle), Don Saxton, Bud Woods, and Al Scheetz.

Leonard Tomash is too sick to come by anymore.

I like mashed potatoes with gravy, pork chops, and chicken. I like that New York strip steak, too, with baked beans and sauerkraut salad (my wife puts in red peppers and onions). I used to like pie and cake, but I stay away from sweets these days.

I'll be eighty-six this month. I can't believe it, but I feel it. I hope I make it till ninety. I never drank. Never drank coffee, either. We can't all be like Jesus, but my wife and I consider ourselves good Lutherans. He's always seen me through with food, shelter, clothing, and health. I pray every day.

We'll be married this fall sixty-three years. I'm a happy guy every day. There's no other way.

ABOVE AND PRECEDING PAGES, LEFT: **PAUL REIHMAN** (b.1921)

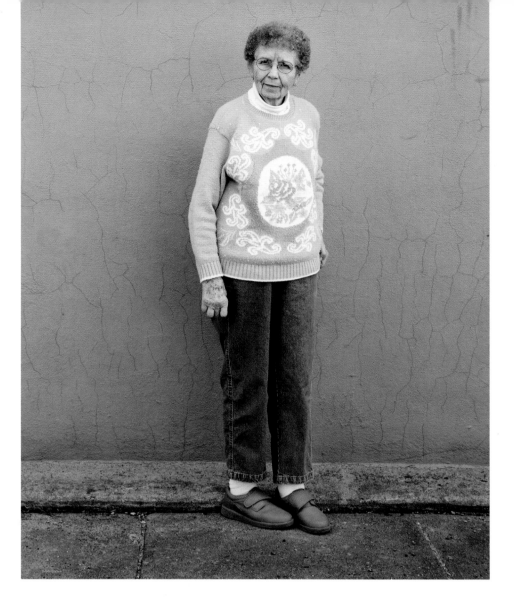

"We've lived here for sixty-one years. We paid
$1,650 for our home back in 1944. It's the only
house we've ever lived in."

VIOLET REIHMAN

I WAS BORN IN OXFORD. My father was a blacksmith.

I have neuropathy. It's like a real bad case of arthritis. I try to get by with a cane, but it's not easy. Tomorrow we're going to Wal-Mart to talk to an insurance man about the new Medicare drug plans. I hope we'll get some answers.

Two of our sons were wounded in Vietnam. One had his femur shot off, the other was shot in the shoulder. If my boys were of draft age today, we'd leave and move to Canada. We've got the worst president. We're so far in debt now I don't know how we're ever going to get back to normal.

We've lived here for sixty-one years. We paid $1,650 for our home back in 1944. It's the only house we've ever lived in.

Once a month we go to Tama to play bingo and the slots. We don't take much money.

I have my daily devotions. As long as you believe in God and go to church, that's all that's necessary.

Baking is good for me. I like to make kolaches.

ABOVE AND PRECEDING PAGES, RIGHT: Paul's wife VIOLET REIHMAN (b.1923)

"We've had the Ford dealership in town for thirty-four years now. It's not easy to compete with the big boys, but we do alright."

—Mary Ann Carter

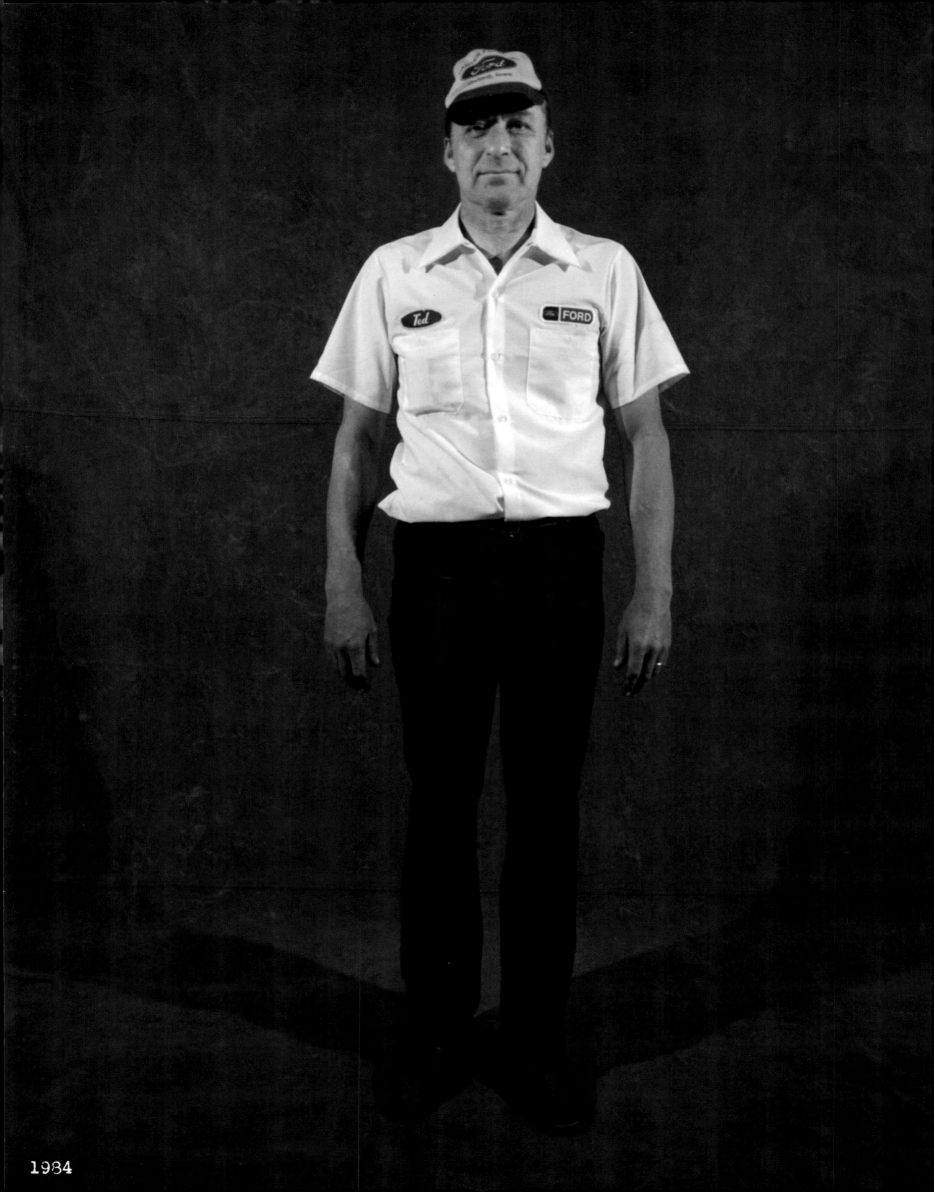

1984

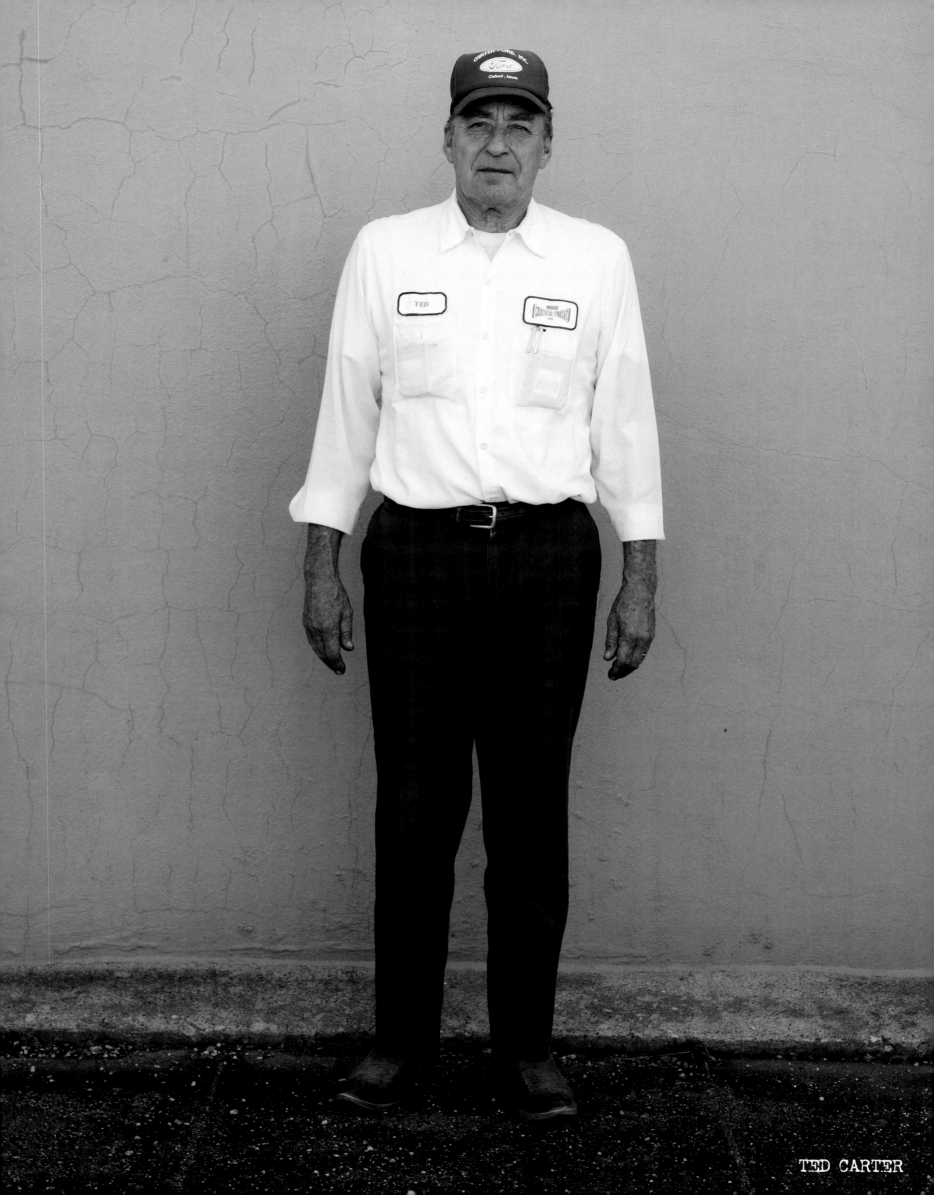

TED CARTER

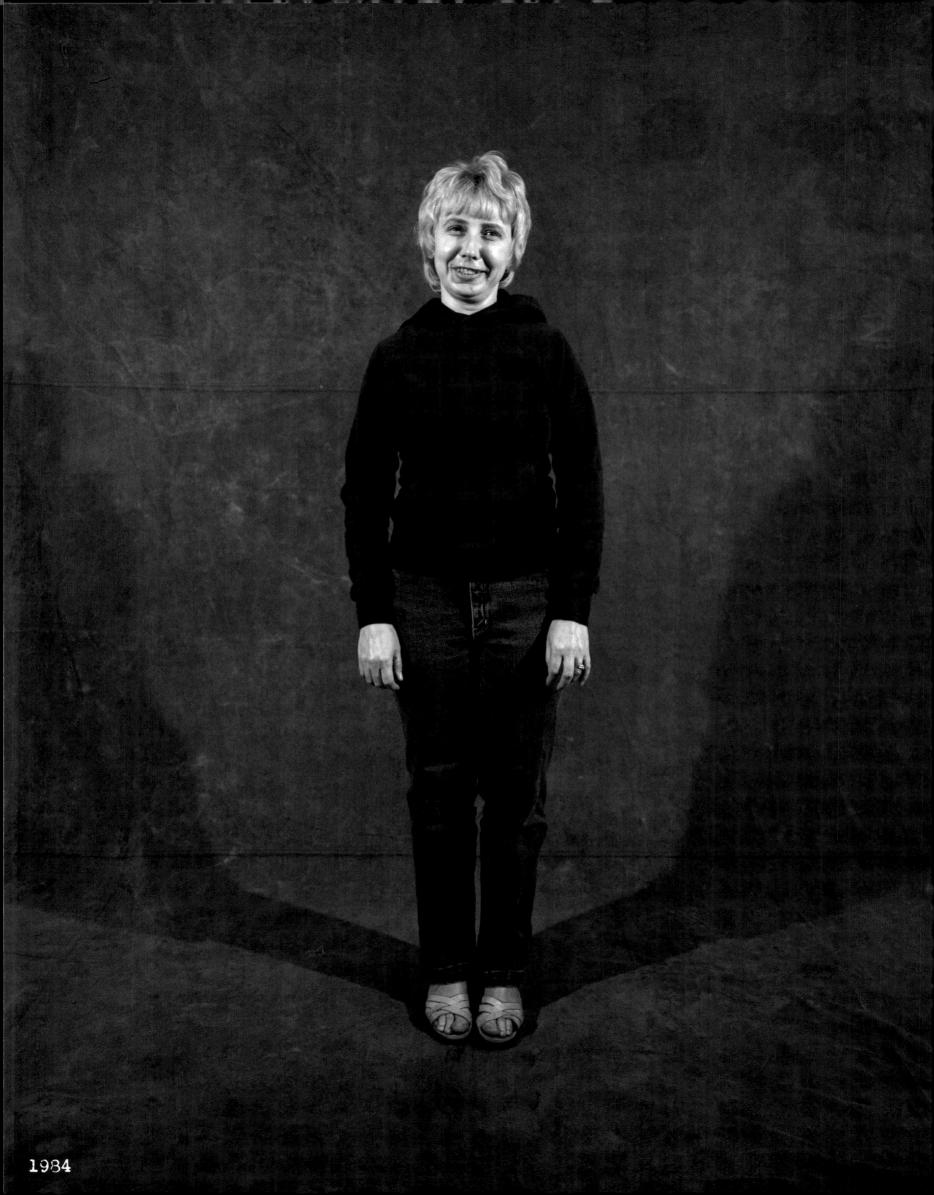

1984

MARY ANN CARTER

TED DIDN'T SHOW UP FOR OUR FIRST DATE. He got into a car accident and ended up in the hospital. The next weekend he didn't show up again. That time, he tried to outrun a highway patrol car and got arrested.

I graduated from the University of Iowa when I was fifty. I got to wear my daughter's cap and gown. Carole Ann and I are close. We go mushrooming two or three times a week during the season. We just got back. We look for dead elms. They're supposed to have the right spores. I don't really like mushrooms, but it's exciting to find them.

I cut them in half, then let them sit in a salt bath overnight. Next day, you clean the brine off, and dip them in eggs, milk, and cracker crumbs. Then you fry them in butter.

We've had the Ford dealership in town for thirty-four years now. It's not easy to compete with the big boys, but we do all right. Our customers are loyal. They realize we have to make a profit to stay in business. Our biggest sellers these days are Explorer SUVs and Ford-150 trucks. But I drive around in a white pickup or a Thunderbird.

Carole Ann, our son-in-law, and our two grandchildren live next door to us. We have eight acres, they have two. Ted and I have been married forty-two years. I feel blessed.

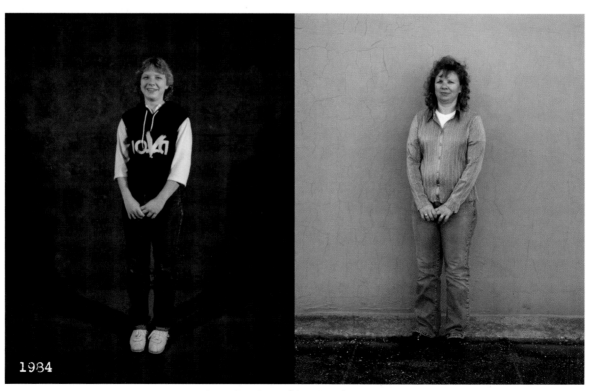

1984

Carole Ann (Carter) Hebl

OPPOSITE AND TOP: **MARY ANN CARTER** (b.1944) PRECEDING PAGES: Mary Ann's husband **TED CARTER** (b.1941)
BOTTOM: Ted and Mary Ann's daughter **CAROLE ANN (CARTER) HEBL** (b.1965)

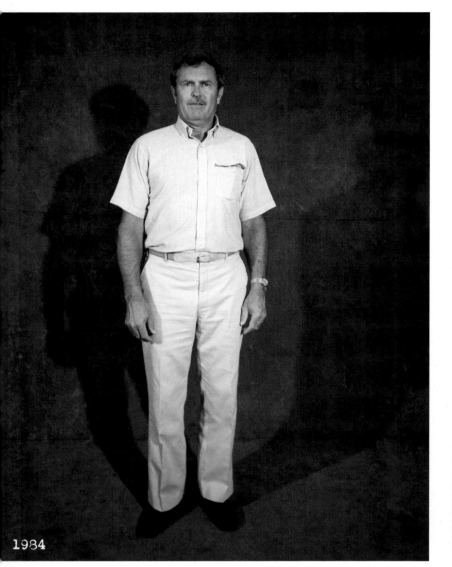

1934

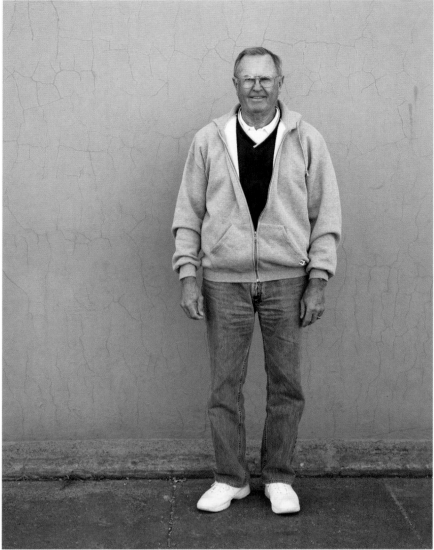

"I'm a tree hugger."

BUD MILLER

I STAYED ON THE FARM FOR A YEAR, then I enlisted in the Army. They sent me to Arlington National Cemetery. It was a lot of spit 'n polish, and I wanted to go someplace else. So they sent me to Wheeler Air Force Base in Hawaii, where I was a clerk-typist.

When I got back, I farmed for five years. But I didn't like it. I ended up selling life insurance for Western Bohemian Fraternal Association. I stayed on for twenty-six years, the last twelve as president.

You're selling an intangible. You have to be persistent.

It's harder today than it used to be. People don't plan as much for the future. If someone says no, you move on, but you never sever ties. You want to stay active in community affairs. I was on the school board for six years. And I helped with girls' softball and Little League.

I'm a tree hugger. I've planted five to six thousand trees on my property—pines, ash, and oaks. I also have a two-acre pond.

My only regret is that I would have went to college. Maybe I'd have had more confidence.

BUD MILLER (b.1936)

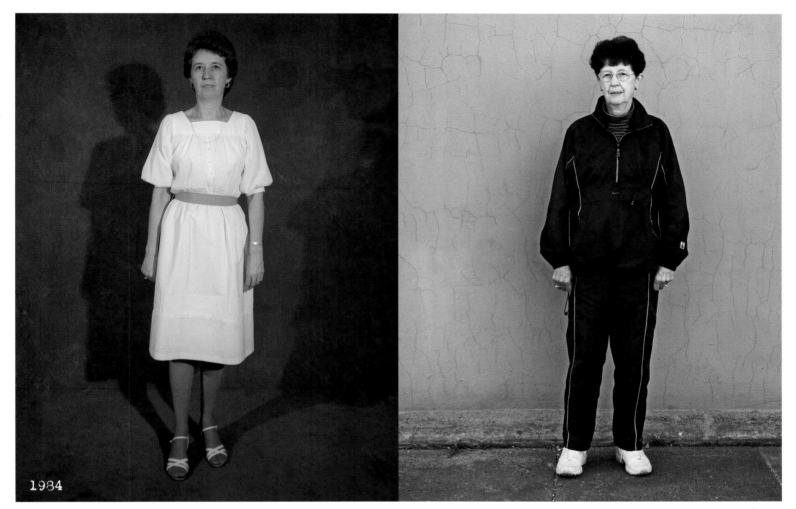

Lee Ann Miller

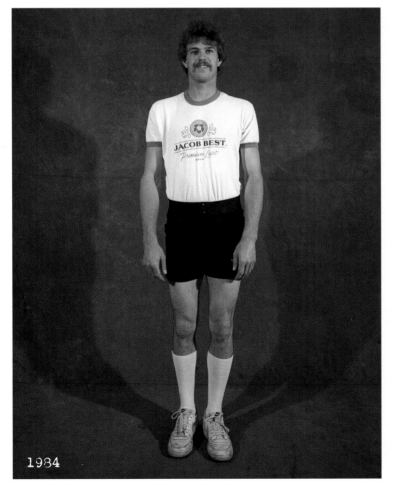

Mike Miller

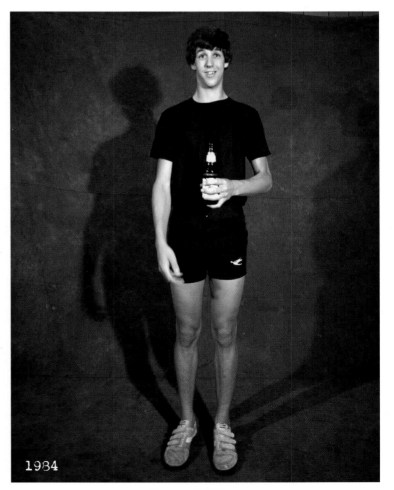

Terry Miller

TOP: Bud's wife LEE ANN MILLER (b.1936) ABOVE: Bud and Lee Ann's sons MIKE MILLER (b.1960) and TERRY MILLER (b.1963)

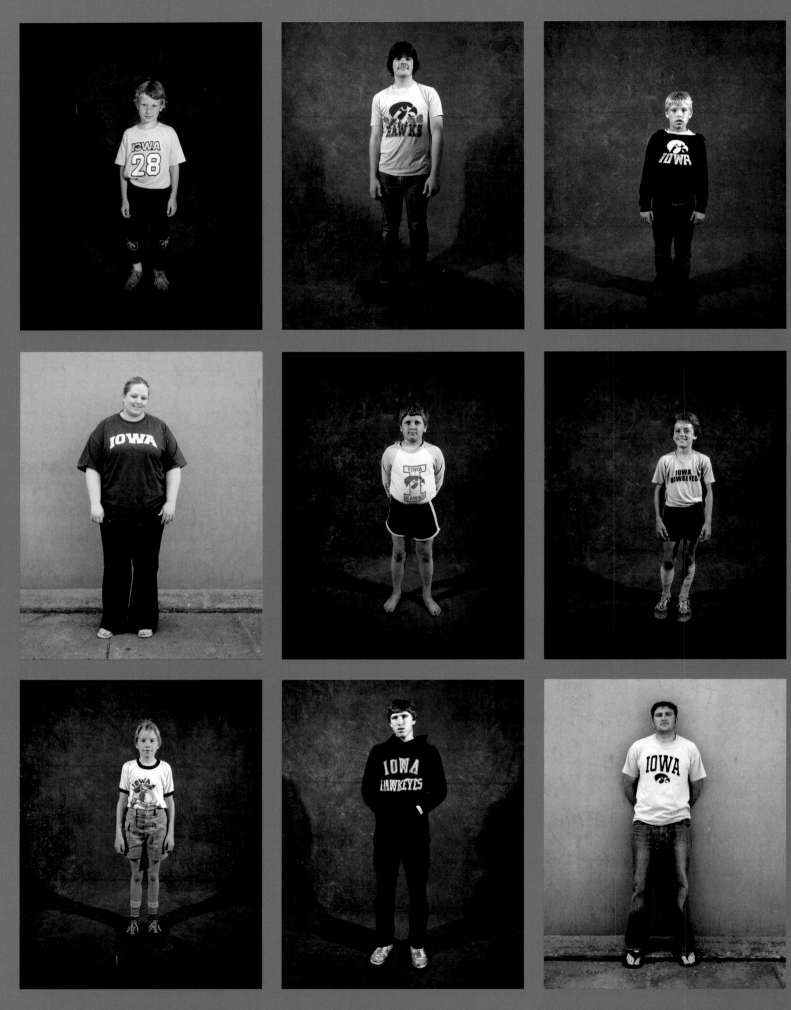

Oxford residents in 1984 and 2005/6 wearing their pride for the University of Iowa.

LEFT: **LINDA POTTER** TOP ROW: **BEN STRATTON** (b.1976), **DALE MILLER** (b.1968), **JAMIE COX** (b.1974) MIDDLE ROW: **KARLA REIHMAN** (b.1978), **BOBBY WILCUT**, **DAVID KUTCHER** (b.1974) BOTTOM ROW: **JASON FULL** (b.1970), **JEFF KUEPKER**, **PATRICK SPIRIT STOAKES-HUGHES** (b.1976)

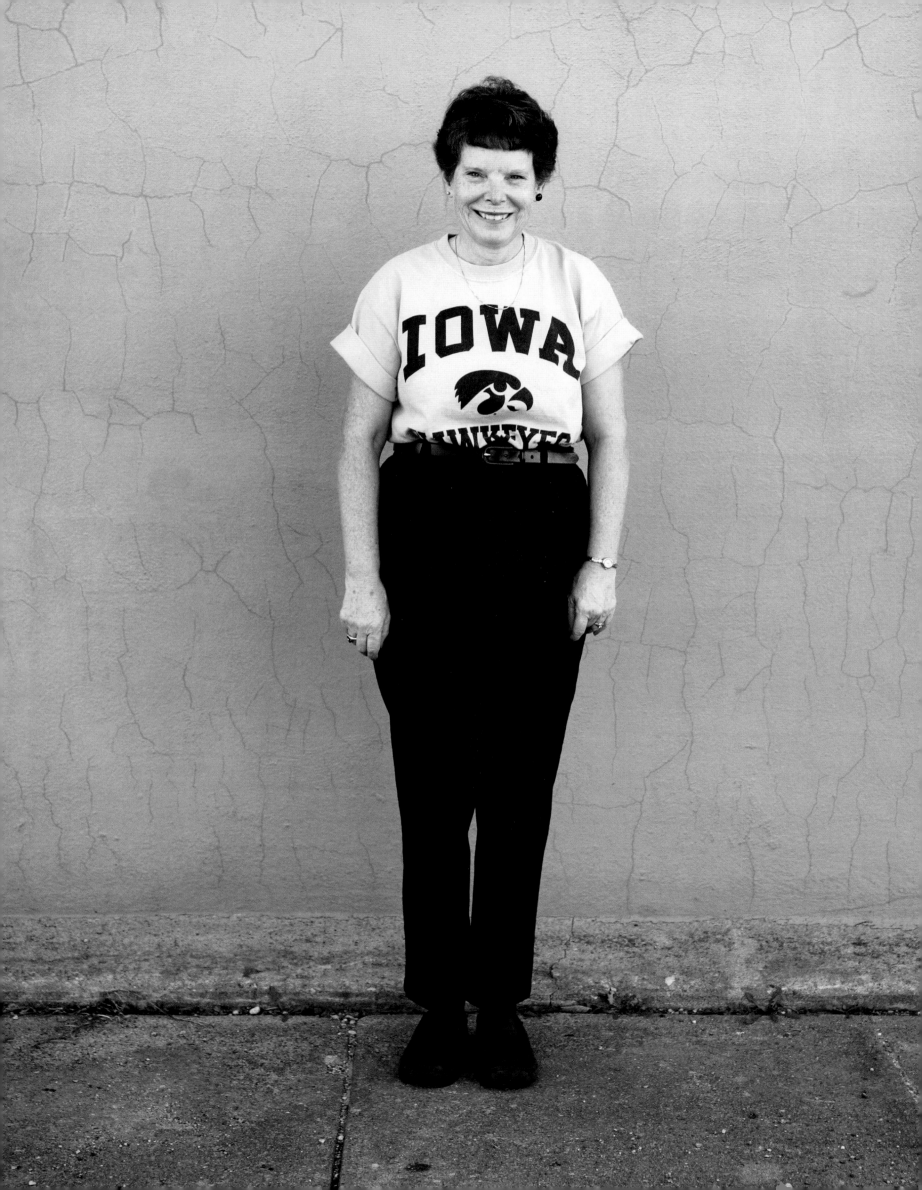

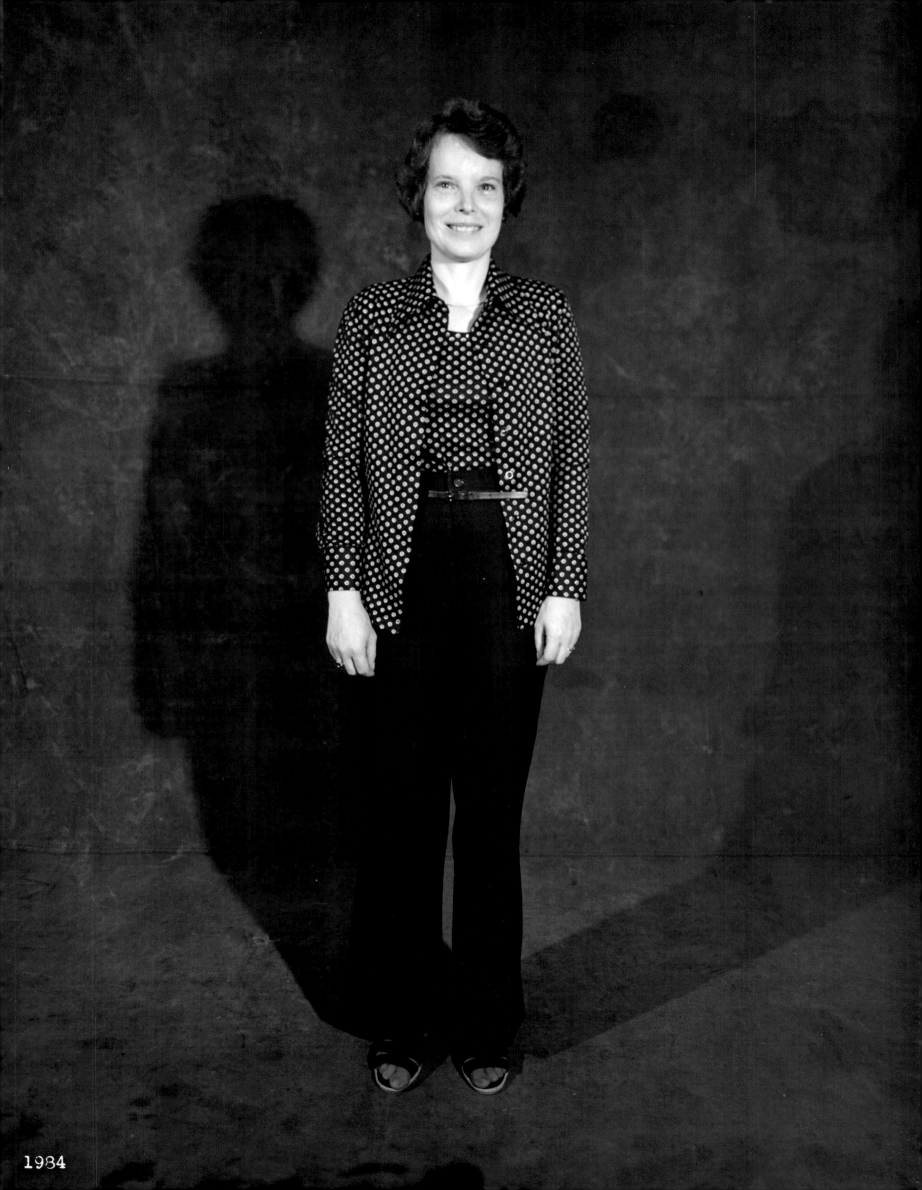

1984

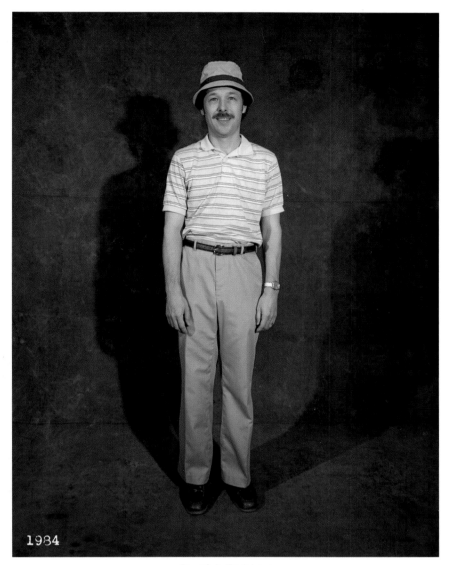

1984

David Potter

"I teach first grade in Oxford. No Child Left Behind makes us test the kids to death. There's no time to make fun any longer."

LINDA POTTER

ONE SATURDAY, I had plans to go to supper with my friends, Dan and Bev Flink. Dan said he had to make a quick stop in Tiffin to pick someone up. So Dave gets in the car and we drive to Mr. Steak in Coralville. Afterwards, the four of us went to a movie—I can't remember which one. Dave's kinda shy and I'm kinda shy, but it went fine.

I don't know whether Dave planned it this way, but he left his jacket in the car. So, two or three weeks go by, and one Saturday I had my hair in rollers and Dave comes by to pick up his jacket. I looked real cool. *Not!*

The next Christmas I got my engagement ring and in June we got married. Jennifer was born in 1978, and in 1981 Amy came along. A couple of weeks ago, we found out we're going to be grandparents.

I teach first grade in Oxford. No Child Left Behind makes us test the kids to death. It's a lot of paperwork. You're always watching the clock. There's no time to make fun any longer.

I love to garden—lettuce, cabbage, beans, tomatoes, raspberries. Perennials, annuals, and roses. My dream job would be to work in a greenhouse.

OPPOSITE: **LINDA POTTER** (b.1951) ABOVE: Linda's husband **DAVID POTTER** (b.1947)

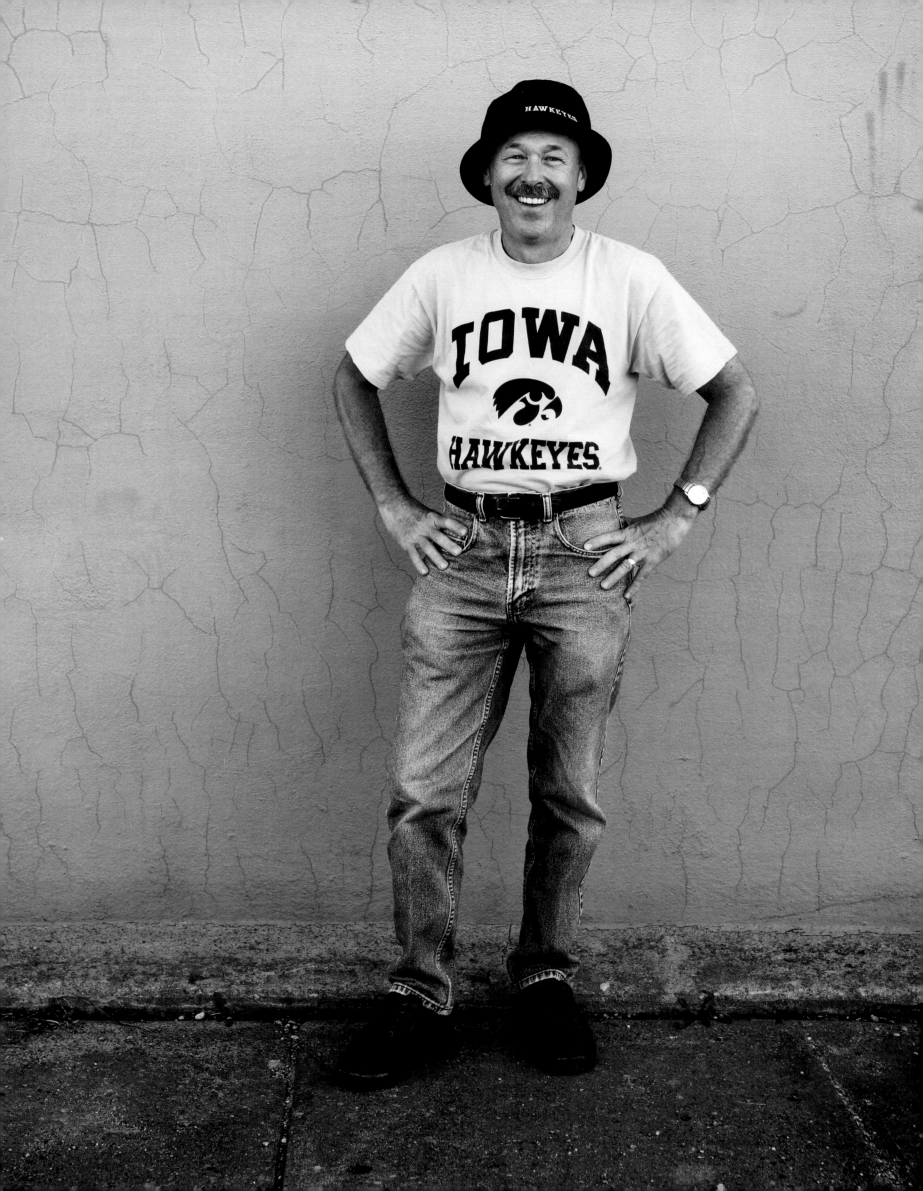

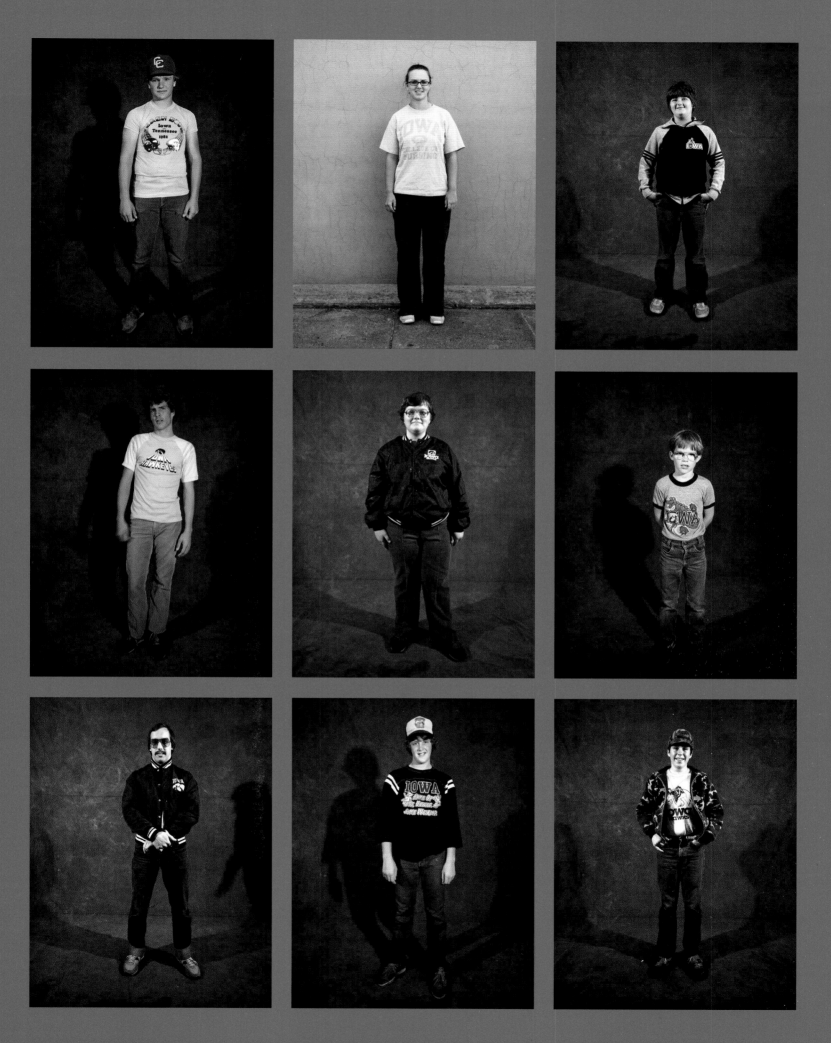

TOP ROW: KEN KUEPKER, JULIE REIHMAN (b.1982), CHAD KOENIGHAN (b.1972) MIDDLE ROW: KEVIN EALY (b.1968), MARY ROBERTS,
ANDY WELDON (b.1976) BOTTOM ROW: WILBUR ROHRET (b.1960), TOM COCHRAN (b.1970), STEVE JIRAS (b.1972) RIGHT: DAVID POTTER

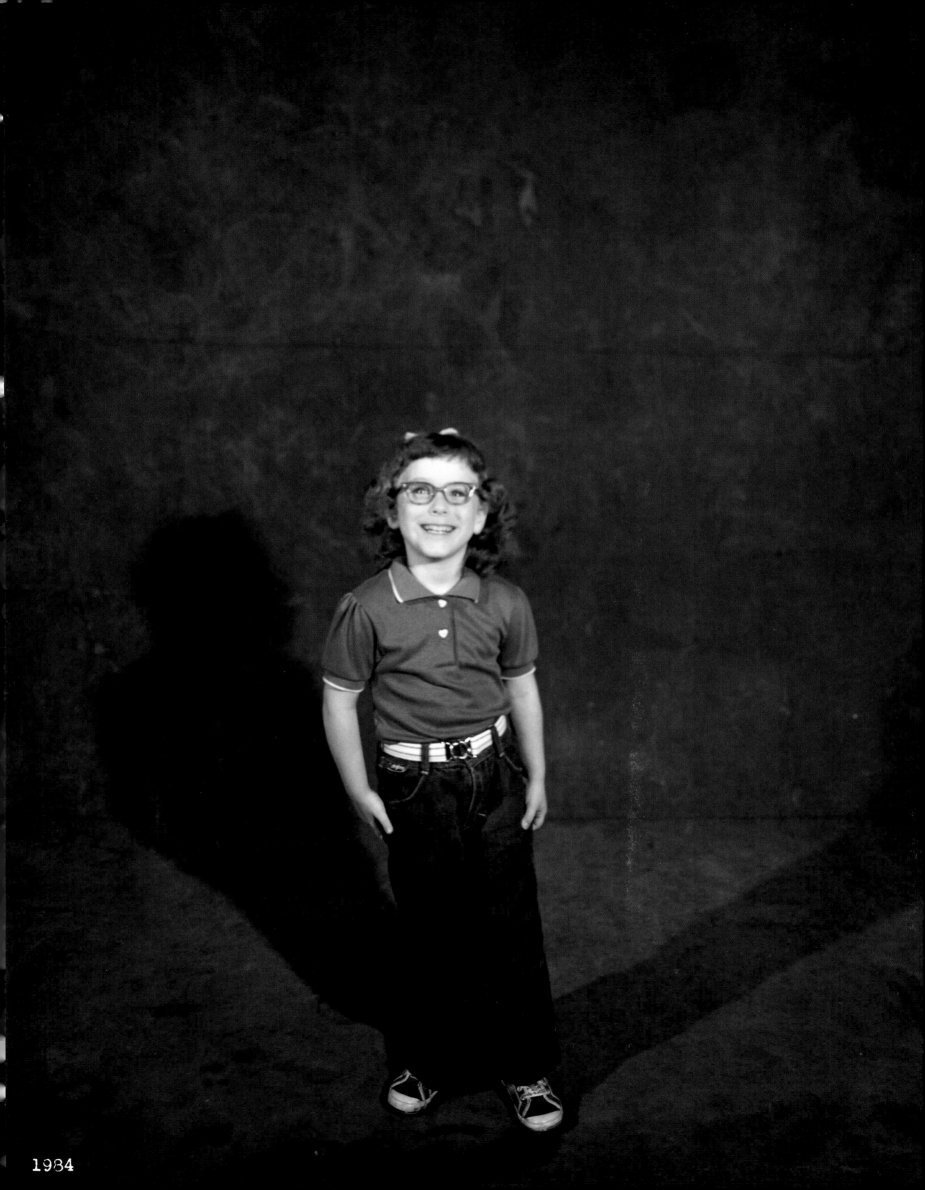

1984

"I'm a third-generation schoolteacher. My main thing
is to get the kids to know they're musical beings."

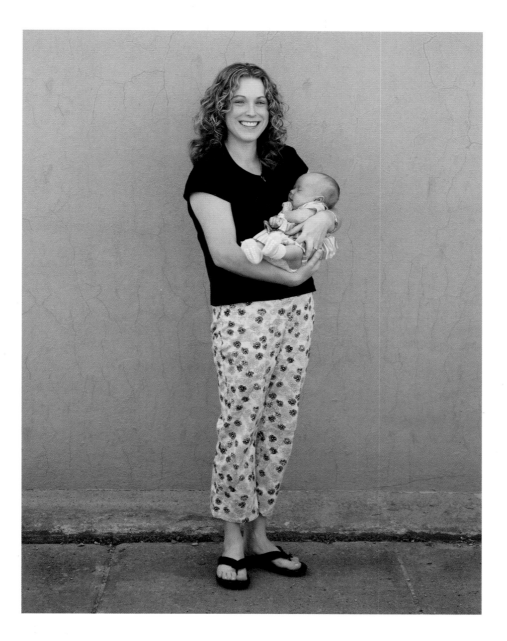

JENNIFER (POTTER) WALKER

THE FIRST INSTRUMENT I EVER PLAYED WAS THE ORGAN. I was the organist for eight a.m. mass at St. Mary's. In high school, I played clarinet and saxophone in jazz band, but my favorite activity was singing soprano in the choir. I went to Luther College and studied music education. That's where I met my husband. He teaches music at North-Linn Community Schools. We named our baby Lilly Beatryce, but we call her Lilly.

I'm a third-generation public-school teacher. I teach K–5 music in Marion. My main thing is to get kids to know they're musical beings. I might start out by singing to a student:

"HEL–LO, LU–CAS"

And they'll sing back:

"HEL–LO, MRS. WAL–KER"

I go back to teaching in two weeks. I know it'll be hard to leave Lilly in daycare. But I'm ready to see my students again. I know Lilly's ready to meet other people in her life.

David and Linda's daughter **JENNIFER (POTTER) WALKER** (b.1978) with daughter Lilly Beatryce

"Kids are growing up way too fast. In 1984, kids barely touched each other. Today, they hug in the hallways, and they're doing a lot more."
—Kathy Brack

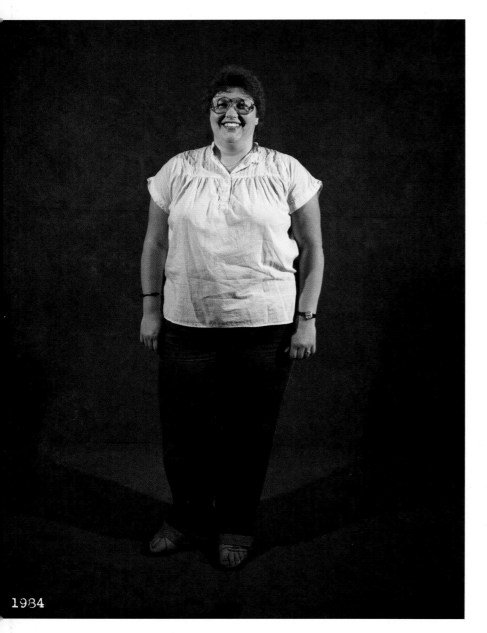

1984

KATHY BRACK

I'VE BEEN A SCHOOLTEACHER for thirty-four years. I'm teaching the kids of kids I used to teach. It's a little weird.

I teach eighth grade. Some days they're little kids, and other days they think they're all grown up. The operative word is *drama*. Everything is a very big thing to them.

The whole look of families has changed. Now it's not necessarily the biological man and woman who are the parents. Kids have more power. Now they can say, "I'll go live with Mom," or "I'll live with Dad."

Kids expect immediate gratification. They want everything now. Five years ago, it was an exception for a kid to have a cell phone. Now it's an exception if they don't.

When I started teaching, we stressed capitalization, punctuation, spelling—that's what I was expected to teach. People say I have high standards. But I've adjusted the bar over the years. I've had to.

Kids are growing up way too fast. In 1984, kids barely touched each other. Today, they hug in the hallways, and they're doing a lot more. "P.D.A." is what we call it—Public Display of Affection.

If I'm in the mall and I hear a kid using inappropriate language, I'll say, "Knock it off!" Sometimes I have to restrain myself.

There were seven children in my family. We grew up three miles south of Oxford on a farm. The farthest anyone's moved is Belle Plaine. We're all pretty much within fifteen minutes of each other. It's been a blessing. I don't know how people live far away from their families.

I've never married. I adopted a little girl when she was thirteen. Now she's twenty-seven and she has a seven-year-old boy of her own.

I've had some relationships. I guess I'm just too strong. If the right person came along, I'd still be open to it. I'm starting to look at retirement in three years, when I'm fifty-seven. I've never been to Yellowstone or the Grand Canyon, and I'd like to see New England in the fall. I'd love a companion to come along—just as long as I get my own way.

KATHY BRACK (b.1952)

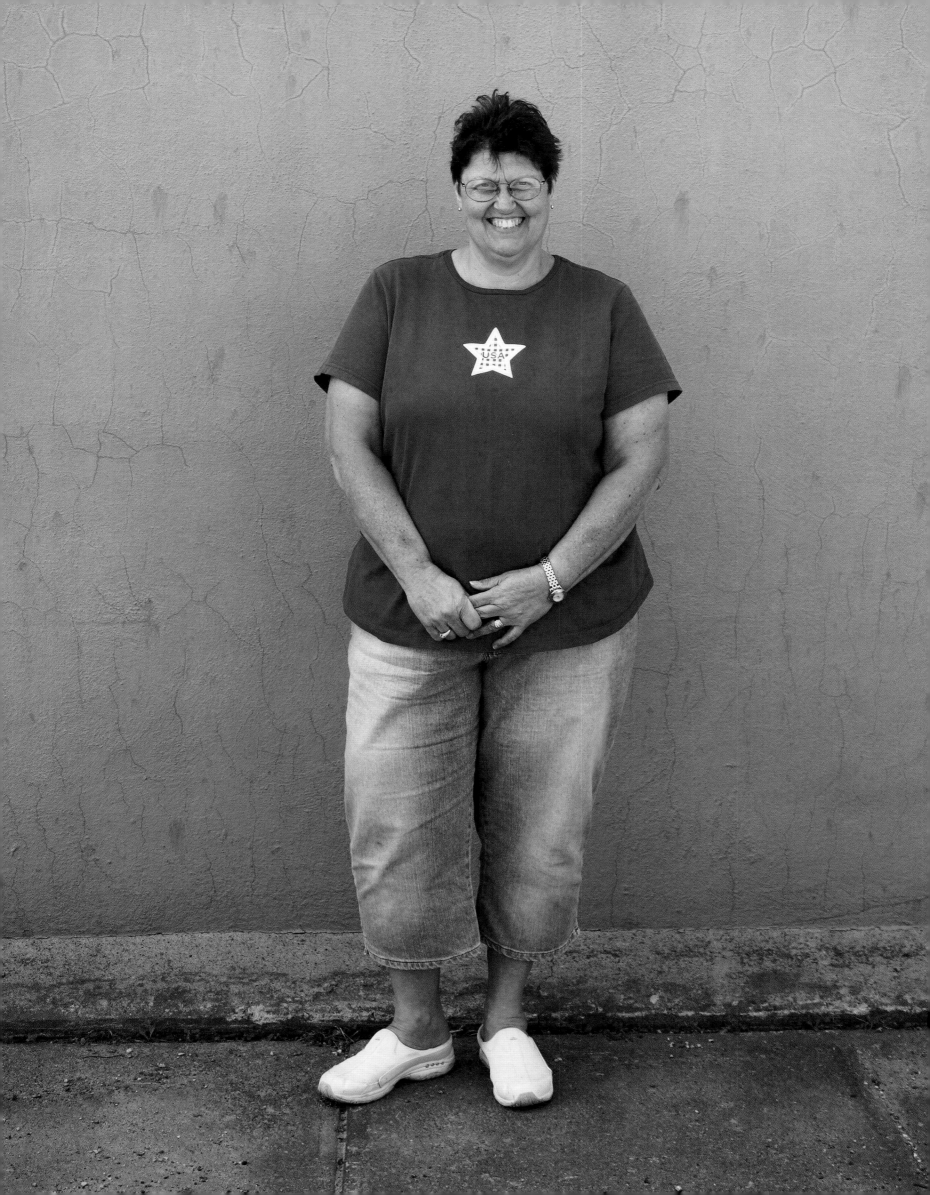

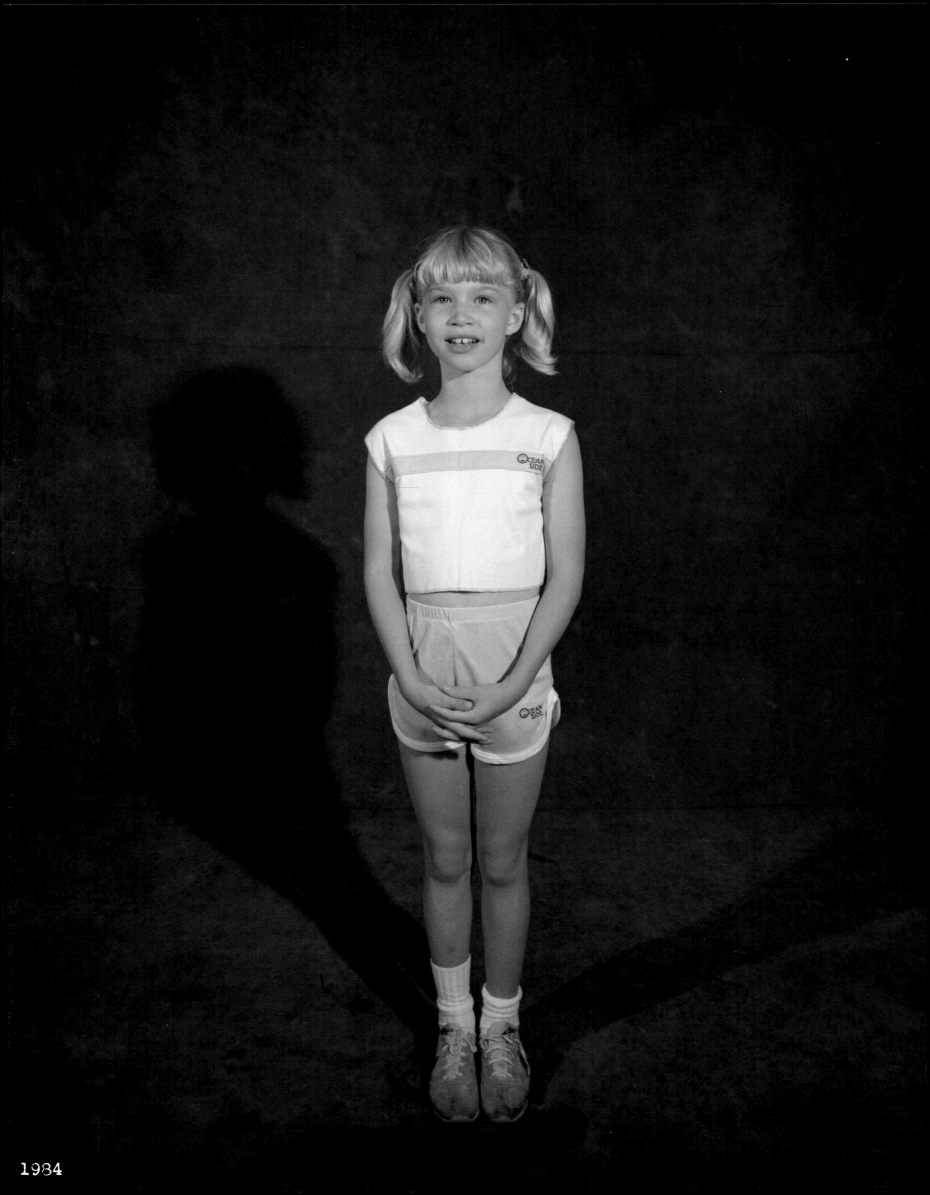

1984

"When I was born, my dad was sixteen and my mother was seventeen. I was in their wedding." —Tonya (Stratton) Wehrle

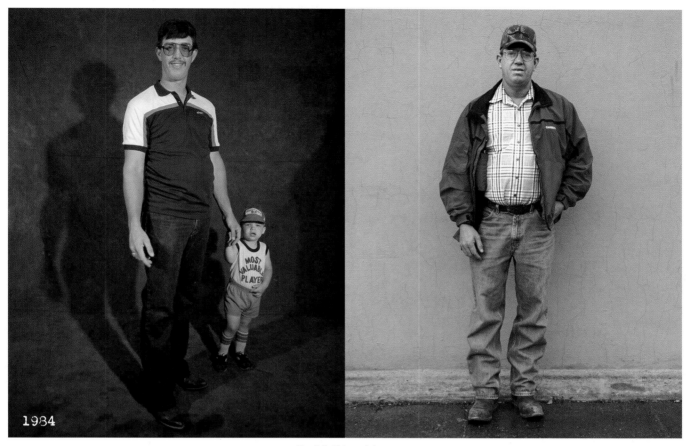

Jeff Stratton

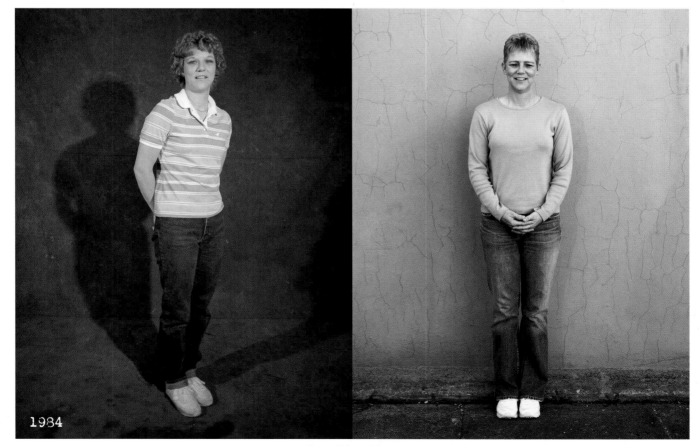

Dea Stratton

OPPOSITE: **TONYA (STRATTON) WEHRLE** (b.1974) ABOVE: Tonya's parents **JEFF STRATTON** (b.1958) with son Jay, and **DEA STRATTON** (b.1957)

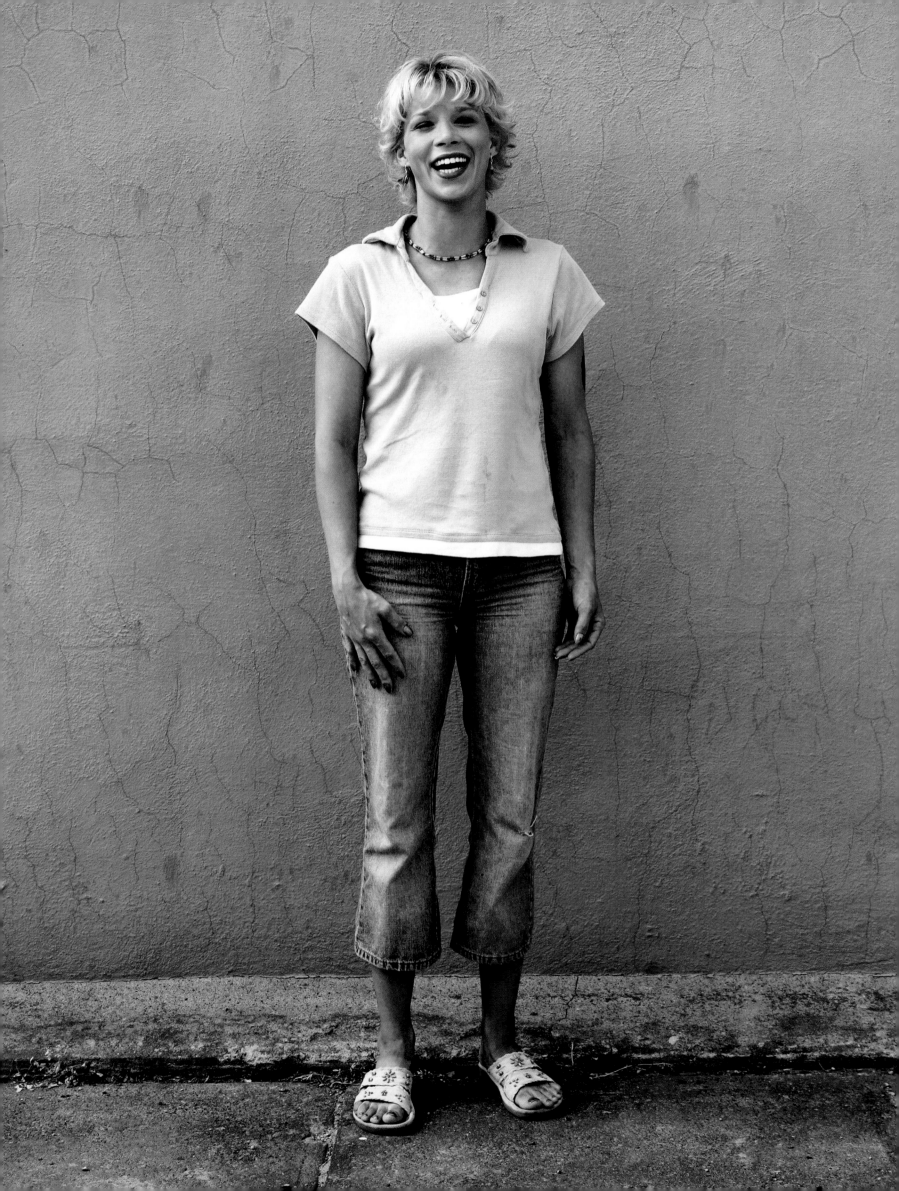

TONYA (STRATTON) WEHRLE

WHEN I WAS BORN, my dad was sixteen and my mother was seventeen. I was in their wedding. As a little girl, my mother did my hair every day. She dressed me in frilly dresses. I was immaculate.

In high school, I wanted to get in and get out as fast as I could. It was all about partying. I was a curfew-breaker. If my parents told me they didn't like what I was wearing, it'd be my favorite outfit.

When I was fourteen, I was sitting with my dad in his pickup outside the Alibi, and my dad was talking to this really cute guy. A couple of years later, he came over to our house for dinner. I was sixteen and he was twenty-two. He was one of the bad boys in town. He had long hair and this mullet thing going on. I was looking for maturity and someone who could buy alcohol. He had his own place, and the day I graduated high school, I moved in. We were married in Las Vegas on Valentine's Day.

Las Vegas is my favorite city. But while everyone else is gambling, I give away my money. I think I am a pretty good judge of character. Once at a bus stop, this guy dressed all in Armani said his wife had taken his credit cards and he didn't have a cent. I gave him thirty bucks and he promised to send me a check. My friends are still talking about that one.

If I wasn't married and with kids, I'd be working a craps table and partying around the clock. My kids are my number-one priority. Without them, I'd be very, very naughty. The more dangerous, the more excited I get. I'm flirtatious. At the drive-through, I'll hand a young boy my money and say, "Thanks, sweetie."

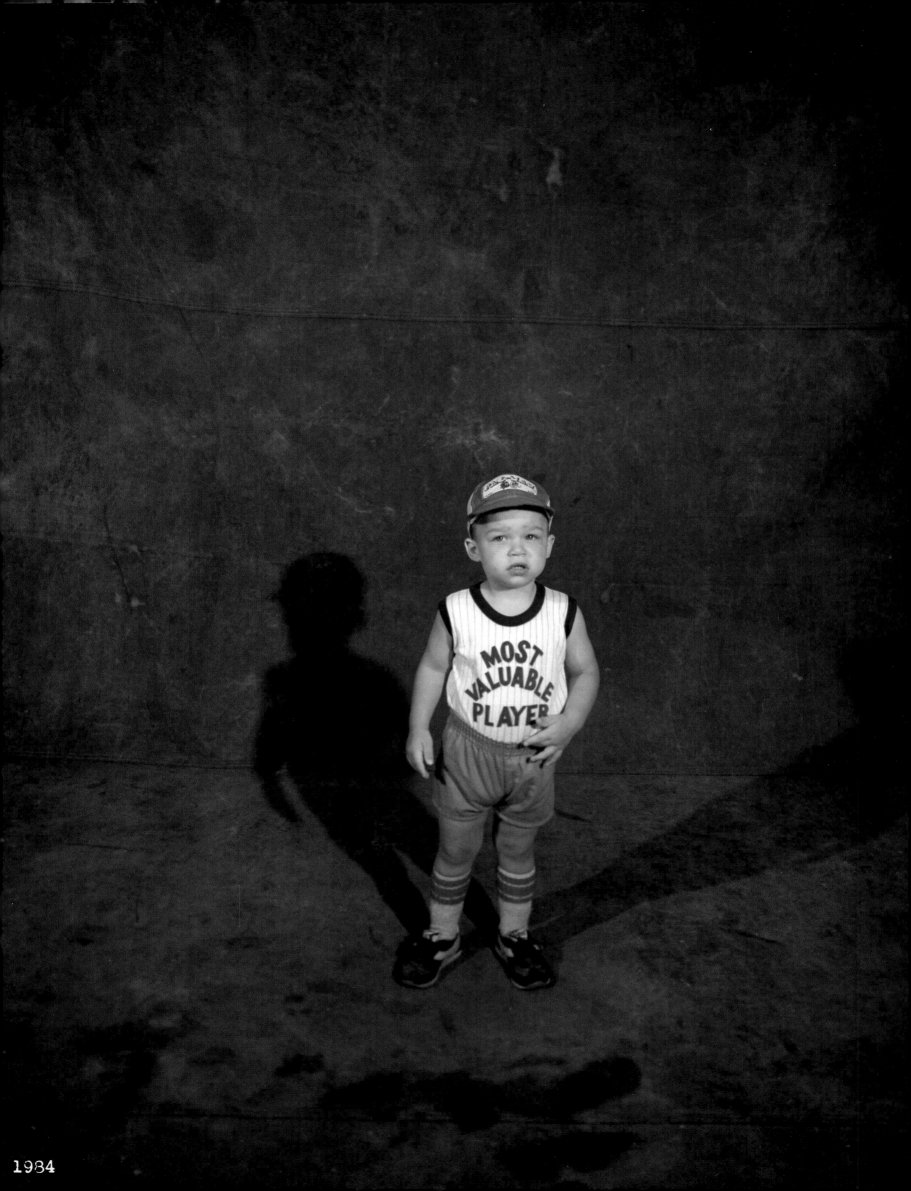

1984

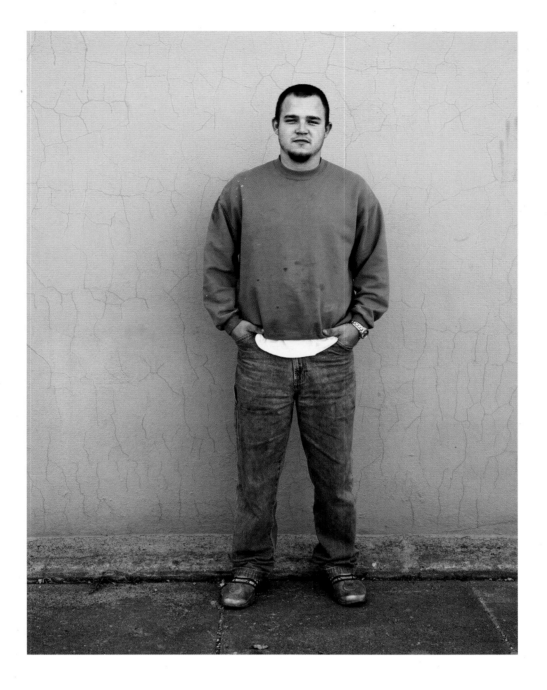

"Sometimes I get up in the middle of the night and start cleaning."

JAY STRATTON

I WORK EIGHTY HOURS A WEEK driving an asphalt dump truck. I get up at five in the morning and get home at ten at night. I don't like my job, but I like the money. I make a thousand bucks a week clear.

I'm twenty-three, but I have an eighteen-year-old stepson and a thirteen-year-old stepdaughter. I met my wife at a gas station. We have a baby on the way.

I've never talked to a black person in my life. I don't have any trust with them. There's two kinds of blacks. There's the no-good kind, and then there's the white black. I don't agree with how they talk, the jibber-jabber. I don't like the baggy, hip-hop clothes.

I'm a major clean freak. My house is spotless. I don't allow people in my yard because they'd leave tracks. I rake the gravel. I have four four-wheelers, but I don't drive them because I don't want to get them dirty. In my closet I put one-inch marks on the clothes rack, so each hanger is evenly spaced. Sometimes I get up in the middle of the night and start cleaning.

We have a miniature chihuahua, but she doesn't shed.

Tonya Stratton's brother **JAY STRATTON** (b.1982)

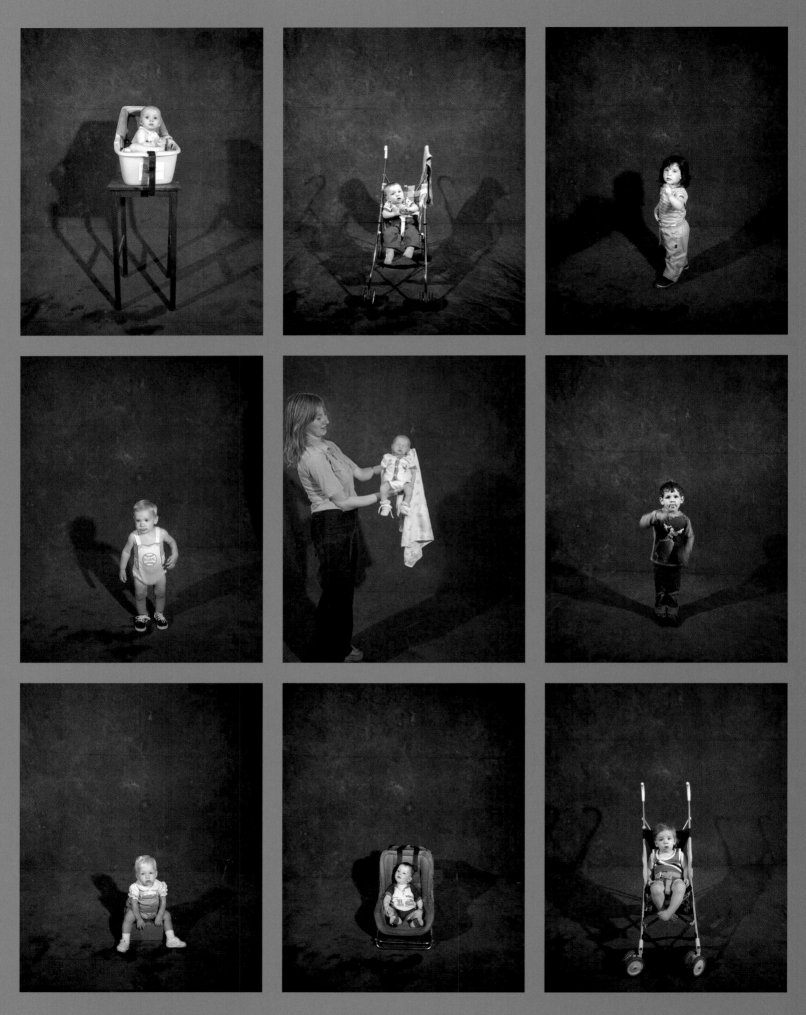

BOTH PAGES, LEFT TO RIGHT, TOP ROWS: ERIN STRAIT (b.1983); JOSHUA PRYMEK (b.1983); KRISTI SOMERVILLE (b.1982) MIDDLE ROWS: CORY BERG (b.1983); RAY REYNOLDS (b.1984); BRIAN PORTWOOD BOTTOM ROWS: STEPHANIE STRATTON (b.1983); SETH SOMERVILLE (b.1984); MICHAEL HENKELMAN (b.1983)

stars at night, I go to the forest behind our house." —Erin Strait

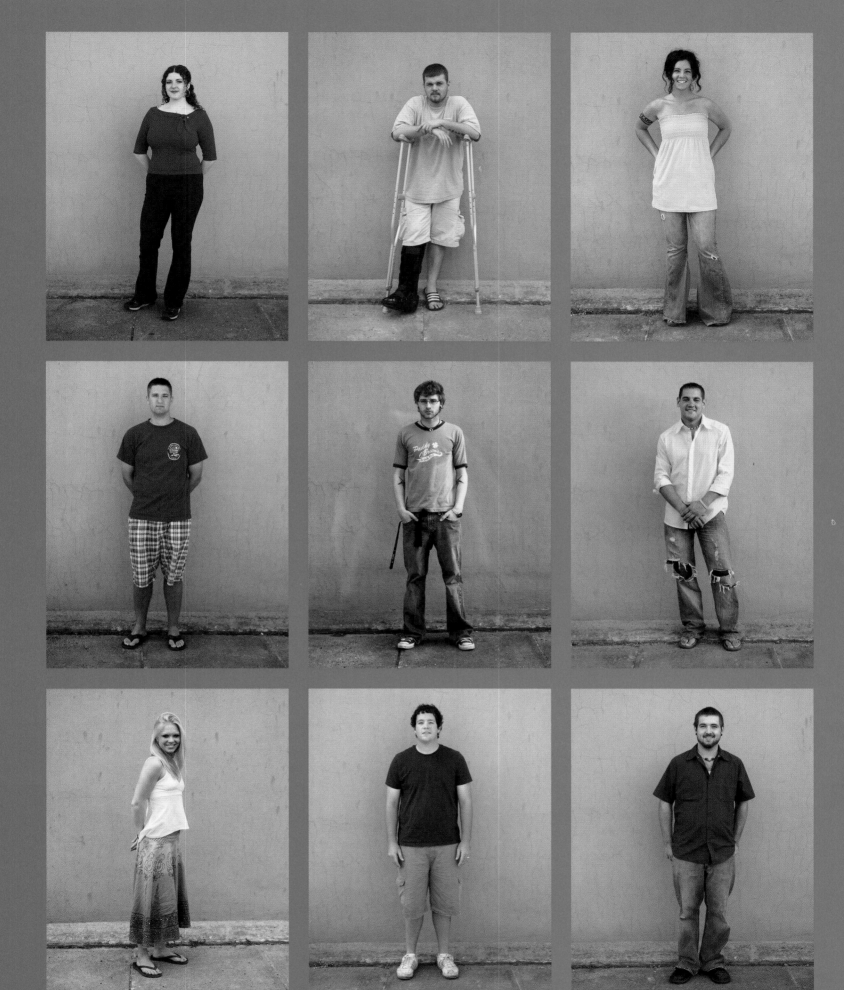

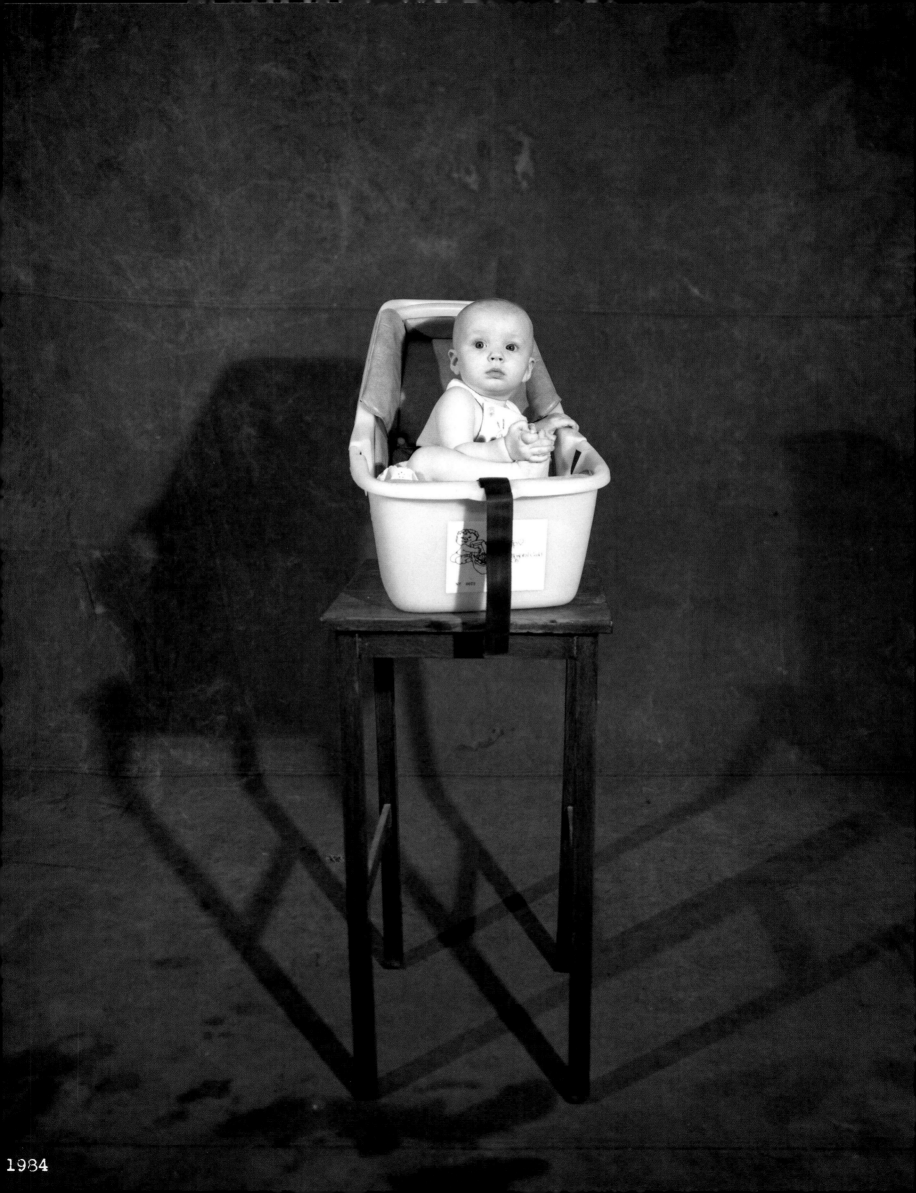

1984

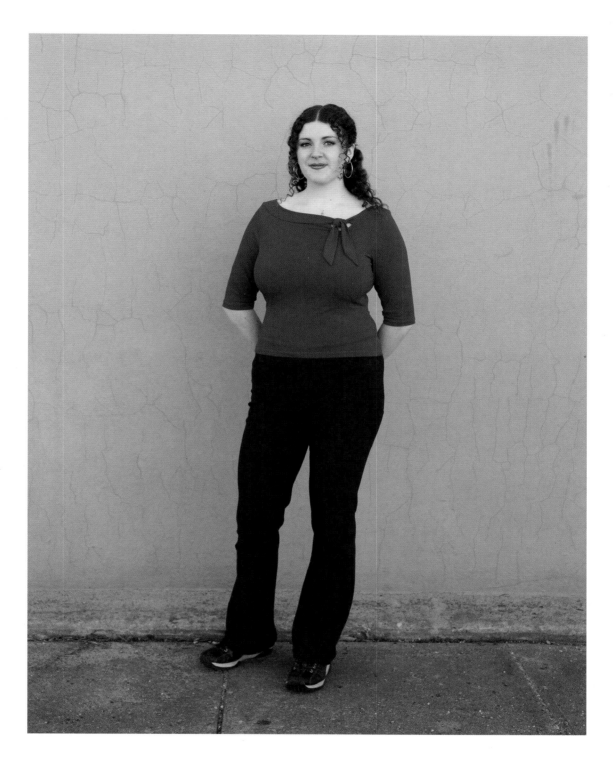

ERIN STRAIT

I'M A BUDDHIST. Every morning I do my prayers. I've just finished one hundred thousand prostrations, which is a requirement for ngondro. I'm about to do mandala, where I'll do another one hundred thousand offerings.

I live with my folks in Oxford. They're Buddhists, too. We have three horses and a pony. I'm not a party person. If I want to see the stars at night, I go to the forest behind our house. I can sing there.

I'm a senior at the University of Iowa, majoring in International Studies. Sometimes when I tell people I'm a Buddhist, they'll say, "Oh cool!" They think it's a fad or a fashion, not a religion.

In Buddhism, once you pass on, you're in limbo, or *bardo*, for forty-nine days. Depending on your karma, that's when you'd have a rebirth. You could turn into a dog, a bird, a human. There are six realms: hell, ghosts, animal, human, demigod, and god. The best way to get to nirvana is to accumulate merit, take vows from a qualified Lama, and study hard.

There's not a second in my life when I don't live as a Buddhist.

ERIN STRAIT (b. 1983)

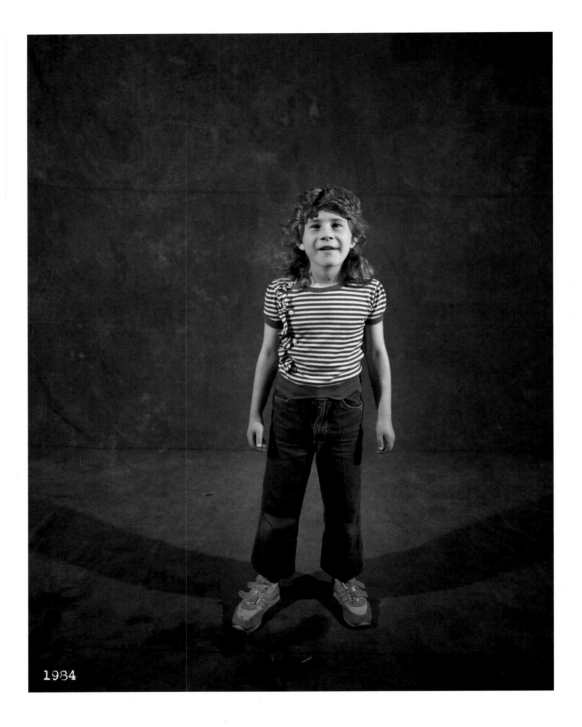

1984

"I'm a plant fanatic. I feel close to God when
I'm out walking. It makes me feel at peace."

MARY ANN (BECICKA) STORCK

I WORK IN A FACTORY from seven to three-thirty. We make car parts like radiator supports and dashboard things. I've been there seven years. I don't like the work, but I like the people. It's not bad pay. I'm on my feet all day. I've gotten so used to it that I don't like to sit down when I'm off.

I have a boyfriend now who I met at the factory. I took him to a Cubs game last year. He's going to move in with me if things go as planned.

We're planning a trip to Alaska when my boyfriend turns thirty. I love nature, and I know there's a lot of that up there.

I'm a plant fanatic. I feel close to God when I'm out walking. It makes me feel at peace. I do a lot of mushroom hunting, and I also like "shed" hunting. That's looking for deer antlers. I probably have twenty.

MARY ANN (BECICKA) STORCK (b.1975)

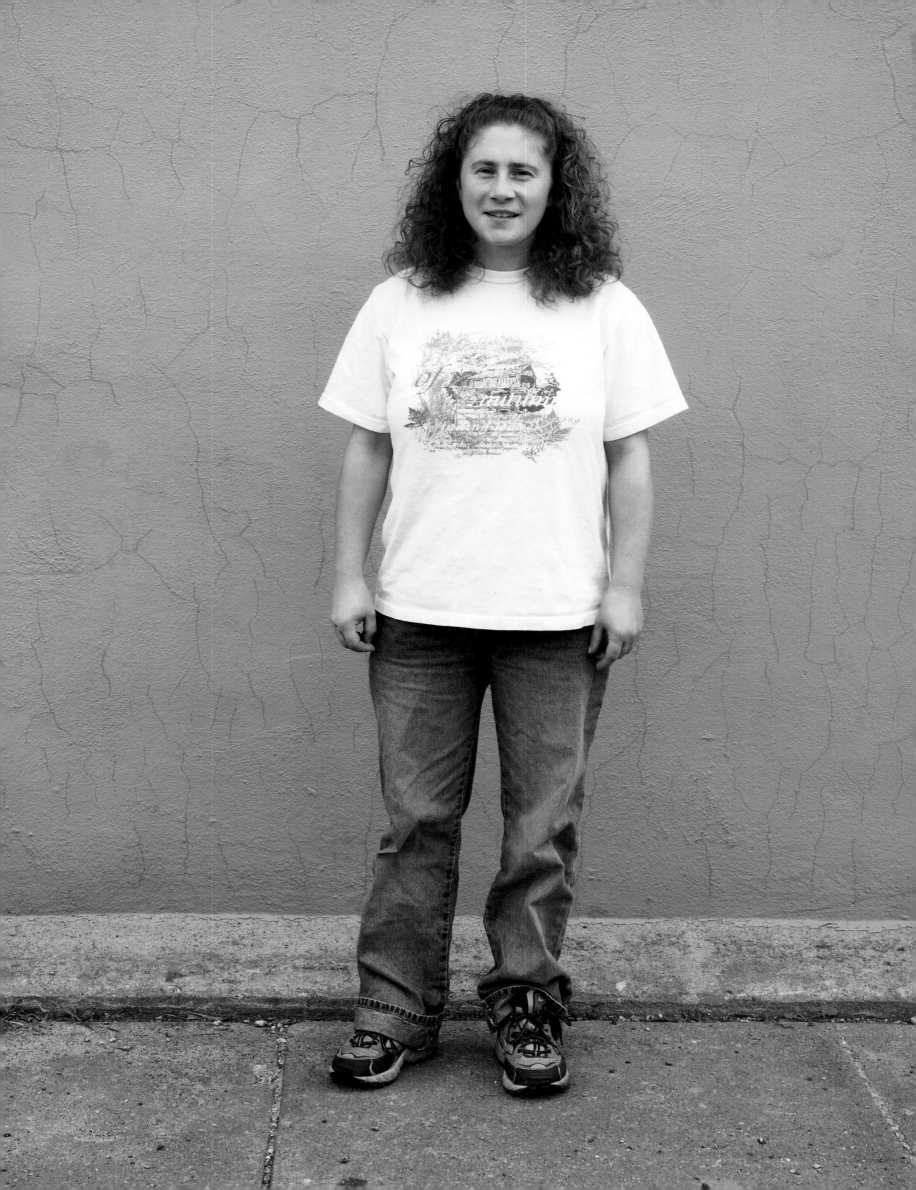

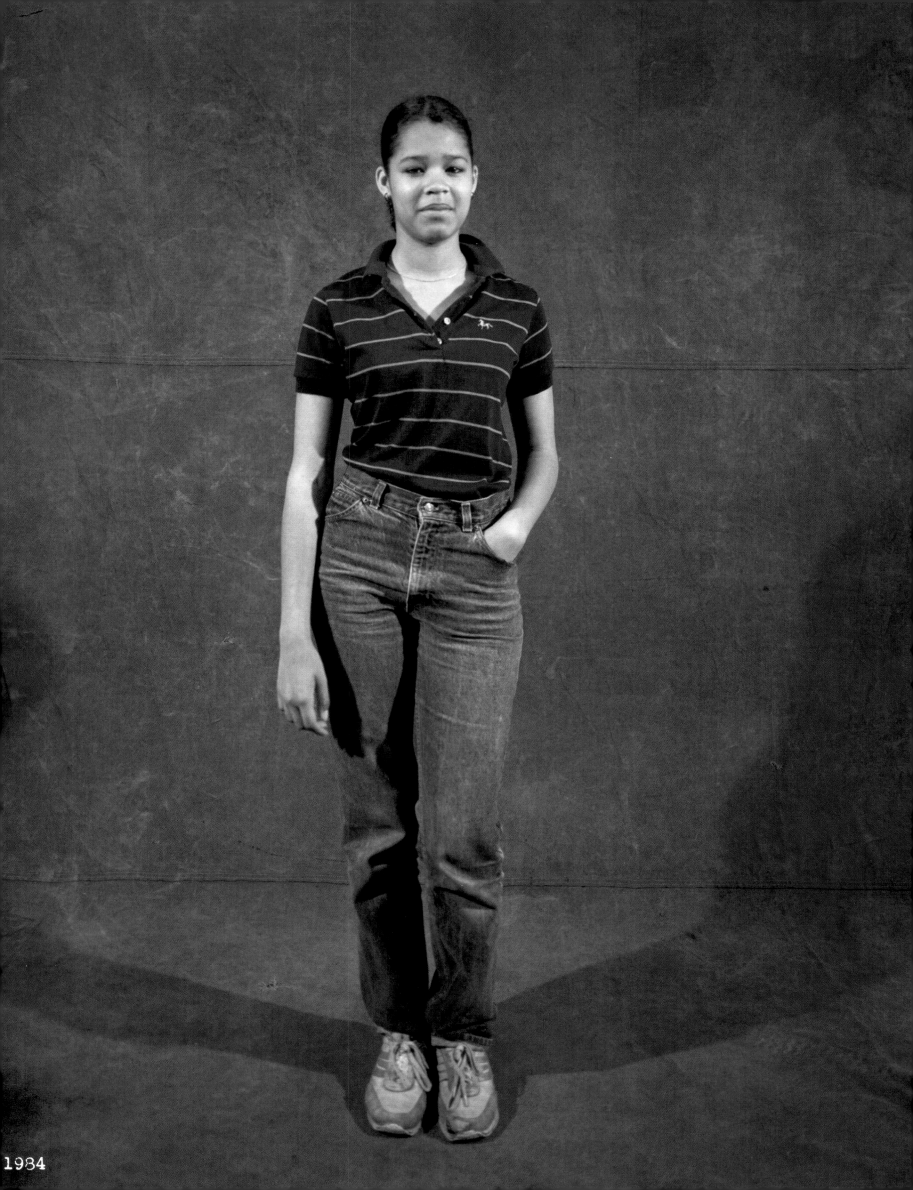

1984

1984

"If someone asks, I just tell them what I am."

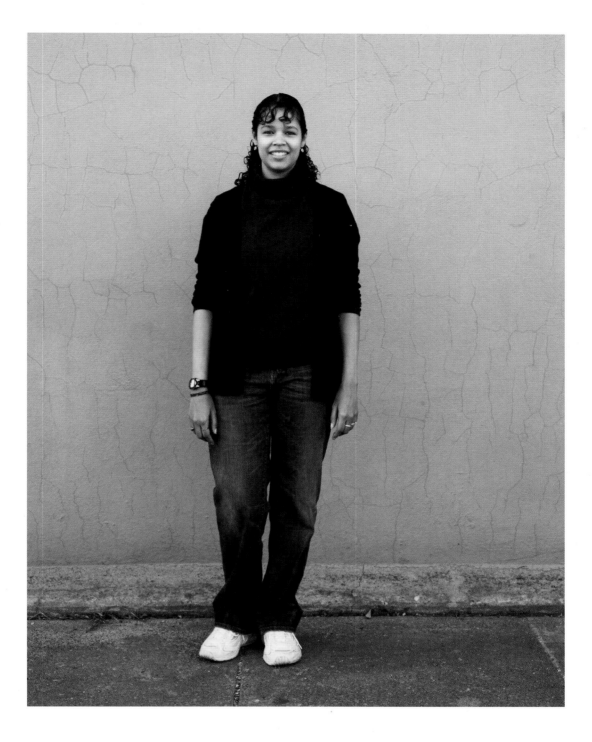

EBONY (WILLIAMS) ANDERSON

I'M OF MIXED HERITAGE. But I don't think much about it. If someone asks, I just tell them what I am. No one has treated me badly. At least nothing I can remember.

My family moved to Oxford when I was eight and I left when I was nineteen. I met my husband at the Arby's in Coralville. He's out fishing today.

For the last seventeen years I've been a cashier at the municipal parking ramps in Iowa City. I don't sit there bored. My job isn't the focus of my life. Raising happy children is.

The girls and I go to Heartland Community Church every weekend. I get a chance to be surrounded by things that are important to me.

EBONY (WILLIAMS) ANDERSON

"I like the term 'Old Hippie.' That's who I am."

—Kevin Somerville

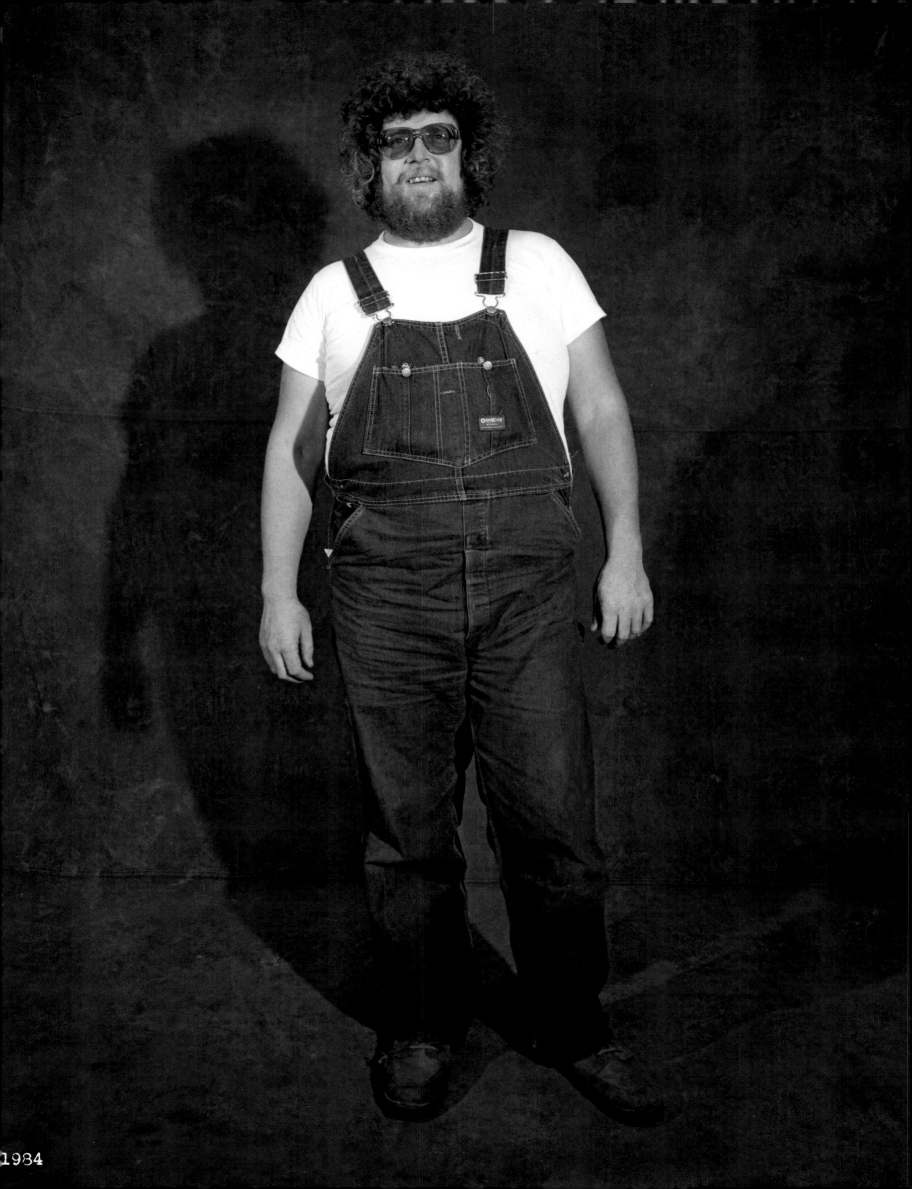

1984

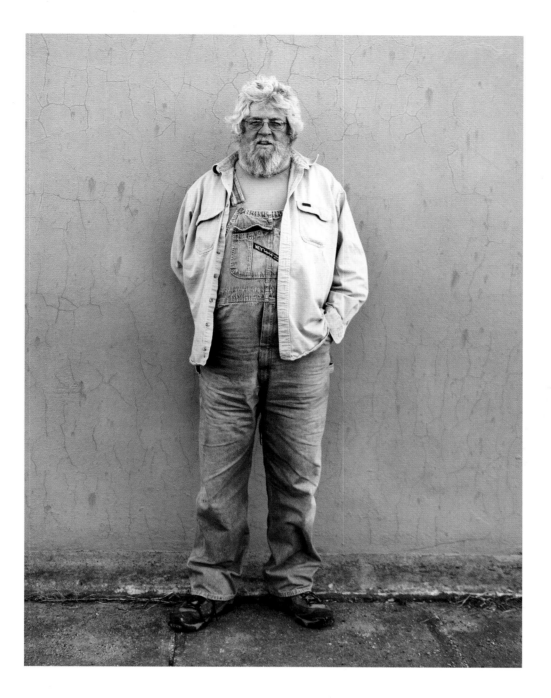

KEVIN SOMERVILLE

I HAD THE PERFECT CHILDHOOD, growing up in Wyoming, Iowa. I used to cruise out on my bicycle to my grandmother's house all the time. One day my mom tied me to the clothesline because I was always wandering around town.

When I was twenty-nine, I moved to Iowa City with seven buddies. We were all bachelors. We had a good time. There was a lot of partying, but I never stuck anything in my arm. One day, I was drinking boilermakers at Solon Beef Days, and went up to Mary and we struck up a conversation. We took it from there.

I used to hitch out to Mary's with my chainsaw and cut wood for her. I ran a bar, then worked as a garbage truck driver. I'd pick Mary up in the garbage truck and she'd ride with me to finish my run. I figured, "Hey, this is a good woman!"

I'm getting into organic farming. We're trying to make herbal organic compost. I'm working with five Amish men on it. The stuff's made from thistles, sorghum, hay, and prairie flowers.

I like the term "Old Hippie." That's who I am. Material things aren't real important to me. I follow the Golden Rule. I party, just not as much. I work hard and I play hard. I feel like I'm still twenty-one years old.

KEVIN SOMERVILLE (b.1949)

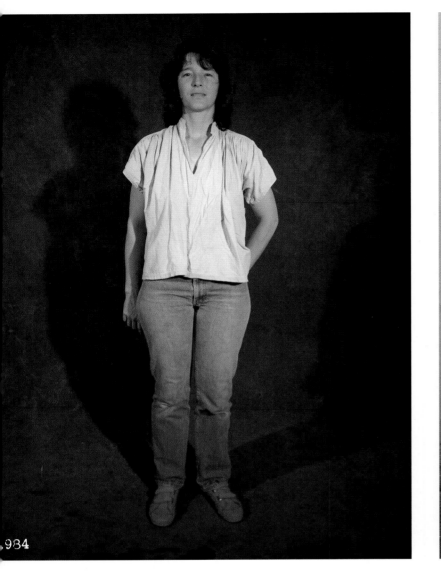

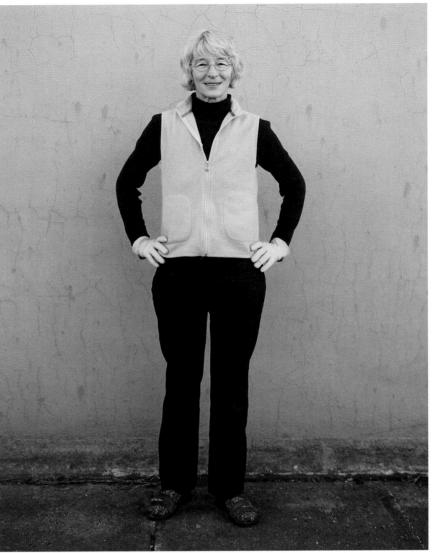

"We're faithful voters. We support school-bond issues. We never miss the caucuses."

MARY SOMERVILLE

I GREW UP ON A FARM and went to a one-room schoolhouse with five other kids—my two brothers, a cousin, and two neighborhood kids. When the road was muddy, our kindergarten teacher, Mrs. Switzer, used to drive an Allis Chambers tractor to school.

In 1972, Godrey Shupitar had a farm up for sale. We bought forty acres at a thousand dollars an acre. The Novaks and the Struzynskis are here, so are the Becickas and the Swenkas. That accounts for pretty much everyone in the neighborhood.

I met Kevin one July day. My son and I went to Solon Beef Days, and Kevin kept on giving my son quarters so he could play a game, and we started up a conversation.

I got pregnant, and Kevin's mom started on us to get married. We were going to get married at home, but it was January, so we got married in the courthouse.

Kevin and I take care of our moms. We're faithful voters. We support school-bond issues. We never miss the caucuses.

Our daughter Jessi moved back in with us when her husband was in Iraq. It was hard not to think nonstop about the war. We'd go three or four weeks without hearing from him. You're always preparing yourself: "What are we going to do if...?"

130

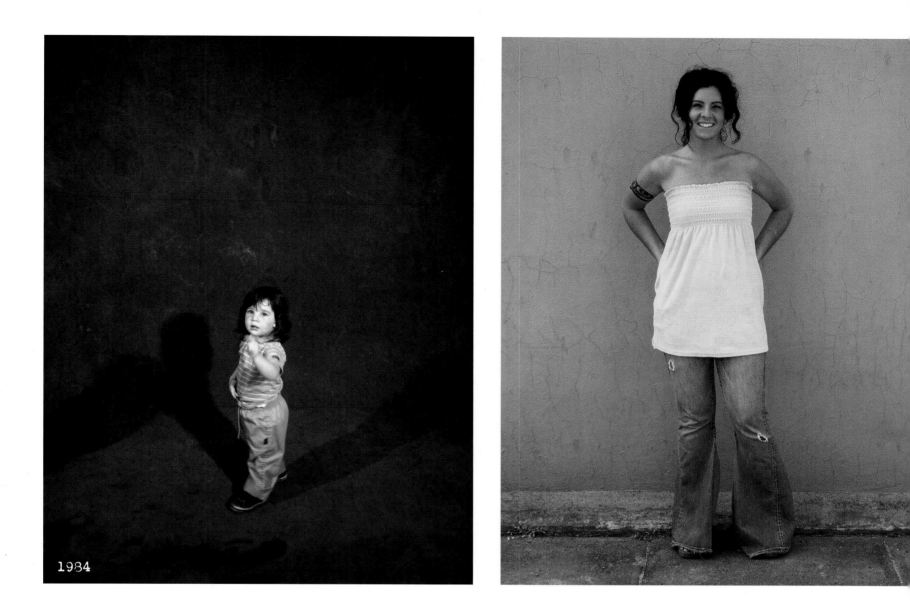

1984

"I have an Obama sticker on my Volkswagen."

KRISTI SOMERVILLE

I JUST GRADUATED FROM THE UNIVERSITY with a degree in psychology. Right now I'm working in a junior high school with kids who have mental disabilities. Eventually I'd like to get a Ph.D. and be some sort of therapist.

When I turned eighteen, I had a small armband with a heart tattooed on my arm, but as I got older, it wasn't me, so I changed it to a Pacific Northwest Indian design. I have a Celtic tattoo on the back of my neck. I know a guy who does tattoos, so I traded one of my paintings for the tattoo on my arm.

I do mostly acrylics on canvas. I paint a lot of trees, plants, and leaves. I like to be outside, and I love going to concerts. I just went to Lollapalooza in Chicago. My parents didn't run a very tight ship, so I went to a lot of concerts around the country when I was growing up.

I have an Obama sticker on my Volkswagen right now. He's really charismatic. It's not that I'm anti-Hillary. I like the idea of Bill back in the White House. I just think Obama would bring some change.

I want to travel to Eastern Europe, South America, Central America, Mexico, Asia, and more places in the U.S. I've been to Europe a couple of times. I can't see myself ending up in Oxford, but you never know.

OPPOSITE: Kevin Sommerville's wife **MARY SOMERVILLE** (b.1945) ABOVE: Kevin and Mary's daughter **KRISTI SOMERVILLE** (b.1982)

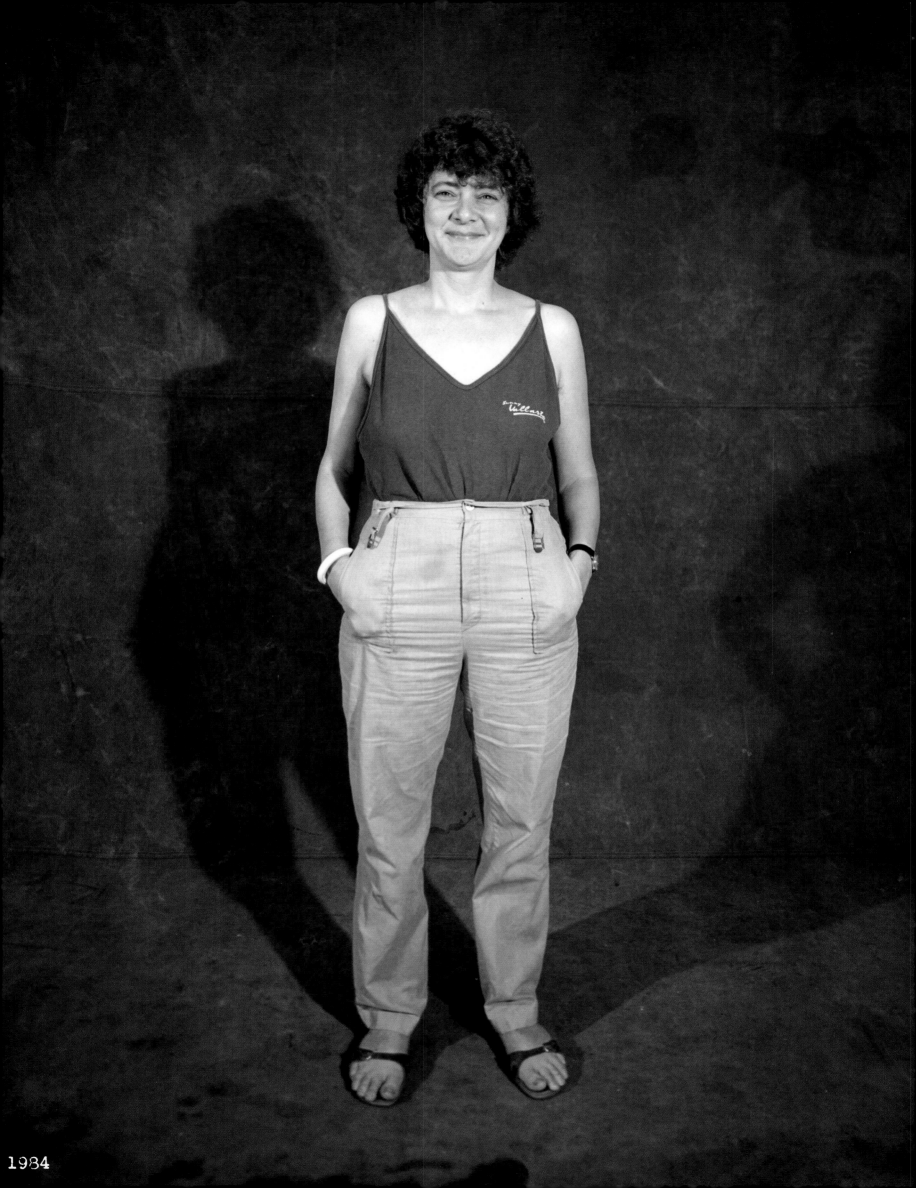

1984

"I'm a Taurus. It's all about taking time out now."

JEANNE STOAKES

I WENT INTO LABOR the morning of the Dylan concert, but I thought I could last. I kept doing my breathing exercises, but by the evening we had to leave. We went to some friends' apartment and had this real mellow atmosphere where Unity was born. When we got to the hospital, the doctor was nasty. The nurses didn't like our kind. One of them yanked the placenta out of me.

I still think, "Be here now." I still follow Baba Ram Das. I'm an agnostic, but I can lean towards Buddhism and spiritualism. I'm a Taurus. It's all about taking time out now. I believe in predestiny, that things are meant to be.

After college I hitchhiked around Europe. I met Unity's father in Italy and followed him to L.A. We split, but Patrick, Unity, and I lived in a panel truck. We got a farm and raised milk goats.

We used to have peacocks and we used to rescue burros. Now we have six basset hounds, two or three roosters, and two (outside) cats.

It doesn't get any better than this. I'm being here now.

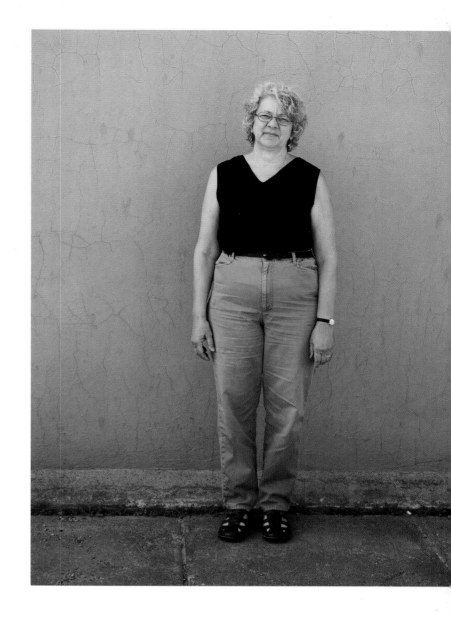

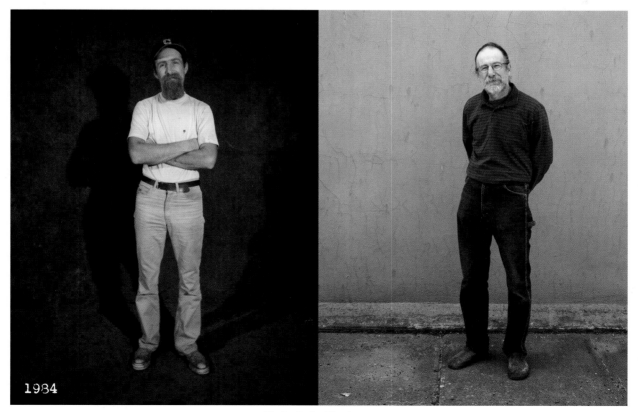

Patrick Hughes

OPPOSITE AND TOP: **JEANNE STOAKES** (b.1947) BOTTOM: Jeanne's husband **PATRICK HUGHES** (b.1948)

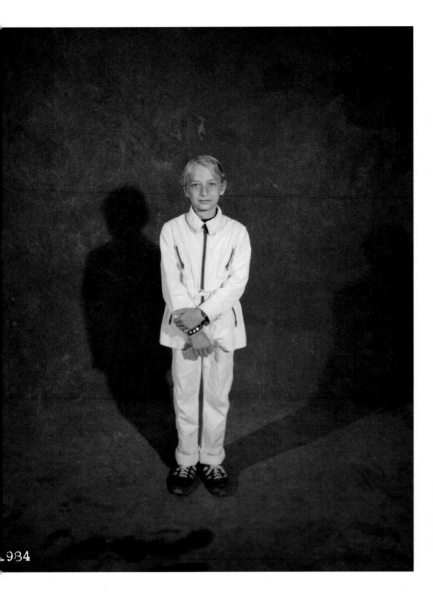

UNITY STOAKES

WHAT I REALLY LOVE ABOUT OXFORD is the land, the green rolling hills. It's so big and vast and open and quiet. I lived in Oxford till I was eighteen, then I went to Boston, and now I live in New York City.

I started my own company. It's an online health website, called Organized Wisdom. It's practical advice from real people. We're constantly reviewing the site so that the information is high quality and safe. We're trying to leverage technology to improve lives. Our prospects look bright.

The name Unity's been really helpful. People never forget you. You always stand out.

Jeanne Stoake's son **UNITY STOAKES** (b.1974)

"I was born at home. My mother preferred
to have me standing up."

1984

CAYENNE STOAKES-HUGHES

MY PARENTS USED TO TELL ME I was named after Cayenne pepper because I had red hair. But
a couple of years ago, my mother told me it was because I was born after a night of hot, passionate
lovemaking.

They were old-school hippies. They traveled around in a van. I was born at home. My mother
preferred to have me standing up. She and my father planted the placenta in the garden at their farm.

I studied Japanese in high school and taught English in Japan for two years. I've backpacked
in Malaysia, Singapore, Vietnam, Cambodia, and Thailand. I still want to get to Africa, New Zealand,
Brazil, and Australia. My dream job would be to travel the world taking photographs.

Unity's brother **CAYENNE STOAKES-HUGHES** (b.1978)

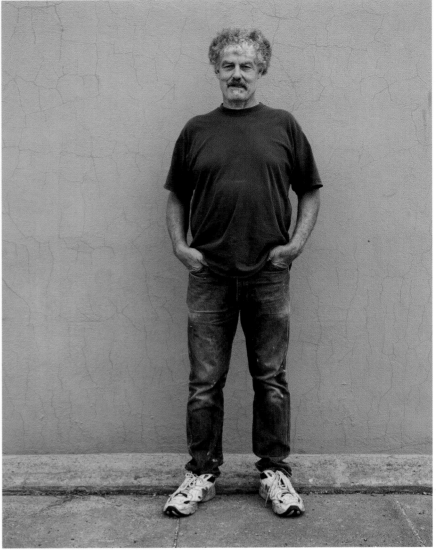

"I was living in my Volkswagen bus, driving
a cab, and growing cucumbers."

ROGER GWINNUP

I WAS A BOUNCER FOR SALLY RAND. Sally did that fan dance of hers at a bar called RJ's in Iowa City. I got to pick up the diamond she popped out of her navel.

I was living in my Volkswagen bus, driving a cab, and growing cucumbers. One day I brought them to town. I asked this girl if she wanted to buy some. She said no, but we started going out.

We've been married thirty-five years. We have a six-acre field with thirty chickens, one turkey (as a pet), two peacocks, and a couple of dogs and a cat. We have three kids and three grandchildren. I'm a carpenter. I remodel homes.

I have to stop off at the Depot to get a red pepper before I go home.

ROGER GWINNUP (b.1946)

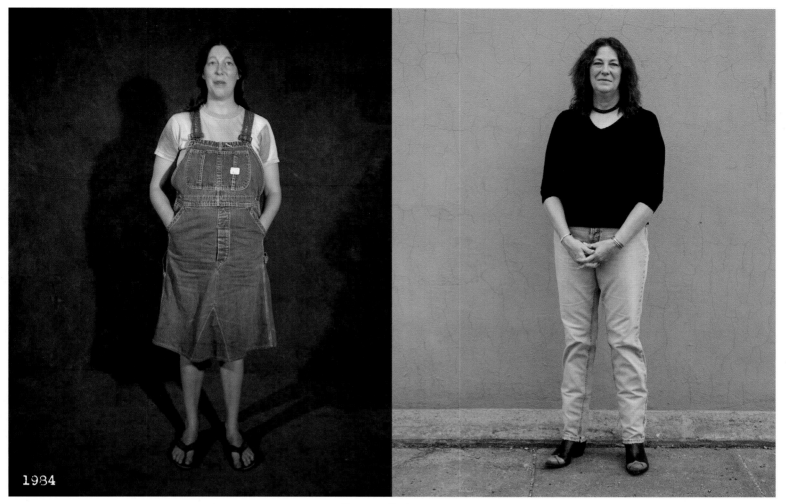

Donna Gwinnup

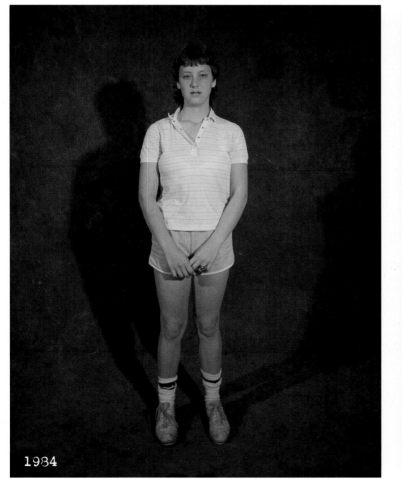

Tracy Gwinnup

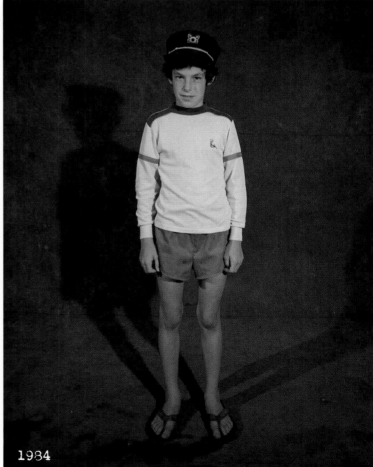

Aaron Gwinnup

TOP: Roger's wife **DONNA GWINNUP** (b.1951) BOTTOM: Roger and Donna's children **TRACY GWINNUP** (b.1969) and **AARON GWINNUP** (b.1973)

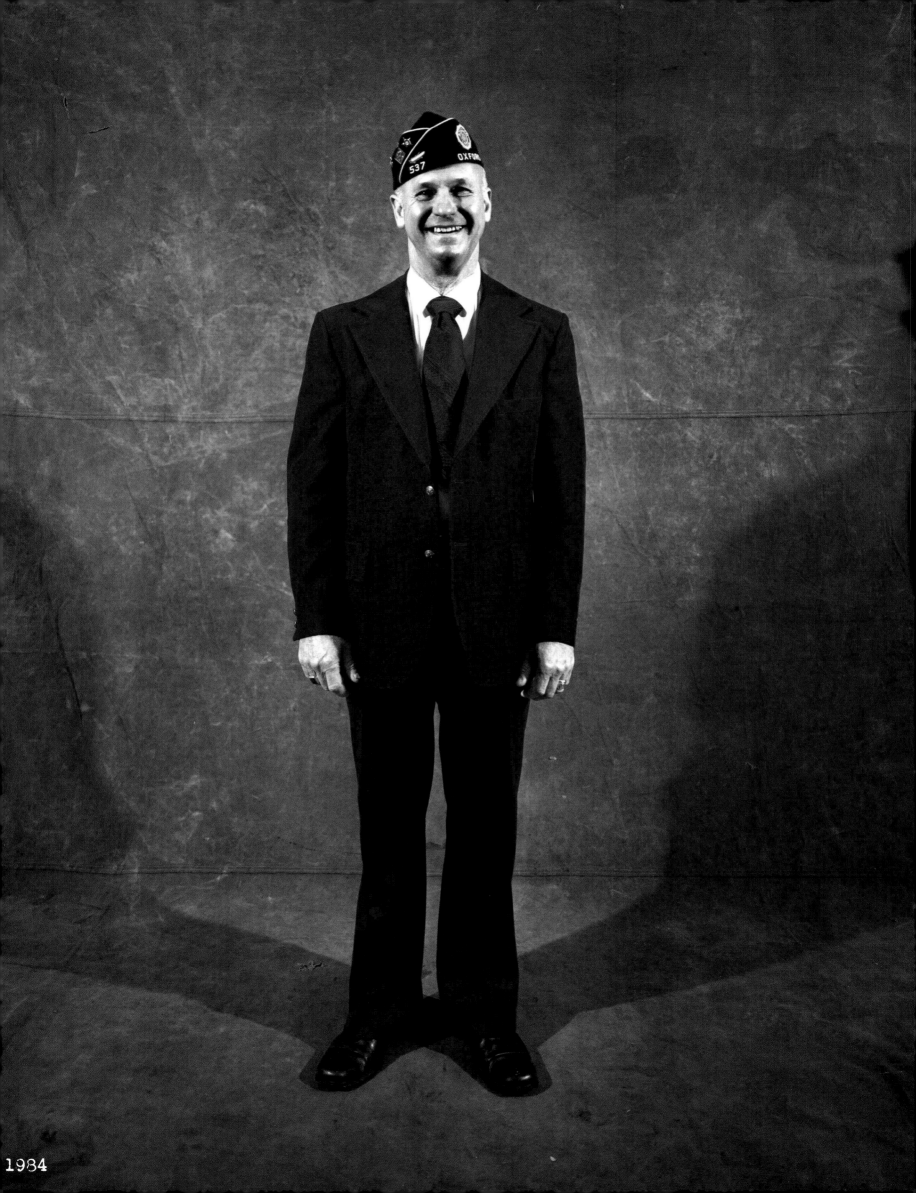

1934

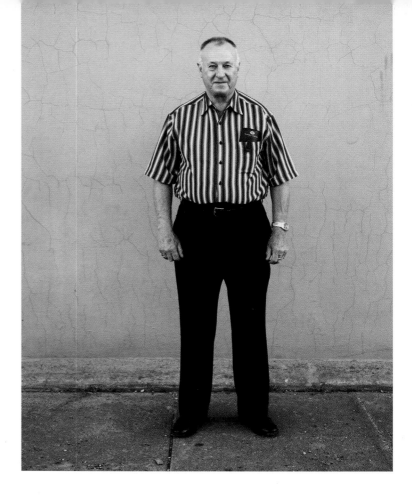

AL SCHEETZ

IT WAS 1947 and we were playing Solon High School. It was a tight game all the way. We were one point behind when he hit me. I made the first free throw. That tied the game.

The whole auditorium went wild. People started throwing money at the free-throw line. Slick Mahoney was there, and he had twenty-dollar bills wrapped around each of his fingers. There was money all over the place.

Then all of a sudden, Waldo Geiger, the referee, grabbed the ball and walked to the dressing room. He was afraid someone would get killed. If I sunk the basket, I'd be a dead pigeon. If I missed, I'd be a dead pigeon.

All five of us from the basketball team—Chuck Rosher, Bob Winters, Tank Harney, Gene Shebetka, and I—we enlisted in 1951. We went to Fort Riley, then they sent us to Fort Bliss, then they scattered us like a bunch of pheasants.

When I got back, I got a job as a rural mail carrier. I did that for thirty-three years, nine months, and twelve days.

I met my wife on a blind date. Gene Shebetka wanted me to meet a girl in Springville. My friends hauled a jackass, a buggy, and a Shetland pony to the wedding. After the ceremony, they put me on the donkey, but he wouldn't budge, so my wife and I got in the buggy. We went to Niagara Falls for our honeymoon.

My wife is a full-blooded Italian. Does that tell you anything? We had seven kids—six girls and a boy. That's what happens when you're Catholic.

We lost our boy in a car accident when he was seventeen. I don't know if a deer jumped out or he was driving too fast, but he had one of the largest funerals ever held in Oxford.

> "My wife is a full-blooded Italian. Does that tell you anything? We had seven kids—six girls and a boy. That's what happens when you're Catholic."

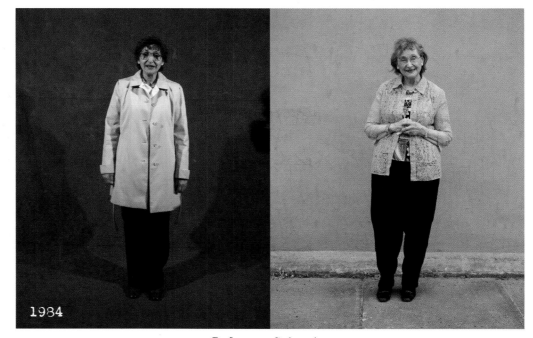

1984

Delores Scheetz

OPPOSITE AND TOP: **AL SCHEETZ** (b.1929) BOTTOM: Al's wife **DELORES SCHEETZ** (b.1929)

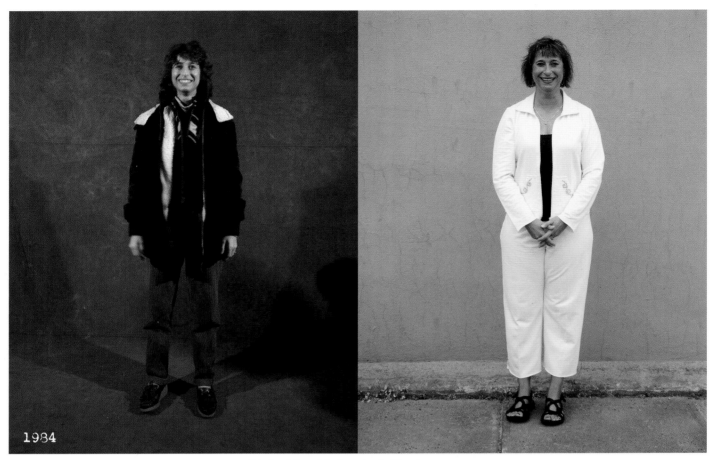

Michelle (Scheetz) Montgomery

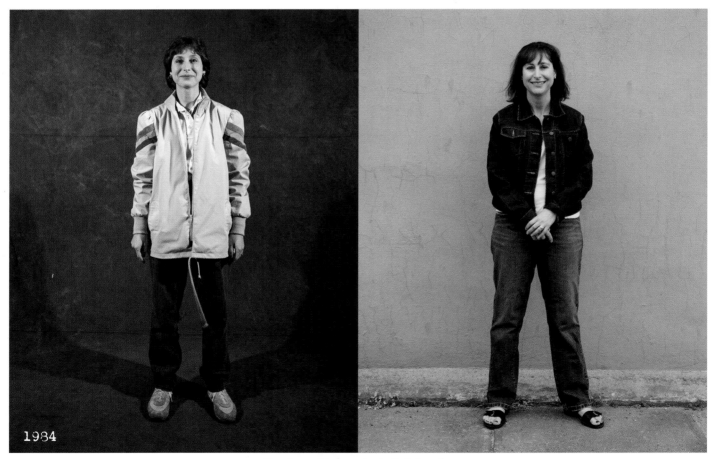

Marisa (Scheetz) Coblentz

BOTH PAGES, CLOCKWISE FROM TOP LEFT: Al and Delores Scheetz's daughters MICHELLE (SCHEETZ) MONTGOMERY (b.1956), MARICARLA (SCHEETZ) ROHRET (b.1963), JANICE SCHEETZ (b.1966), MARISA (SCHEETZ) COBLENTZ (b.1957)

It was impossible." —Magina (Scheetz) Swenka

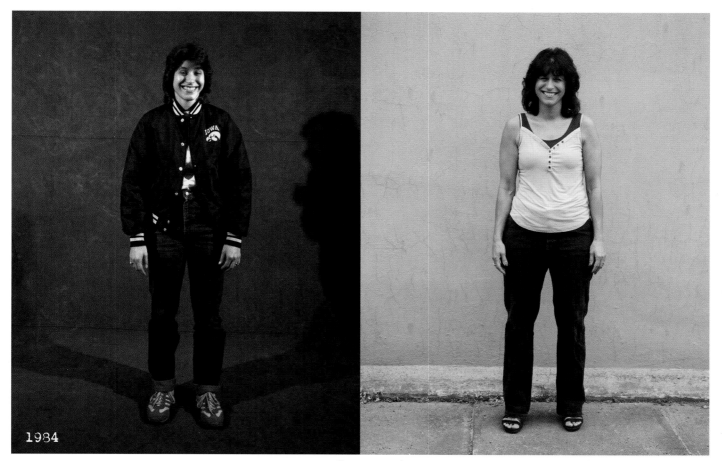

Maricarla (Scheetz) Rohret

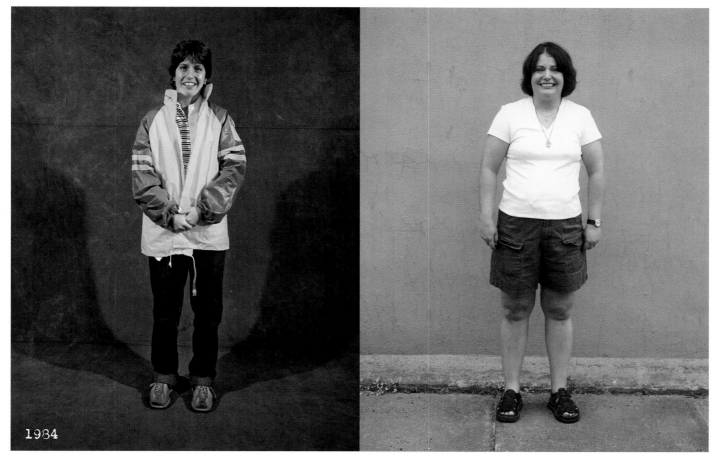

Janice Scheetz

> "We were taught that if you kissed a boy, you'd get pregnant and you'd die. You'd die because my father would kill you."

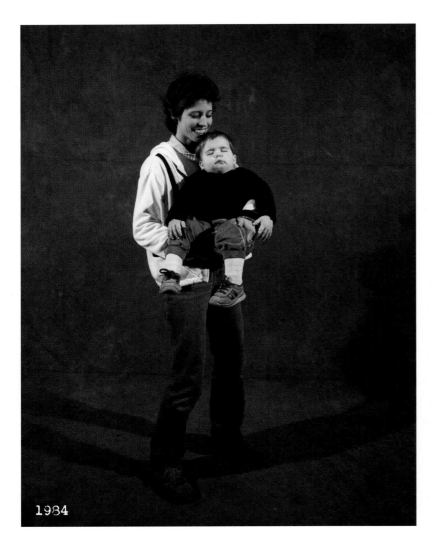

1984

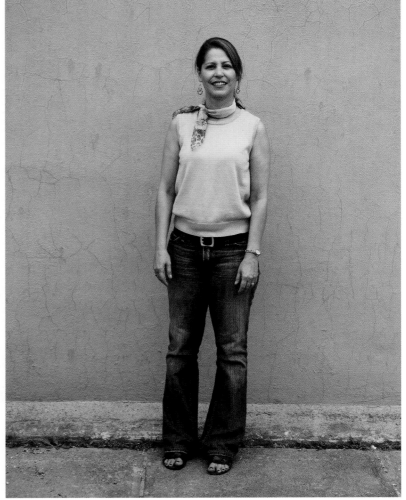

MAGINA (SCHEETZ) SWENKA

GROWING UP, WE WERE SIX GIRLS and one bathroom. It was impossible. We'd walk around with just bras and panties on, fighting over who'd get the bathroom next. My little brother, Joe, would have a different friend over every week, and they'd lay out on the floor, sipping bottles of pop, and just stare at us. It was the best show in town.

Can you imagine six women ovulating at the same time? We had our share of catfights. We could have had a semi deliver tampons at our front door every month.

We were clueless about sex. We heard about sex from our friends. Sex was for one thing—to make babies. End of story.

My parents never kissed in front of us. If there ever was kissing on TV, my mother would get up from the couch and turn the TV off. We were taught that if you kissed a boy, you'd get pregnant and you'd die. You'd die because my father would kill you.

My father would grill every boy who came to our house. He'd ask whether they had shaved and whether they had clean underwear on. He told them when to bring us home, and that if they didn't, he'd hunt them down and break their necks.

Michelle came up with the idea of starting the flower shop, so Michelle, Marisa, Manette, Maricarla, and I opened it together. The name Heaven Scent was little Joe's idea. He came up with the logo and our saying, too: *We deliver smiles.* Not a day goes by without my thinking about Joe.

The downside of the flower shop is funerals. They're a third of the business. Weddings, anniversaries, Valentine's Day, Mother's Day—they're wonderful. But when it came to funerals, I couldn't handle them. I'd break down for three days. I lost my best friend Peggy Stratton when I was sixteen, then my brother, then my nephew, Marisa's son.

I had to get out of the business, so I got into real estate. And I'm having a blast. I love it. I'm the Realtor to go to in Oxford.

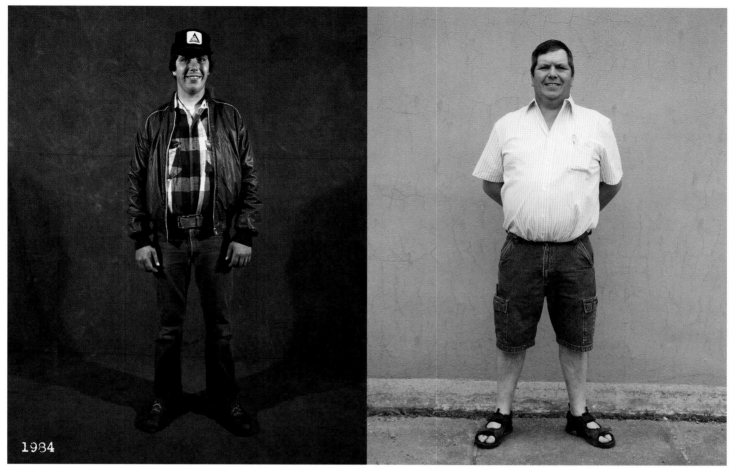

Chuck Swenka

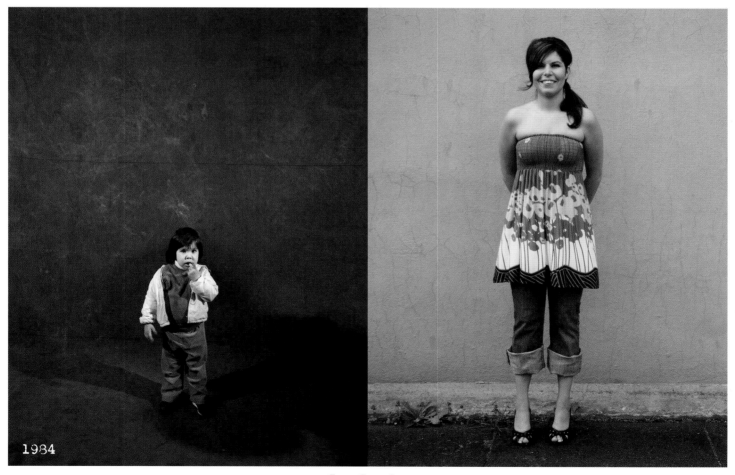

Lea Swenka

OPPOSITE: Al and Delores Sheetz's daughter **MAGINA (SCHEETZ) SWENKA** (b.1961), holding her son **JAKE SWENKA** (b.1982) in 1984
TOP: Magina's husband **CHUCK SWENKA** (b.1957) BOTTOM: Magina and Chuck's daughter **LEA SWENKA** (b.1981)

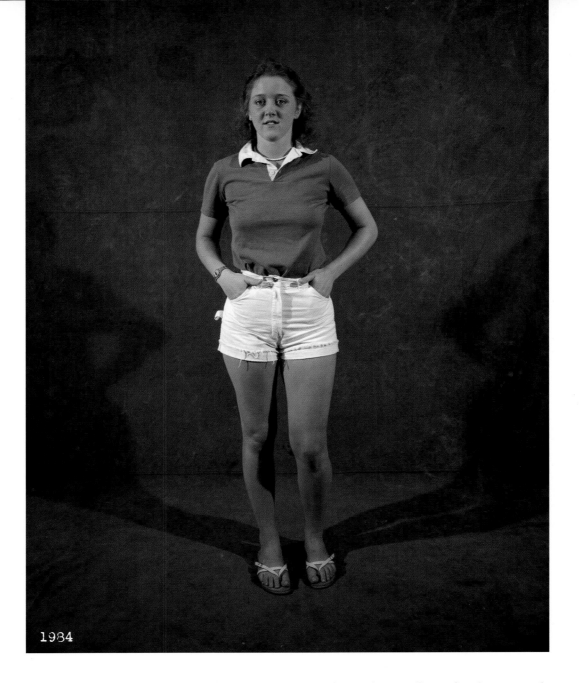

1984

"I drive a school bus, work at a florist, and clean houses, but I have everything I want."

LORI (GORVIN) SWIM

WHEN I GRADUATED from high school, I was naughty and wild. I drank too much—shots, beer, wine, everything. I was promiscuous.

In 1986, I was working at the truck stop in Coralville. There were some guys staying at the Motel 6 across the street. They came over, and I started talking with one of them. Eight weeks later, we got married. We moved to Chicago, where he applied in the Union Hall for sheet-metal work.

I was so ungodly homesick that I could hardly stand it. I cried all the time. By the time we divorced, we had two boys.

The boys and I moved back to Oxford. We lived in a dump above a bar, but I was proud. I went to a friend's wedding, and my old high school boyfriend was there. He was going through a divorce and had two wonderful little girls. They were four and seven. I adored them.

One day, the girls and their mother were killed in an automobile accident just north of Hills.

Today we live on a dead-end, dirt road and have two little girls of our own. I drive a school bus, work at a florist, and clean houses, but I have everything I want. Our girls are angels sent from heaven.

LORI (GORVIN) SWIM (b.1965)

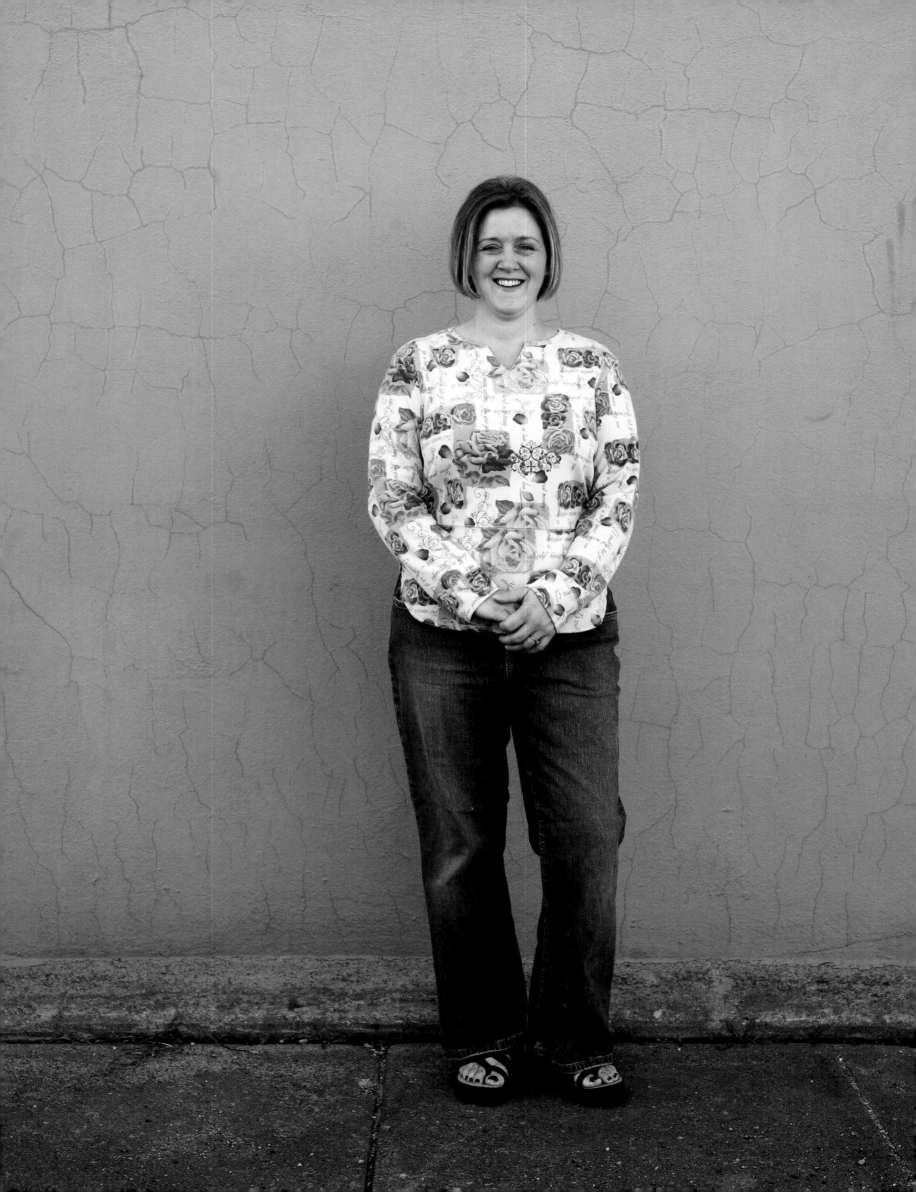

"My wife and I met in 1962. We were throwing snowballs on North Augusta. We've been married forty-four years."

—Raymond Ceynar

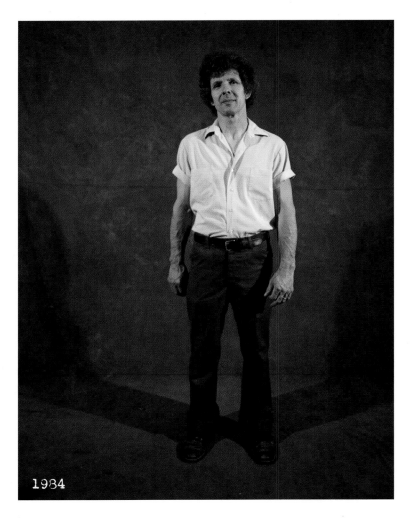

1984

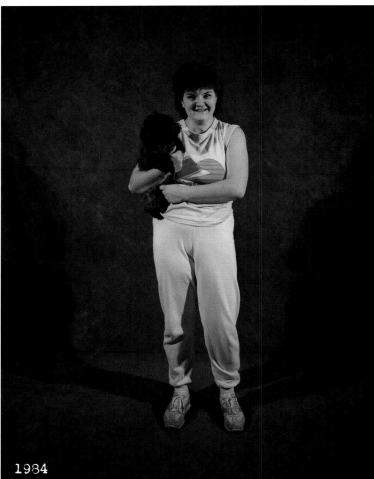

1984

Tammy Ceynar

RAYMOND CEYNAR

MY DAD WAS THE ICEMAN. He also used to pick up mail from the train three times a day. He'd put a sack on a pole and a mechanical arm would grab it without the train stopping.

I didn't finish high school. I wanted to get out and make money. I did odd jobs, then was a car mechanic. I work for the city of Oxford now. I do the streets and mow the grass.

My wife and I met in 1962. We were throwing snowballs on North Augusta. We've been married forty-four years.

Our daughter Tammy had an accident in December of '03. She was on Highway 965, heading north. The wind pushed her to one side, and she went off the road. She lost a lot of blood. It was touch-and-go for two weeks. She died in the hospital. She was thirty-five.

You have to go on. You pray a lot, you go to church. God will help you out, but you have to ask Him.

I'd like to go to Alaska. You hear so much about it—the ice and snow, the big whales, all kinds of fish, polar bears. I don't know if you'd get to see them.

I relax by watching TV or working on small engines.

OPPOSITE AND TOP: **RAYMOND CEYNAR** (b.1944) BOTTOM: Raymond's daughter **TAMMY CEYNAR** (1968–2003)

148

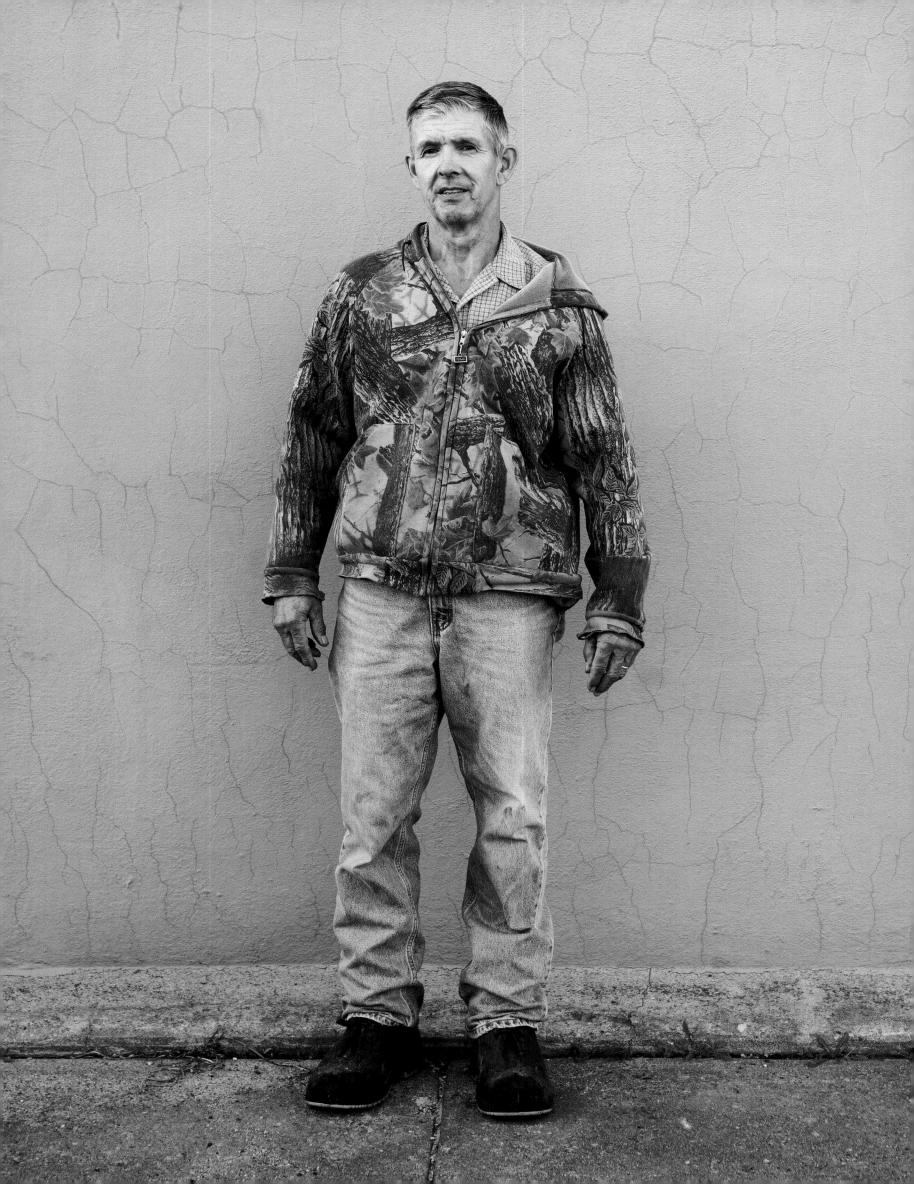

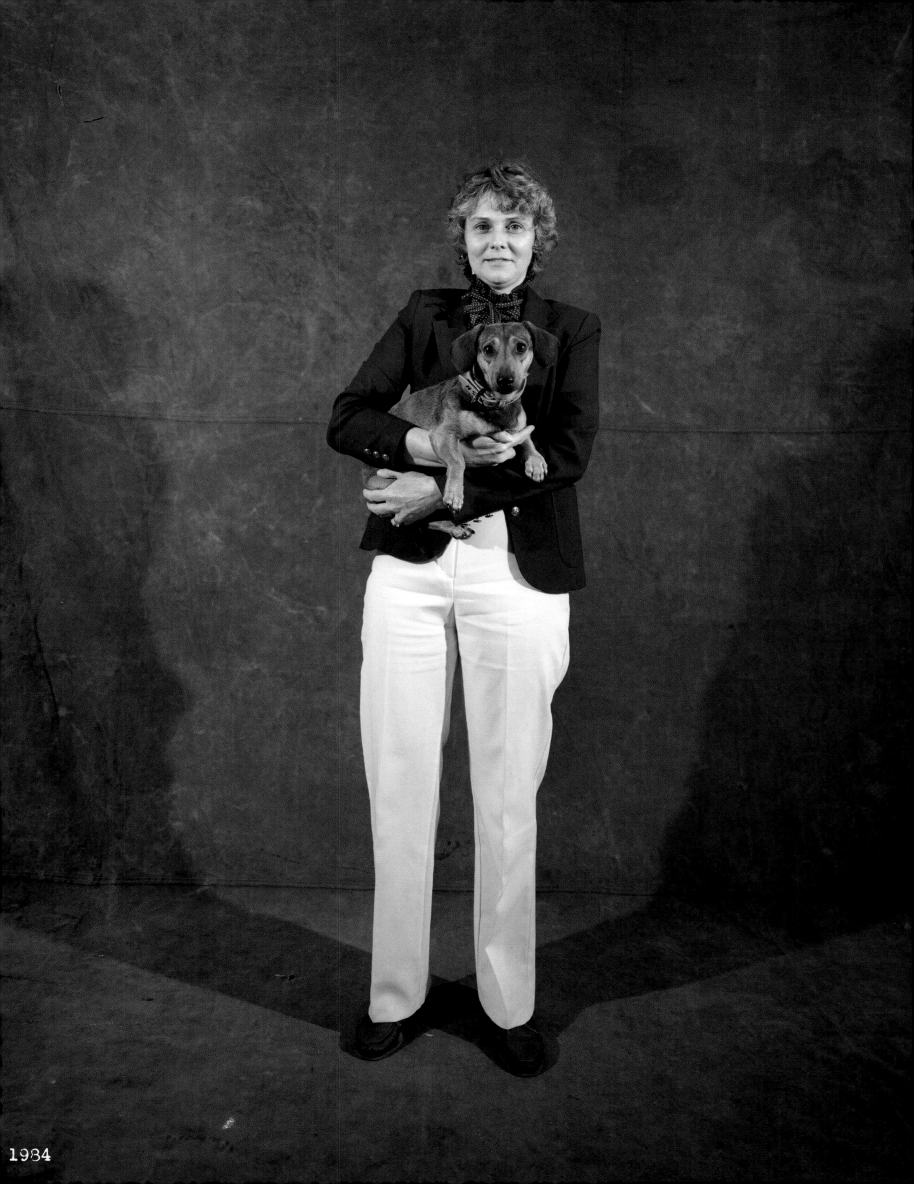

1984

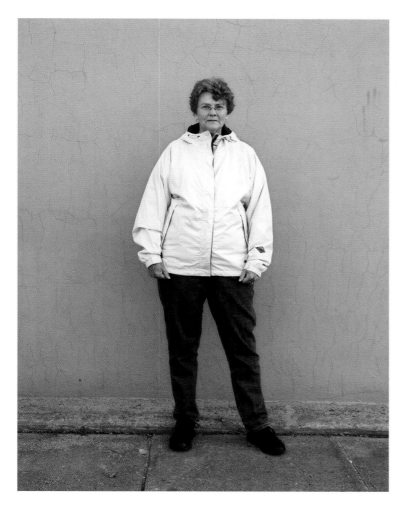

"Leo and I have lost two sons. We're strong Catholics. It helps you."

Leo and I have lost two sons. One son died from a hit and run. He was twenty-nine. That was Chuck. The other, Mark, died of cancer when he was forty-one.

We're strong Catholics. It helps you. It makes you realize that your loved ones aren't suffering. You can't bring them back, and you miss them. But your loved ones would want you to keep on going. I do a lot of volunteer work, especially for hospice, ever since Mark died.

We spend a lot of time fishing. I don't go ice-fishing because I'm scared of walking on the ice. I don't hunt, and I don't clean fish. My family likes my meatloaf. I might serve chicken or turkey, but I always serve it with a meatloaf.

This summer we'll be married fifty years. You have to have trust, communication, and a good sense of humor. One of my favorite sayings is, "Everyone should smile because a smile is a curve that sets everything straight."

CAROL TOMASH

THAT DOG SCHNITZEL CAME TO ME on Easter, and sixteen years later, on Easter, he got hit by a car. Isn't that something?

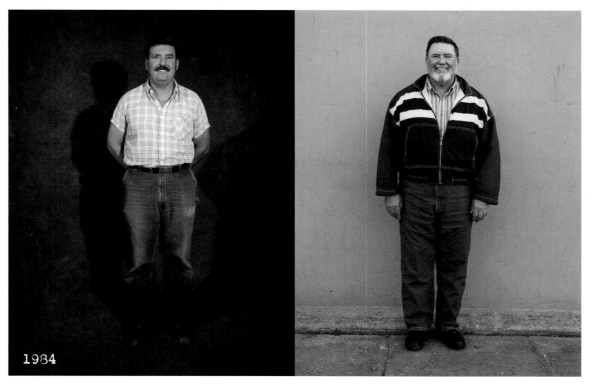

1984

Leo Tomash

OPPOSITE AND TOP: **CAROL TOMASH** (b.1938) with her dog Schnitzel BOTTOM: Carol's husband **LEO TOMASH** (b.1937)

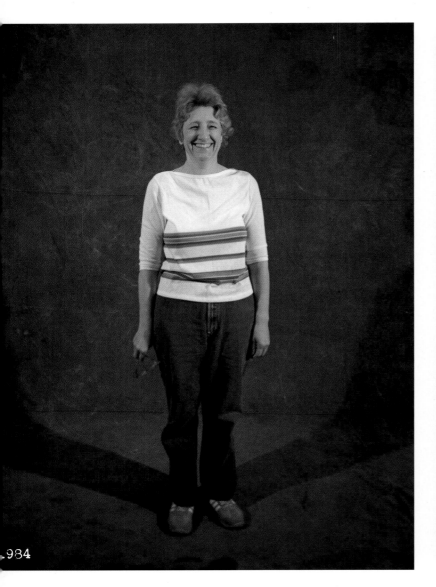

1984

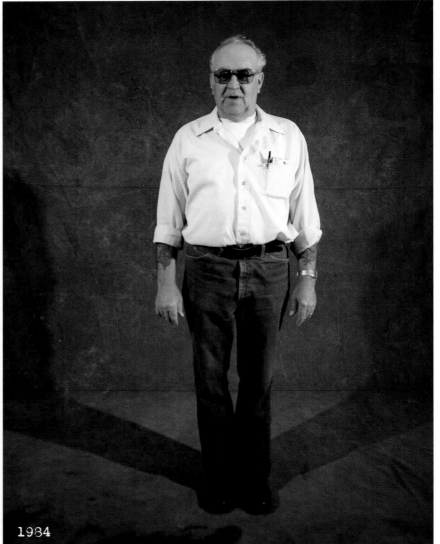

1984

Carl Paintin

"I still look out my dining room window and
think he's going to drive up in his '56 Chevy."

ELLEN PAINTIN

I WORK FOR THE FUNERAL PARLOR. Every family is different. Some grieve real hard, others you can hardly tell. If they're like me, they don't cry in public.

Carl was ten years older than me. He had gone to the river to fish and was driving home. He always used to say, "Good night, Mom" whenever I laid down on the couch, and I swear I heard him say that the day he died. I thought he must have gone to bed, but not long after that, the First Responders came and told me.

I still look out my dining room window and think he's going to drive up in his '56 Chevy. It seemed like we were always together.

We have eight children. I had a child almost every year. My oldest is fifty-four and my youngest is forty-six. I have seventeen grandchildren and ten great-grandchildren.

I'm a member of the Women of Faith. Last year they had a blind speaker from Springfield, Missouri. We laugh a lot and cry a lot. It makes you feel good.

Nowadays what makes me happy is just being alive, breathing every day.

ABOVE LEFT AND OPPOSITE: **ELLEN PAINTIN** (b.1935) ABOVE RIGHT: Ellen's husband **CARL PAINTIN** (1924–1985)

152

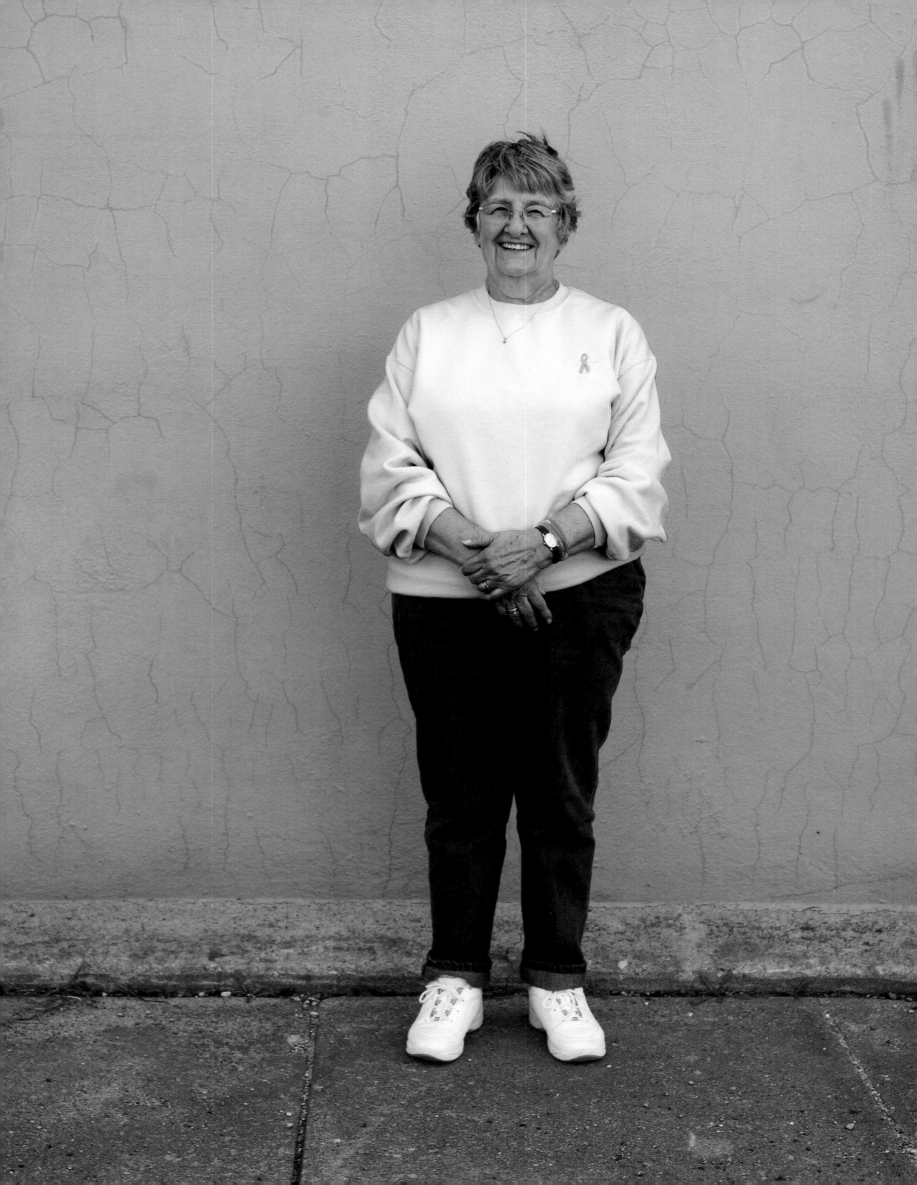

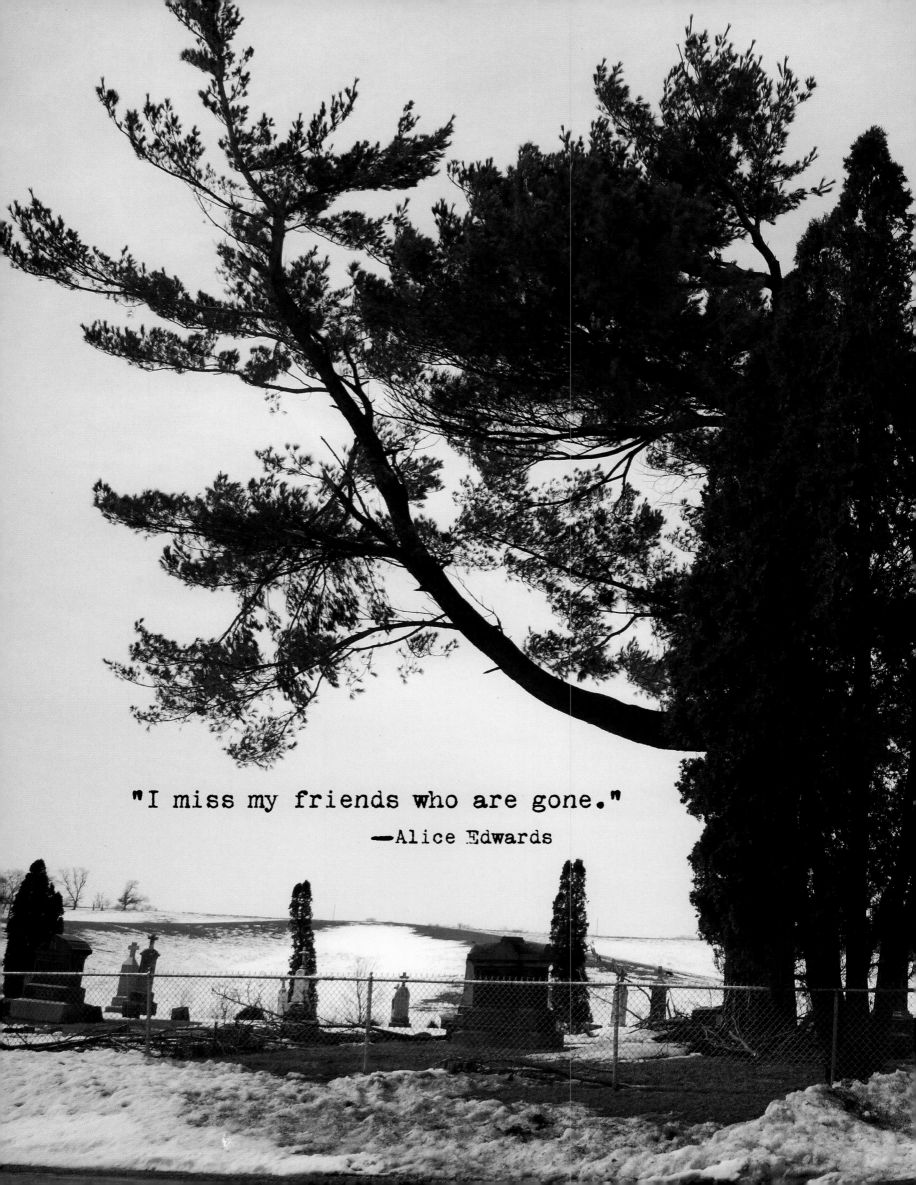

"I miss my friends who are gone."
—Alice Edwards

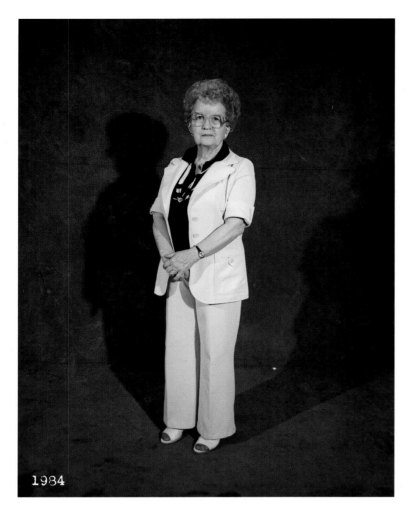

1984

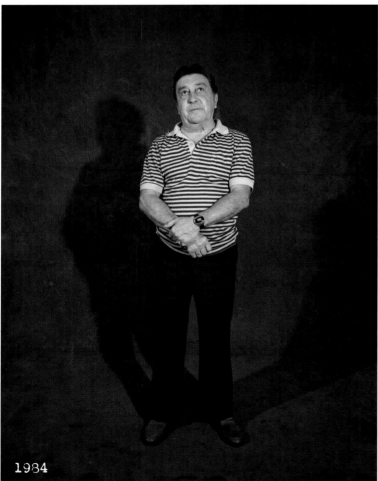

1984

Harold Edwards

> "I remember a man saying
> he never thought he'd see
> the day when a woman would
> be driving a truck."

ALICE EDWARDS

MY FATHER WAS BORN IN OXFORD when Indians lived at the river bottom. The Indians wanted to buy my mother because she had blue eyes. I was born at home. I met my husband in high school. He was a real dapper, polished dresser. He used to iron his own shirts. He was going with another girl, Dorothy Johnson, and he asked me to a basketball game. I said he'd have to choose between her and me, so we went to the game, but I found out later he continued going out with Dorothy.

We got married by the Justice of the Peace. I quit school. I was seventeen. I worked for my father's produce store. Women would come in and choose feedbags to make curtains, blouses, and dresses. I used to candle eggs, and I drove my father's cream truck. I remember a man saying he never thought he'd see the day when a woman would be driving a truck.

In 1962 I went to beauty school, and then ran a salon till 1990. I called it Town & Country. My husband had really wavy hair. Every day, he'd hold a mirror and I'd comb the back of his hair.

Christ died for our sins and he's coming back to save us when the end comes. I miss my friends who are gone—Katie Donahue, Kathryn Dunn, Thelma Floerchinger, Lilly Williams. I saw Lilly in the hospital and she asked me, "Am I dying?" I said no, but fifteen minutes later, she passed on.

Tomorrow I'm going out with the Leeney girls—Melva and Vivian. We're going to the Country Buffet. I think Evelyn Gegenheimer will join us. We all went to high school together. We'll visit for two hours, maybe three.

TOP AND OPPOSITE: **ALICE EDWARDS** (b.1920) BOTTOM: Alice's husband **HAROLD EDWARDS** (1918–2002)

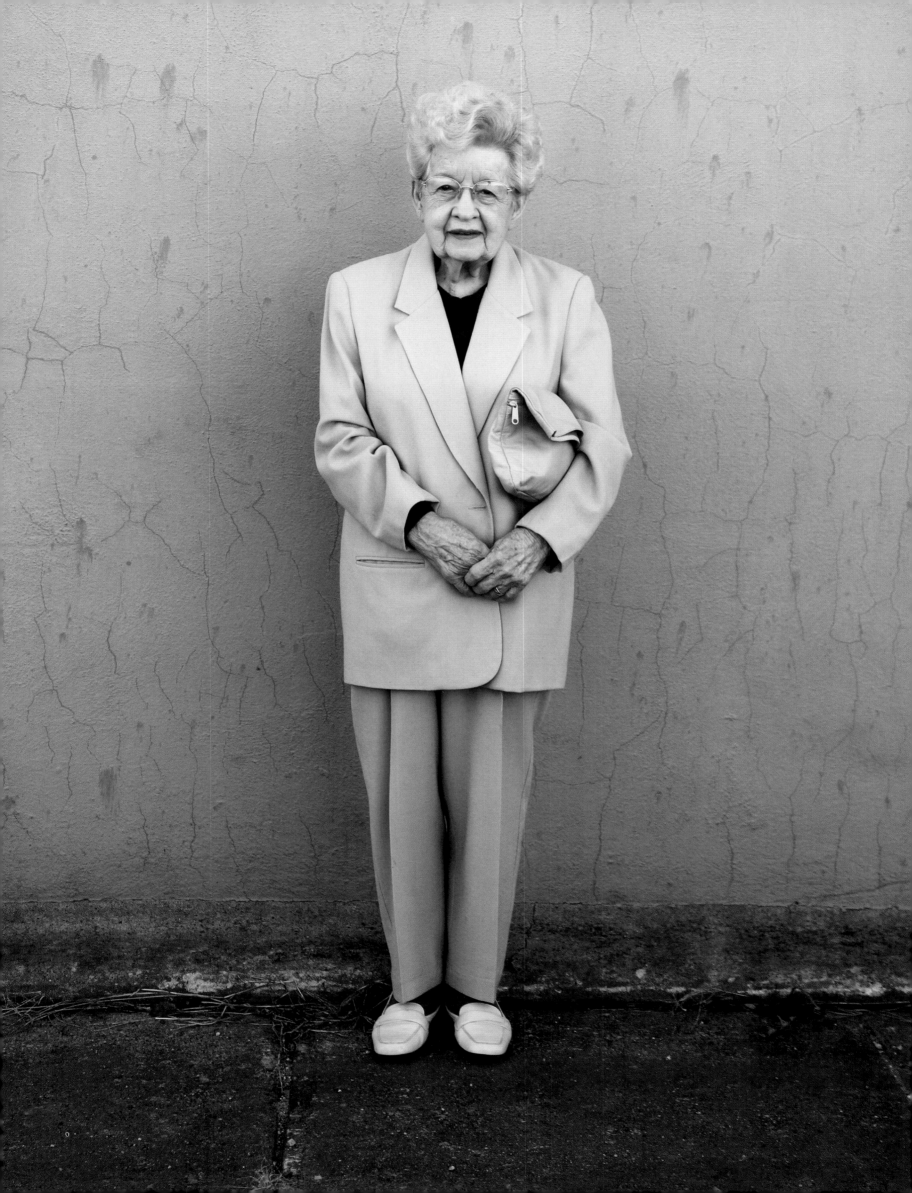

"Life is a pretty thin string." —Bob Tandy

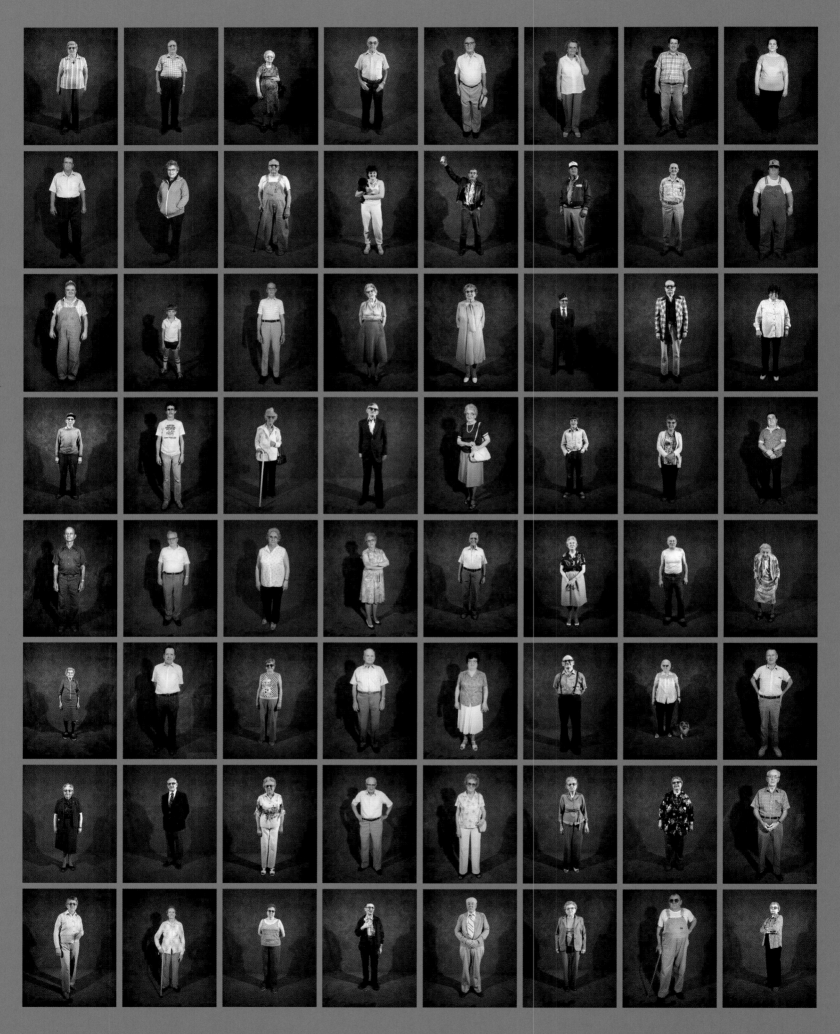

THESE PAGES: Oxford residents who have died since being photographed in 1984.

"After I die, I'll go to heaven to be with God.
I'll see my baby and husband there, too."
—Iowa Honn

THROUGH
THE
YEARS

With Iowa Honn

A Collection of Poetry
Compiled in March, 2000

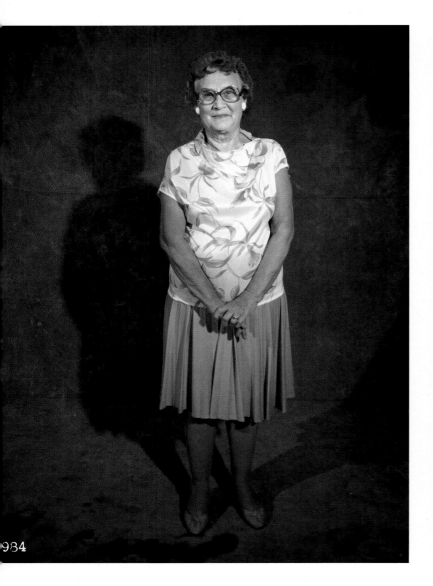

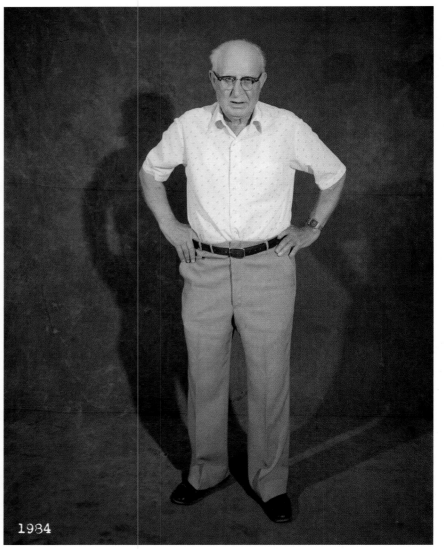

Faye Honn

IOWA HONN

I WAS BORN IN OXFORD ON APRIL 1, 1910. My father said I was the most beautiful baby in the most beautiful state, so he named me Iowa.

My father owned a general store with his brother. It was called John and Bill's. I met my husband in kindergarten. His name was Faye, but everyone called him Friday. We graduated high school in 1928. He had a car—a blue, four-cylinder Whippet. In those days there weren't many kids in school with a car. We got married in 1931.

I read the Bible every day at breakfast and at bedtime. It gives me a sense of quietness and contentment. Tonight I'm going to read Ezekiel. After I die, I'll go to heaven to be with God. I'll see my baby and husband there, too. If you're a believer, God opens the door. If you aren't, he says, "I've never seen you before. You go to the other place!"

I hate to sew. But I can cook or bake almost anything.

ABOVE LEFT AND OPPOSITE: **IOWA HONN** (1910–2007) ABOVE RIGHT: Iowa's husband **FAYE HONN** (1909–1988)

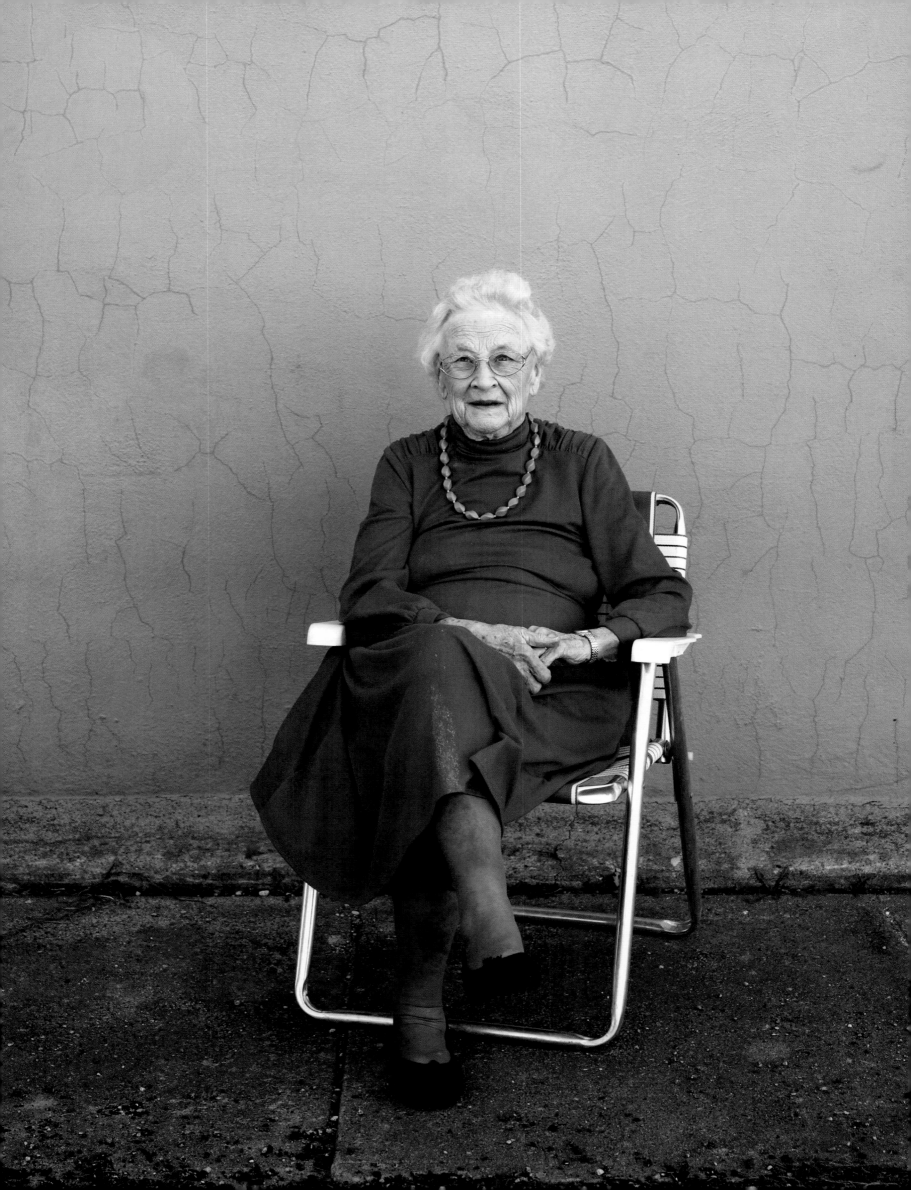

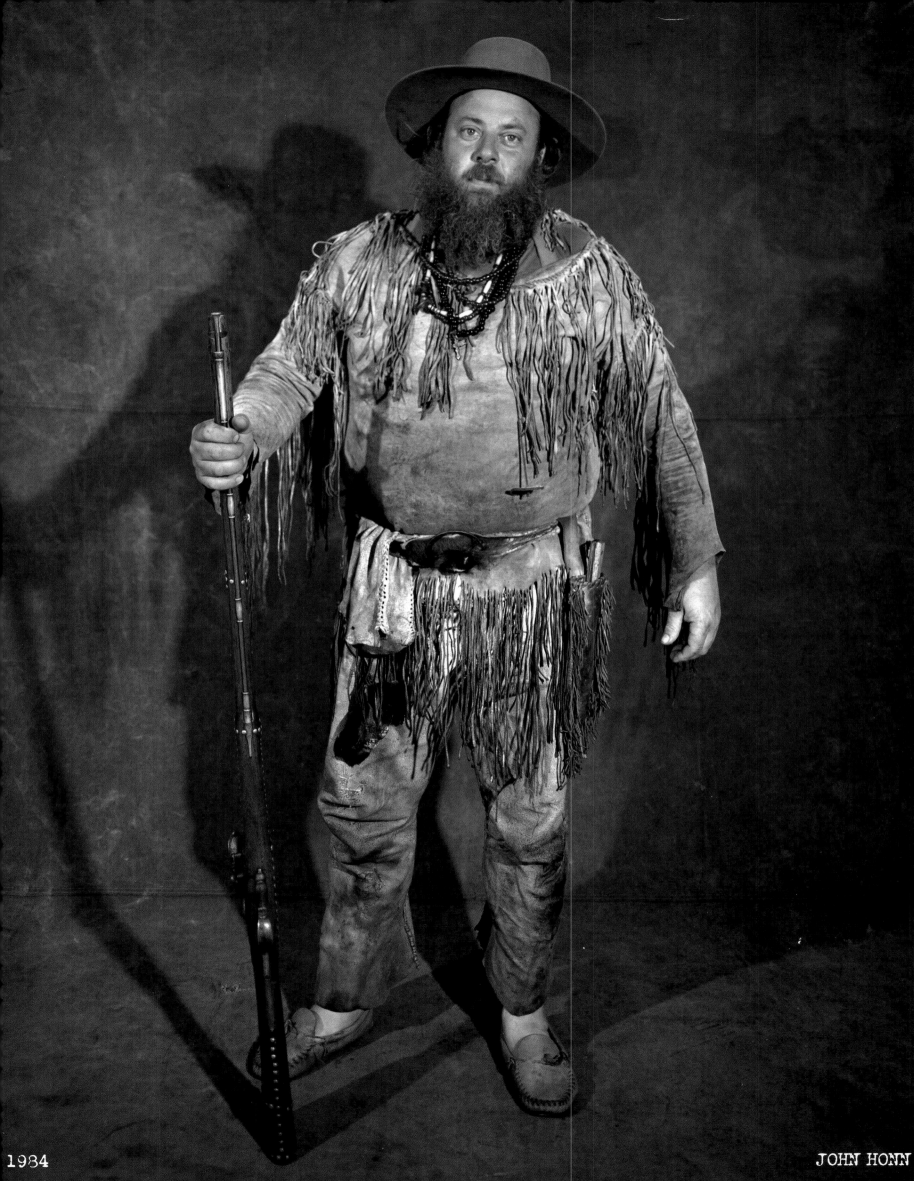

1984

JOHN HONN

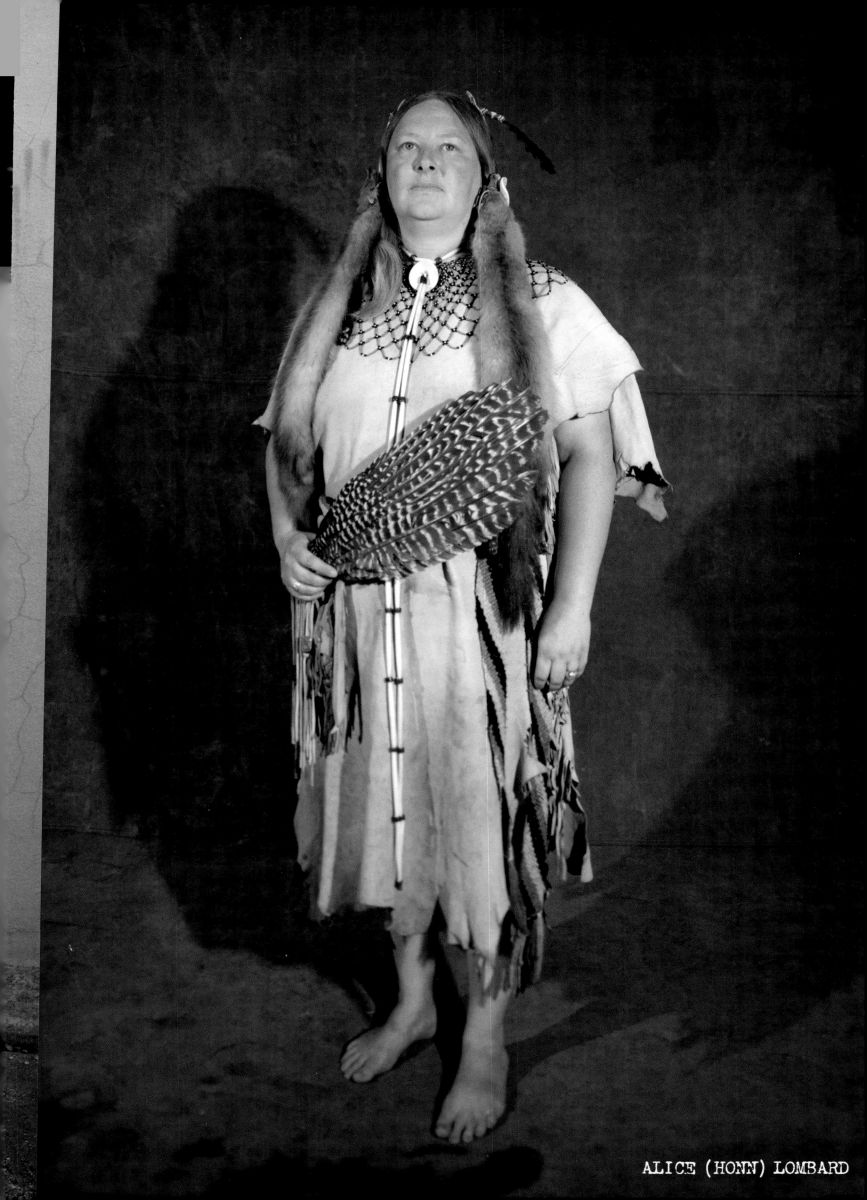

ALICE (HONN) LOMBARD

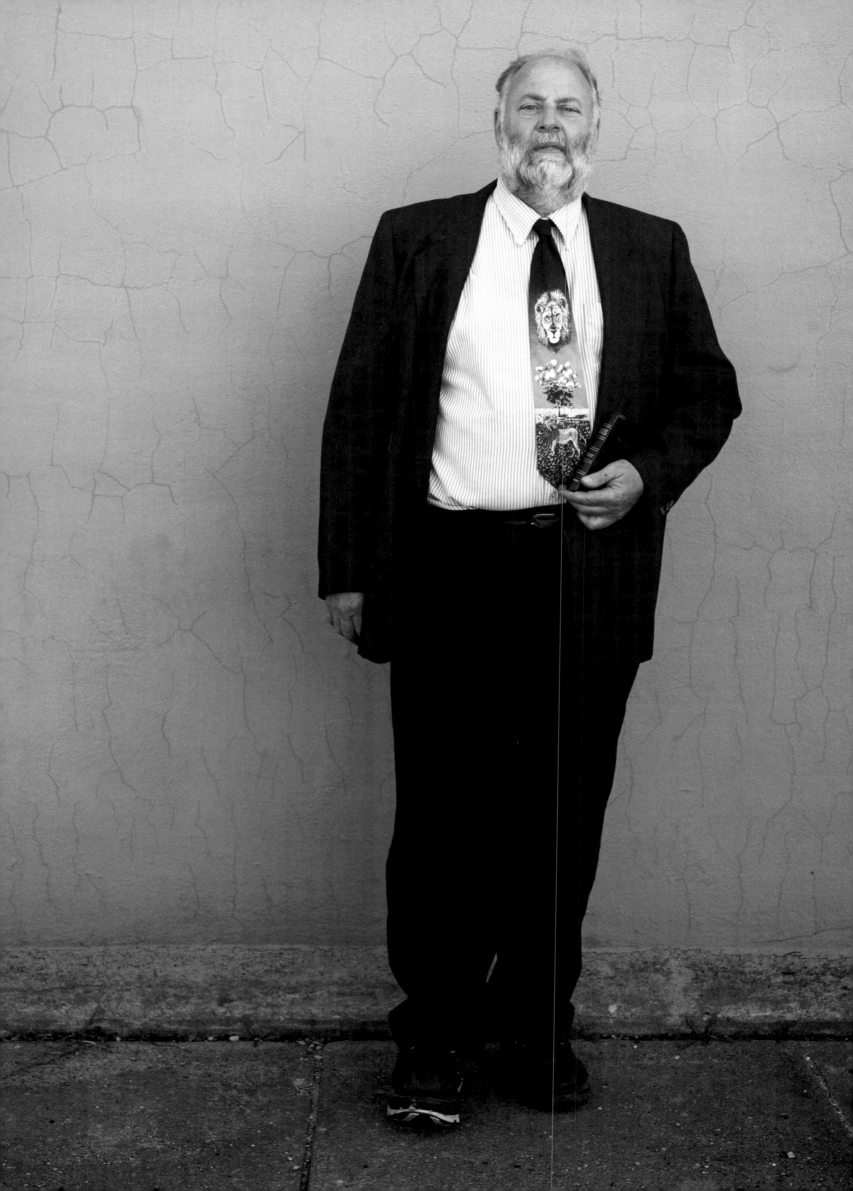

"I first heard the Lord speak to me when I was sixteen."

JOHN HONN

I USED TO BE A BUCKSKINNER, shooting muzzle-loaded rifles, throwing knives and tomahawks. I was obsessed with coon hunting. It wasn't about the kill. It was the chase.

I first heard the Lord speak to me when I was sixteen. I took four years of correspondence Bible college and from then on I've given myself to the Lord. He told me to start a gospel church and call it Anchored in Faith. In our church we have a horse tank with a heater in it to do baptisms. We've done more than a hundred.

We had a lady from Malaysia who was cured of a heart condition with one of our prayer cloths. We've had three people with epilepsy healed. We prayed with a lady who had a brain tumor and she was cured. We've had several people healed from total insanity. I once saw a blind man whose sight was restored.

I've spoken in tongues on three occasions. It happens when you allow God to speak through you.

God is more than we can comprehend. He can do anything. He's everywhere. Jesus Christ was God wrapped in flesh. I believe in Adam and Eve. I don't believe we came from monkeys.

I've seen devils, demons, and angels. I once had a demon come to my bedroom. He was tall, almost touching the ceiling, and cold—like a cold-blooded animal. He was dark and drapey, like Darth Vader without the helmet. I rassled with him on the bed. Another time, a three-foot-tall demon came at me carrying a piece of roasted meat in one hand, and a cup of of blood in the other. He told me, "Drink the Devil's Communion and you will be well!"

Angels are like florescent light. They're radiant. You can almost see through them.

The year 2028 will be when Jesus returns. I may be off by a year or two, but I believe it'll be around then when the Resurrection will take place.

LEFT AND RIGHT: Iowa and Faye Honn's son **JOHN HONN** (b.1945) FRONT OF GATEFOLD: John's former wife **ALICE (HONN) LOMBARD** (b.1951)

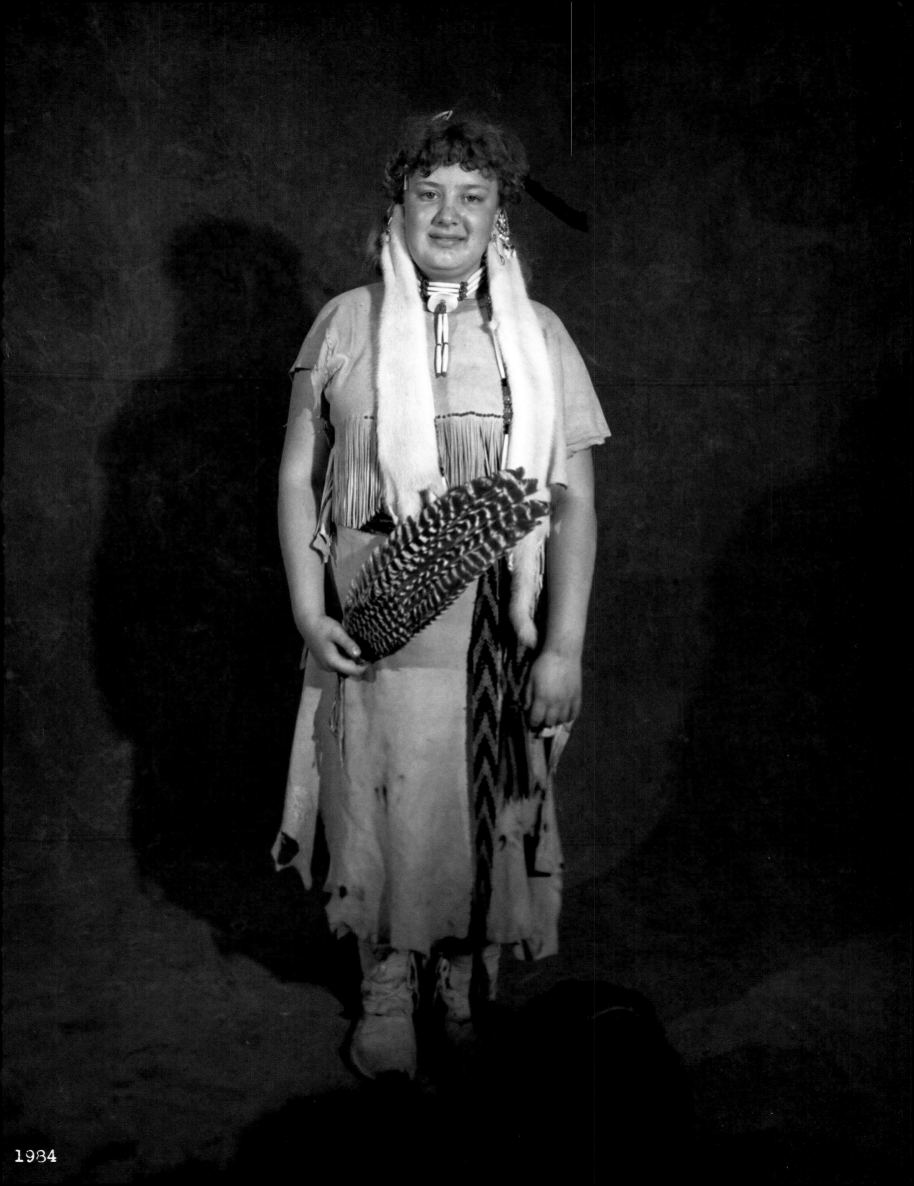

1934

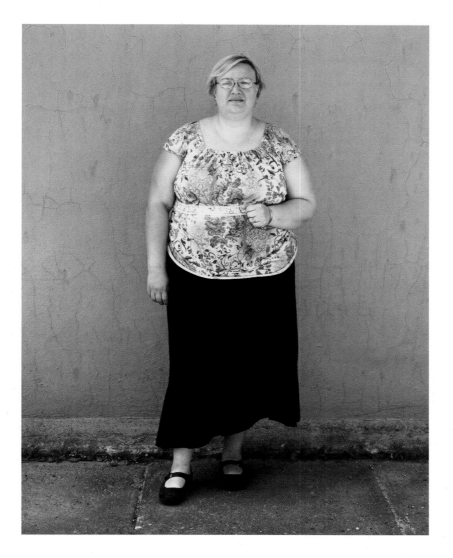

"I had two or three boyfriends, sometimes all at the same time. That's the life of a buckskinner girl."

MELODY (HONN) HILLIER

I USED TO WORK IN A STRIP CLUB in Phoenix called the Kitty Kat. I was a good pole dancer. I was thin then, between 130 and 150 pounds. If it was male, I'd find my way there. I used to do alcohol, marijuana, and speed. I was a bad girl.

In high school, we all drank. My parents would buy us bottles of alcohol and say, "Have at it!" Whatever we wanted, they gave us. I had two or three boyfriends, sometimes all at the same time. That's the life of a buckskinner girl.

After I graduated high school, I went for a semester to a community college and I dated a moron. The moron and I broke up, so me and two girls got stupid and crazy and drove to Phoenix. Stripping didn't bother me. It kept me in dope. Everyone I knew was getting thrown in jail.

I got burned out and I wanted to try something else. My dad picked me up at the bus station. While I was gone, he had found religion. I went to church, and it was like God grabbed me by the back of my head and gave me a sound whoppin' on my noggin and said, "Get your act together, girl!"

Later that year, I got baptized. I met Dexter at a friend's house and we've been together ever since. We have one daughter and we home-school her, using a Christian-based curriculum.

Heaven is where the streets are paved with gold and there's no tears. It's a place of eternal happiness, no anger and no hunger. The Book says it. Once you accept Jesus in your heart, you just know.

John Honn and Alice (Honn) Lombard's daughter **MELODY (HONN) HILLIER** (b.1970)

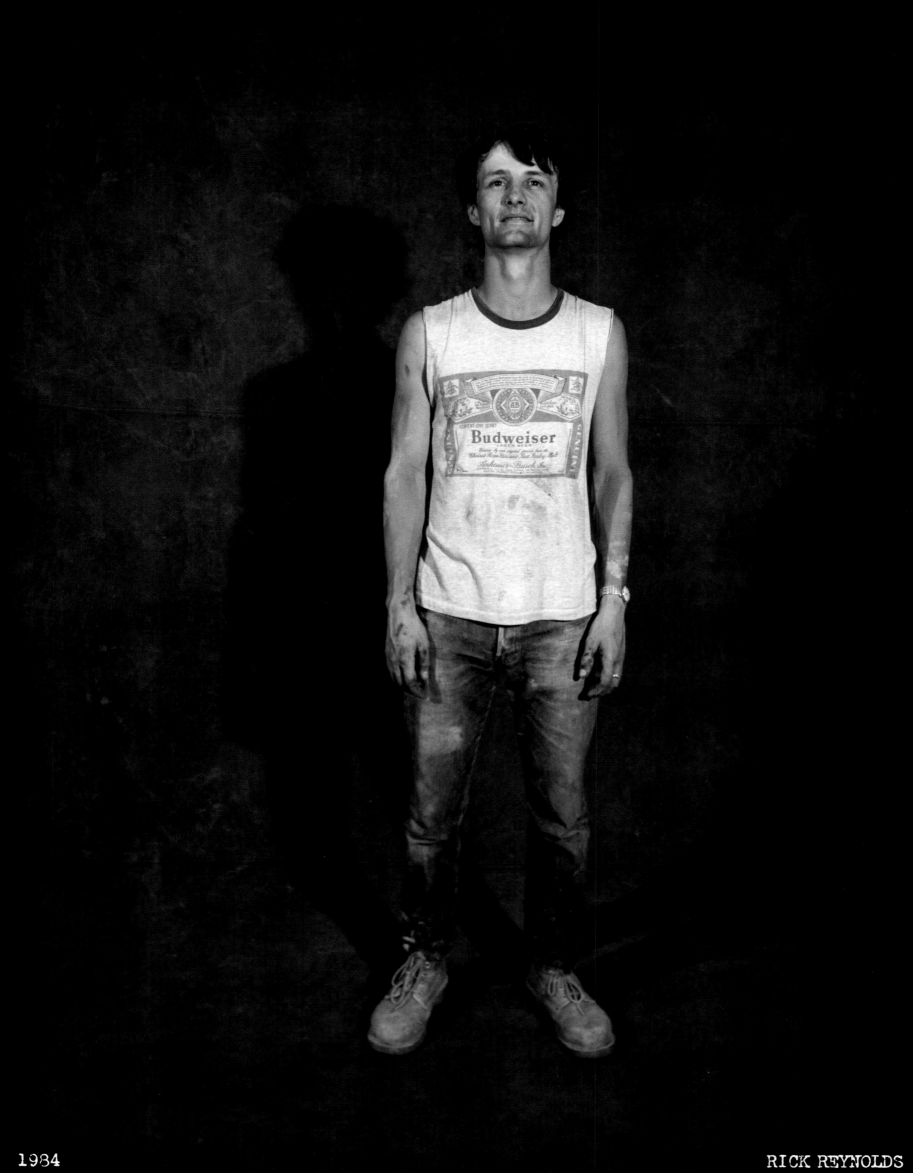

1984

RICK REYNOLDS

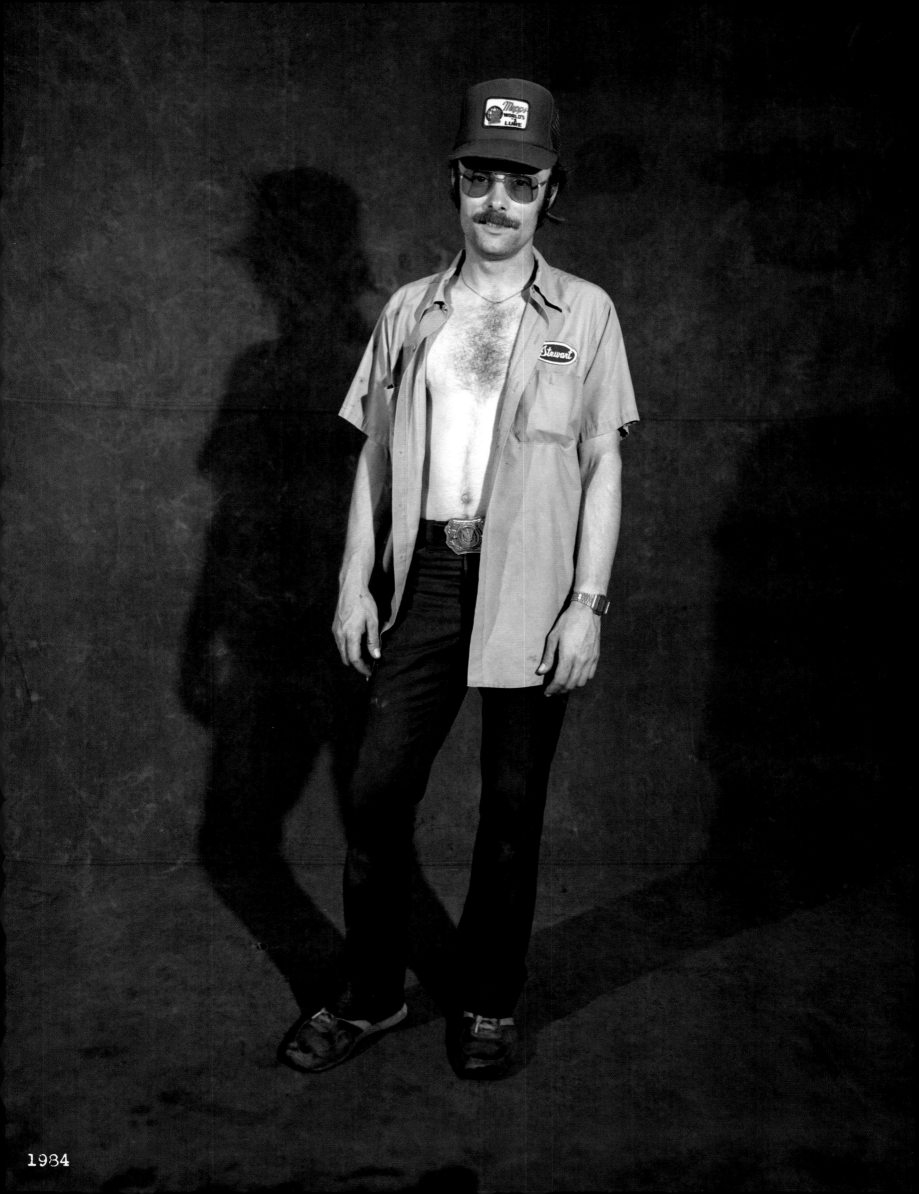

1934

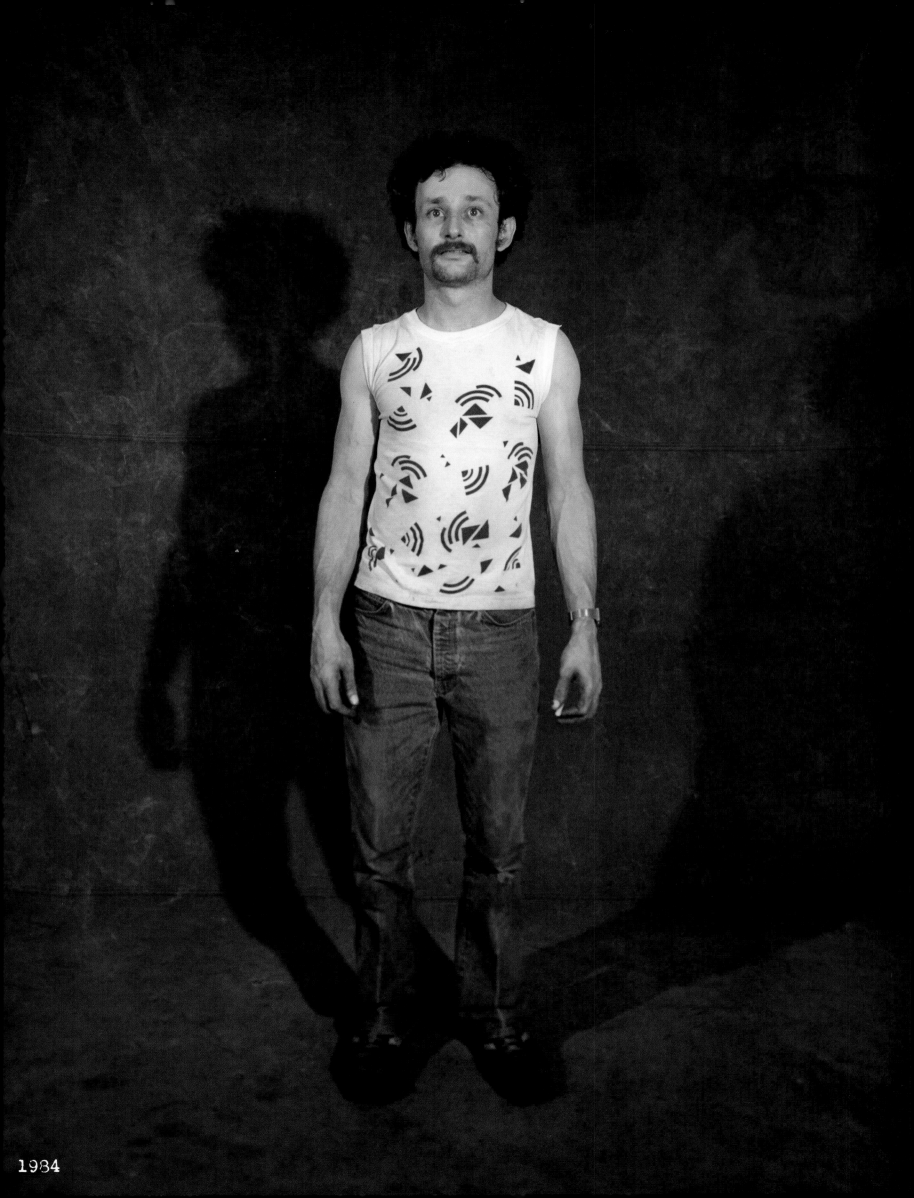

1984

"I've found that video games help me from thinking too much."

ALAN REYNOLDS

I'M AN ARTIST.

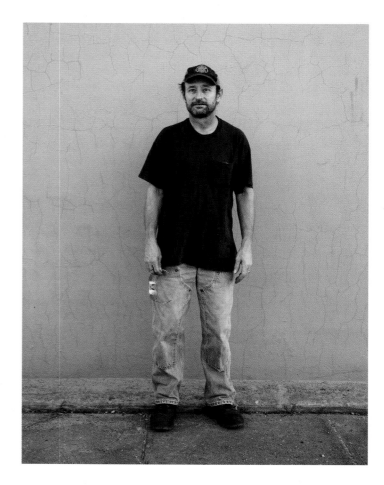

I get into real fine detail. Some of it is fantasy, some is realism. I like to do dot drawings. Some can be as big as a table. I've had offers to move to New York to be an illustrator.

I want to do art that'll get people's attention. I want people to think their world isn't what they think it is. I like to mess with 'em.

My mind is always going. I try to slow it down. I've found that video games help me from thinking too much. I like the shooter games and the strategy games.

I've worked landscaping, plumbing, refrigeration, blacksmithing, welding, sign-painting. I was a DJ at my wife's first wedding. Now I'm working with copper art—lawn art, flowers, critters, big giant insects. My ideas never stop.

I'd like to move to Seattle, to see the rain forest and to be in a cooler climate. It's getting harder and harder to cool off.

I don't go to church. I don't work on Saturdays because that's the Sabbath. I don't know what to call my religion. I try to be as Christ-like as I can.

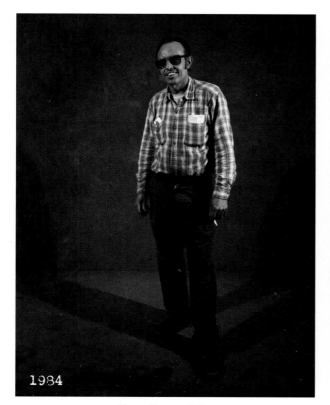

Don Reynolds

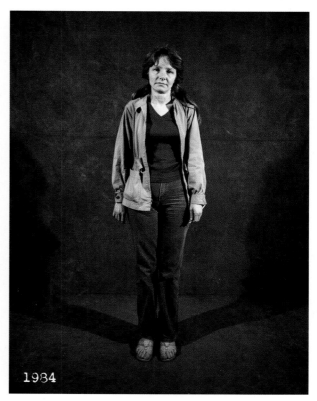

Susan Reynolds

OPPOSITE AND TOP: **ALAN REYNOLDS** (b.1957) BOTTOM: Alan's parents **DON REYNOLDS** (1930–1996) and **SUSAN REYNOLDS** (1941–1988)
INSIDE GATEFOLD: Alan's siblings **STUART REYNOLDS** (b.1958), **RICK REYNOLDS** (b.1962), **ERIC REYNOLDS** (b.1965), and **JULIE (REYNOLDS) EALY** (b.1967)

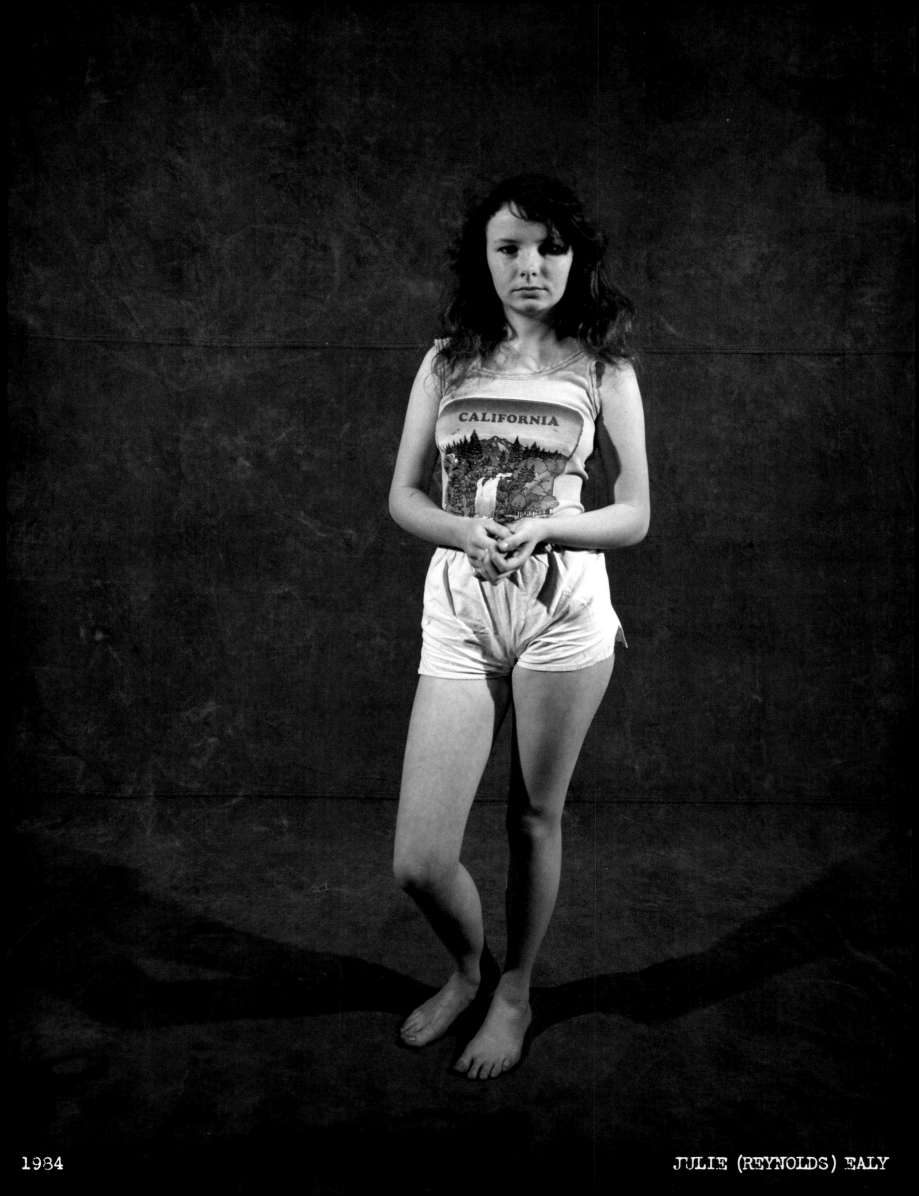

1934

JULIE (REYNOLDS) EALY

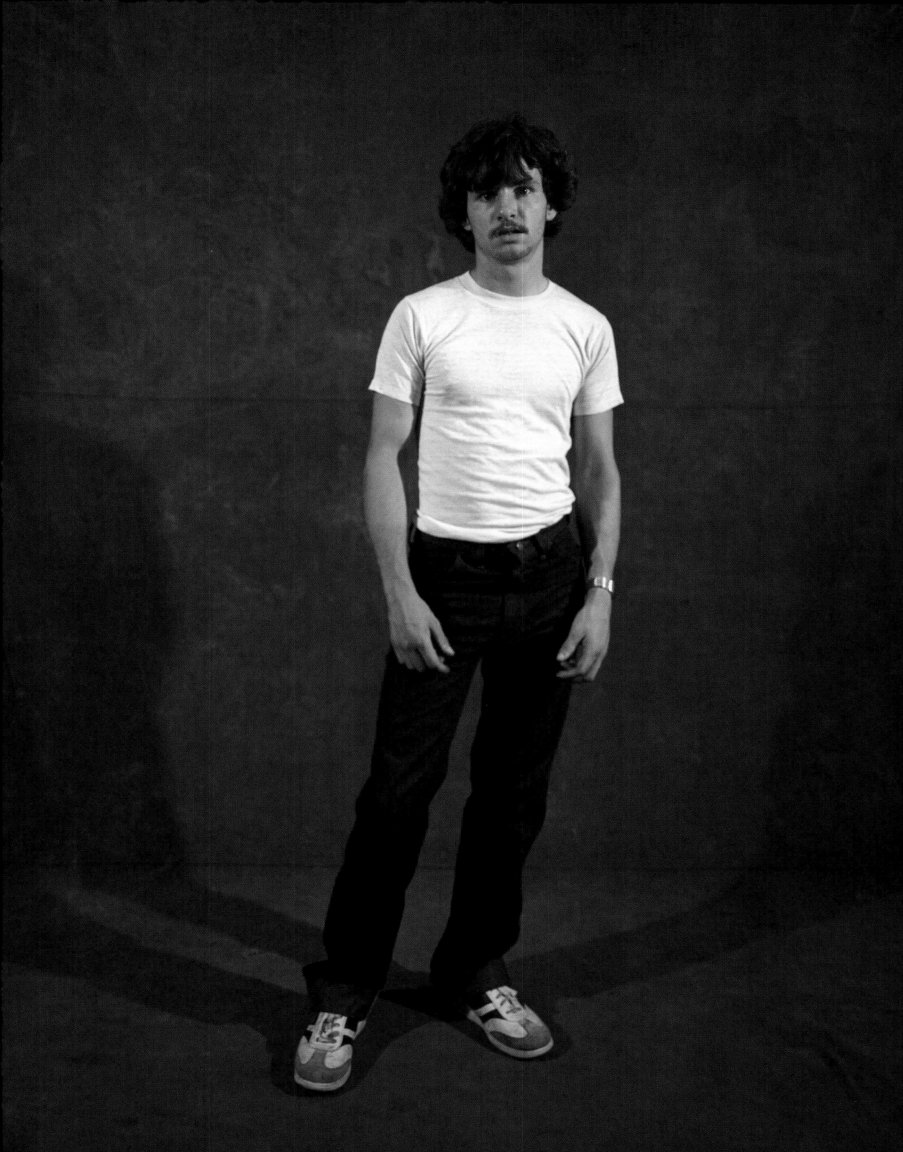

1984

ERIC REYNOLDS

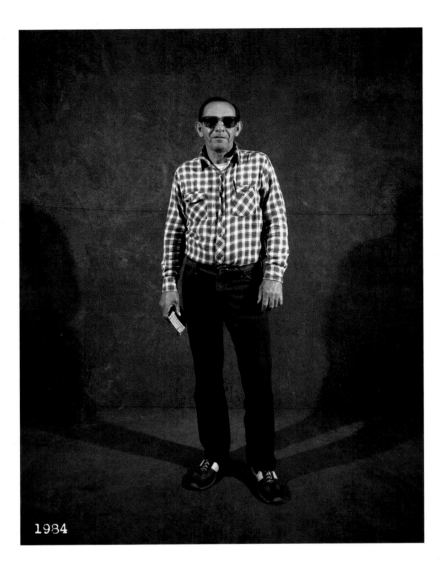

1984

> "My theory is that Woman came from outer space and Man came from the ocean."

ROY BERG

I'VE BEEN CALLED FRANK SINATRA. People think I look like him.

When Marilyn and I lived in California, I worked at a Shell station in Culver City. I saw the guy who played Eliot Ness in *The Untouchables*. I pumped gas for the Indian who always got killed. I met James Dean and Sal Mineo.

I don't think man ever landed on the moon. It was all done on a Hollywood set. Why would they leave the spaceship and the American flag if it wasn't rigged? My theory is that Woman came from outer space and Man came from the ocean. Women were brought here in a spaceship.

I've been clinically dead four times. I was struck by lightning when I was three. I was at a water pump when the lightning hit me. I was out four days. The next time, my brother pushed me in a swimming pool and I was under for twenty minutes. The third time, I was driving my '48 Plymouth with a '52 engine in it, and my left front tire blew out, and I made three complete flips, and I never got a scratch on me. The last time, a guy pulled me into the water at the power plant. When they pulled me out, I didn't have no water in my lungs.

If I wear a watch, it'll burn up because of all the electricity in my body.

I know how I'm going to die—in fire. There's not going to be anything left by then. Man's going to destroy everything.

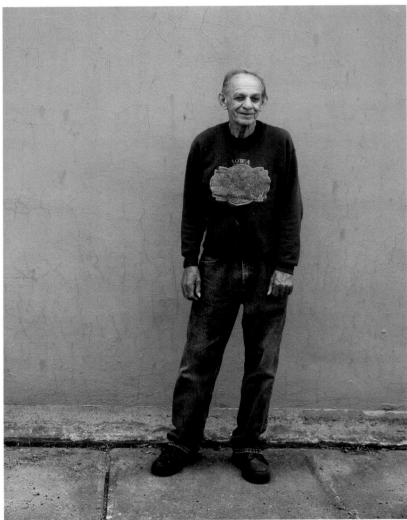

ROY BERG (b.1936)

176

"I'd like to win the
lottery, but not the big
one, just enough to make
me happy."

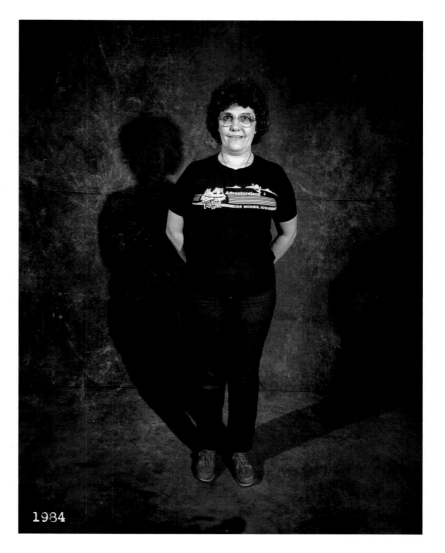

1984

MARILYN BERG

I MET MY HUSBAND one summer day when I was sunbathing in the front yard. He was driving a '38 Oldsmobile. I waved to him and he slowed down and we got to talking. My first impression was that he was nice looking. On our first date, we went to the movies and saw *The Thing.* I was so scared, I ran out of the theatre.

I quit high school in the ninth grade. I didn't care much for school. I became a waitress. I've also worked as a nurse's assistant and as a cashier at Wal-Mart.

We lived in California for a while. My eyes would burn from the moment I woke up till when I'd close them at night. I saw some movie stars out there. Once I saw Danny Thomas. My husband pumped gas for Preston Foster and Vic Morrow. He also did some painting in Dorothy Provine's house.

I'd like to win the lottery, but not the big one, just enough to make me happy.

When people die, I think the Lord must have needed them for something else. When we die, Roy and I are going to be cremated. We can't afford a spot to be buried in.

Roy's wife **MARILYN BERG** (b.1938)

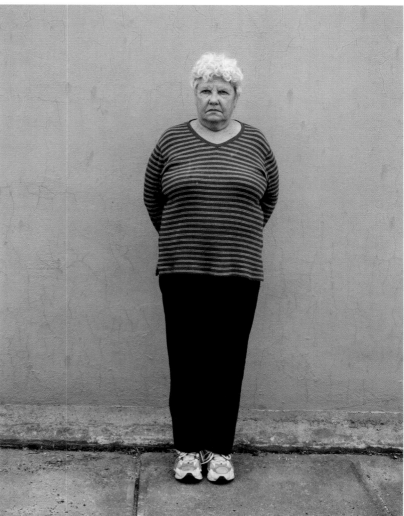

"I met my wife at a party or a dance,
I can't remember which. We used to ride
horses in the riverbed."
—Vince Grabin

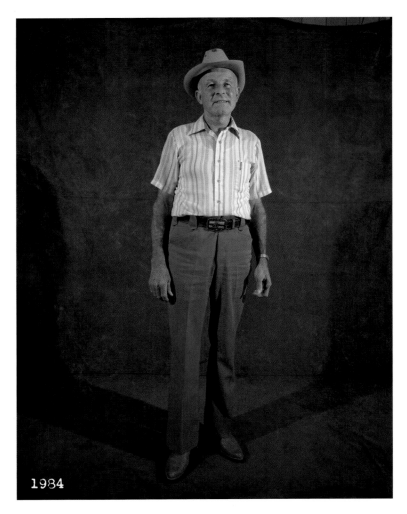

1984

1984

Katheryn Grabin

VINCE GRABIN

MY GRANDFATHER FARMED DOWN THE ROAD, so did my father and so did I. Our land runs to the county line, through Grabin Cemetery Road. We farmed oats, corn, beans, and cattle. I went to a little country school a quarter mile from our house. The teacher lived with us.

I met my wife at a party or a dance, I can't remember which. We used to ride horses in the riverbed. My father-in-law was a barber.

The military expected me or one of my brothers to go to war, so I got drafted. I was an MP for a year, then I went overseas. My job was guarding German prisoners.

My wife is in a nursing home now. I try to see her every day. They don't allow visitors to eat with residents, so I bring a sandwich and eat it in her room.

My left hand got caught in a corn picker in 1967. I was reaching back, trying to get something unstuck, and my foot pushed the auger. That's when I lost the two fingers. After the accident, I started to go to church more. I now go every Sunday.

Today I got a haircut. I usually get up at daylight. I eat pork and beans sometimes. I like cranberry sauce. I don't eat too many vegetables. I read the newspaper. The mail gets here by five p.m. I watch the news, *Wheel of Fortune*, and *Antiques Roadshow*. I get to bed by seven p.m.

I haven't really thought about death. My wife and I have a stone with our names on it. You think you're going to live forever. But I know it's coming. We die, they bury us, and that's the end of it. I don't know enough to have any regrets.

I always wear a hat. I don't go out without one. Sometimes I splash on a little Old Spice. I always carry a pocketknife, a pen and paper, and pliers. You never know when you're going to need pliers.

TOP AND OPPOSITE: **VINCE GRABIN** (b.1919) BOTTOM: Vince's wife **KATHERYN GRABIN** (b.1919) FOLLOWING PAGES: Vince's brother **RAY GRABIN** (b.1928)

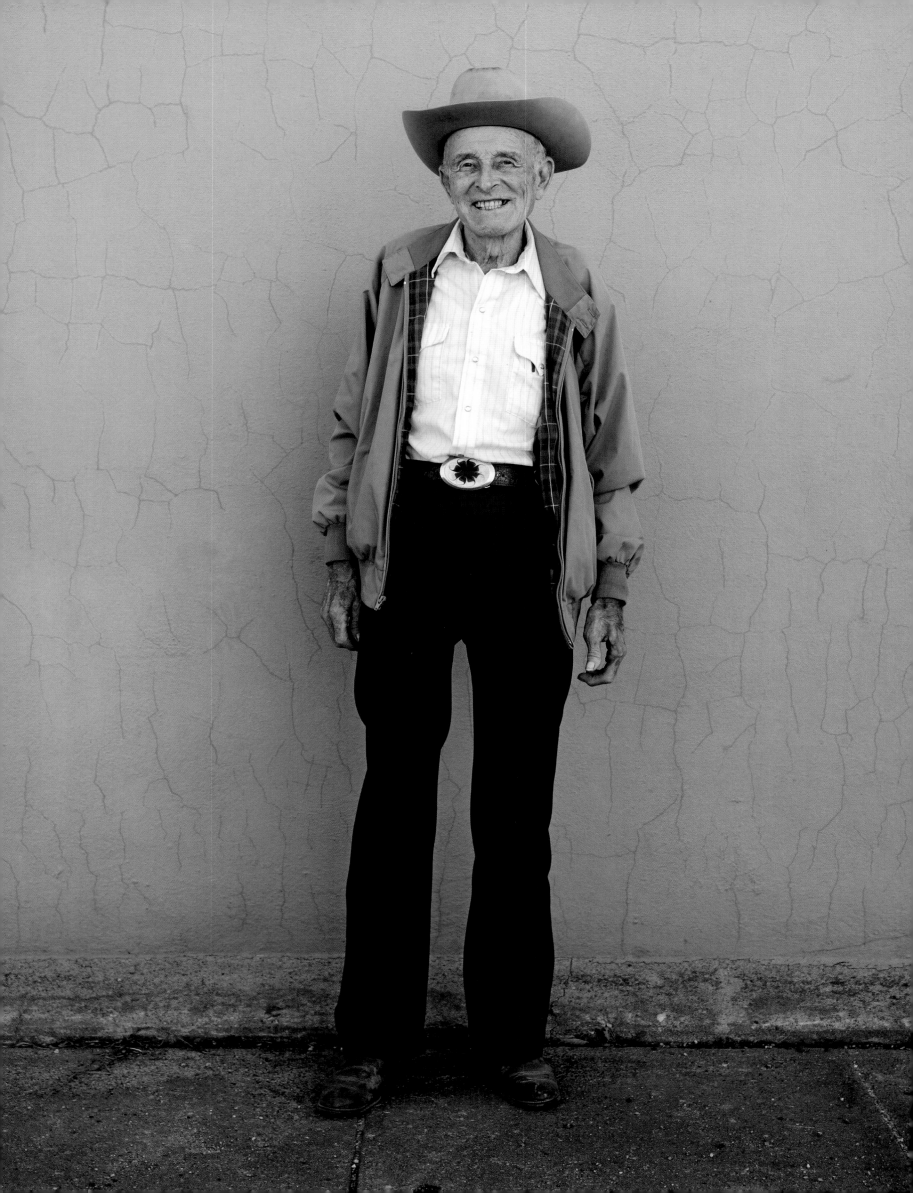

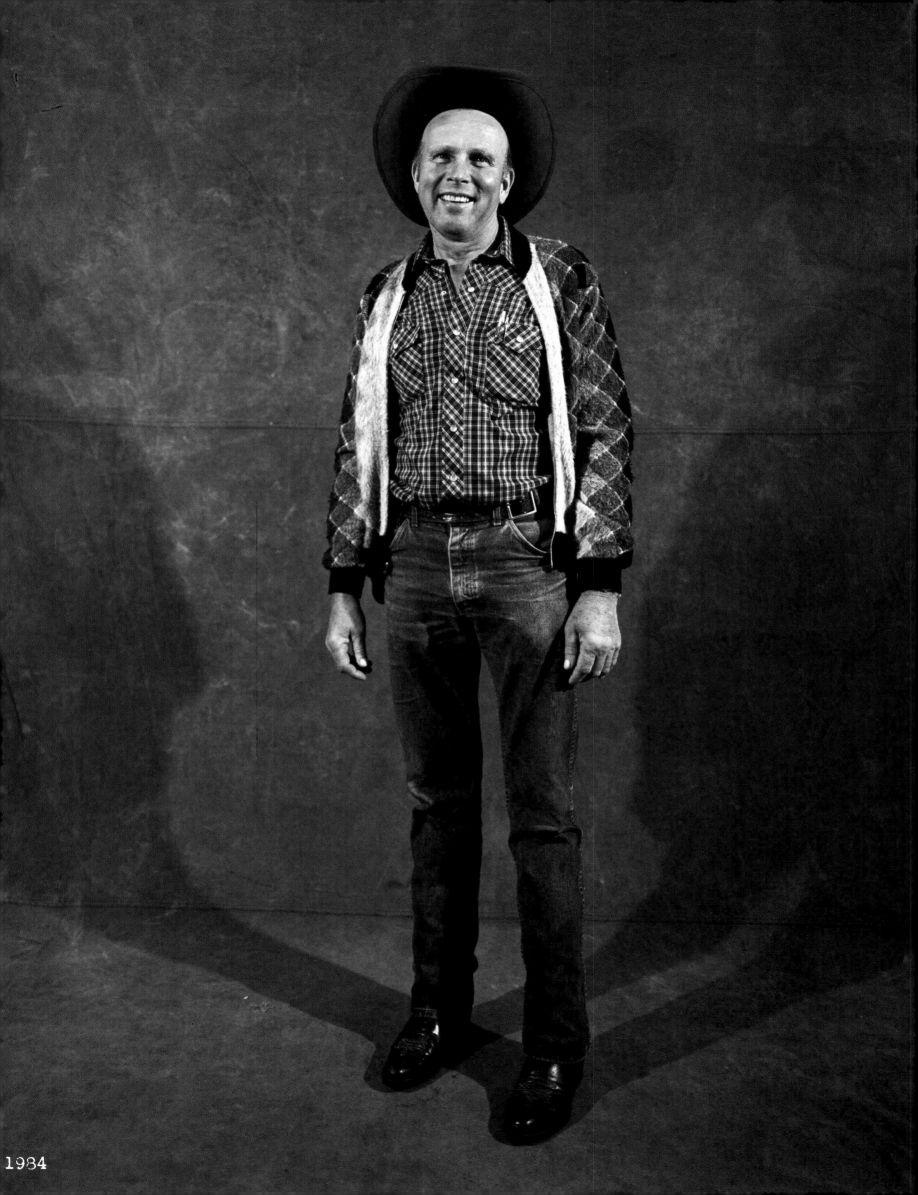

1984

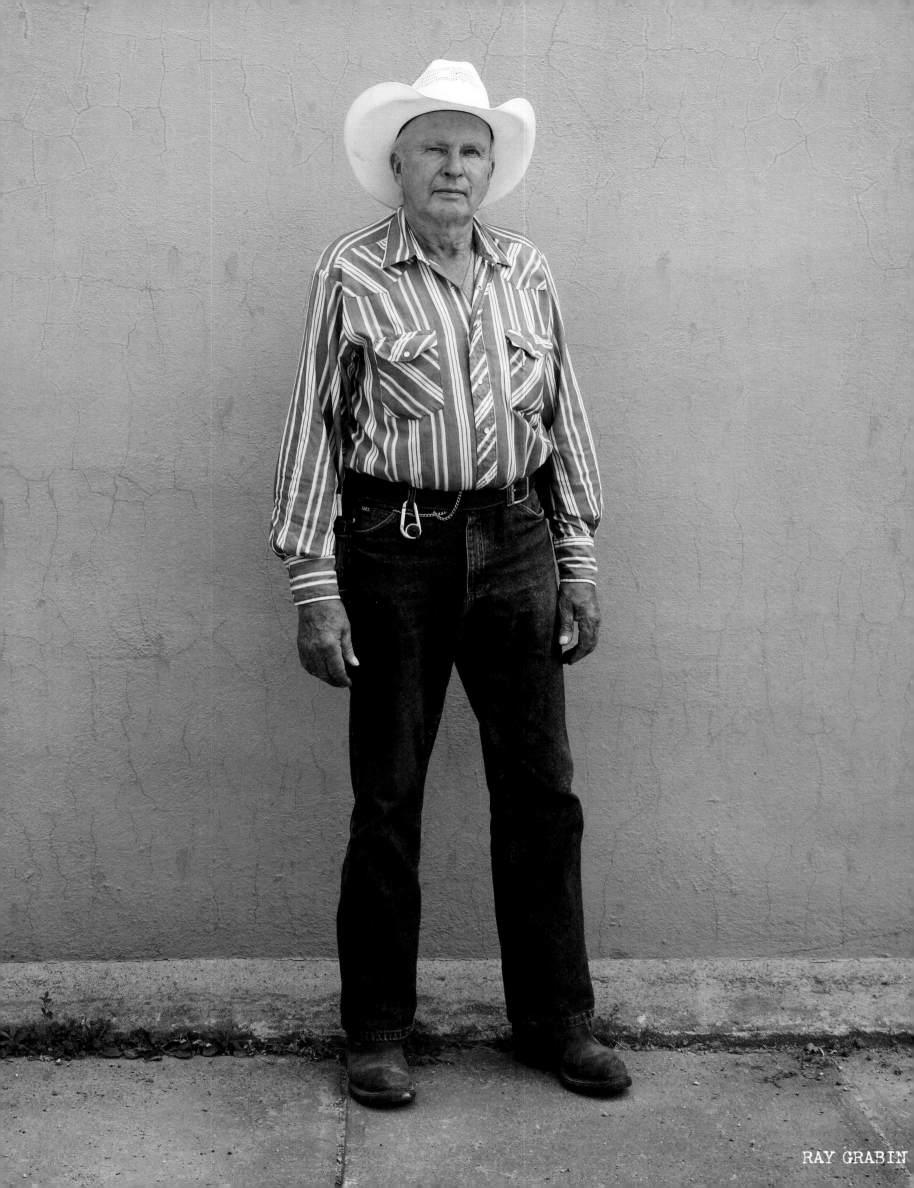

RAY GRABIN

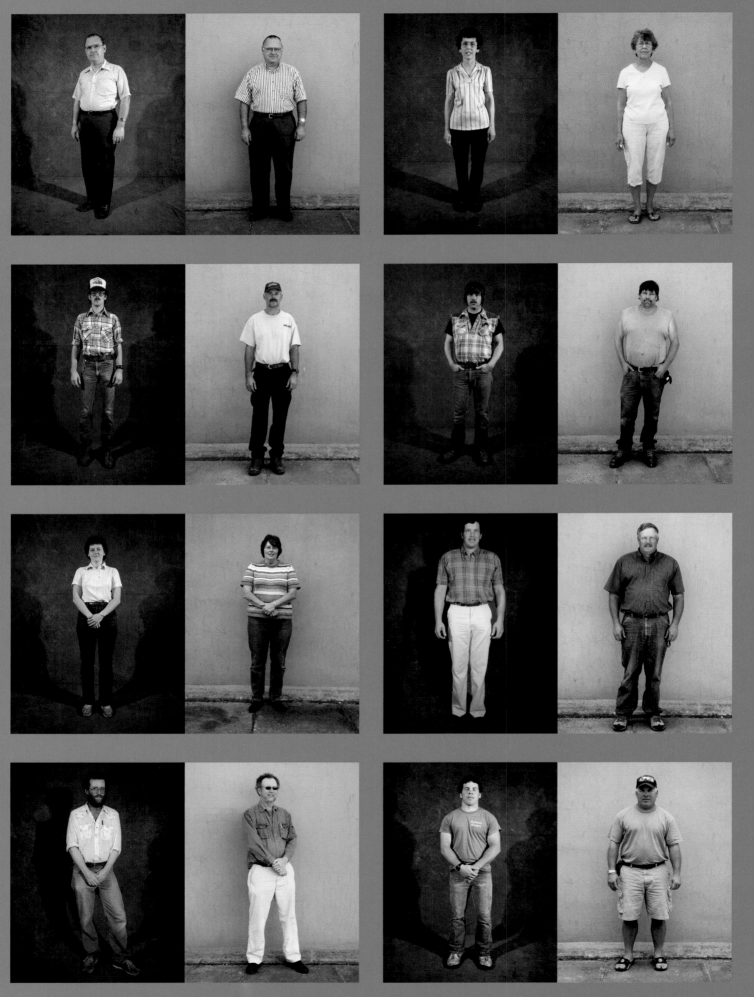

THIS PAGE, LEFT TO RIGHT, FROM TOP: DON SAXTON (b.1939), MONA WALLS (b.1939), SCOTT BLOCK (b.1963), BOB SPEERS, SHARON KUTCHER (b. 1949), BURT STRUZINSKI (b.1952), STEVE STRAIT (b.1953), BILL WALLS, JR. (b.1961)

THIS PAGE, LEFT TO RIGHT, FROM TOP: EARL BERG (b.1956), HAZEL COOK (b.1931), BONNIE JIRAS (b.1946), PAT KINNEY (b.1946),
DAVE COOK (b.1956), MARY STRUZINSKI (b.1935), TERRY BRACK (b.1963), JEFF JIRAS (b.1961)

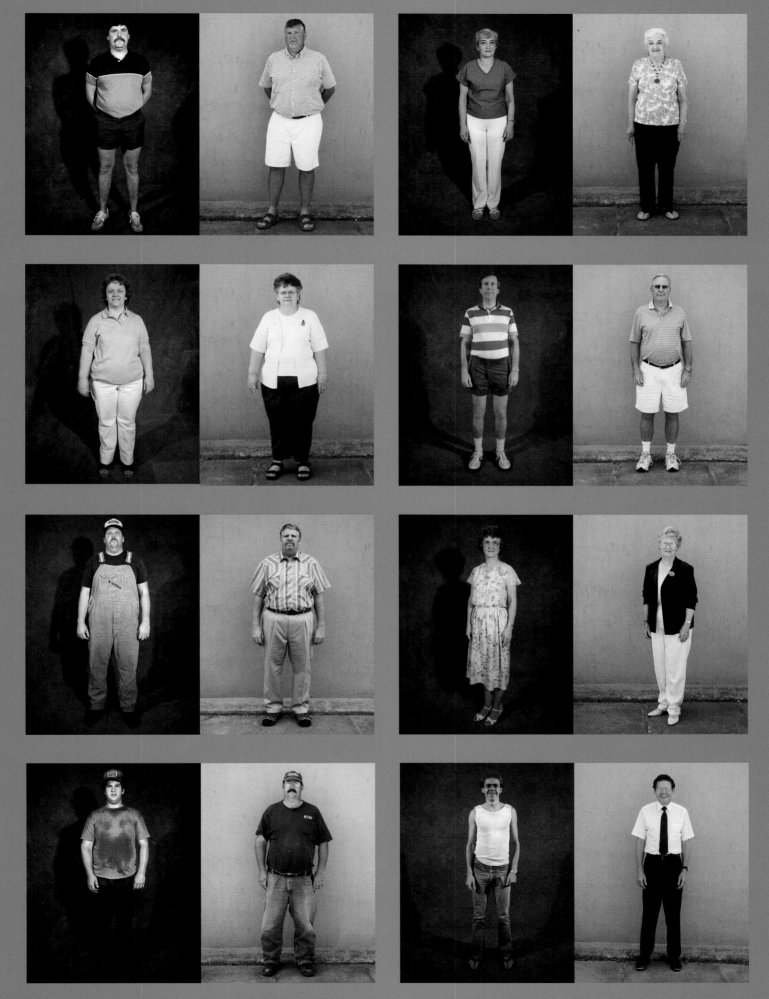

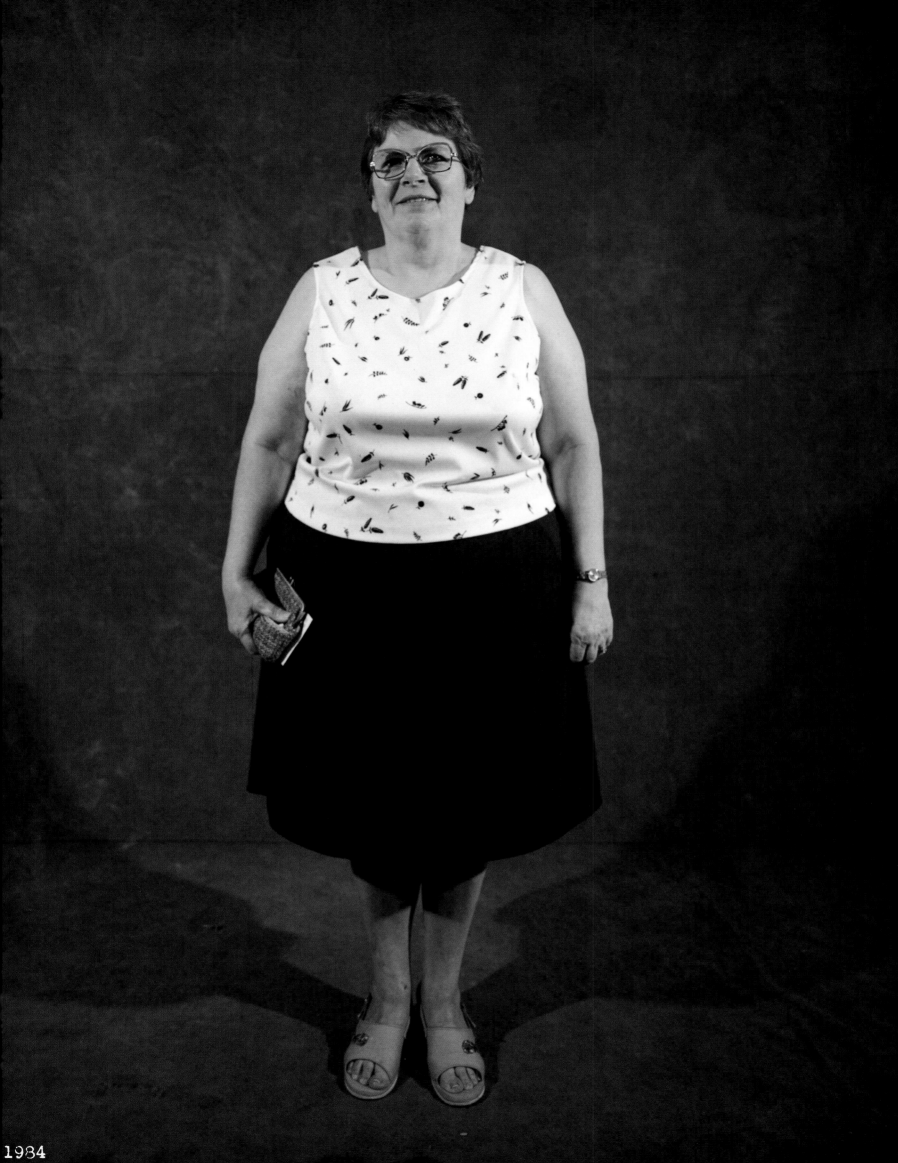

1984

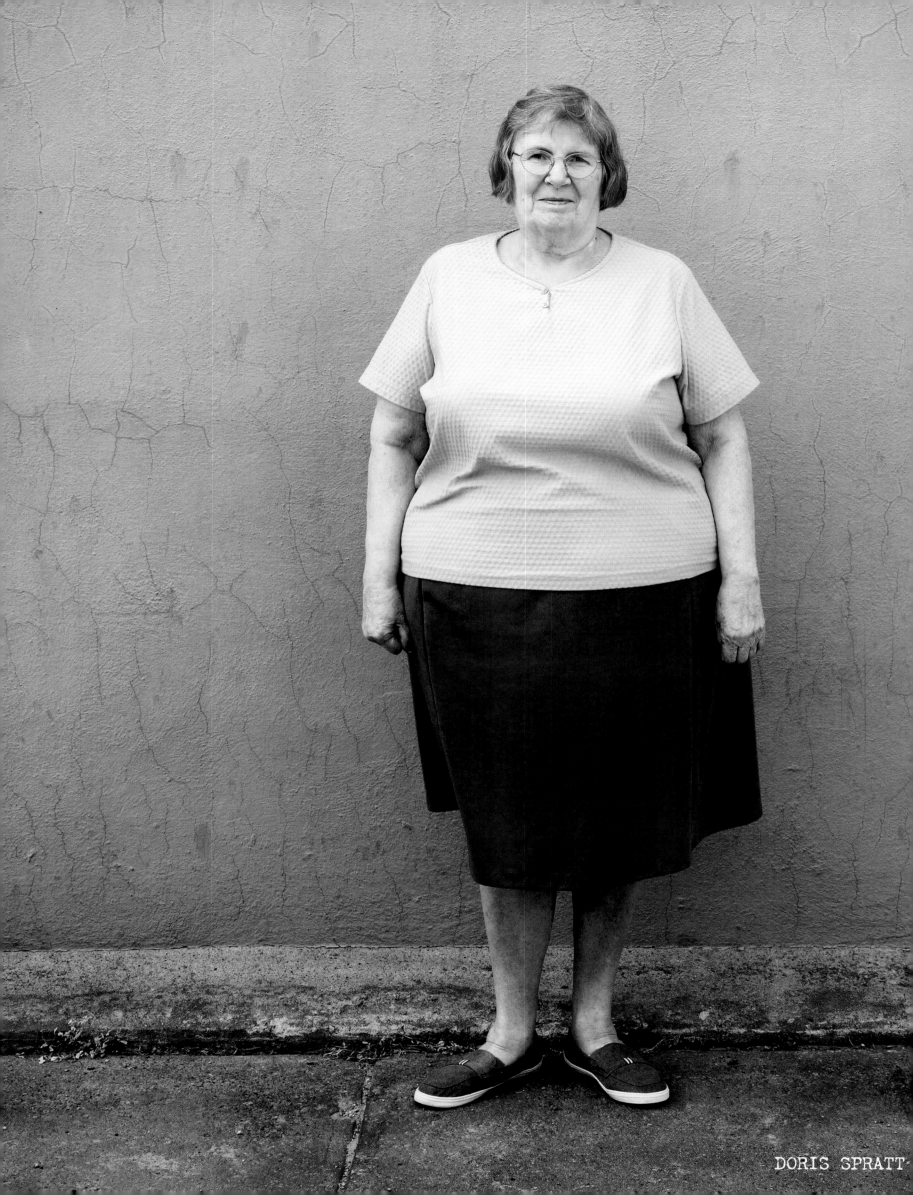

DORIS SPRATT

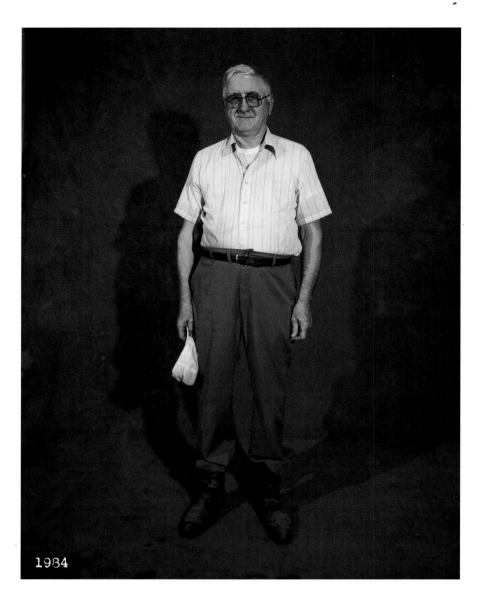

1984

"When Doc Hennes was in town, you could go in
there anytime and he'd take care of you. Now it
takes forever to get in to see the doctor."

RICHARD SPRATT

THERE WERE SEVEN KIDS in my family. I'm the only boy
left. It ain't a very close family, to tell you the truth.

My wife and I were next-door neighbors. Her father
was in the grocery business. We met after school and that
was that. She's been a good lady. We'll be married fifty-
seven years.

I woke up one morning and I couldn't breathe. Dr. Dole
worked on me, and told me to wear oxygen for two years. If
I can get the swollenness out of my legs, maybe I'd be able
to circulate a little. Usually I sit around and grumble all day.

When Doc Hennes was in town, you could go in there

anytime and he'd take care of you. Now it takes forever to
get in to see the doctor.

When the doctor looked at my lungs, he said, "You
were a smoker." But I only smoked till I was twenty-six.
I think what he was seeing was when I worked at the
smokehouse in Homestead. I cut meat for twenty years. I'd
go in there and the smoke would be billowing out.

I called my old boss the other day and told him what
the doctor said, and he asked, "How old are you?" I said
eighty-four.

He said he didn't feel so good either. He's got cancer.

ABOVE AND OPPOSITE: **RICHARD SPRATT** (1923–2007) PRECEDING PAGES: Richard's wife **DORIS SPRATT** (b.1931)

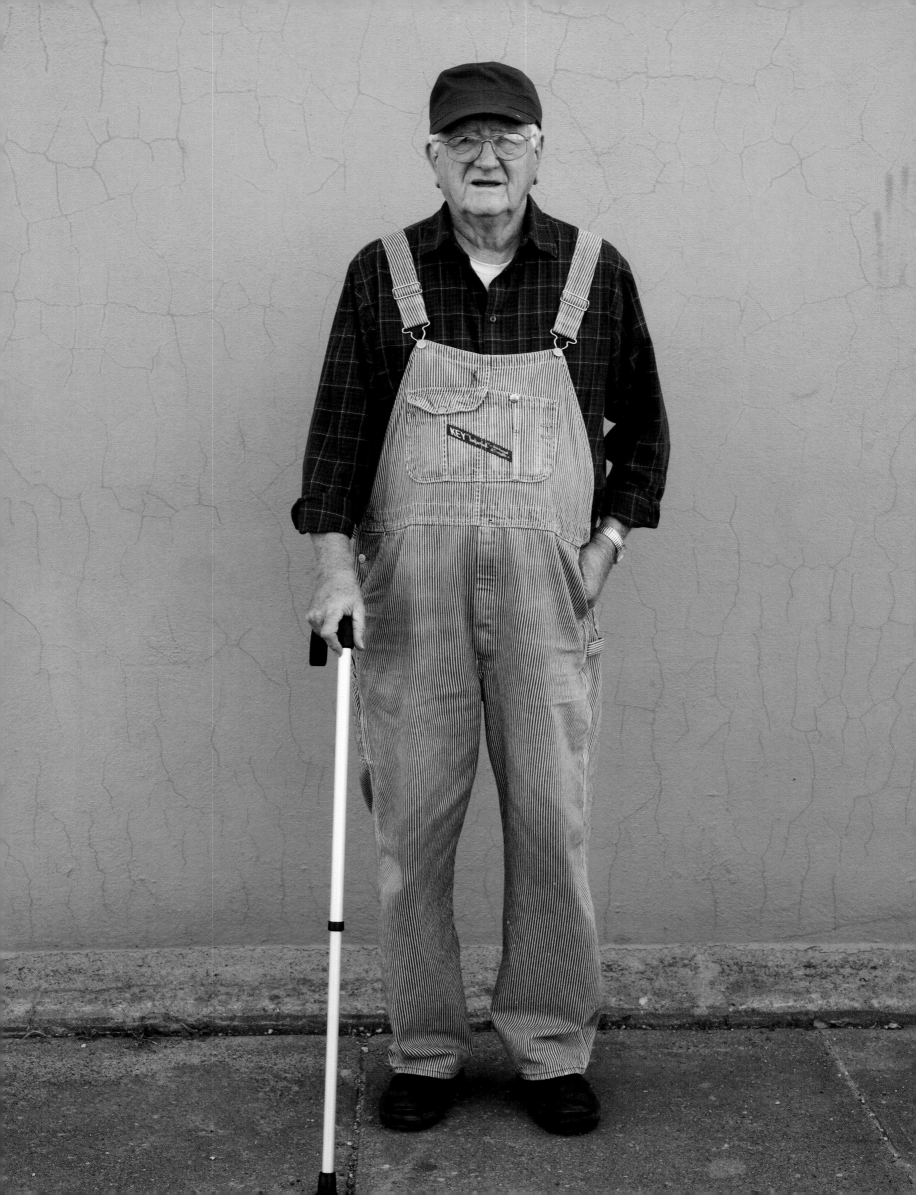

1984

RAPHAEL "DOC" HENNES

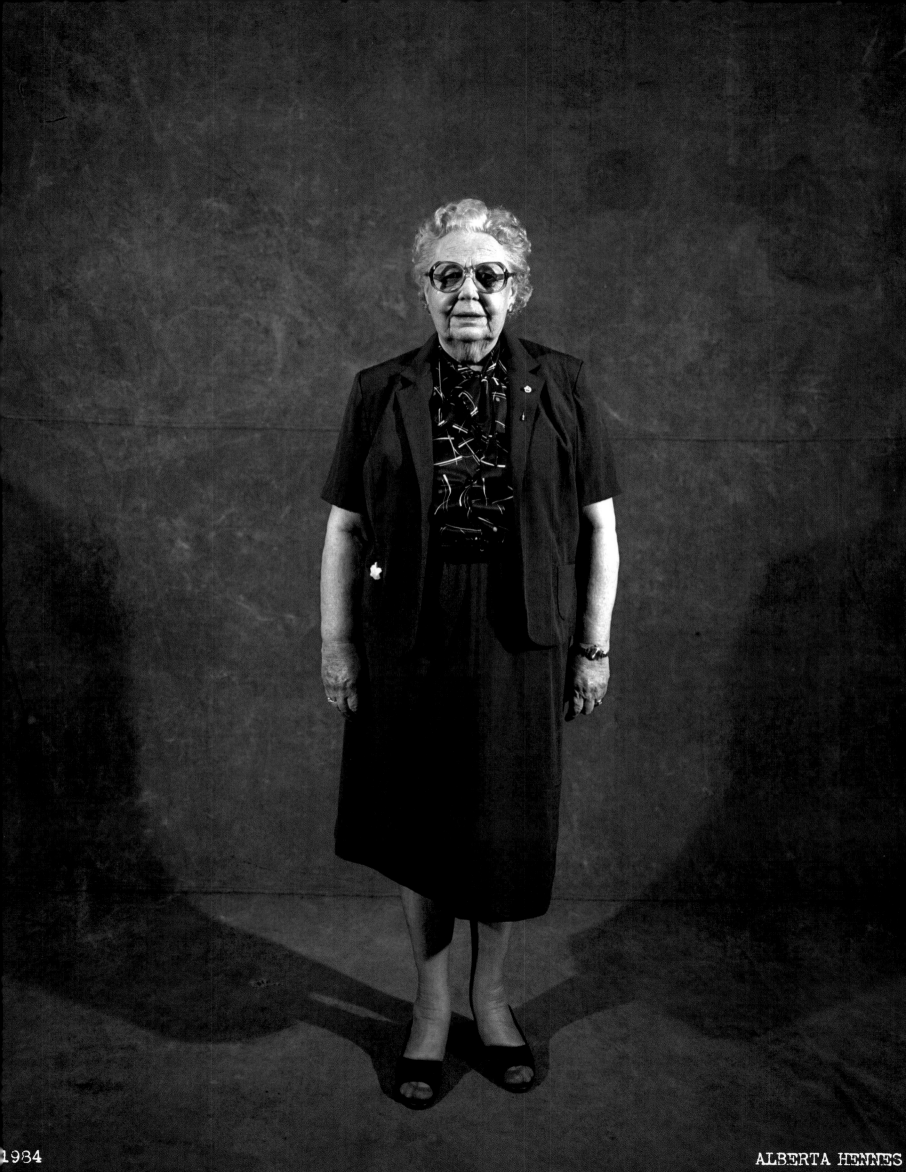

1934

ALBERTA HENNES

"My grandfather was the doctor in town for fifty years. My dad is retired from Amana Refrigeration. I've been at my job for twenty-six years."

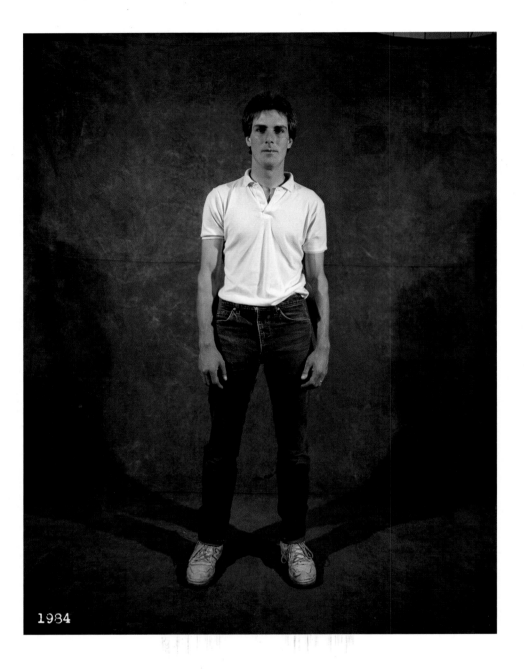

1934

MIKE HENNES

I'M THE FOREMAN for the county secondary road crew. I get up at a quarter to four, then I go online and read the local news. On my way to work, I eat a Pop-Tart.

My grandfather was the doctor in town for fifty years. My dad is retired from Amana Refrigeration. I've been at my job for twenty-six years, from the day I graduated high school. I had a job offer once in Missouri, but I got cold feet.

I have three kids from my current marriage and three from my previous marriage. My first wife and I were high school sweethearts. We broke up after five years of marriage. Maybe I could have done something different. Maybe not.

We separated in 1989. I was pretty gun shy for a while. I dated one girl for seven years, and I didn't get remarried for thirteen years. I met Aja one summer when she was working for the county. I'm seventeen years older than she is. Her father didn't like that, but now he and I get along fine.

ABOVE AND OPPOSITE: MIKE HENNES (b.1960)
PRECEDING PAGES: Mike's grandparents RAPHAEL "DOC" HENNES (1903–1995) and ALBERTA HENNES (1905–1989)

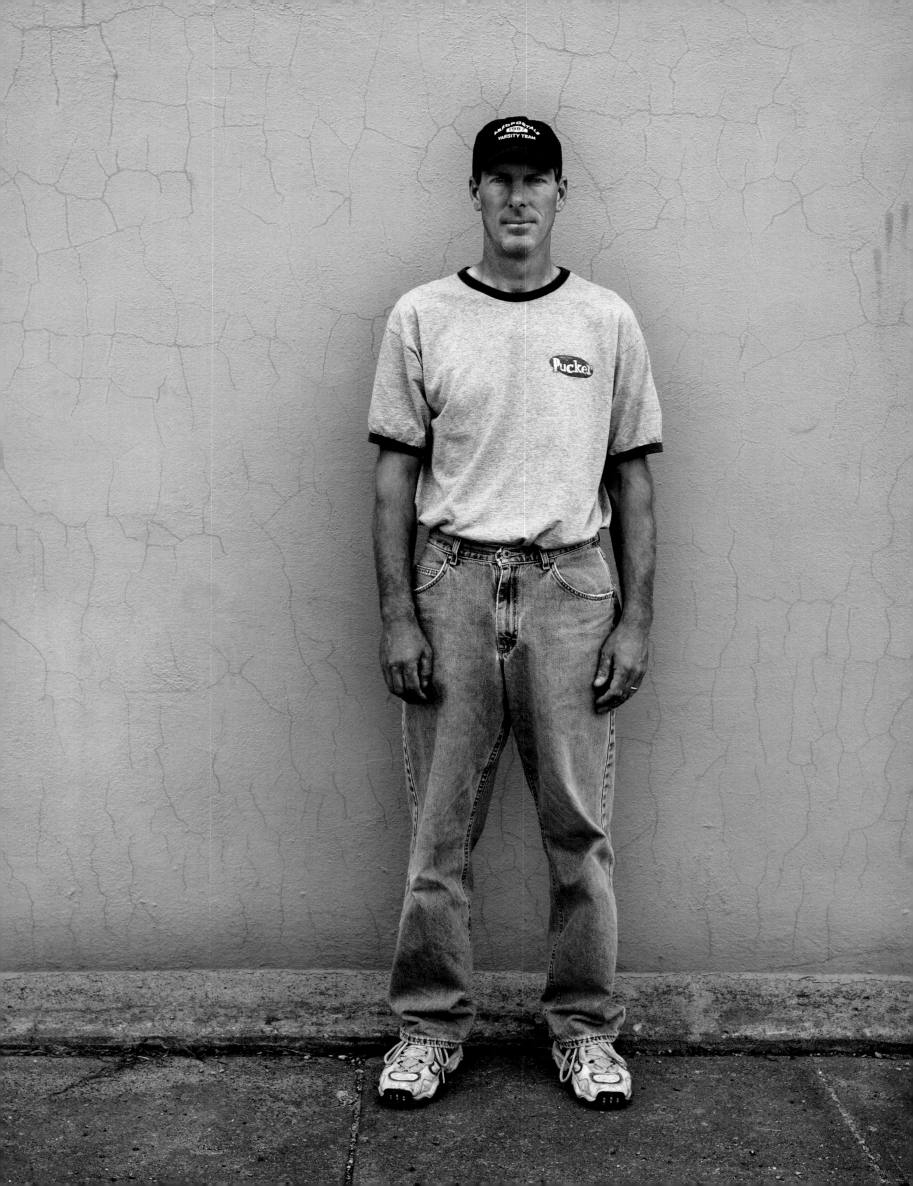

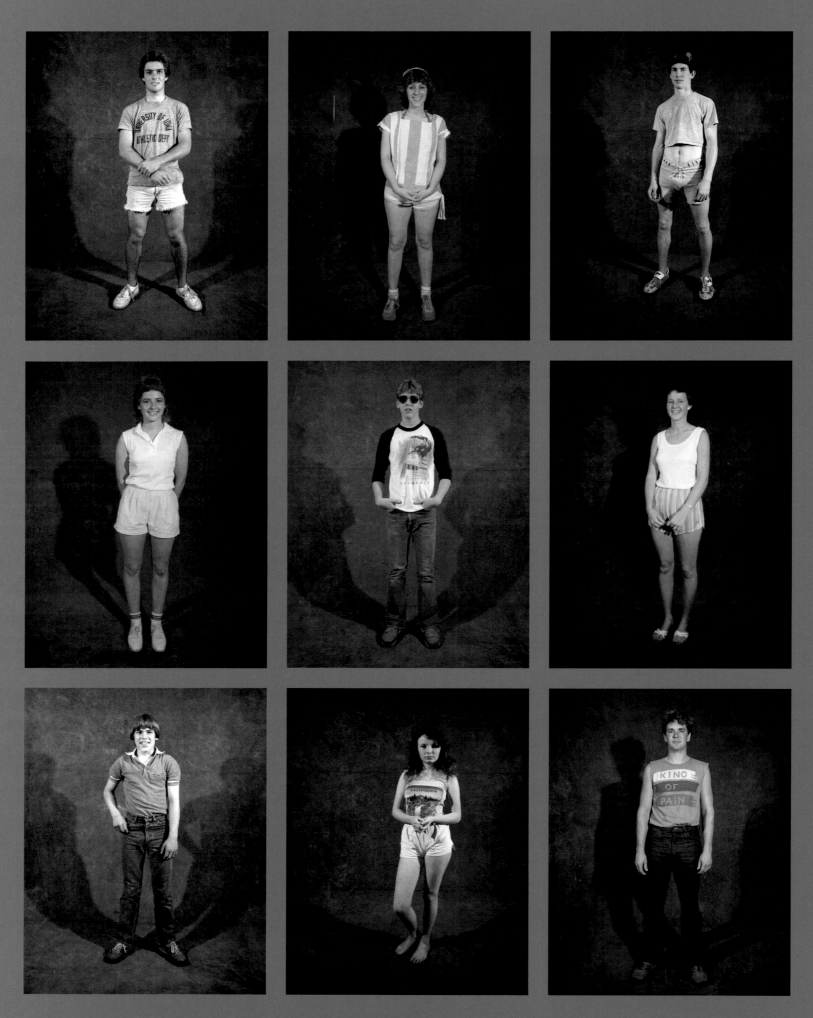

BOTH PAGES, TOP ROWS, LEFT TO RIGHT: **TIM HENNES** (b.1963), **MELODY MORRISSEY** (b.1966), **JEFF WALLS** (b.1967) MIDDLE ROWS: **DENISE (CELLMAN) OGDEN** (b.1966), **JAMIE DOLEZAL** (b.1967), **TAMMY JIRAS** (b.1964) BOTTOM ROWS: **BRIAN COX** (b.1971), **JULIE (REYNOLDS) EALY** (b.1967), **JIM VILLHAUER** (b.1963)

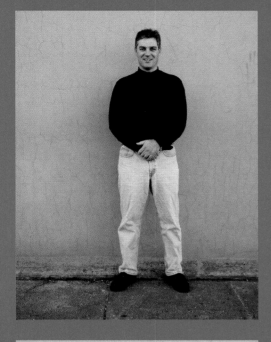
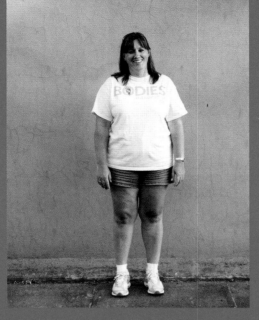
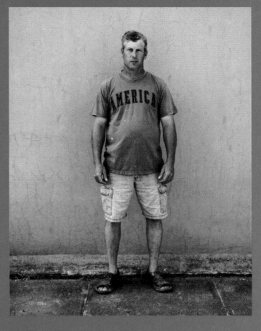
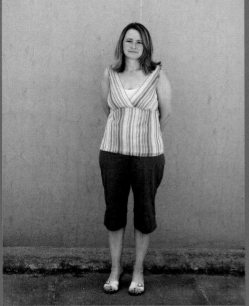
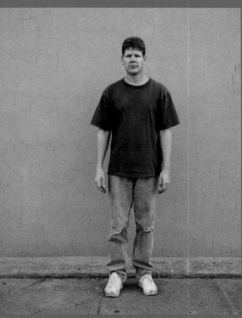
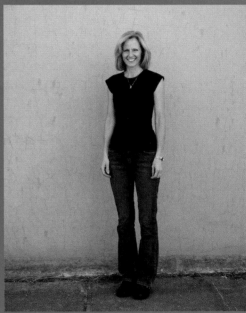
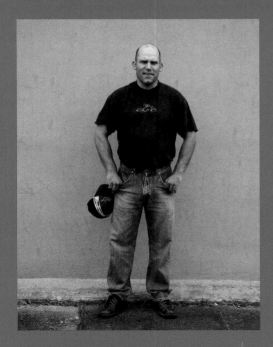
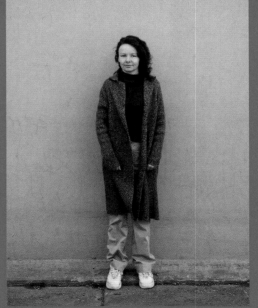
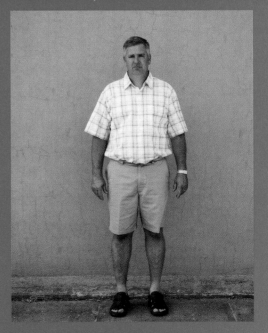

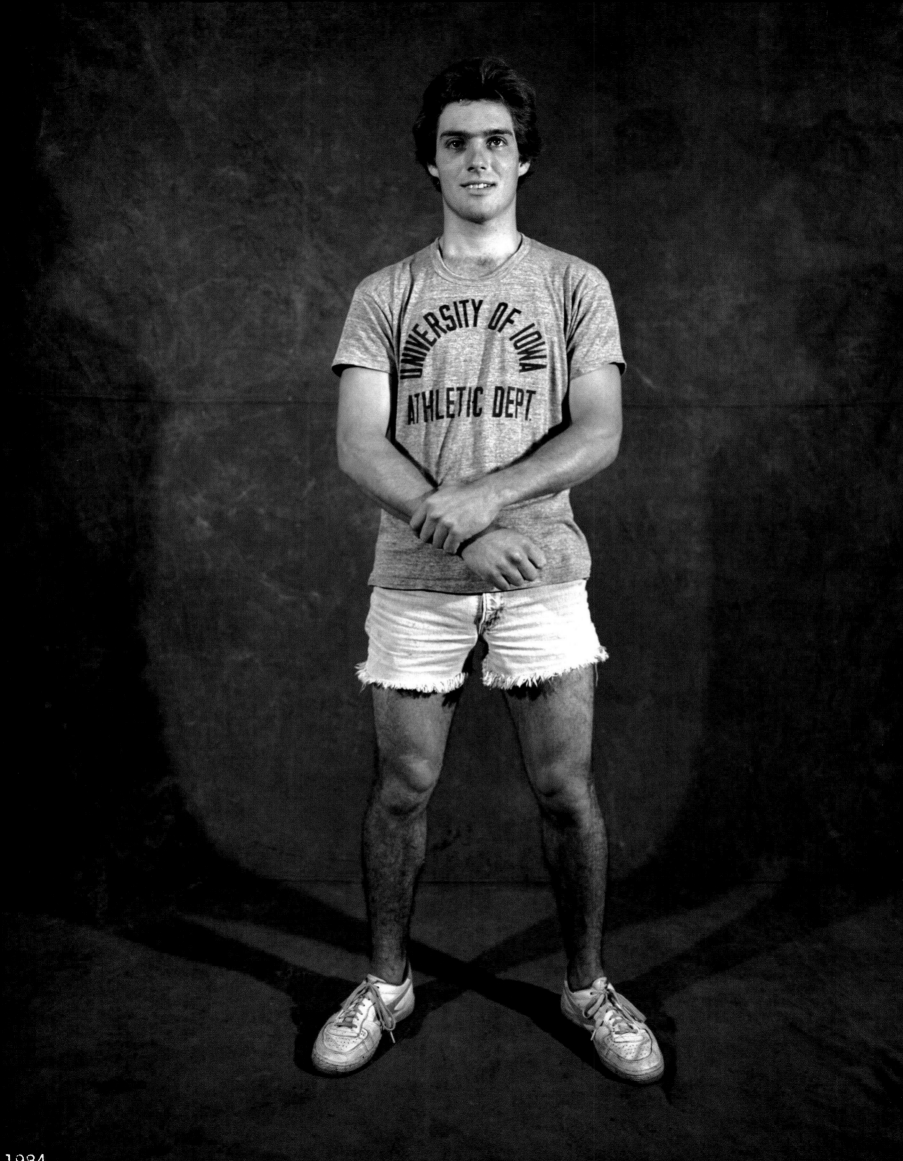

1984

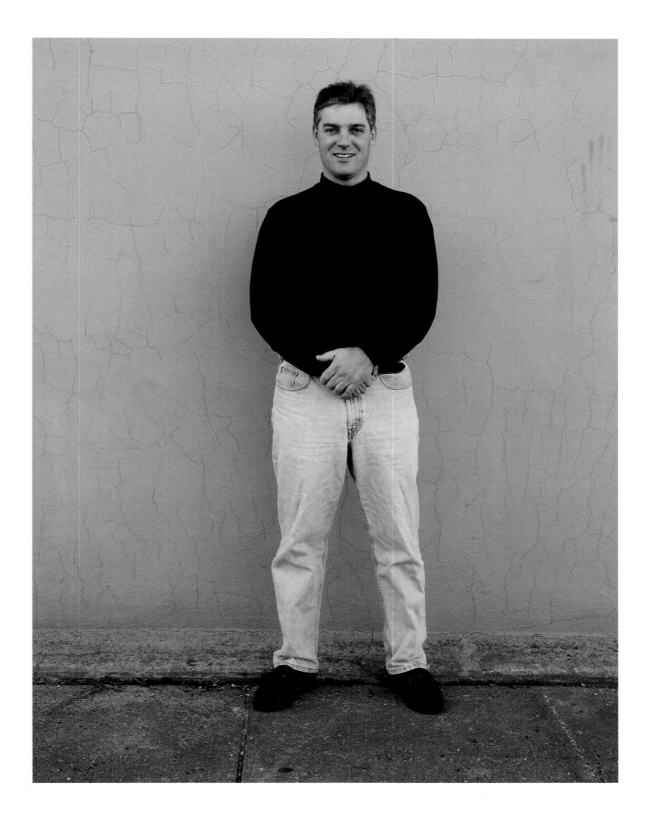

TIM HENNES

I HAD THE WORLD BY THE ASS in those days. I could work eight hours, party till three in the morning, then be at work by seven. My idea was to work a year, then attend college in Hawaii. That was my plan. Nothing really was tying me down here. So I got a job doing construction to save up enough money.

On the way home one day, I stopped in at Slim's, and that's where I met Robin. Today we have two girls, ages sixteen and thirteen. I've been on the Oxford City Council for eight years, and now I'm in my second term on the school board. I work as a building inspector.

I'd love to travel Route 66, see New York City, Vegas, maybe Alaska. Sometimes I feel like George Bailey, the Jimmy Stewart character in *It's a Wonderful Life*. That trip to Hawaii was my ticket out.

Mike Hennes' brother **TIM HENNES** (b.1963)

> "My mother was Patty Hackathorn's sister. She died of cancer when she was forty. I was sixteen."

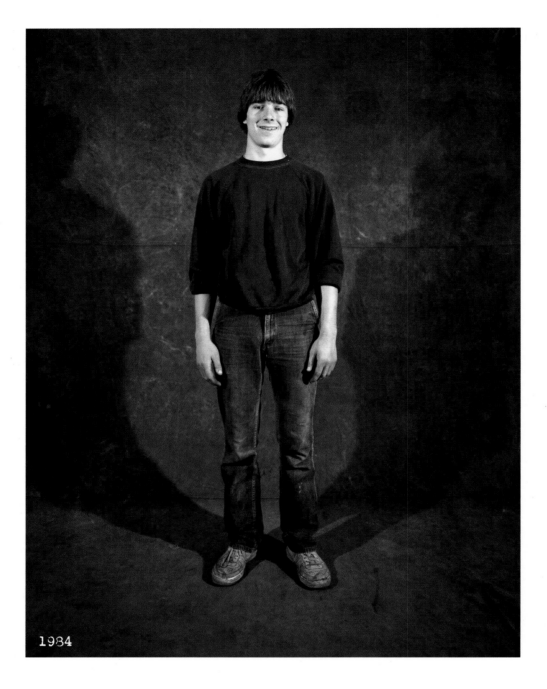

1984

JIM HENNES, JR.

JONELLE'S MY GIRLFRIEND. She's the town veterinarian. We've been going together for ten years. She was Mr. Potato Head at Slim's for the Halloween party. I haven't really thought about getting married. If it happens, it happens.

I'm on the Fire Department and I'm a First Responder. We had a trailer fire one winter. There must have been eight inches of snow that night, and the wind was blowing like crazy. The mother had gotten two children out, but there was still one inside. When we got in, we found the child on the bed. There was nothing we could do.

My mother was Patty Hackathorn's sister. She died of cancer when she was forty. I was sixteen.

I'm a Catholic, but I don't go to church regularly, unless you call showing up for Christmas regular.

I hate roller coasters, but last year I jumped out of an airplane. You free-fall for five seconds, then you glide like a bird.

Mike and Tim Hennes' brother **JIM HENNES, JR.** (b.1967)

198

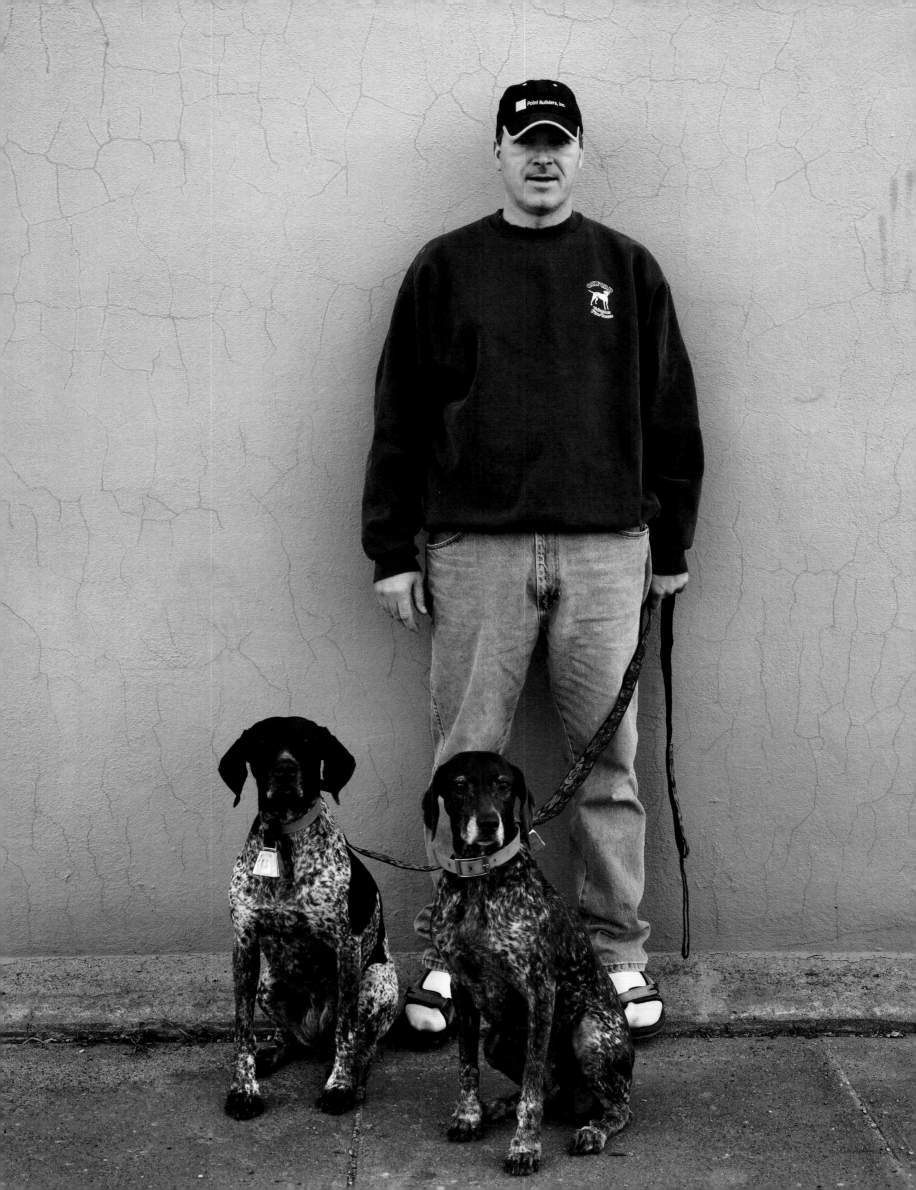

"We're kinda wild. We don't drive drunk,
but we do stop and have a beer or two.
I've never flashed."

—Patty Hackathorn

"I used to be scared that everyone close to me
was going to die."

PATTY HACKATHORN

MY MOM DIED FROM CANCER in 1982, and ten months after that, my sister died from cancer. My father died when I was twelve. I used to be scared that everyone close to me was going to die.

Kevin and I met in high school. His family had just moved to town. I thought he was really cute, but I was afraid to say anything to him. We went to a 4-H dance in the high school gym and danced to "Never My Love." I was fifteen and Kevin was sixteen.

I'd say only ten or fifteen percent of our graduating class went to college. If you could get a job with benefits, that was the thing. I got a job working at the bank in town. I could walk to work, come home for lunch, hang clothes on the line at noon. It was more than I could ask for.

Kevin always has had motorcycles. For my fiftieth birthday we went to Sturgis. This summer we're going to Colorado. Most of the people who ride with us are empty nesters. We're all down to earth and we look out for one another. We're kinda wild. We don't drive drunk, but we do stop and have a beer or two. I've never flashed.

I'm real big on family. We have two daughters. I think I'm the most boring person in the world because I've always lived here. We've talked about moving to Florida, but I think we'd miss the seasons. You're happy when spring comes 'round. And autumn, that's harvest. That's one of the best smells there is.

PATTY HACKATHORN (b.1952)

1984

PATTY HACKATHORN

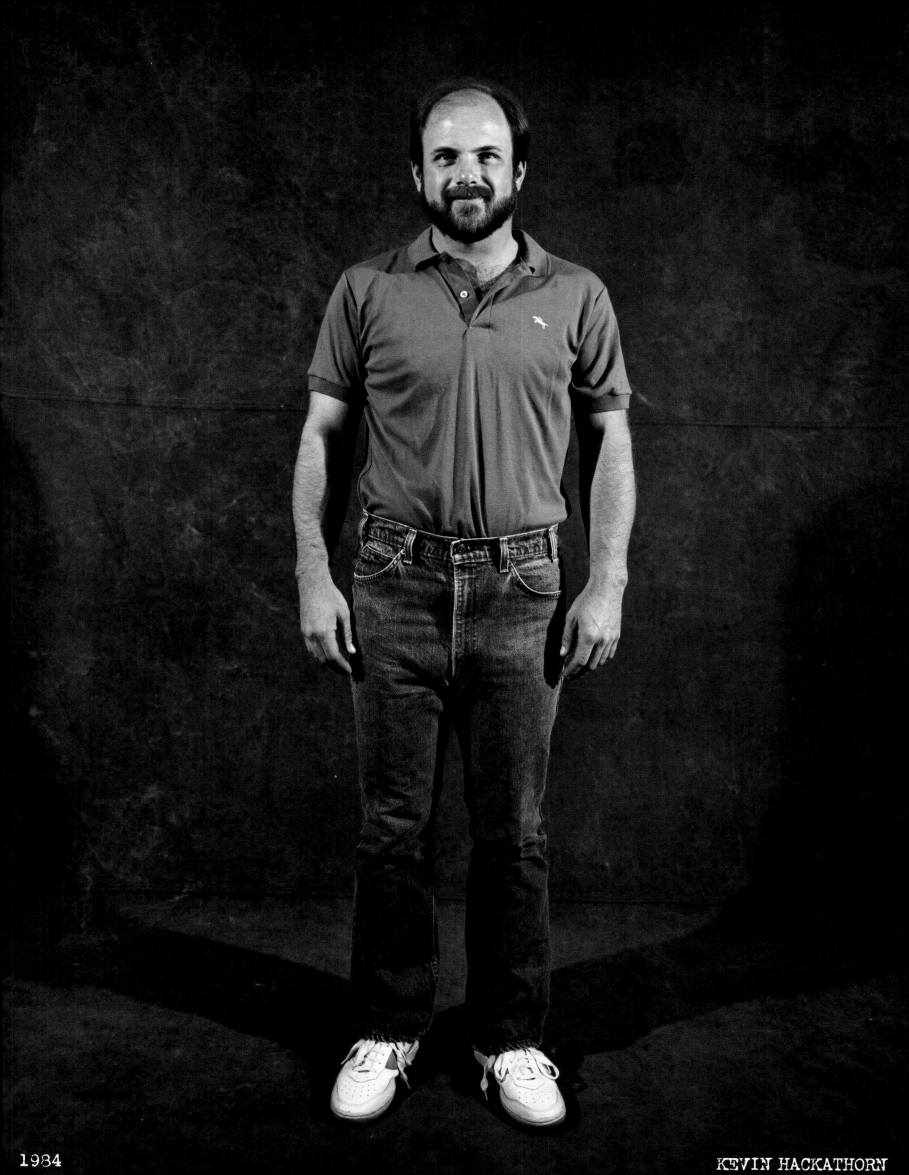

1984

KEVIN HACKATHORN

"I don't wear a helmet. I like the freedom. If you're involved in a bad accident, it's pretty much over anyway."

KEVIN HACKATHORN

I WAS THE CLASS BULLY. I got into a lot of fistfights and brawls. I didn't back away from anybody. I had an ornery streak. All the fights I picked were pretty well justified. You do that now and they'd send you to rehab.

Most everyone I knew drank homemade wine from their parents, or they took whiskey and put water in the bottle so their parents wouldn't find out.

For thirty-four years, I've worked with Johnson County Secondary Roads. I'm the maintenance supervisor—the guy at two a.m. driving around who decides to call out the snowplows.

I like my Harley. It's a Softail Classic. They run about $22,500. I don't wear a helmet. I like the freedom. If you're involved in a bad accident, it's pretty much over anyway. The only difference is an open or closed casket.

I have a great family. Patty's been fun. That's what's made it for me.

Patty's husband **KEVIN HACKATHORN** (b.1951)

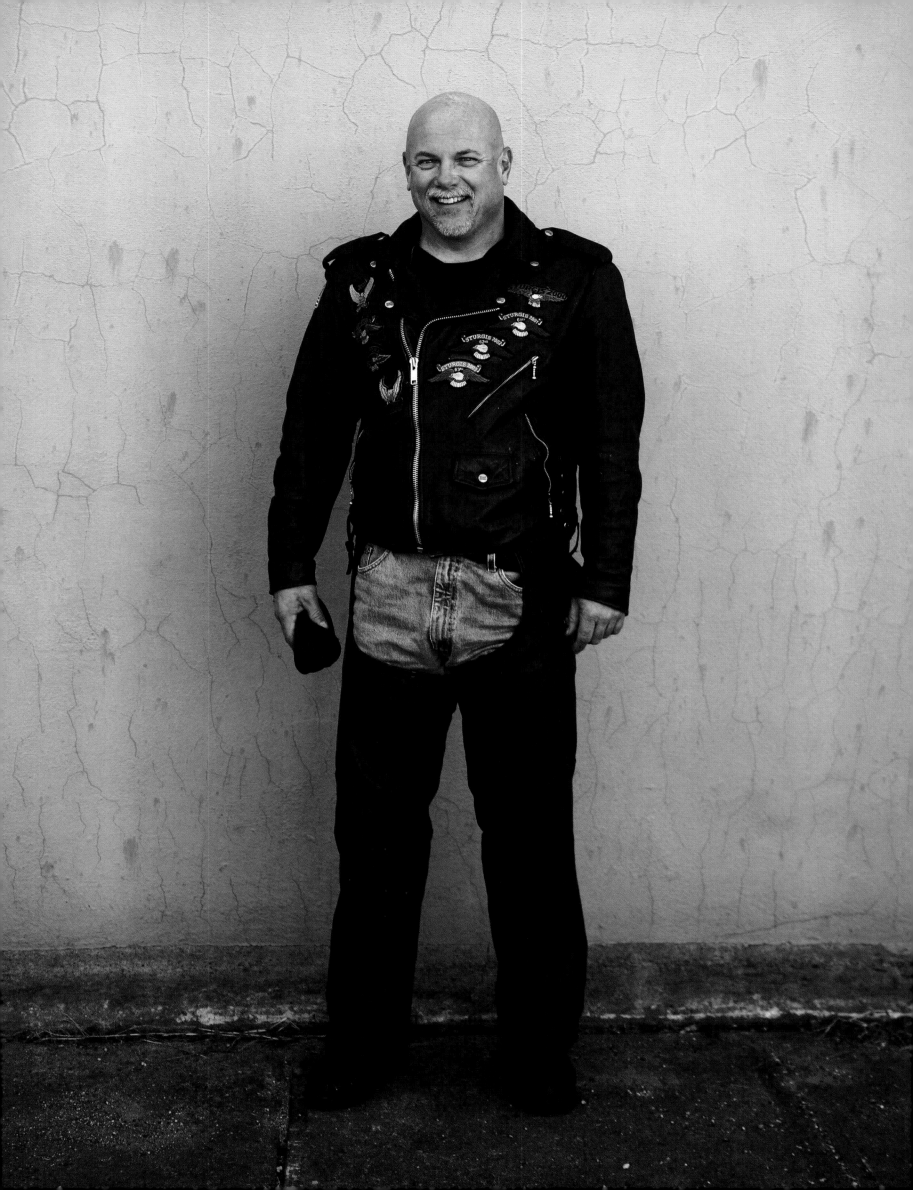

"I'm not a fan of traffic. I like the fresh air."

—Erin Hackathorn

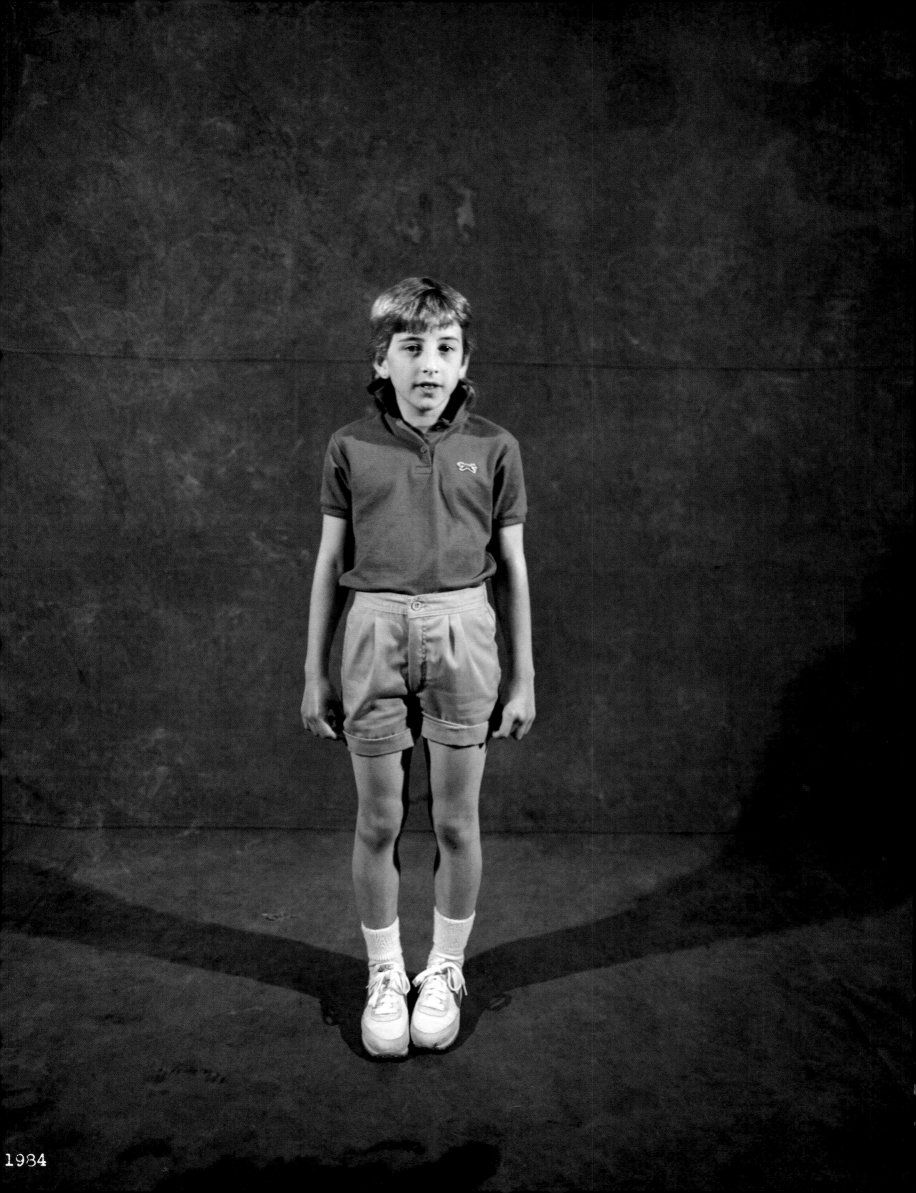

1934

ERIN HACKATHORN

I LIVED IN CHICAGO FOR A YEAR with my sister. I'm not a fan of traffic; it drove me nuts. The crime also made me feel uncomfortable. It was kinda scary. We missed our family.

I'd like to be married, but if it doesn't happen I won't be crushed. It's not one of my priorities. By the time I'm thirty-six or so, if I'm not married, I wouldn't mind adopting a child.

I haven't been out on a date for a year. I don't go to bars. I don't smoke. I like to hike and garden. I like the fresh air.

I was raised a Catholic, but I'm not religious. I have problems with all the strict rules. I'm really curious about Buddhism.

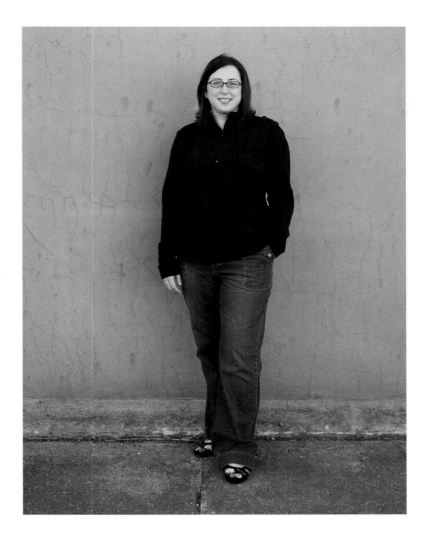

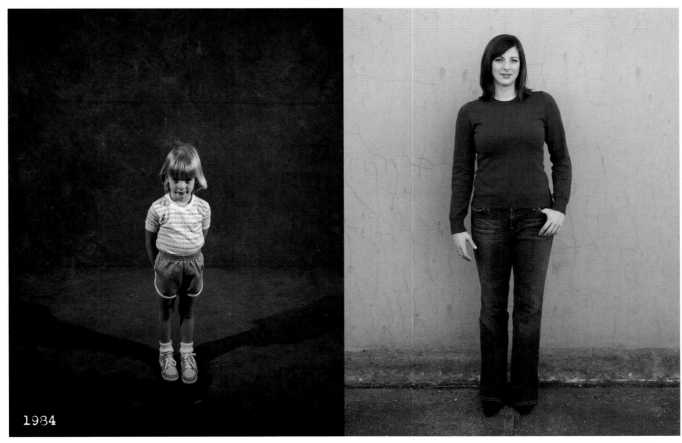

1984

Kelly Hackathorn

OPPOSITE AND TOP: Patty and Kevin Hackathorn's daughter **ERIN HACKATHORN** (b.1975) BOTTOM: Erin's sister **KELLY HACKATHORN** (b.1980)

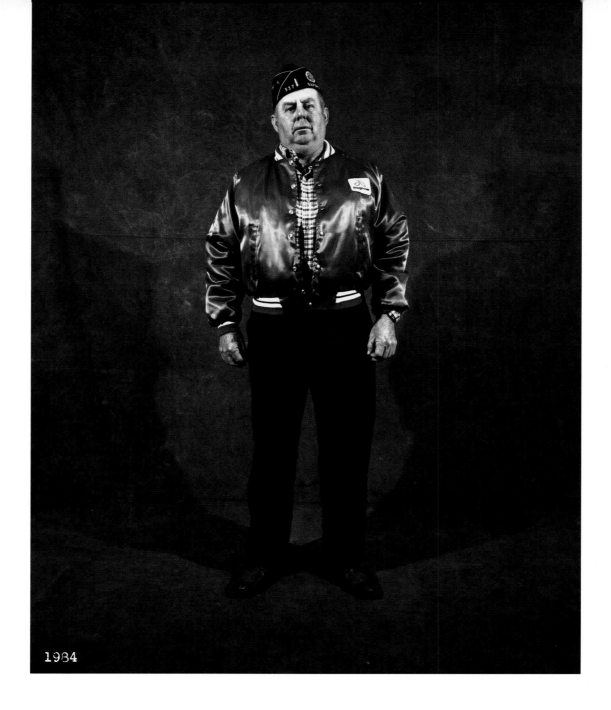

1934

"My top speed is between twenty-five and thirty
miles per hour, but I wouldn't go thirty unless
it was downhill and wide open."

LORIN "BUD" WOOD

THERE USED TO BE QUITE A FEW BUDS around town—Bud Miller, Bud Scheetz, Bud Cellman, Bud Zimmerman. But Bud Miller and I are the only ones still alive.

My father was the manager of the Singer Sewing Machine store in Grinnell, and then he ran the Singer store in Iowa City. You don't see many women sewing today.

Religion isn't that important to me. It's one of the things I don't do, but probably should. I've always thought you could be a religious person without going to church.

I have a Honda moped. My top speed is between twenty-five and thirty miles per hour, but I wouldn't go thirty unless it was downhill and wide open.

I'm taking a bus trip to Northern Minnesota in April. My wife's coming, too.

LORIN "BUD" WOOD (b.1926)

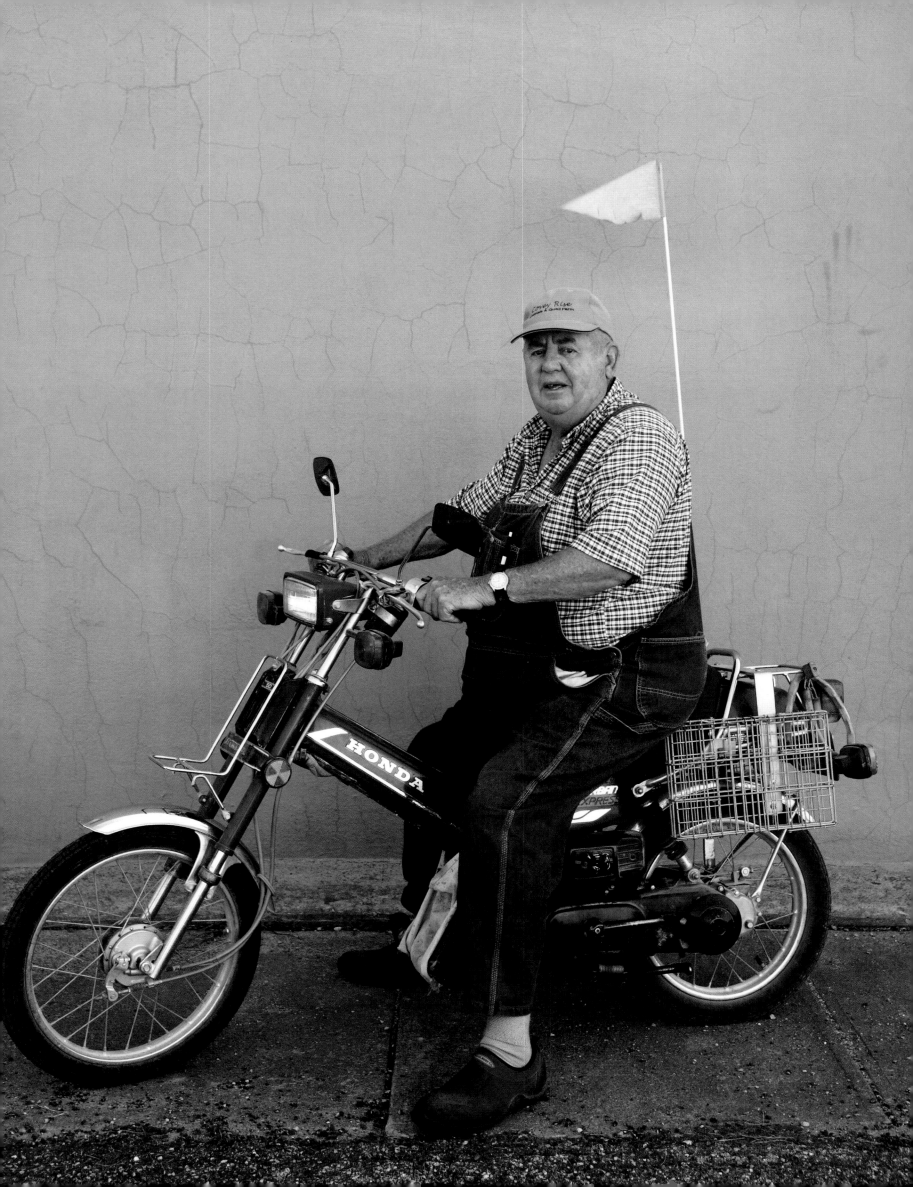

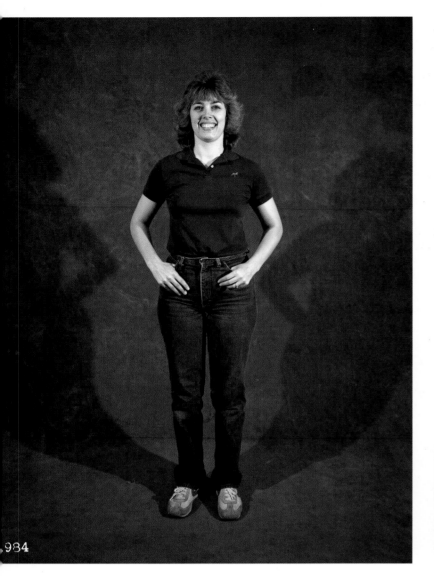

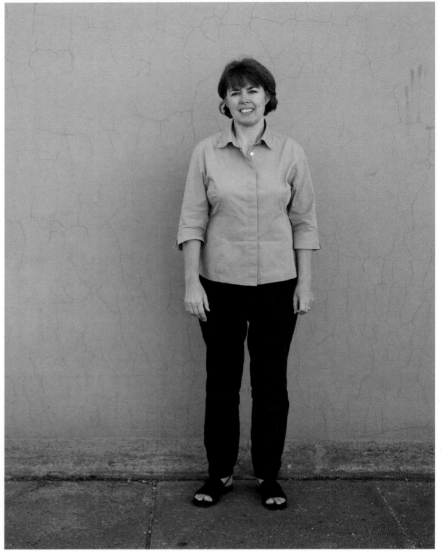

LYNETTE SCHEETZ

I WANTED TO GO TO COLLEGE, but I needed to get a job when I graduated from high school. I got hired as a secretary at Amana Refrigeration. That's where I met Tom. We have two boys.

I like small-town living. I feel safer here. You get to know so many people. You gain wisdom from seeing the ups and downs of the same people every day.

Life's been difficult. I grew up in a troubled home. My faith is very important. My biggest disappointment was not having faith back then. I used to be pretty stressed out. I was scared—not knowing what comes next.

Life is still difficult. But I have a better way to make choices now. I make decisions based on prayer, the Holy Spirit, Jesus, and God.

I'm no longer struggling with what I'm supposed to do next. I realize now that God's in control.

ABOVE: **LYNETTE SCHEETZ** (b.1954)
OPPOSITE, TOP: Lynette's husband **TOM SCHEETZ** (b.1952) OPPOSITE, BOTTOM: Lynette and Tom's son **DAVID SCHEETZ** (b.1981)

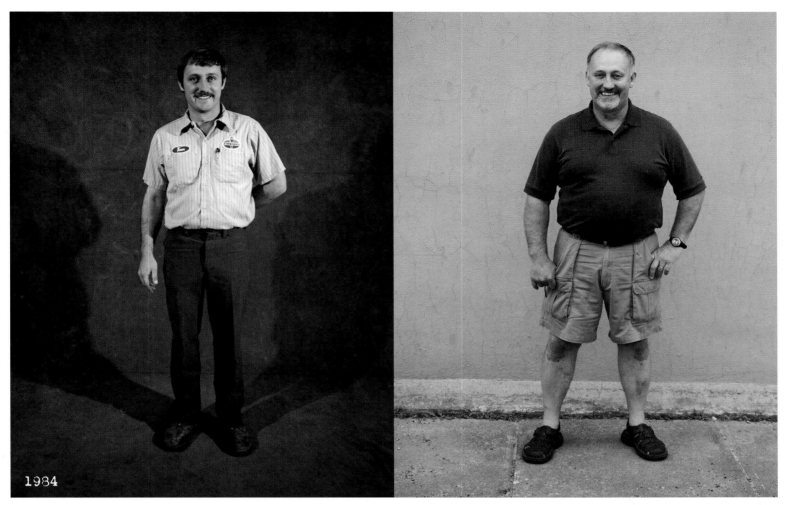

1984

Tom Scheetz

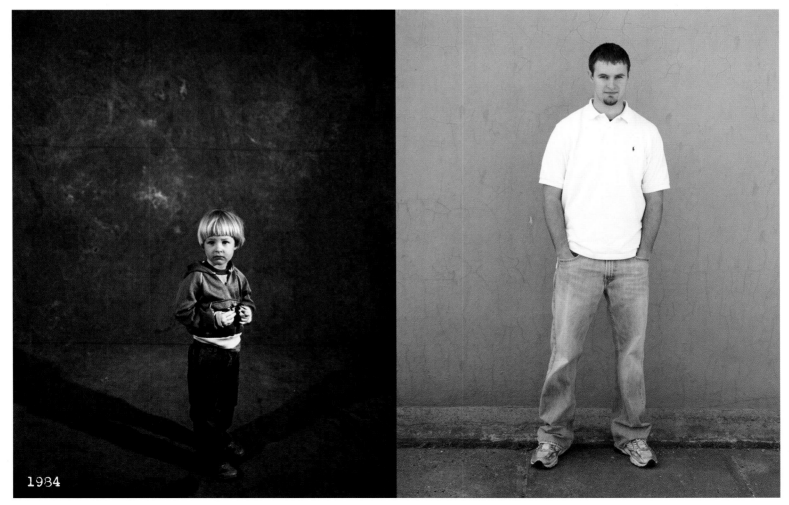

1984

David Scheetz

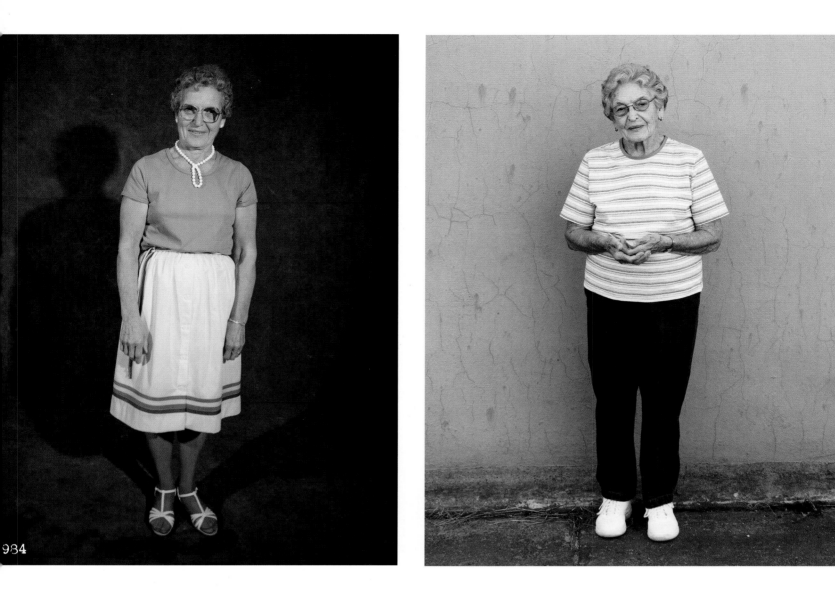

"I had never seen colored people before. I was almost afraid to open my mouth and say something wrong. I guess I'm not a good mixer."

LUCILLE STOCKMAN

I WORKED FOR ALL THREE GROCERY STORES in town—Homer and Irene Nunn's, First Mercantile, and Rohret's. I met my husband at a dance. He was in Pearl Harbor when it was bombed. His real name was Sylvester, but everyone called him Wimpy. They called him that because of the character in the cartoons.

After the war, we moved to Philadelphia. I didn't feel safe there. If he wasn't home, I'd stay indoors. To walk on the streets alone, I just wouldn't do it. We went to a boxing match once, and I had never seen colored people before.

I was almost afraid to open my mouth and say something wrong. I guess I'm not a good mixer.

My six children all live around here, except one who lives in Denver. My youngest, Deb, lives with me. We do a lot of gardening together. We grow radishes, onions, lettuce, cucumbers, tomatoes.

Wimp would bathe the kids at night. He loved to cook and garden. He died of a heart attack on July Fourth in 1982. He was, and still is, the love of my life.

LUCILLE STOCKMAN (b.1923)

216

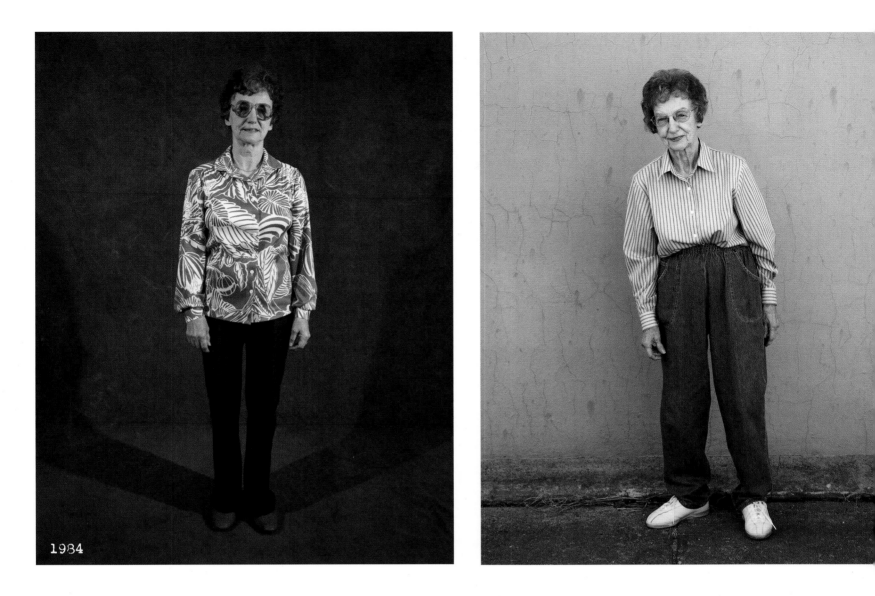

1984

"My four grandparents were born in Ireland. I think the Irish are good people. I'm not of mixed race. I'm one-hundred-percent Irish."

MARGUERITE STOCKMAN

I USED TO GET TO SCHOOL IN A HACK—a covered wagon. If it was cold, my mother would put a brick in the oven the night before, and in the morning she'd wrap it in newspaper to keep me warm during the ride.

I met my husband Tuck when I was fourteen. He was the hired man. I made a chocolate cream pie, but it was runny. He liked it anyway.

One night, our son Rick was in the east field, husking. He was using headlights from his tractor for light. The cornhusks got caught in the picker and he reached in and got one of his hands stuck. Then he reached in with the other and that hand got caught. He stayed there overnight. In the morning, a neighbor boy ran across the field and found him. They took him to the hospital and removed both his hands at mid-forearm. He still has his elbows.

I used to make cinnamon rolls every Saturday morning. I grew potatoes until last year.

My four grandparents were born in Ireland. I think the Irish are good people. I'm not of mixed race. I'm one-hundred-percent Irish.

The most I've ever weighed is 130 pounds. I feel sorry for people who can't lose weight. I can't ever gain any.

Lucille's sister-in-law **MARGUERITE STOCKMAN** (b. 1921)

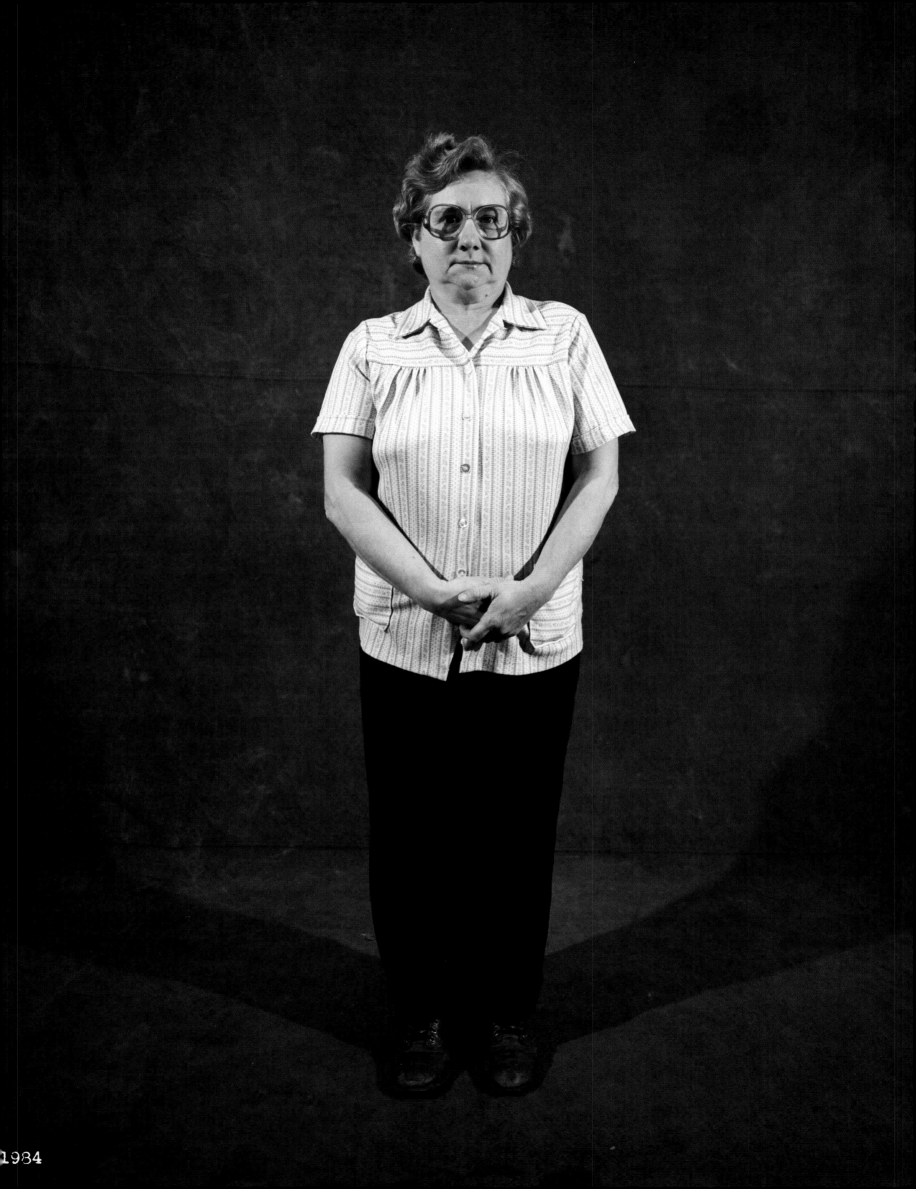

1934

> "I don't like crowds.
> It's hard for me to
> converse with people."

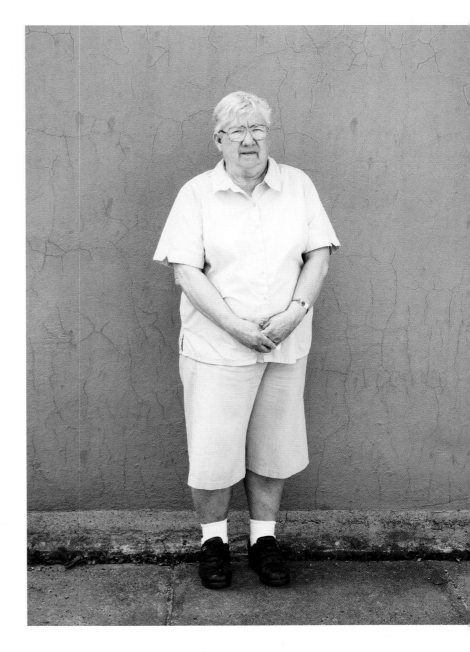

DELORES BOOTH

I WORKED AT THE UNIVERSITY LAUNDRY for twenty-nine years. When I retired, I got diagnosed with type 2 diabetes, and I've slowly been going downhill.

My oldest brother died a week ago. He had a stroke. At the funeral, my youngest brother told me that these are supposed to be the golden years, but I don't see much golden about 'em.

I don't like crowds. My mother and father never taught me how to socialize. It's hard for me to converse with people.

My husband was hauling freight and I was working as a waitress at the Palace Cafe in Vinton when we met. I think he ordered a bowl of soup, but I'm not sure. He had just got out of the Army in 1948, and I had just graduated from high school. He poured it on. He walked in and says, "Where have you been for all my life?"

We only went together for three months, and then we got married. My parents were shook up. I was eighteen and he was thirty. We had six children—three girls first, then three boys.

I'm a terrible housekeeper. I like to read, mostly pioneer stories, *The Oregon Trail*, Louis L'Amour, westerns. In the evenings I watch TV. My favorite dish is goulash and navy bean soup.

Big cities don't impress me. I've been to New Mexico and Wisconsin. I've been to Illinois a time or two, and I've been to Nebraska. One state I don't care ever to go to is California. I can do without earthquakes. New York is another state that doesn't impress me. Who wants a city with bombs being dropped on it?

I'm a Mormon. Two missionaries came by my house. It was in the middle of the week. Joe was jumping up and down in his crib and I was scrubbing the kitchen floor. They convinced me I could pull myself up by my bootstraps. It took about six months to convert.

We lived in the most ragged house in town. People weren't the nicest to us because we were Mormons or poor. I'm not sure which.

Everyone has his own opinion, I suppose.

DELORES BOOTH (b.1931)

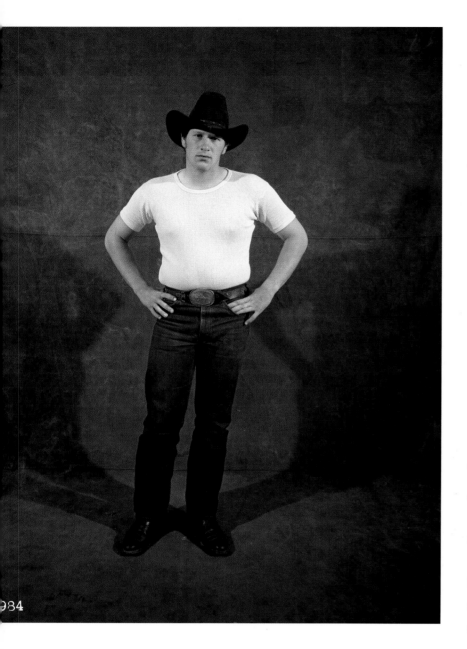

984

"It's like a chicken riding a windmill. You just let her go and hang on for dear life."

had knee surgery. Once I got bucked right out of the arena. You gotta have a strong right arm and a sense of balance. And you gotta want to do it. You gotta be rodeo-smart, too. I seen guys spend all their money on pints of whiskey, steaks every night, craps and poker.

If you're worried about gettin' hurt, then you better stay home. If it was easy, then girls and young children would do it. It's like a chicken riding a windmill. You just let her go and hang on for dear life.

I never liked riding bulls. I've been run over by 'em and I've been hit by 'em. With bulls you have less of a distance to fall, but with horses, they don't come back looking for you. Dick Moore said it best: Bulls are meant to be eaten, not ridden.

In 2001, I made $22,000, but I was paying for my own gas, food, motels, entry fees. There wasn't much left over. I was good enough to win around here, but not in Cheyenne or Calgary. In 2002, it was time to call it quits. I was thirty-eight, and I was tired. It got to be sorta like jump-starting a car in the morning.

These days, I deliver doors and windows for a lumberyard. I'm a delivery-truck driver.

JOE BOOTH

WHEN I WAS THIRTEEN, my mom, dad, and me drove to a rodeo on Highway 151. It cost me six dollars to ride, and I was hooked.

Hooter Brown, Joe Marvel, Marty Wood (an Indian from Utah), Money Hawkeye Henson, Red Lemmel—these guys were the guys I wanted to be when I grew up.

In 1984, I was in the top ten in the United Rodeo Association in the Bareback Riding category. Jo-Jo Booth was what they called me.

I had a horse kick me in the face. I had my front tooth knocked out. I broke my nose, busted my sternum, and

Dolores Booth's son **JOE BOOTH** (b. 1962)

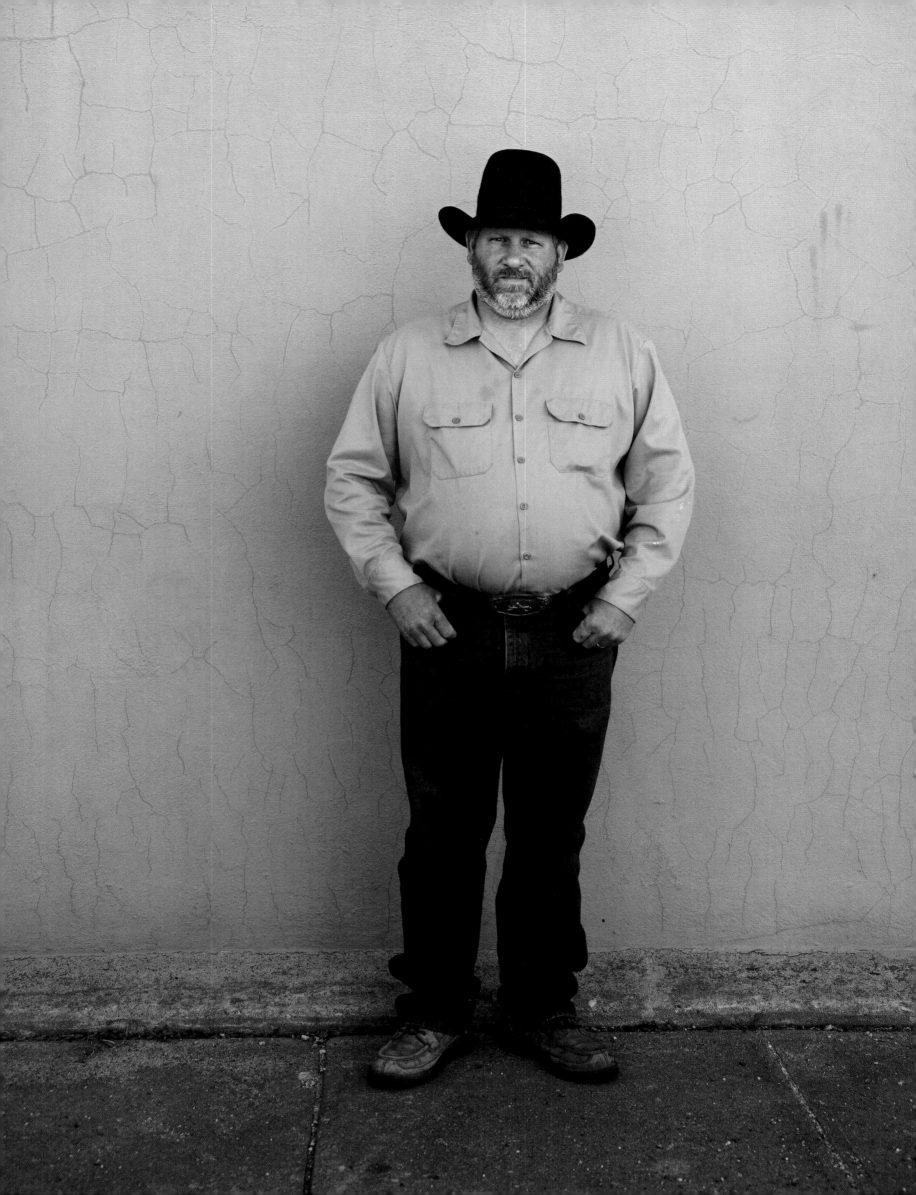

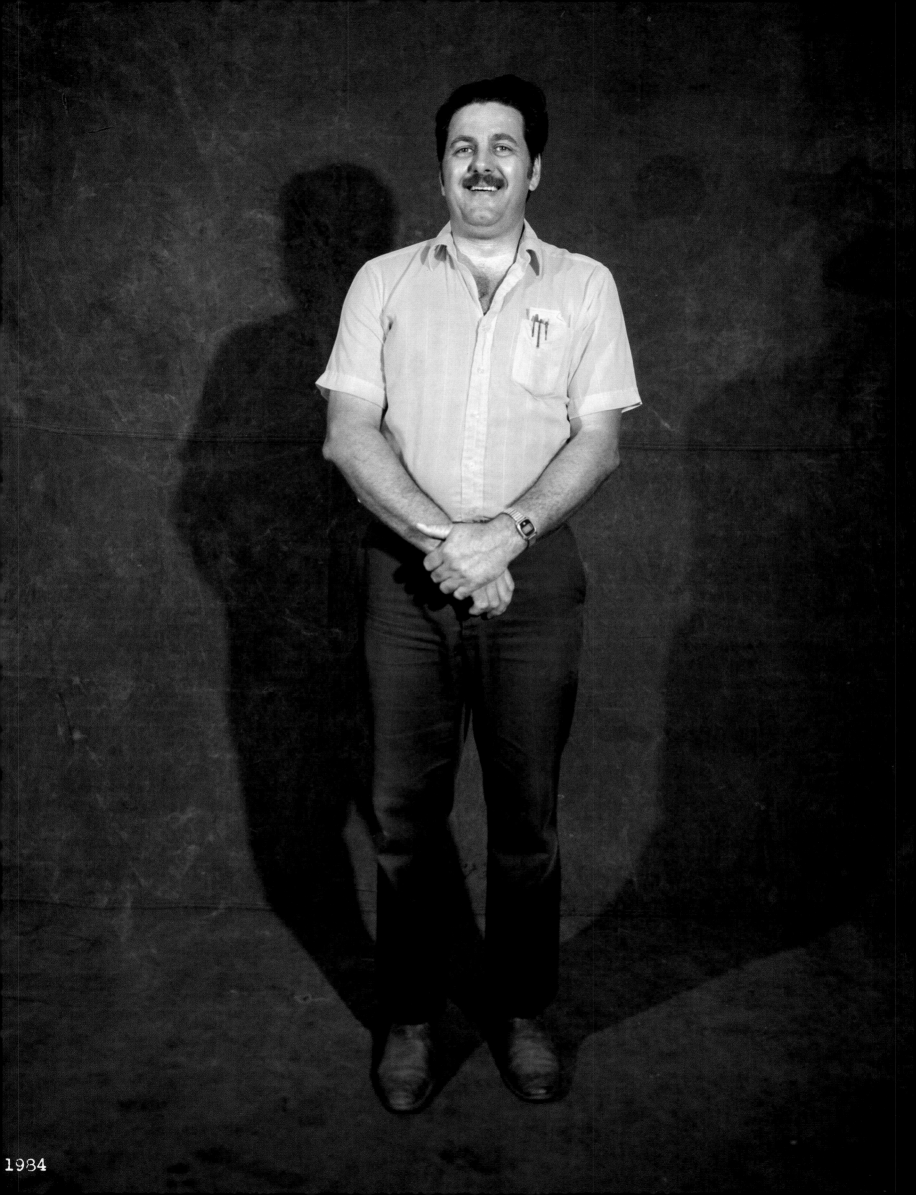

1984

"I don't bounce like I used to."

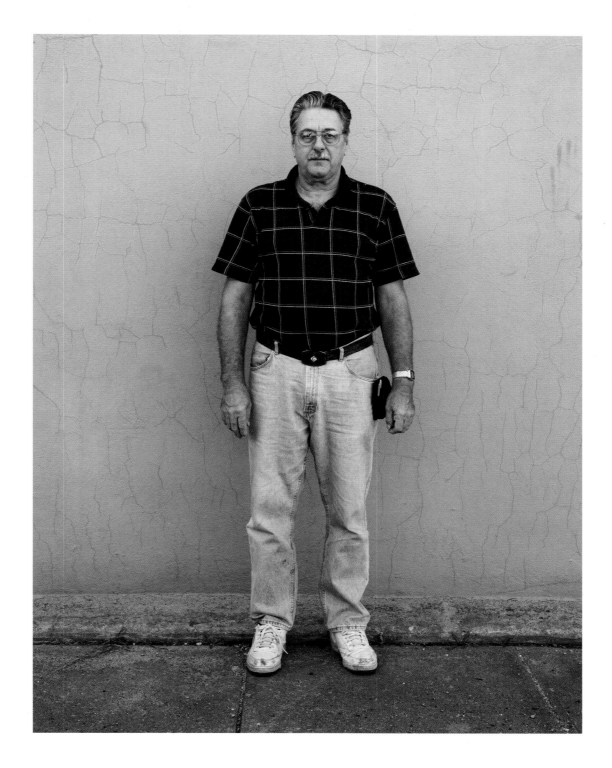

HARRY DOLDER

I'VE HAD A HEART ATTACK, triple bypass, and diabetes. I've got a lot more aches than I used to.

I used to service TVs, now I install TV dishes. I love what I do. You're in the fresh air. If it's a flat roof, that's not a problem. But a two-story house or a three-story apartment building, no thank you. I don't bounce like I used to.

We live on top of the shop, next to the Legion Hall. Sometimes they get a band or a DJ, open the door, and entertain the whole neighborhood. I've had to call the sheriff a few times. On some mornings, cars are still parked in front. They belong to people too drunk to drive or to the ones who got lucky.

HARRY DOLDER (b.1939)

> "I love being on the move. My mom and I just got back from a seven-week car vacation."

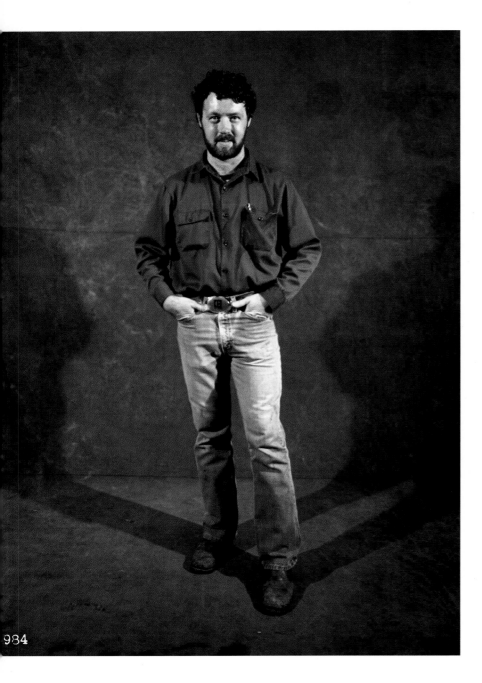

984

LOCKE BEARD

WHEN I WAS A KID, we'd drive to Cedar Rapids, and I'd always wonder where Highway 151 would take me.

As soon as I could, I started driving semis. I must've put on close to two million miles.

I love being on the move. My mom and I just got back from a seven-week car vacation. We went everywhere—Florida, Texas, Arizona, California. We put 9,562 miles on my car. I've done fourteen sea cruises. I've been to Colombia, Panama, and Mexico.

We come into this world with nothing and we leave with nothing. I want to live life to its fullest.

These days, I'm driving a truck for Consumer's Co-Op, doing errands, spreading fertilizer, whatever comes up. I have a 1973 two-door Impala. I cut the roof off and made a convertible out of it.

I've never been married. I've always been close to my folks and to my brother and sister. I guess I'm a little gun shy. I've had so many friends who got divorced, I always wanted to make sure.

I've had the same girlfriend for two years. I was waiting tables at the Brick Haus in Amana, and she came in with a neighbor lady. I looked at her and asked, "Aren't you a Stratton?"

I asked her if she was married, and she said, "Divorced." So I scribbled down my name on a piece of paper and said, "Call me in the off-season."

And she did.

LOCKE BEARD (b.1960)

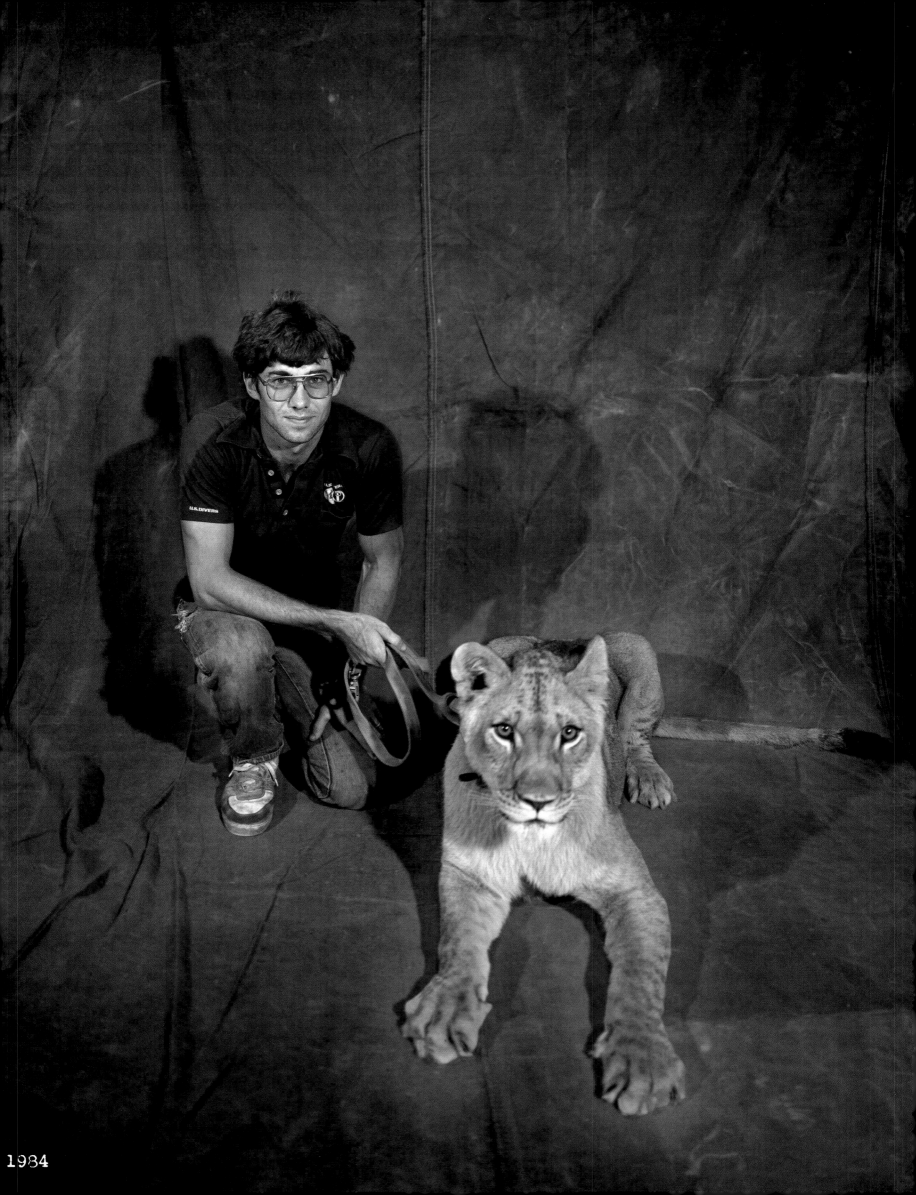

1984

"I've had maybe thirteen lions over the years.
You can train 'em, but you can never tame 'em."

CALVIN COLONY

I'M A PLUMBER, but I'm also a diver for the county. I dive for drowning victims, hunting accidents, snowmobiles that go through the ice. It's black down there and you're crawling through logs. I've probably pulled out twenty bodies since '73.

I've had maybe thirteen lions over the years. You can train 'em, but you can never tame 'em. You can't trust 'em around children. They're like cats around mice. They'll kill a dog pretty quick. I used to feed 'em road-kill deer.

I fly gyrocopters. They're a lot of fun. I also fly a World War II photo reconnaissance plane. It's dark green and still has D-Day invasion stripes on it.

For the last six years, I've been going to a resort in Jamaica called Hedonism. On one beach, you have to have your bottoms on. On the other beach, you can't lay out unless you're naked. You'll see people having sex if you stay around long enough. All the alcohol you want is included in the price. It's a good time. You don't have to take many clothes.

CALVIN COLONY (b.1956)

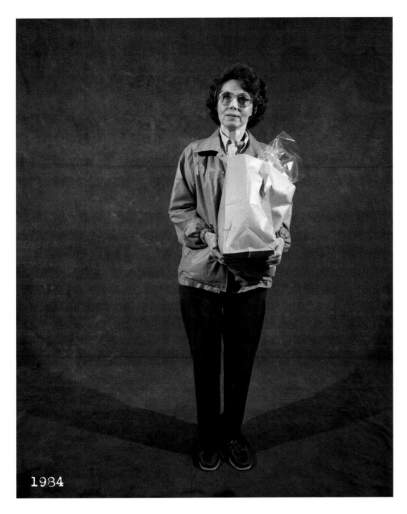

1984

"After forty-five years of marriage, he left me for another woman. I didn't know who the woman was, but everyone else in town did."

PAT HENKELMAN

I GET UP AT FIVE A.M. My son—he works as a prison guard—stops by for breakfast every morning. He usually wants Cream of Wheat or oatmeal. Then I say my morning prayers, take a bath, and eat breakfast. After that, I clean houses. I come home and have lunch, usually a sandwich and a cup of green tea. I watch TV, usually CNN. Sometimes I take a nap.

In 1940, Harry and I were working at a bee factory in Harlan, and when I came back from lunch one day, he was filling my jars. That night we met at the county fair and had our picture taken, and that was that.

In 1985, after forty-five years of marriage, he left me for another woman. I didn't know who the woman was, but everyone else in town did. I would have felt better if she was young and beautiful, but she wasn't. They used to play euchre at the Legion Hall. My faith helped me get through. I don't have malice or anger. You have to forgive. For a while I thought I hated him. But that stopped.

Jesus died to suffer for our sins, but you're still responsible for the sins you commit.

I think the instant you die, you step out of your body. You have to be perfect to go to heaven—like Mother Teresa— but almost everyone else goes to purgatory.

There used to be a hat store in town. I wish it still was here. I love hats.

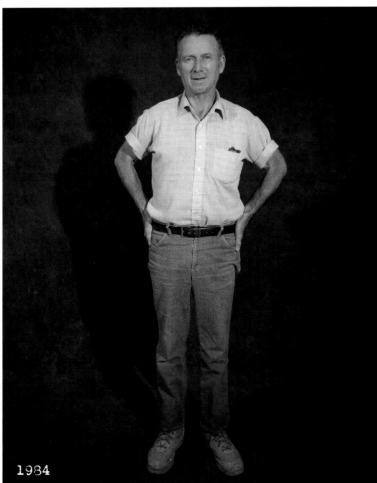

1984

Harry Henkelman

TOP AND OPPOSITE: **PAT HENKELMAN** (b.1929) BOTTOM: Pat's former husband **HARRY HENKELMAN** (1927–1990)

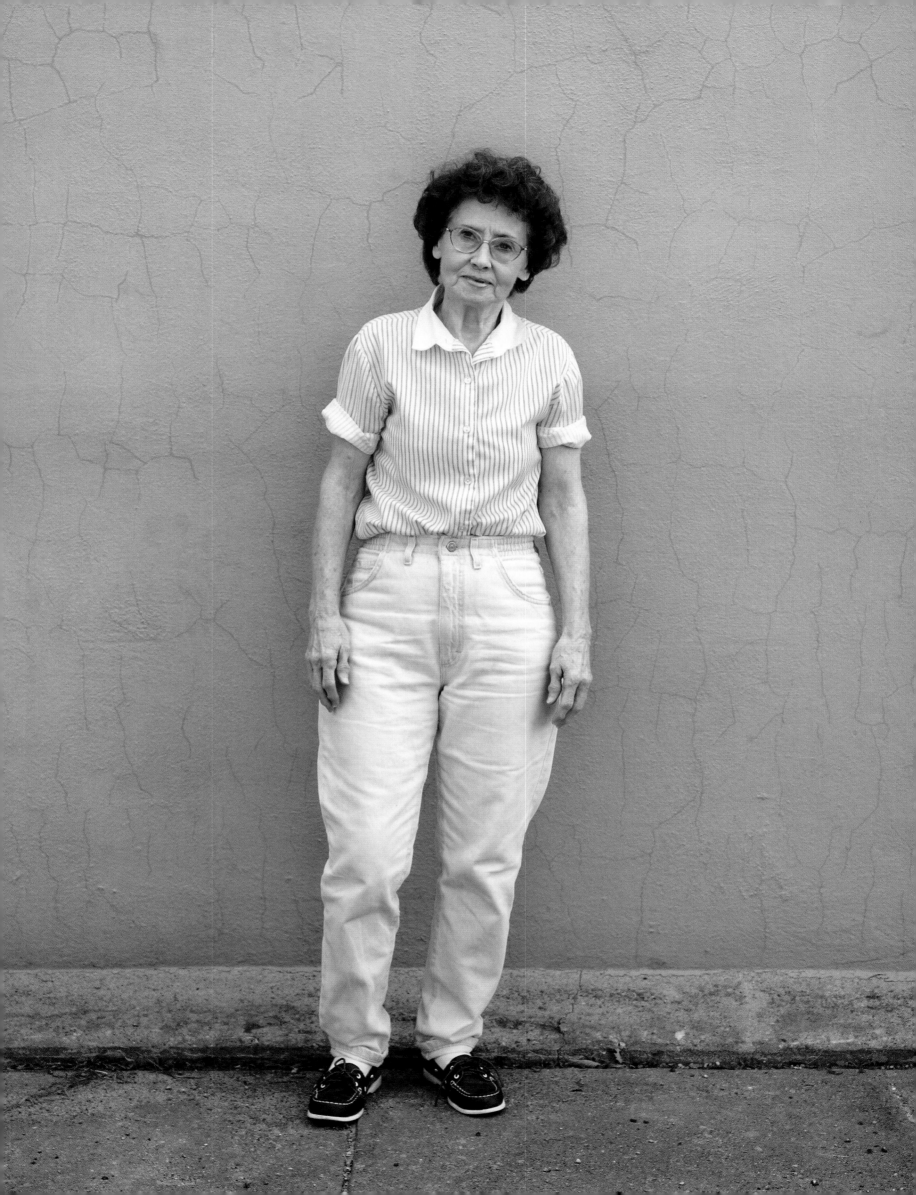

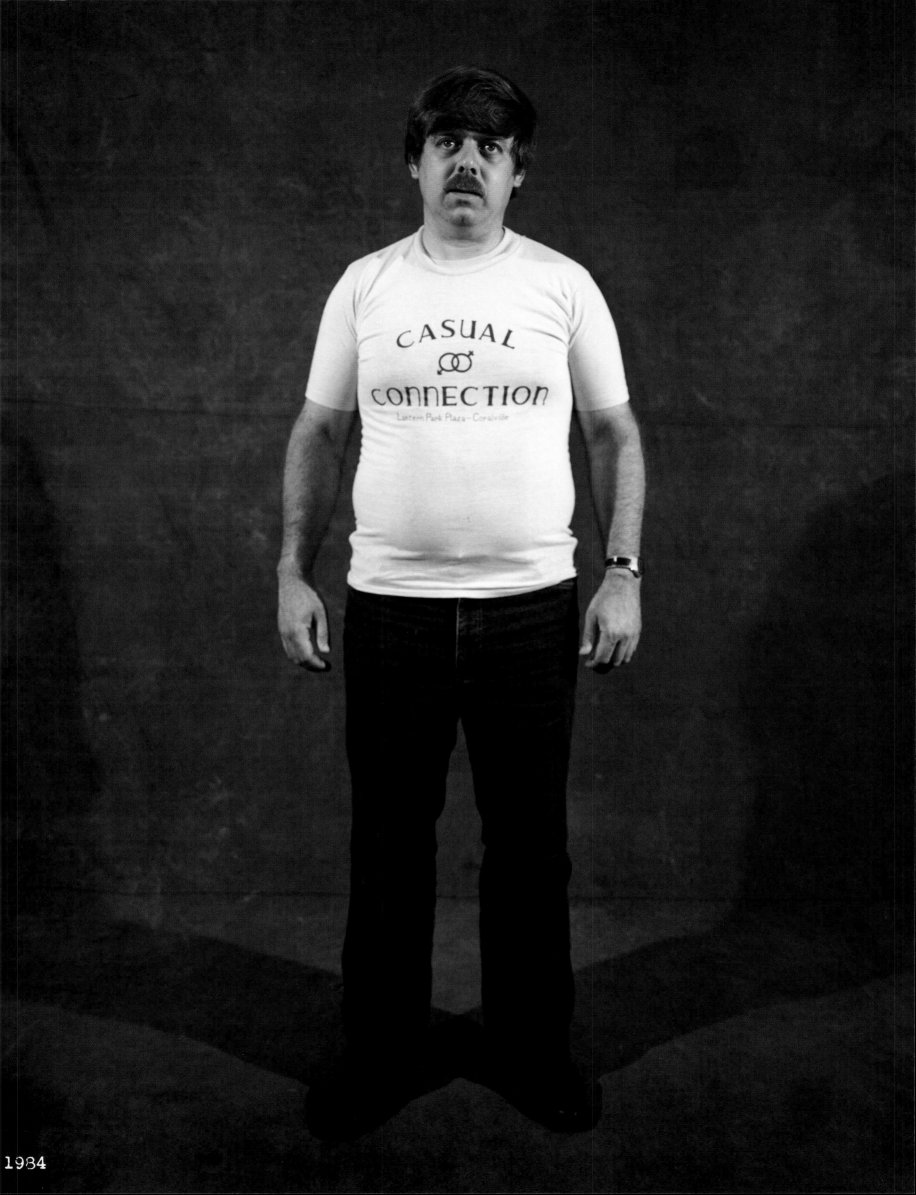

1984

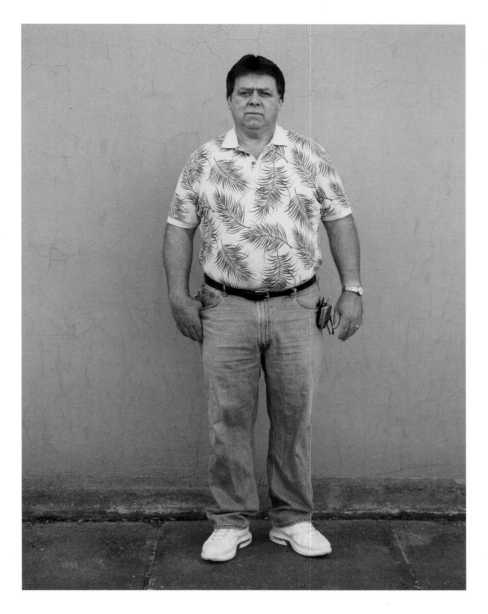

"My wife and I collect Aladdin lamps and sell them on eBay. We belong to a group called the Aladdinites."

STEVE HENKELMAN

I'VE WORKED FOR THE PRISON SINCE 1984. I go with prisoners for their hospital trips. I have to sit with them when they get enemas. We had a guy swallow a Bic lighter once. I don't know how he did it. They had to pull it out with a wire.

I've never been hit, but I've been spit at. I haven't had urine or feces hit me, but I've had it thrown at me.

We've had inmates in the same family—mom, dad, brothers, and sisters. We have a lot of lifers. They're the best inmates. They want their time to be as easy as possible. I get to know some of them. They're not all bad, but they've made some bad mistakes.

I leave for work at six thirty in the morning, but mom still makes breakfast for me. I go over to her house and she cooks oatmeal once or twice a week. She says it's good for my cholesterol.

My wife and I raise English bulldogs. We've got twelve. We also collect Aladdin lamps and sell them on eBay. We probably have three hundred. We belong to a group called the Aladdinites.

Pat and Harry Henkelman's son **STEVE HENKELMAN** (b.1950)

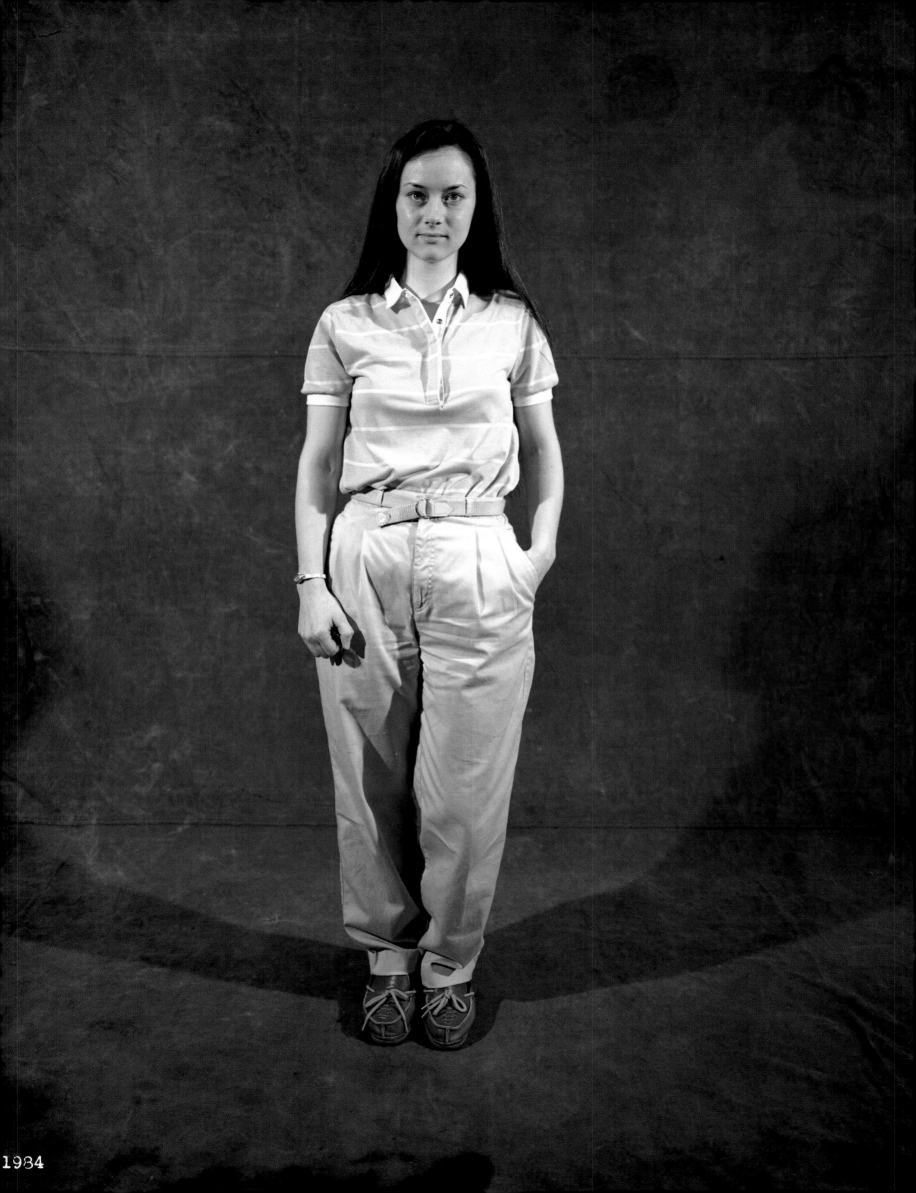

1934

"If I see a pair of shoes I like, I buy
them in every color. My motto should be,
'See it, love it, buy it.'"

THERESE (HENKELMAN) SCHEBLER

I NEVER GOT A SPANKING. I was the kind of kid my
mother never had to worry about. I used to dream about
living on the top floor of a high-rise in a big city, looking out
at the bright lights.

My first husband and I met at a bar. He bought me a
drink, and when I asked the bartender who paid for it, he
pointed to a guy walking into the men's room. So I followed
him there. We knew each other four months. The marriage
lasted four years. Emotionally I was a wreck, and I moved
back with my parents.

I met Joe where I work. We'd see each other in
the cafeteria, but we'd never talk. I tried to start up a
conversation, but he just didn't get it. I found out he was
from Davenport, so I went up to him and said that I'd really
like to go on one of those riverboat cruises. Three years
later, we got married.

I go to church every Sunday. I haven't missed a Sunday
since I made my first Communion. I usually pray before I go
to bed.

Everything that's important to me is here—my mother,
my daughter, my husband, my family. My sister and I go to
a euchre tournament every Monday night.

If I see a pair of shoes I like, I buy them in every color.
I started collecting chickens a couple of years ago. Not the
real thing, but plates, paintings, figurines. Anything to do
with chickens I've gotta have. My motto should be, "See it,
love it, buy it."

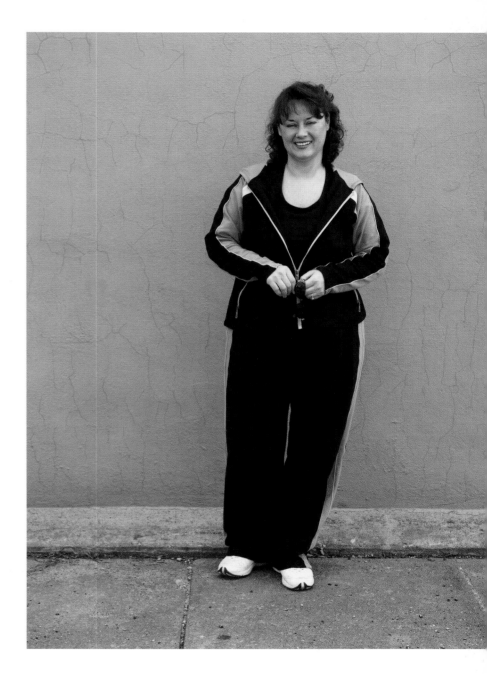

Steve Henkelman's sister **THERESE (HENKELMAN) SCHEBLER** (b.1958)

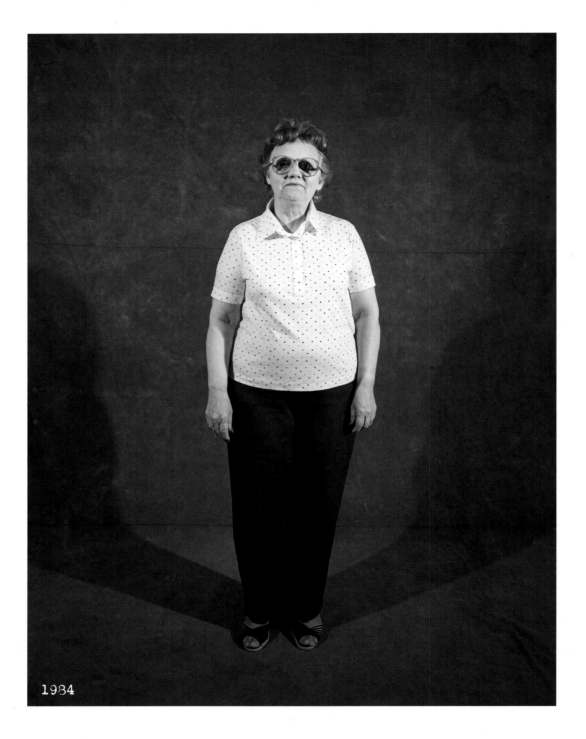

1984

"I think my husband's drinking made us stronger."

VIRGINIA SCHEETZ

I PLAY THE ORGAN. I'm not the best player in the world, but I enjoy it.

My husband was an alcoholic. He had every intention of quitting. He tried, and I had hopes he'd succeed. Once he went to Oakdale where they treated alcoholics, and he came home drunk. His roommate had a car with bottles of alcohol in the backseat.

I thought of leaving lots of times, but what was I going to do with four kids and no money?

It was rough sledding. At one time, I had five jobs.

I'm content now. I'm happy that the kids are successful. I have ten grandchildren and fifteen great-grandchildren. My mother is ninety-eight. We have five generations.

I think my husband's drinking made us stronger.

VIRGINIA SCHEETZ (b.1926)

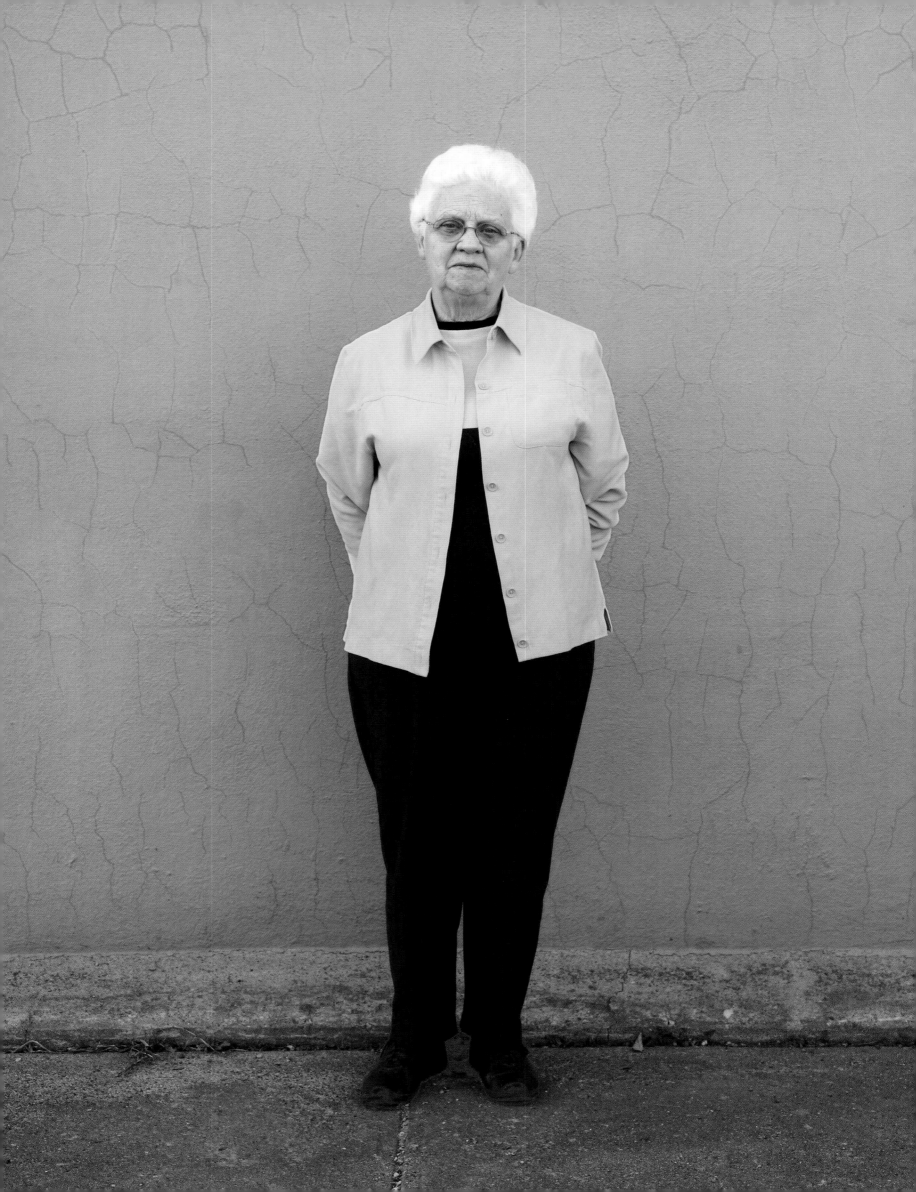

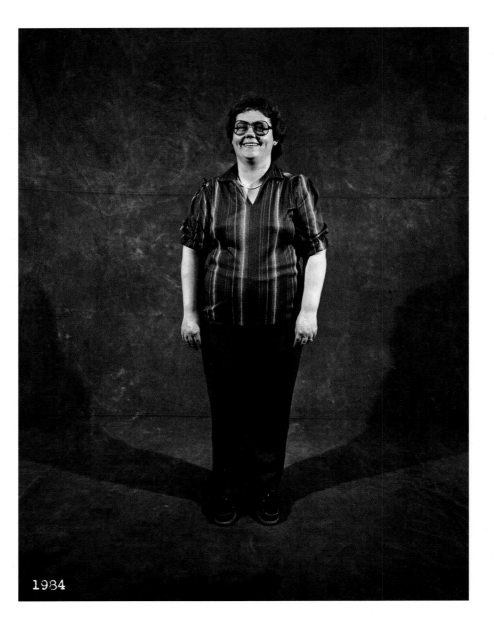

1984

"My prom dress was pink with sequins and straps.
I borrowed it from Judy Henderson."

MARY SUE JIRAS

AS A LITTLE GIRL, I remember playing outside on a blanket with my dolls. We had a pony named Buck.

Growing up, we didn't know we were poor. We ate a lot of potatoes and eggs. I remember our family not having enough money to buy coal to heat the furnace. We used to take baths in a galvanized tub in the kitchen. At night, we tried to stay warm under the blankets.

My father was an alcoholic. He used to drink morning to night. He drank little bottles of Falstaff beer. I can still see him standing at the kitchen sink, looking out the window, smoking a cigarette, and talking to himself. He wasn't a mean drunk. He had an illness, and he didn't want

to be cured. My mother held down two jobs and raised us four kids. He died in his sleep when he was fifty-five.

I met Jim when I was laying on the grass outside the high school. All the freshman had to bow to the seniors, and Jim was standing behind me. He asked me to the senior prom and I was only a freshman. My prom dress was pink with sequins and straps. I borrowed it from Judy Henderson.

Jim insisted that I stay home until the kids were in school. I now work for the county health department. My one regret is not going to college. My dream was to get married and have a family. Girls just didn't go to college then.

Virginia Scheetz's daughter **MARY SUE JIRAS** (b.1945)

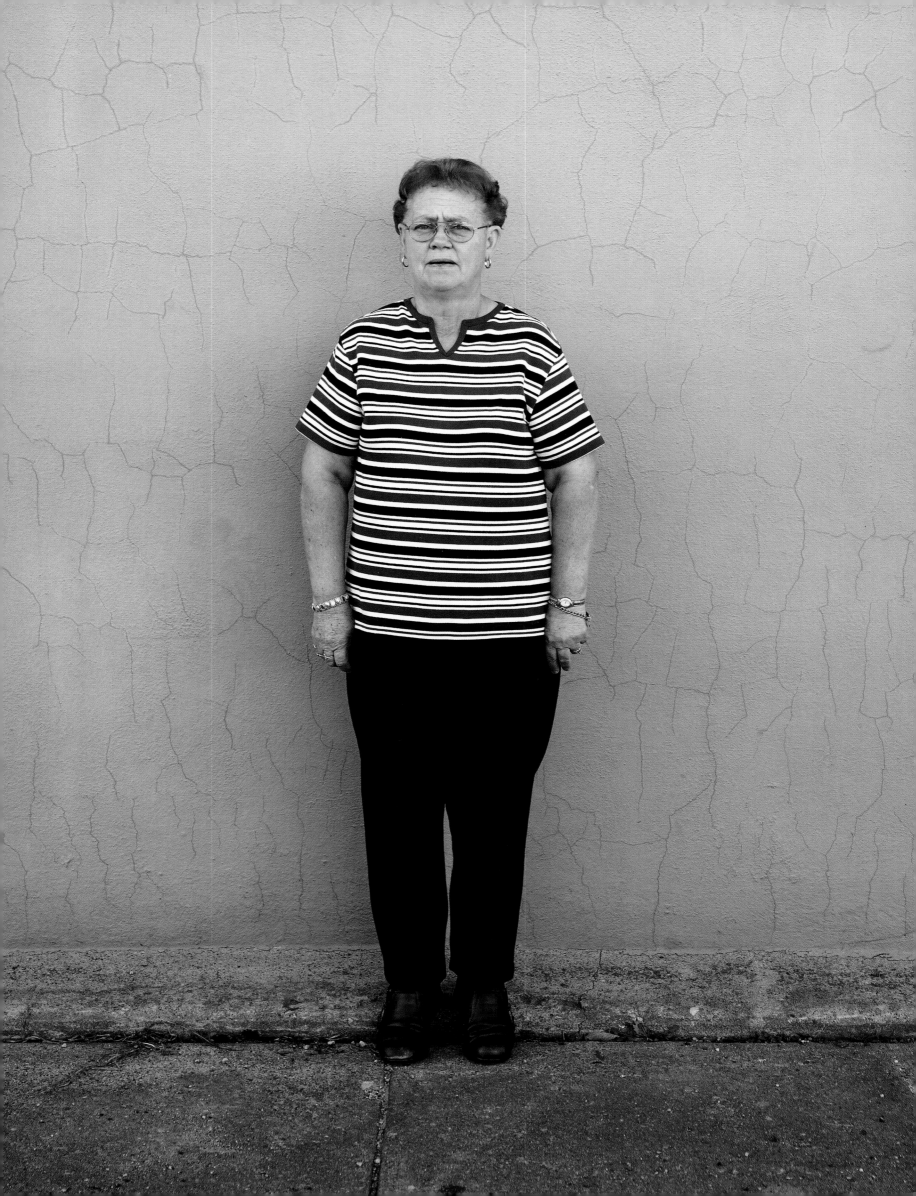

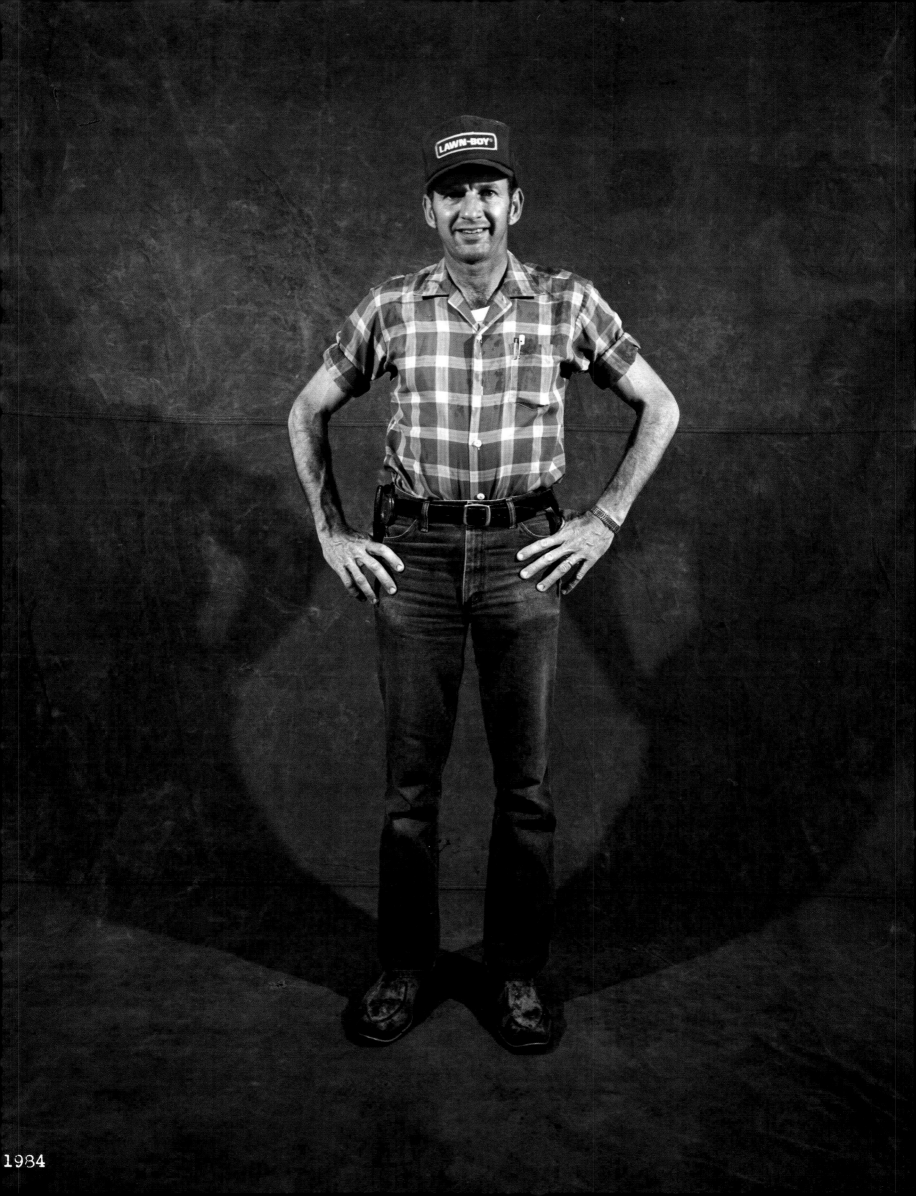

1984

"I met Mary Sue in high school. We'd go ice-skating on ponds and sleigh-riding at the farm."

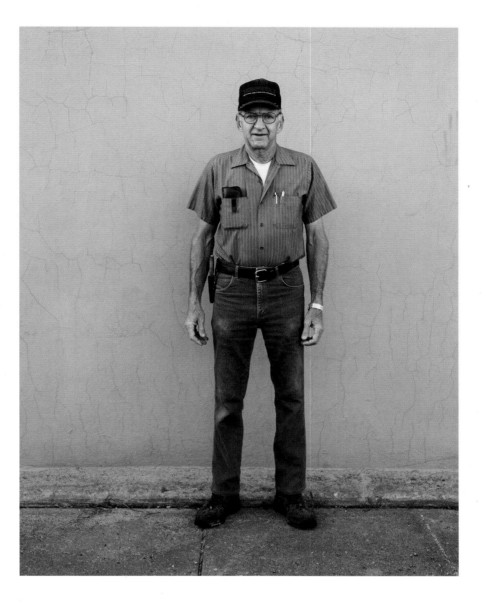

JIM JIRAS

I DON'T CARE FOR TORNADOES. Back in 2001, I saw one coming over the hill from Dick Stockman's farm. It was sixty or a hundred feet off the ground; a perfect funnel, black and twisting. It was twenty feet away and coming right towards me. I almost didn't make it.

My father was a farmer. He died when I was eleven. My intention was to stay on the farm. But I liked to build things, so I became a carpenter.

I can't go anywhere without my pliers, magnetic screwdriver, nail punch, and pocketknife, which has gotta have a sliver digger for splinters.

I met Mary Sue in high school. She was a freshman, I was a senior. She asked me to her junior prom and we started dating. We'd go ice-skating on ponds and sleigh-riding at the farm.

My first car was a 1954 Chevrolet Bel Air. It had a white top, turquoise body, and fender skirts. I'd drive it downtown with all the windows down and the radio up. It was sharp.

I'm an auctioneer. I took a two-week home course. You learn how to say all kinds of things:

Peter Piper picked a peck of pickled peppers.

Sally sells seashells by the seashore.

A skunk sat on a stump. The stump thought the skunk stunk. The skunk thought the stump stunk. What stunk? The skunk or the stump?

I got pretty good at it.

Mary Sue Jiras's husband **JIM JIRAS** (b.1942)

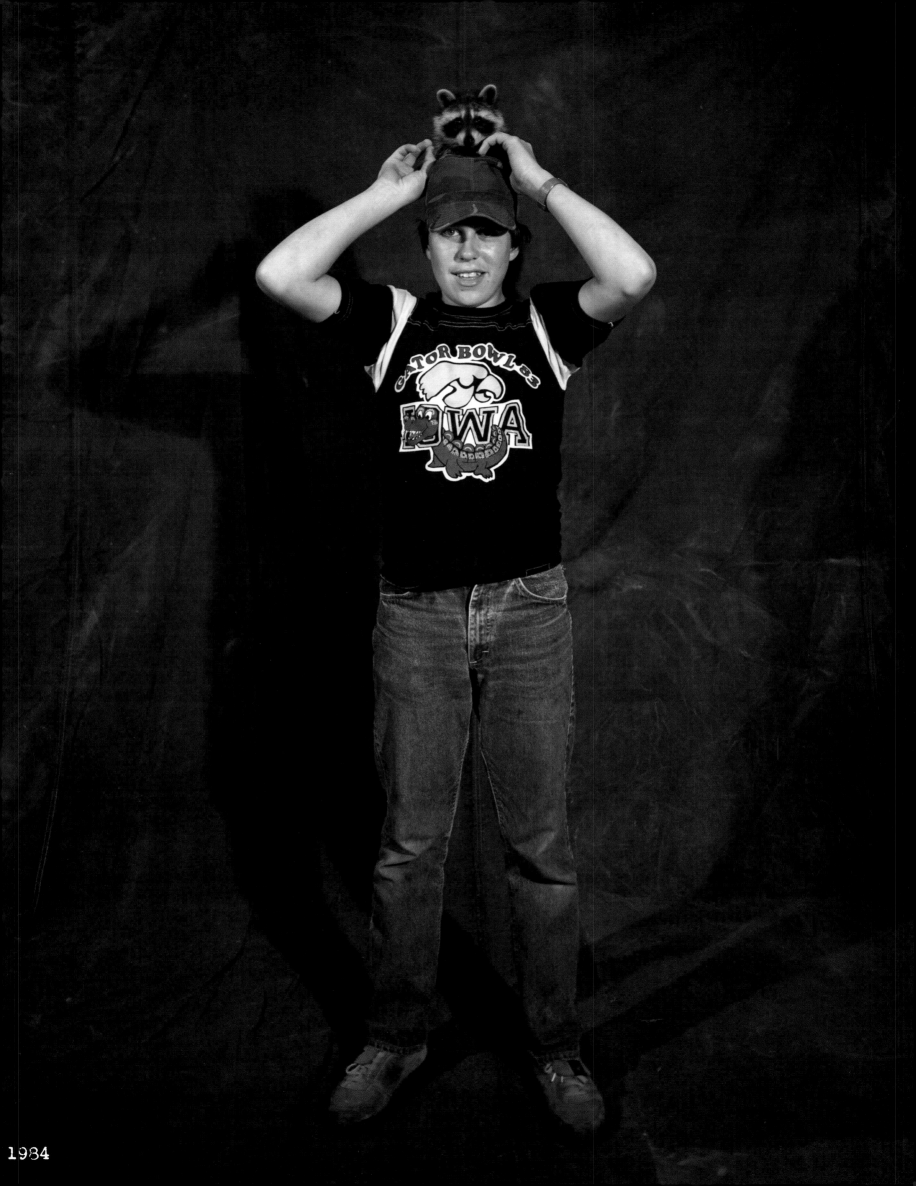

1984

"I used to have a pet raccoon. His name was Willy. He ate scrambled eggs for breakfast."

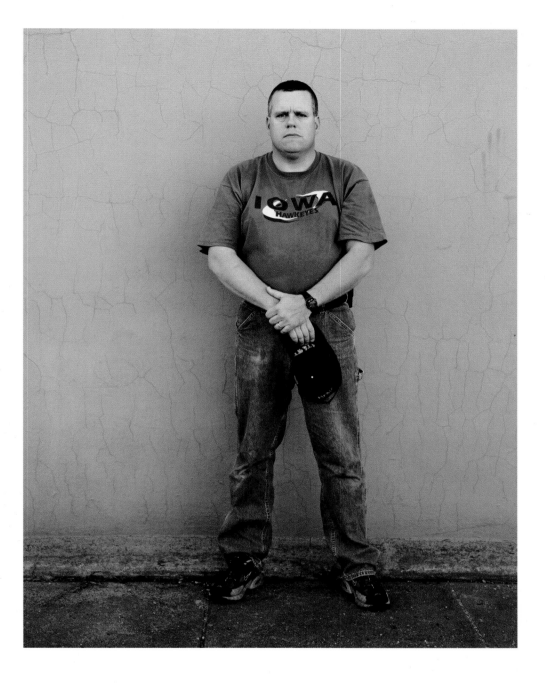

STEVE JIRAS

I'M A FIRST RESPONDER.

The worst call we ever got was for Bud's Tap. There was heavy black smoke pouring out of the ceiling and the roof had caved in. The door had slammed behind Larry Jiras. He was trapped. The only way he got out was through a back window. He came out with burns on his neck, arms, and legs.

Larry Skripsky broke his back and one of his legs. Randy Campbell got a broken shoulder. The funeral parlor burned down, so did the old grocery store and part of the Masonic lodge upstairs.

At the hospital when I was doing security, we dealt with psych patients. Some of them want to get in your face. They try to mess with you. We had officers who got hurt. One got choked.

I used to have a pet raccoon. His name was Willy. He got to be a big ol' boy, 40 pounds. He ate scrambled eggs for breakfast.

Mary Sue and Jim Jiras's son STEVE JIRAS (b.1972)

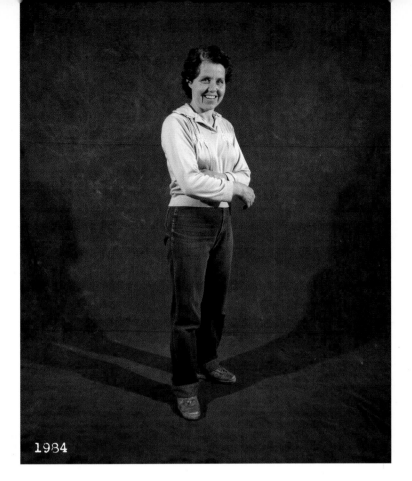

1984

"On Wednesdays we eat dinner at St. Mary's for Super Sixties. The week before we had roast beef, mashed potatoes, gravy, carrots, and a wonderful Cherry Delight."

EILEEN JIRAS

I'VE CLEANED THE BANK for twenty-five years, seven days a week. For fifteen years I cleaned our church. I was a crossing guard for the elementary school. I also babysat. Along the way, I raised four children. Three of them live close by, the fourth is a nurse in Houston.

My husband and I have known each other forever. We lived three miles apart while we were growing up. I always liked him. Our sisters were best friends. We had a pond off of F-28, where we used to swim. We'd all go to Swisher on weekends for dances. We've been married forty-six years.

These days I still have chores. I feed our two dogs, Chloe and Bailey; our six cats, Poppers, Toro Rose, Gidget, Lacey, Stanford, and Lamont; our five hens; Bubbles, who's a lamb (she's pregnant now); fifteen sheep; and two rabbits, Babs and Minnie.

I read character-building books three hours a week to the kindergarten and second-grade classes at the school. I also teach catechism on Sundays and Thursdays.

On Wednesdays we eat dinner at St. Mary's for Super Sixties. Last week we had chicken, noodles, apple salad. The week before we had roast beef, mashed potatoes, gravy, carrots, and a wonderful Cherry Delight.

I don't have time to take a nap.

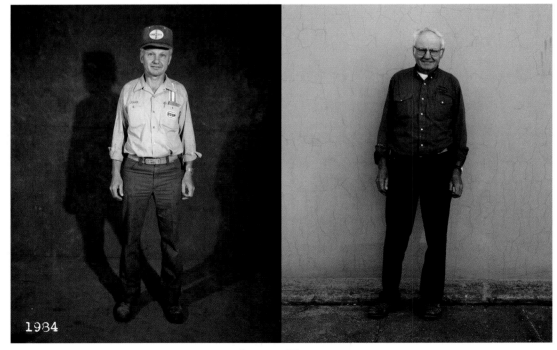

1984

Larry Jiras

TOP AND OPPOSITE: **EILEEN JIRAS** (b.1940) BOTTOM: Eileen's husband **LARRY JIRAS** (b.1939)

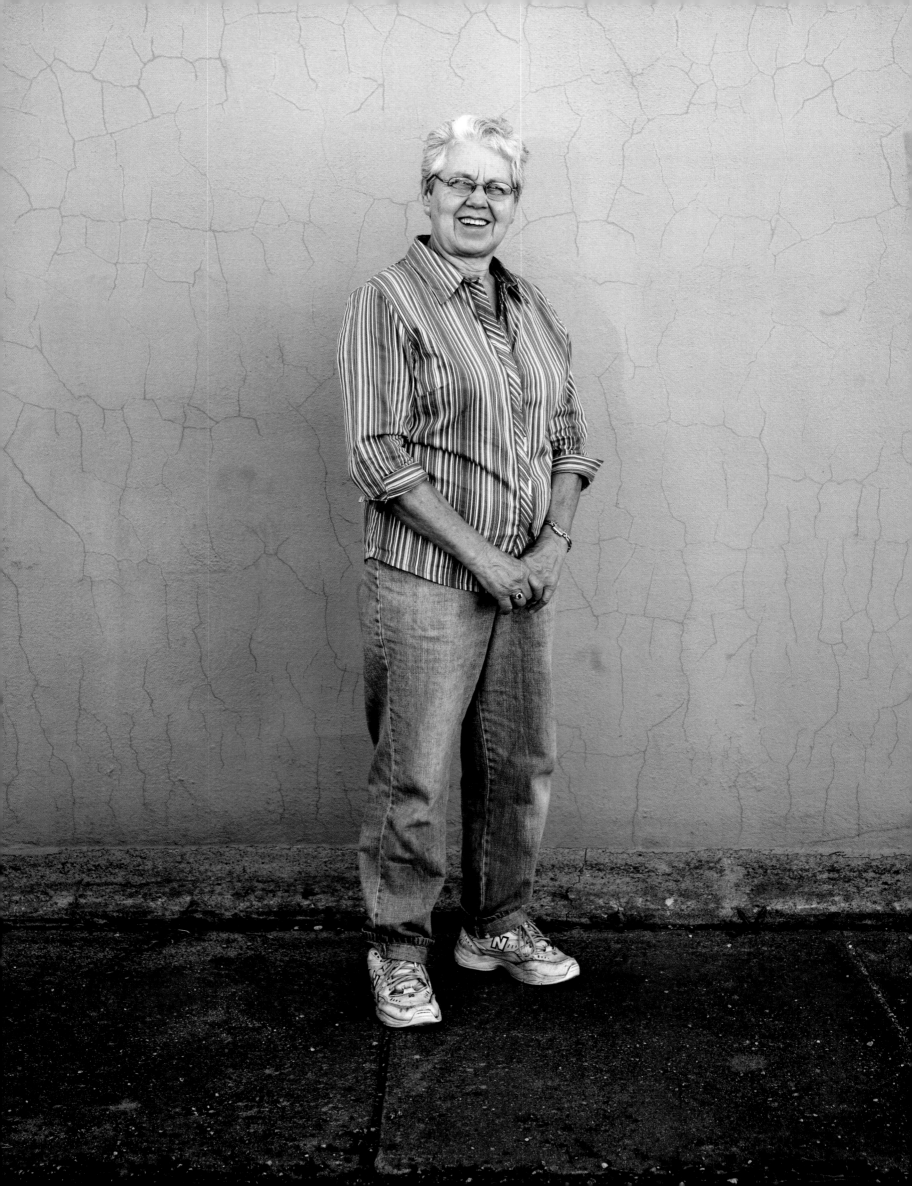

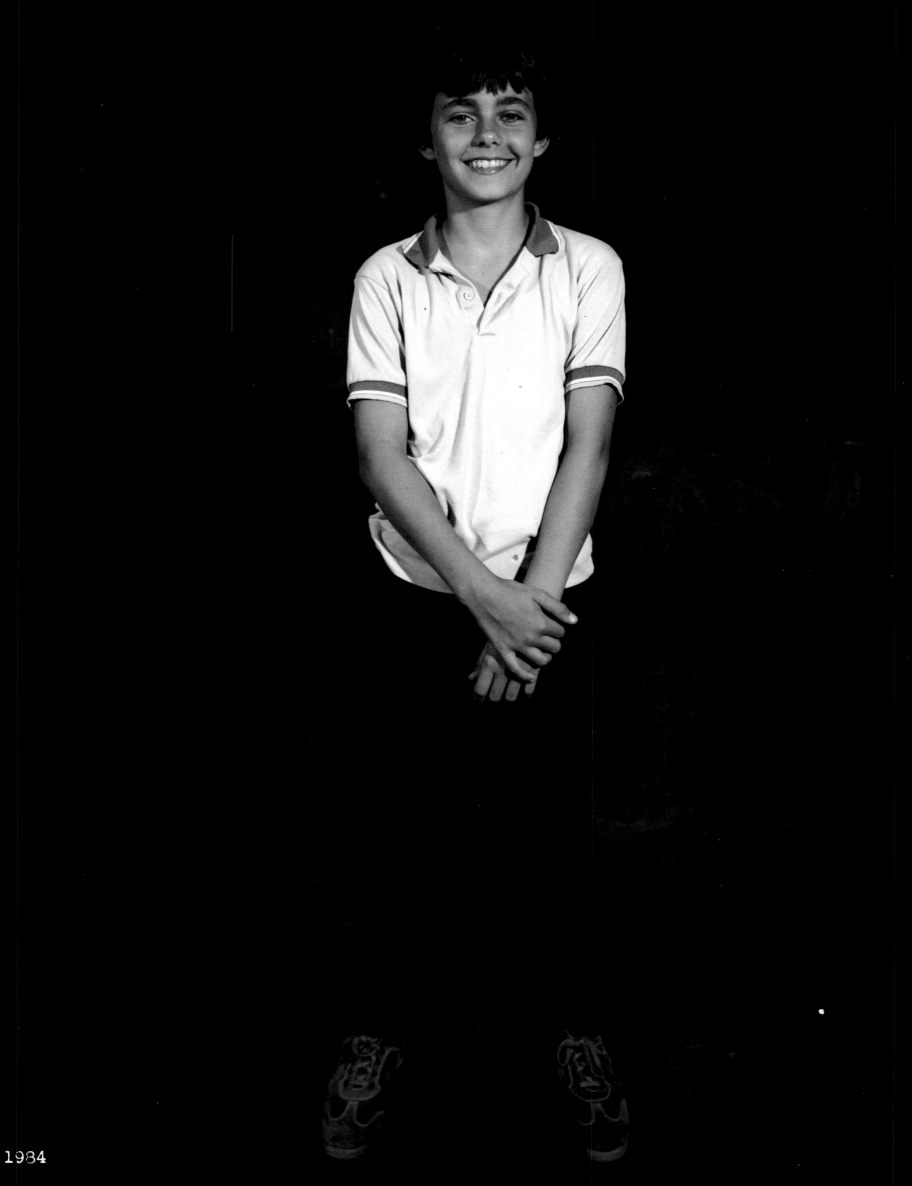

1984

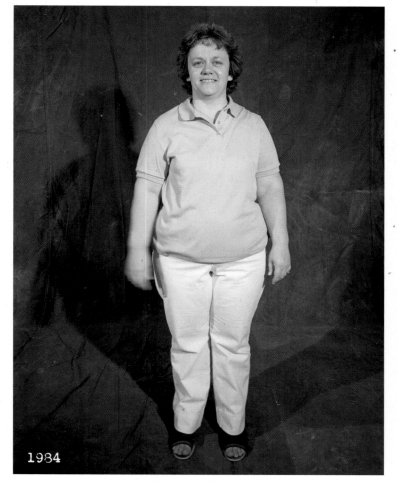

1984

Bonnie Jiras

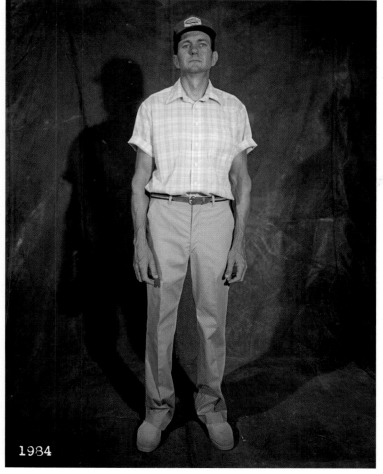

1984

Raymond Jiras

"My mom and dad had four kids—I thought that was crazy."

—Marty Jiras

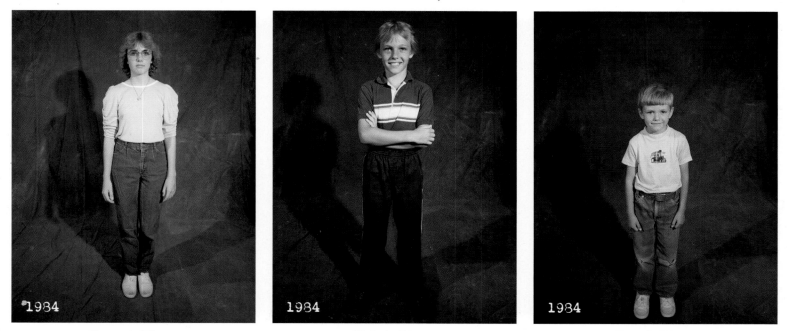

1984

Cherri Jiras

1984

Clint Jiras

1984

Jeret Jiras

OPPOSITE: **MARTY JIRAS** (b.1971) TOP: Marty's parents **BONNIE JIRAS** (b.1946) and **RAYMOND JIRAS** (b.1945)
BOTTOM: Marty's siblings **CHERRI JIRAS** (b.1969), **CLINT JIRAS** (b.1973), and **JERET JIRAS** (b.1978)

MARTY JIRAS

I WAS INTERESTED IN GIRLS, but too shy to talk to 'em. Me and a few buddies would go to country bars, and one time at the Red Stallion, this girl came up to me and said, "Would it be all right if we danced sometime?"

We dated for a year or two, lived together, then we got married. Now we have three girls and a boy. The youngest are twins.

My mom and dad had four kids, and I thought that was crazy. Two in daycare is a thousand dollars a month. If all four are in daycare, it'd be two thousand. I take home twenty-five hundred working as a groundskeeper. So my wife now stays home with them.

I have a part-time job I don't like to talk about. I pick up dead deer on the county roads. It pays seven hundred a month regardless of how many. In the winter, it's twenty, sometimes thirty a month. The bucks can weigh up to three hundred pounds. I take 'em to the landfill. If they're alive, I call the Sheriff and they'll shoot 'em. When they get hit Friday night, I don't get to 'em till Monday afternoon. By then, the eyeballs have been picked out by buzzards or crows, and bees are flying in and out of the eye sockets. There's lots of maggots.

One time I found a deer whose head had been sawed off with a chainsaw, so someone could mount the head and rack. They just threw the deer in the ditch.

If my kids go to college, they'll have to pay their own way. Or get a scholarship. We won't be able to afford Disney World. We'll try to go the State Fair every year, though.

RIGHT: **MARTY JIRAS** with his children Laney, Rylee, Justin, and Kayla

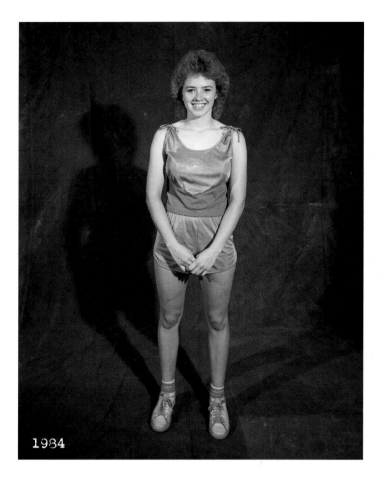

1984

DIANA (CELLMAN) PENCE

I HAVE AN IDENTICAL TWIN SISTER. When we were babies, my father used to paint the bottom of our feet with toenail polish so he could tell us apart. In high school, we ran track and played on the basketball team. I was the catcher on the softball team and Denise played first base. We went to State our senior year.

I remember the last day of high school, thinking, "Now, what am I going to do?" I wanted to go to cosmetology school, but enrolled in a general-secretary program.

When I met my husband, he had just broken up with a girl, and I had just broken up with my boyfriend. My sister had gotten engaged and I felt really alone. I was twenty-two when I had my first, and now we have four kids.

I'd like to do some traveling, maybe take a cruise. Hawaii would be nice, but I'm not crazy about flying these days.

"When we were babies, my father used to paint the bottom of our feet with toenail polish so he could tell us apart."

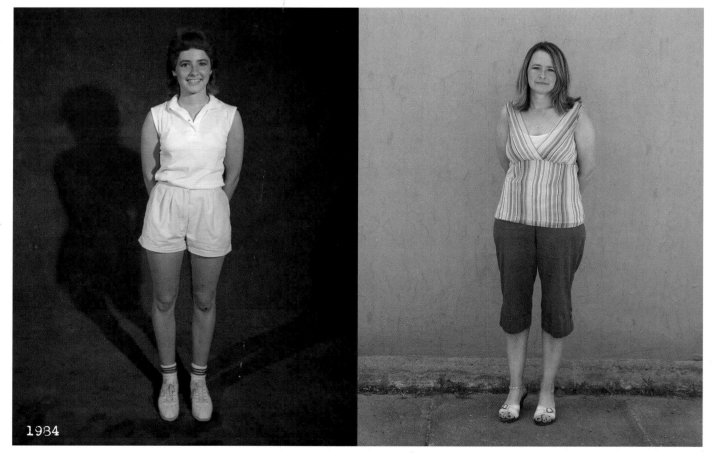

1984

Denise (Cellman) Ogden

TOP AND OPPOSITE: **DIANA (CELLMAN) PENCE** (b.1966) BOTTOM: Diana's twin sister **DENISE (CELLMAN) OGDEN** (b.1966)

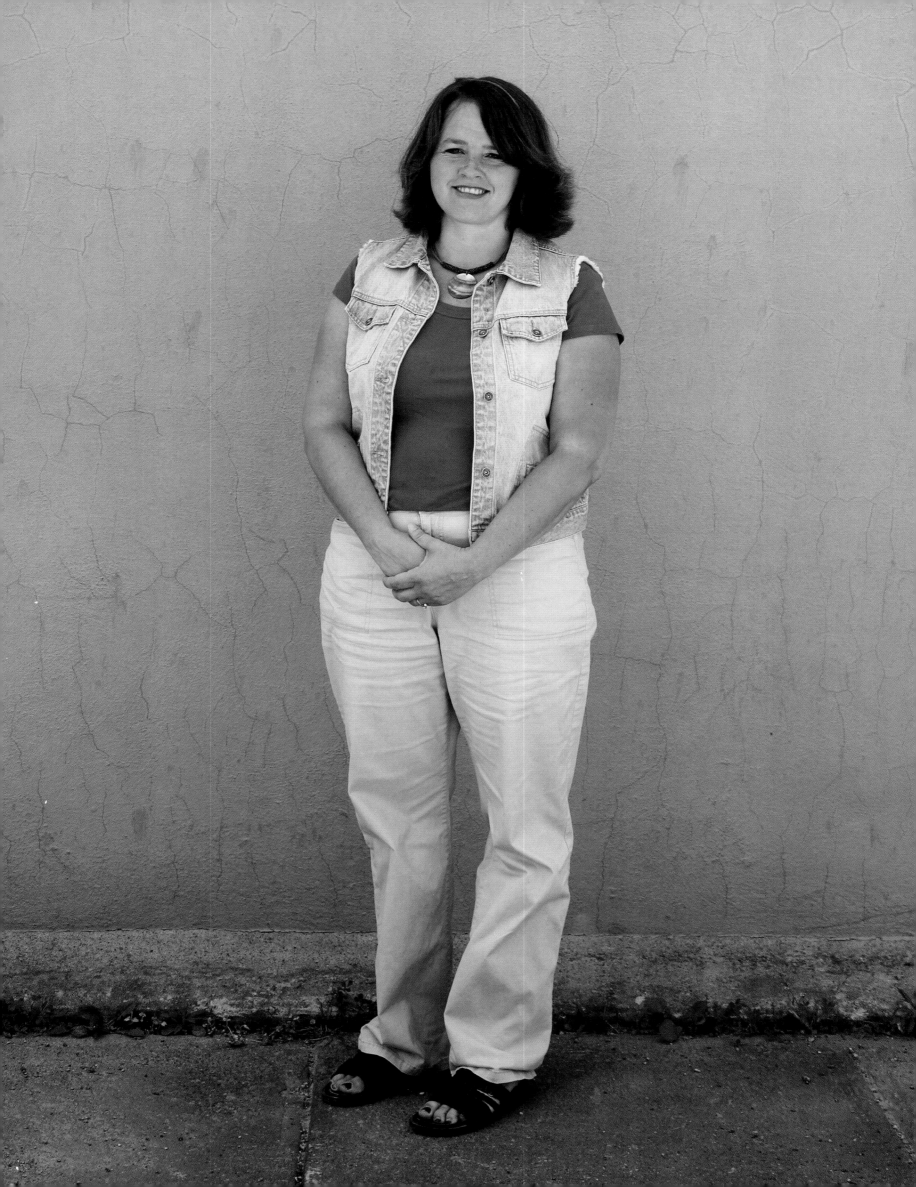

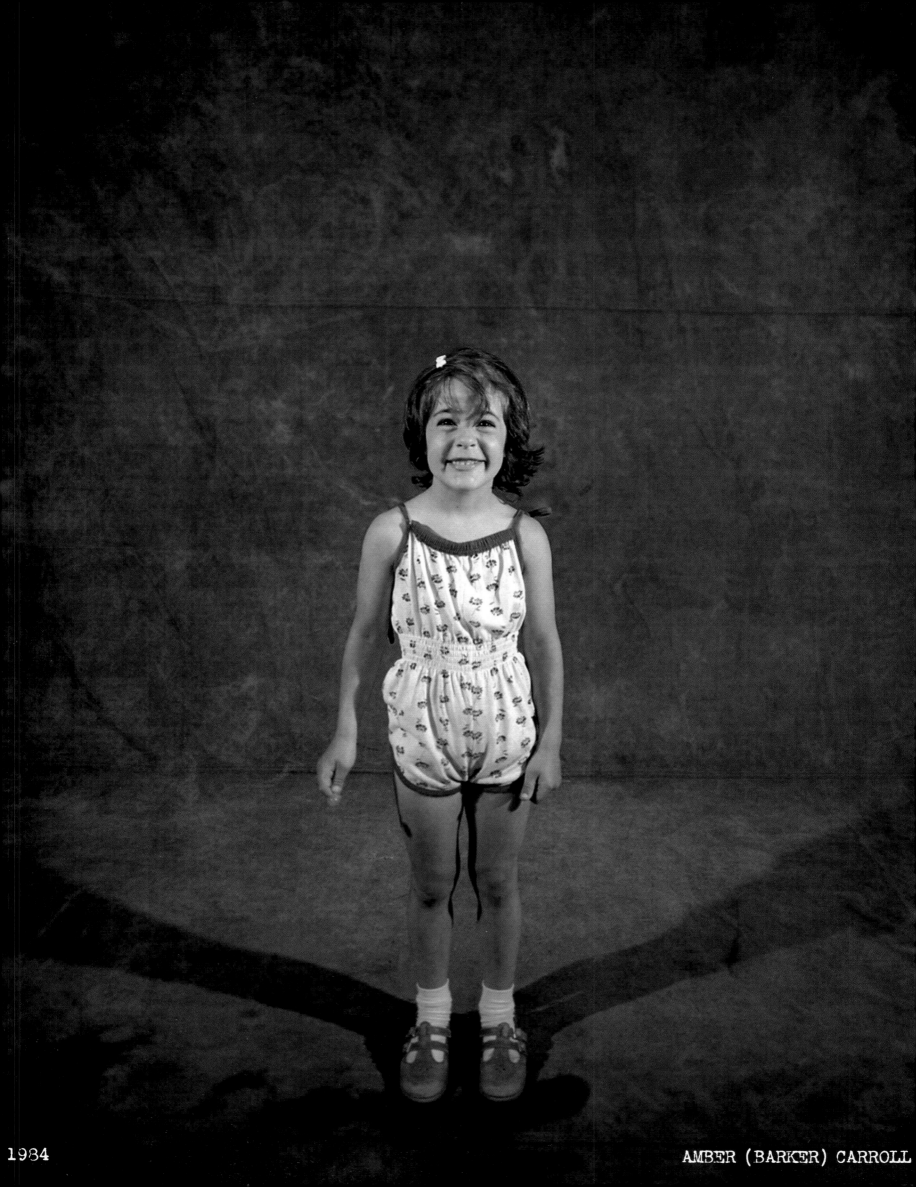

1934

AMBER (BARKER) CARROLL

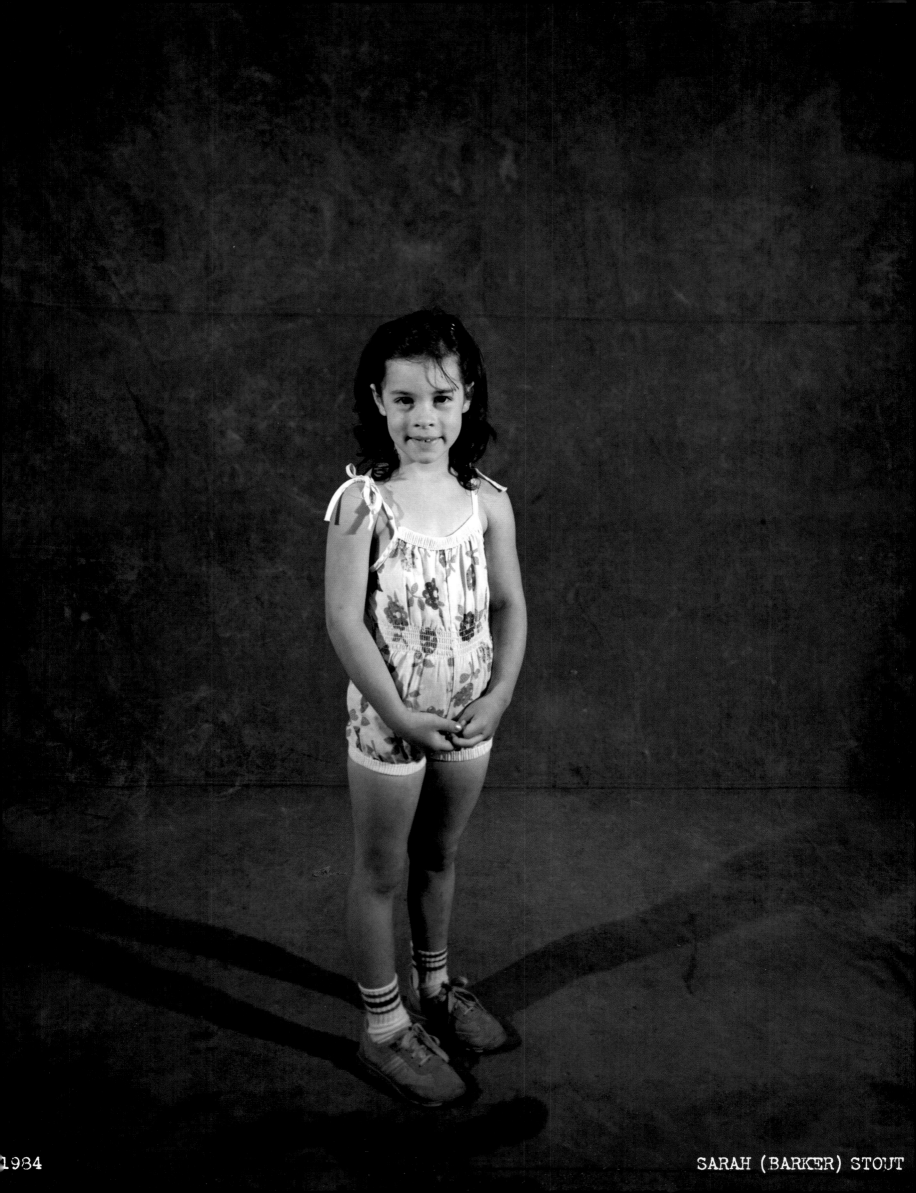

1984

SARAH (BARKER) STOUT

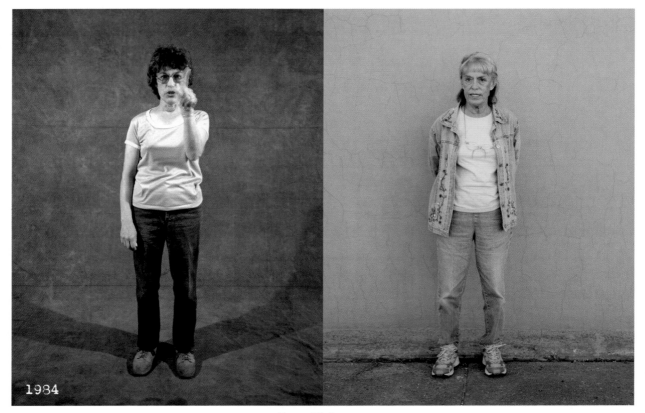

Mary Wyborny

"Al and I bought the Oxford hardware store, and we were in business. Every day, I got my make-up on, and down to the store I'd go."

—Mary Wyborny

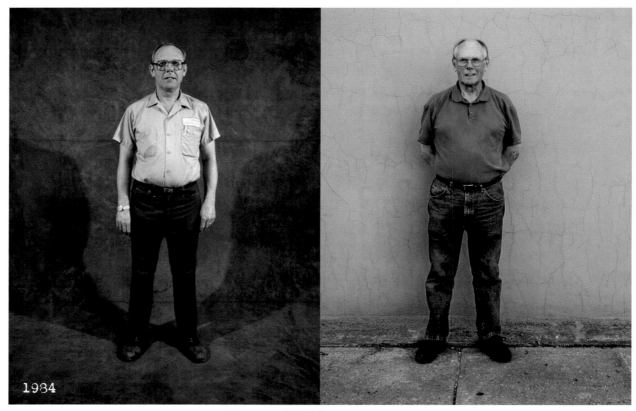

Al Wyborny

PRECEDING PAGES: Sisters AMBER (BARKER) CARROLL (b.1978) and SARAH (BARKER) STOUT (b.1977)
THIS PAGE: Amber and Sarah's grandparents MARY WYBORNY (b.1934) and AL WYBORNY (b.1938)

252

"Every summer my sister and I went to Oxford to live with my grandparents. It was a Mayberry kind of place."

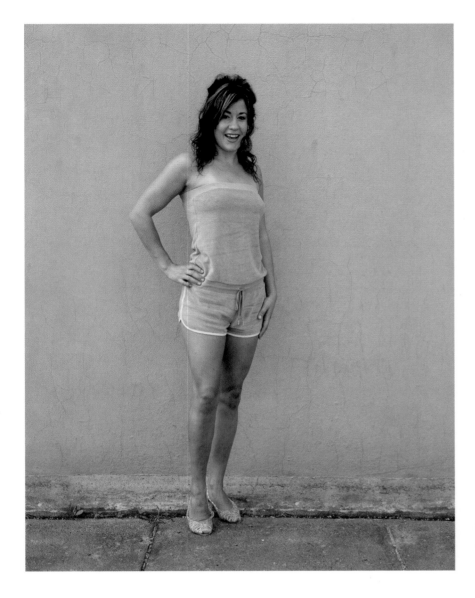

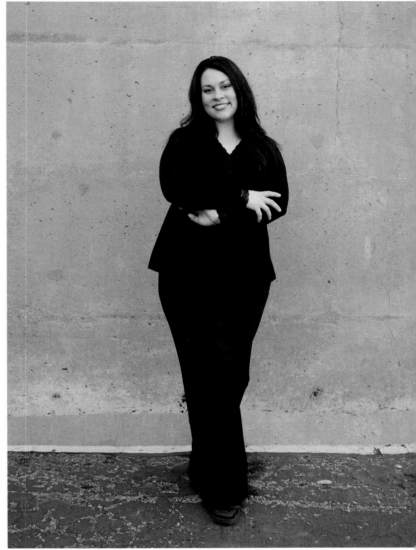

Sarah (Barker) Stout

AMBER (BARKER) CARROLL

MY FATHER'S A CHRISTIAN MUSICIAN. He's won two Grammy Awards. When I was seven we moved to Nashville. I went to public school at first; I was the only white girl in my class.

Every summer my sister and I went to Oxford to live with my grandparents. It was a Mayberry kind of place. I used to skip on the sidewalks, singing, "Step on a crack, break your mother's back."

I had my rebellious stages. I went a little crazy. I was a party girl. But I had fun. You have to live a little. Once I got out of college, I decided what I really wanted to be was a hairdresser. I now work at one of the nicest salons in

Memphis. I consider myself an artist. I try to inspire others to be happy. I'm almost like a psychologist.

I love purses—the kind that are large enough to carry a blow drier in them. And I also love shoes, especially high heels. If they're smokin' hot, they can make a pair of jeans into a sexy outfit. And hats. I love hats, too.

I'm happy with who I am. God knows my heart and my intentions. I'm not close to being perfect, but I'm always trying to be a better person.

I want to travel the world. I want to have a couple of kids. I want to have a big kitchen and a big bathtub. I'm not engaged, but I'm working on somebody.

ABOVE LEFT: **AMBER (BARKER) CARROLL** ABOVE RIGHT: Amber's sister **SARAH (BARKER) STOUT**

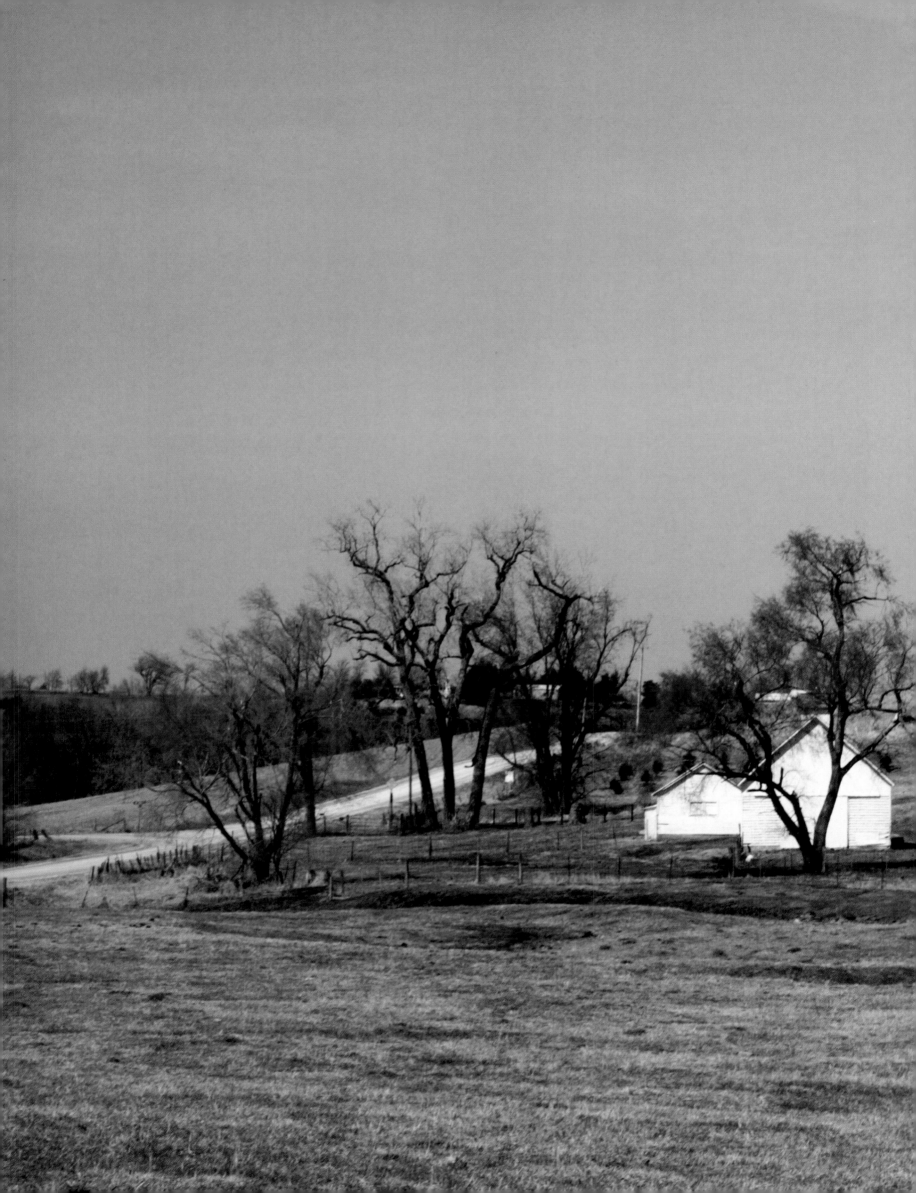

"Here I can open my windows and I hear birds instead of the hustle and bustle. I can go out on our front porch and watch deer in the field."

—Jaime Gorsh

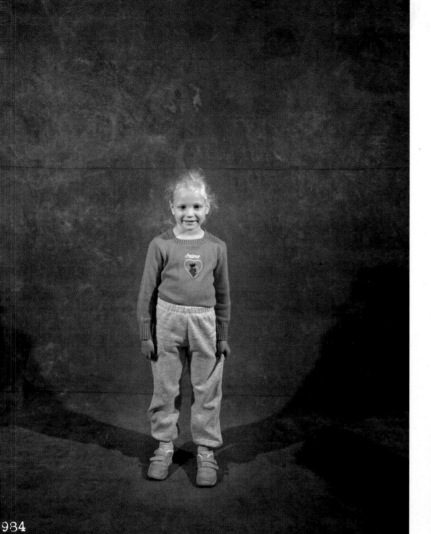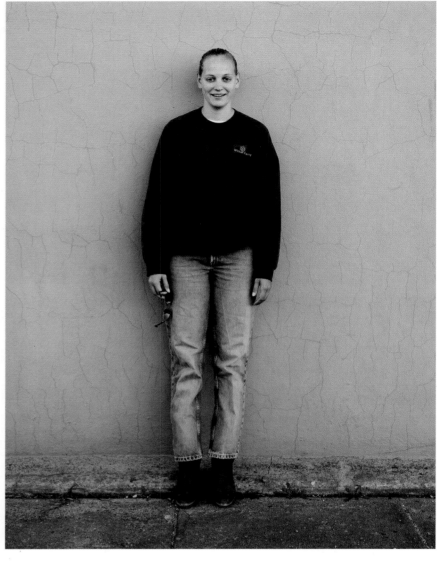

JAIME GORSH

I MET MY FIANCÉ AT THE ALIBI. I was playing euchre there, and a friend of mine got a phone call, so she got up, and Troy filled in for her. We haven't set a date yet. But we've talked about buying the ten-acre farm where we're living now.

I like living here. People look out for you. That's the upside. But everyone knows everybody. Before Troy and I started dating, people asked him when he was going to ask me out.

I've lived in Cedar Rapids. You don't have any quiet there. Here I can open my windows and I hear birds instead of the hustle and bustle. I can go out on our front porch and watch deer in the field.

ABOVE: **JAIME GORSH** (b.1979) OPPOSITE: Jaime's parents **DAN GORSH** (b.1949) and **LINDA GORSH** (b.1953)

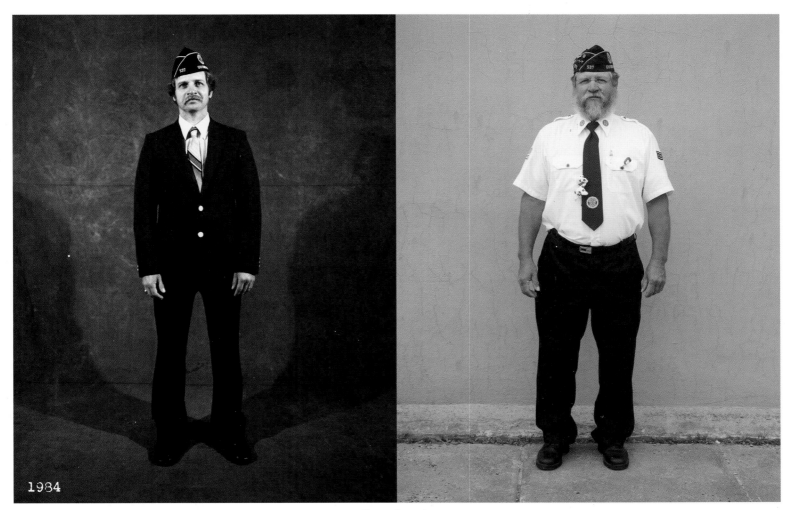

Dan Gorsh

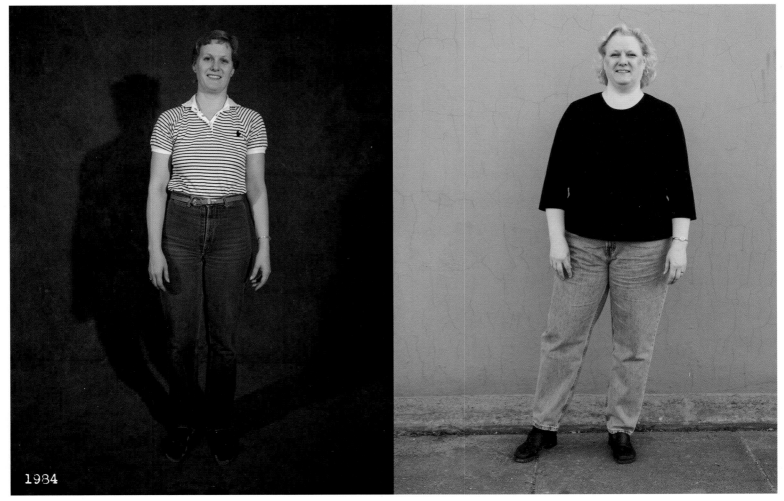

Linda Gorsh

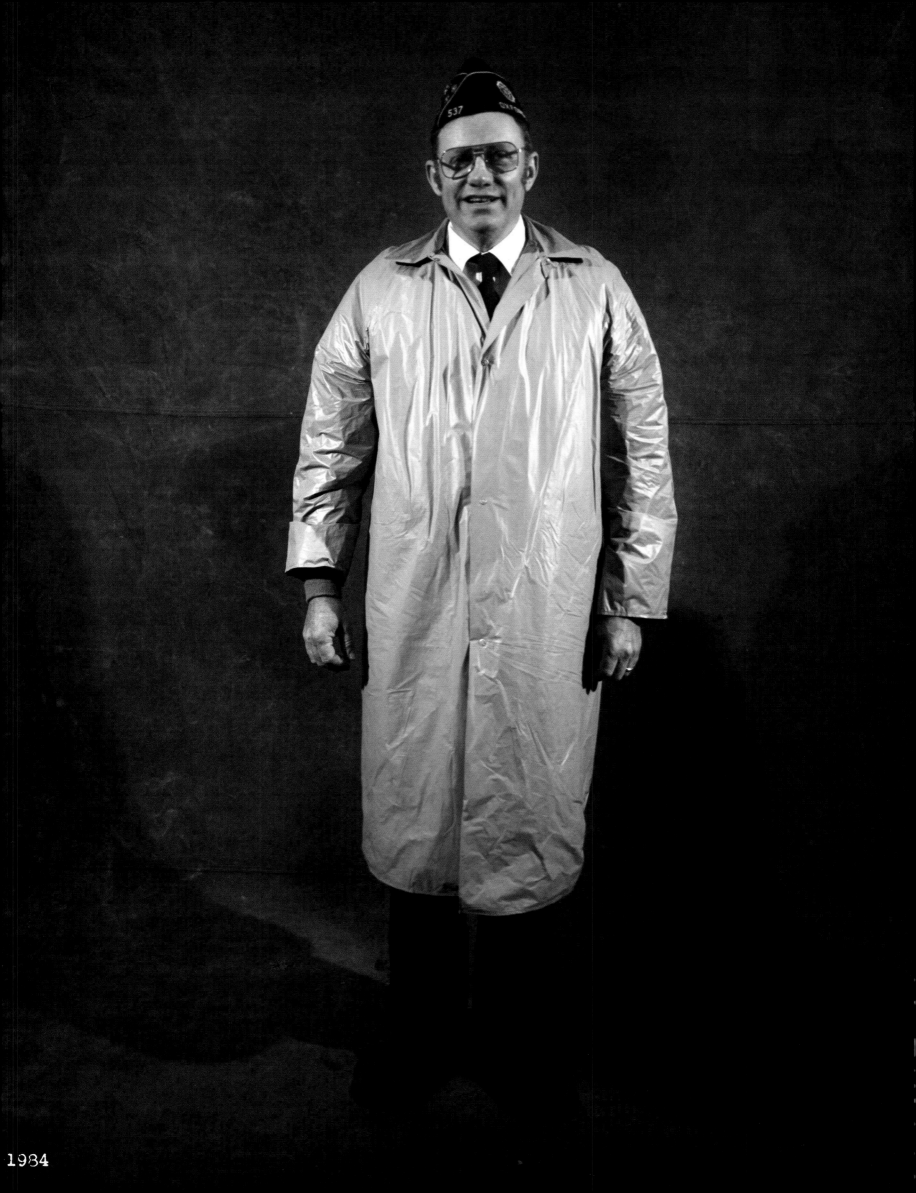

1984

RAY STRATTON

I MET MY WIFE IN IOWA CITY. She was a city gal. We have five children—four living and one deceased. My son does outdoor maintenance, and the three girls are nurses. I don't dare sneeze when I'm around them or they'd put me in the hospital. Peggy, she died at seventeen from leukemia. She's been gone longer than she was alive.

I was Postmaster for twenty-three years. They wanted to get rid of us old people. On a Friday I got the letter, and on Monday morning I called them and said, "I'll take you up on this." I got six-months' severance pay.

In the winters, we go to Tucson. We're in an RV park. We're out doing something every day. We golf Mondays and Thursdays.

I don't hunt or fish. I've come to the conclusion that it's cheaper to go to the store and buy food.

Before I worked for the Post Office, I was in farming, and I had a double corncrib. The door had just two brackets on it, and as I pushed the two-by-six off, the door fell and it severed my middle finger at the tip. They sewed it back, but it turned black and didn't take.

I should have begged, stole, or borrowed to get a college education when I got out of the Marine Corps. I had in mind that I wanted to be a veterinarian. But I was the only boy in my family to graduate from high school, so people thought that was something.

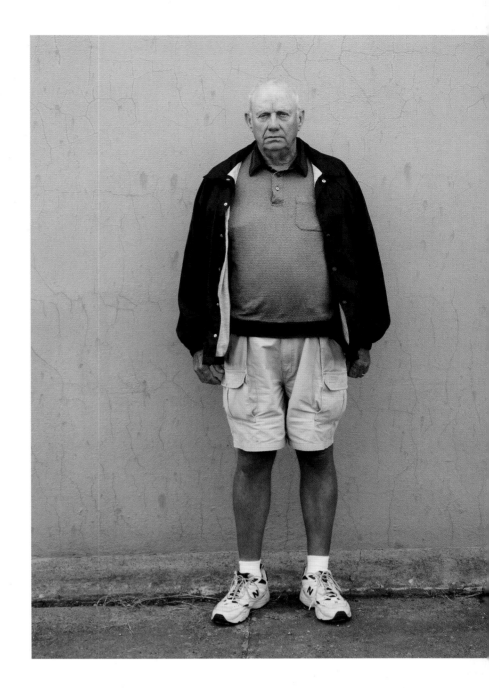

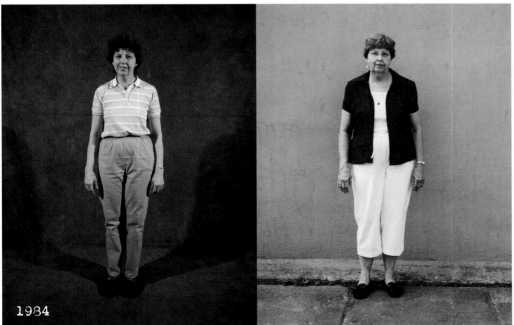

Betty Stratton

"I don't hunt or fish. I've come to the conclusion that it's cheaper to go to the store and buy food."

OPPOSITE AND TOP: **RAY STRATTON** (b.1930) BOTTOM: Ray's wife **BETTY STRATTON** (b.1932)

"Every man is entitled to a good coonhound, a Cadillac, and a wife— not necessarily in that order."

RALPH NEUZIL

I WAS ELECTED COUNTY ATTORNEY IN 1958 when I was twenty-six. I was the youngest county attorney in the state of Iowa.

April 30, 1959, sticks in my mind. Full moon. The police told me to get to Mercy Hospital. A three-year-old child had been slapped by his mother, got a blood clot, and died. Then a man was pulled off the road with a blood-alcohol level of .50. By all accounts, he should have been dead. At eleven-thirty, a guy shot his girlfriend at the Airliner Bar and then put the gun in his mouth and blew out his brains.

Later the same night, I got a call to go to the Park Motel, where a barn had gone up in flames. It was arson, plain and simple, and we had the plaster-cast footprints to prove it.

At the trial, the jury stayed out twenty-four hours. The foreman said he knew the man had set the fire, but the jury felt the fellow had a nice wife, two nice children, and what would be the point of sending him to jail?

I started my law practice in the old meat locker, then I moved to a room above the old bank. On Thursday afternoons, I'd go to the LP Club around the corner. I'd have a bottle of pop and watch the guys play cards, mostly euchre, but sometimes gin rummy. LP stands for either "limp prick" or "limber prick." I'm not sure which, but considering the old geezers there—fellows like Brownie Welch, Carl Dalton, Ross Beard—I have a pretty good idea.

My hobby from the time I got married till I had heart problems was coon hunting. I've traveled all over the county coon hunting. Every man is entitled to a good coonhound, a Cadillac, and a wife—not necessarily in that order.

RALPH NEUZIL (b.1930)

260

1984

"I take a shower, a bath, then I use human-scent neutralizer. I wash my clothes in stuff that makes them smell like dirt. Then I douse myself with buck urine."

JOE PRYMEK

I CAME UP HERE from Washington, Iowa, when I was eight or nine. My father sold the farm, but I wished he would've kept it for me. I played football at City High, then I worked roofing and construction. I met my wife at a roller-skate rink.

I do a lot of bow hunting. I take a shower, a bath, then I use human-scent neutralizer. I wash my clothes in stuff that makes them smell like dirt. Then I douse myself with buck urine. I've got four-hundred-and-fifty dollars worth of camouflage clothing.

I go up twenty feet in a tree. You sit there for four or five hours. Hell, sometimes it's longer. I start in the morning when it's dark. I take pop and coffee, maybe a few pieces of candy, sometimes a turkey or ham sandwich. If you gotta pee, you do it in a milk bottle.

Deer are real smart, and the bigger they are, the smarter they get. I'm accurate up to forty yards. I butcher them myself, but I give most of it away to my kids. I don't have any heads, just two or three racks.

In the winter, I go ice fishing. If it's real cold, I bring a tent. I get up early. That's when it's the best—crappies, bluegills, walleyes, northerners. I use wax worms with red or white hooks. I know how to get me some fish.

JOE PRYMEK (b.1949)

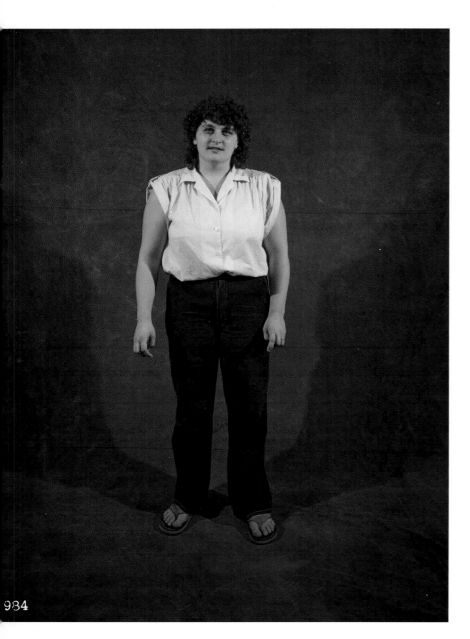

984

"We'd play baseball on Augusta in front of the Alibi. We'd use beer cans as bases and beer bottles as bats. We had to clean up a lot of glass."

JACKI PRYMEK

I LIKE TO GO DEER HUNTING. You wanna get set by six-thirty so you can start shooting when daylight breaks. There'd be twenty-five of us and we'd each chip in ten dollars. The money would go to mount a buck's head. Or if we didn't get one, then we'd drink it up at the Alibi.

I wear pantyhose for my thermal, two pairs of socks, boots, blue jeans, a thermal shirt, Carhartts, a hat, scarves, and orange. Orange is important. You gotta do a headcount at the end. I use my mom's twelve-gauge shotgun. It's a Squires Bingham from Kmart.

My mom died of cancer in 1982. I was nineteen and she was only forty-one. She was the block mom. She'd ride up and down the street on her bicycle. We had a shitload of kids on the block: the Bergs, Wallses, Booths, Paintins, the Hagens. They'd all come over and one of our neighbors, this

old guy Ted Rapp, would throw candy bars at us in our yard from an upstairs window.

We'd do a lot of camping at the river bottom. We'd build a big fire and cook deer meat. We'd share it with whoever was driving by—the Coxes, the Kroftas, the Honns.

My family has always been involved in racing—from dirt tracks to NASCAR. Matt Kenseth, number 17, he's my guy. I'm wearing his T-shirt.

The Prymeks were all rowdy. I've worked in a lot of bars in town. We'd open the door and play baseball on Augusta in front of the Alibi. We'd use beer cans as bases and beer bottles as bats. We had to clean up a lot of glass.

My dad makes me laugh all the time. He's crabby and he can get on you. It's his way or no way. I used to go roofing with him. I don't know what it was, maybe being so high up, but I loved it.

I've never been married, but I had a relationship with Landon's father for seventeen years. I have two kids. Landon is sixteen, and Josh is twenty-four.

I'm a production operator at a factory in Iowa City. I make plastic bottles. I get $12.48 an hour and it's not enough.

Joe Prymek's daughter JACKI PRYMEK (b.1962)

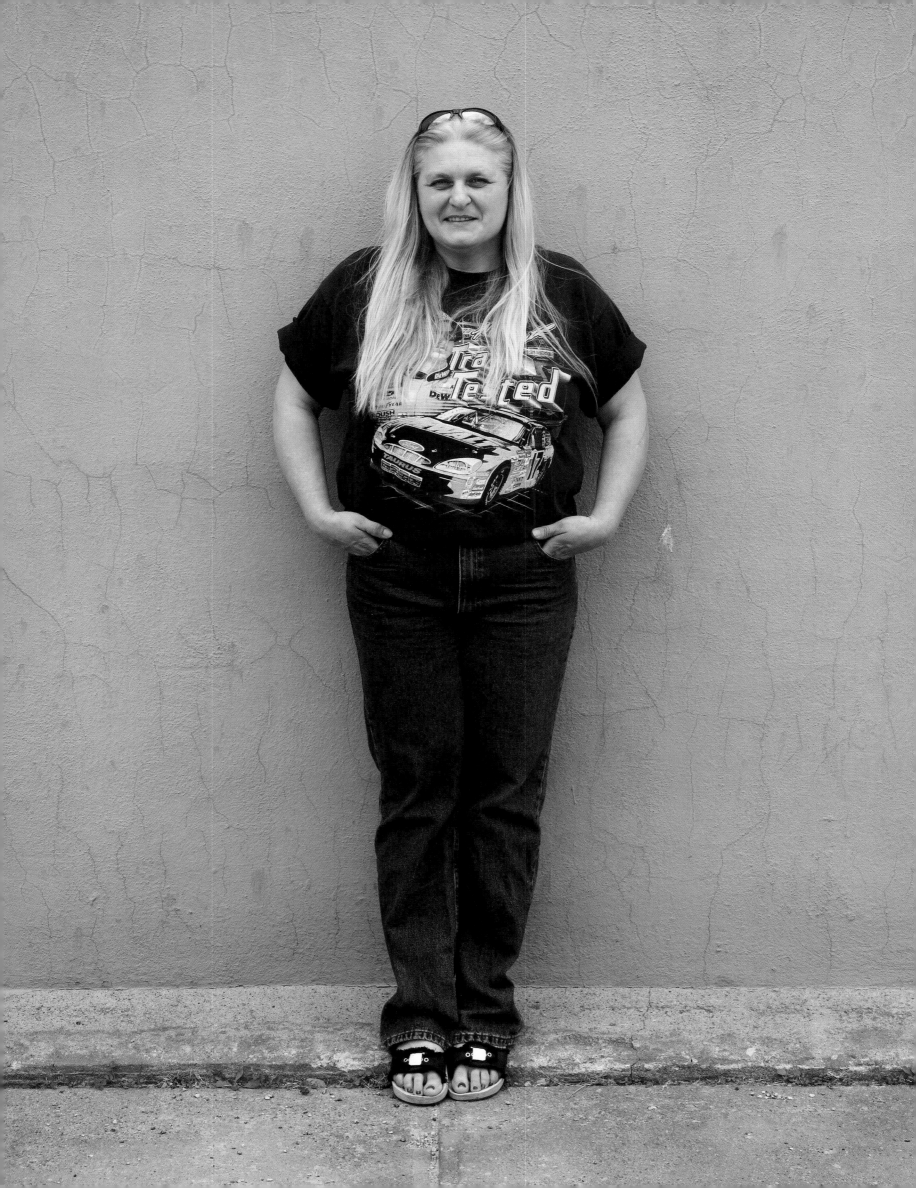

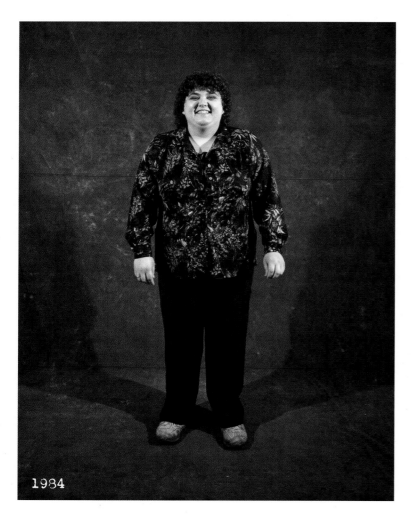

1984

1984

Jere Prymek

JONI (PRYMEK) POTTER

I USED TO BE A BARTENDER at the Alibi. There were a lot of guys who'd want to piss me off. Tommy Collins was the worst. One time, my sister was pregnant and a guy pushed her off a stool. I threw him right out the front door. If the door hadn't been open, he'd have bounced back in.

My mother died when I was twenty-one. My youngest brother, Jere, was ten at the time, so I pretty much raised him.

Zoe's my little girl. I used to have a husky, Bear. He was my protective guy. Zoe would get on top of Bear and ride him, but Bear died of cancer.

We live in Park View Trailer Court. There are one hundred and fifty or so trailers. My husband's been there since 1980.

I work at the Wal-Mart Supercenter. I love my job. I've been there since Day One. I used to be in Frozen, then Dairy, now I'm in Dry Goods. I make sure the chips are completely done and I keep the nuts in order.

TOP AND OPPOSITE: Jacki Prymek's sister **JONI (PRYMEK) POTTER** (b.1960) BOTTOM: Jacki and Joni's brother **JERE PRYMEK** (b.1970)

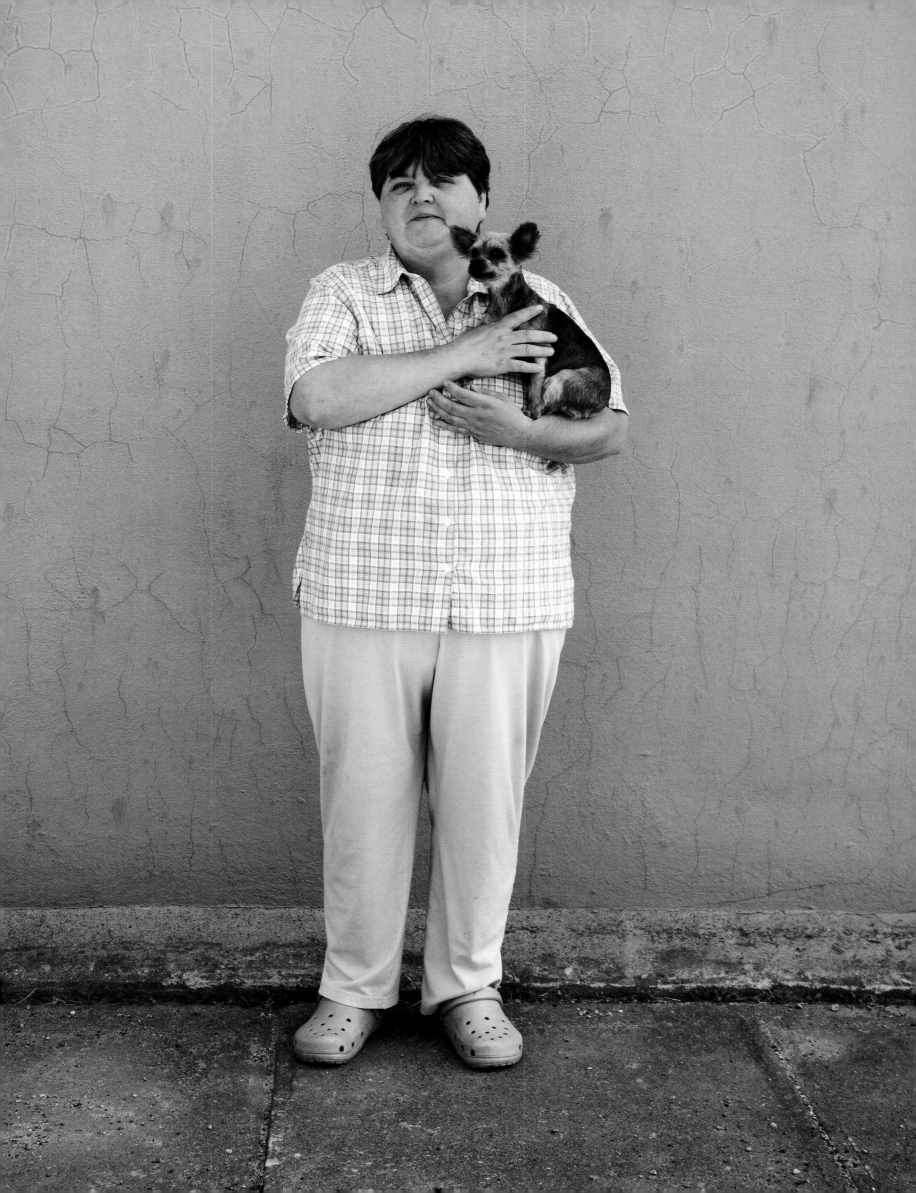

"I call my business Yogi's Mobile Home Service. Yogi's my handle. Towing mobile homes is hard work. Not many people want to do it. I just tote in Iowa. Both of my children live in a trailer park; my daughter's in a double-wide. I moved both of them in myself."

—Sam "Yogi" Stewart

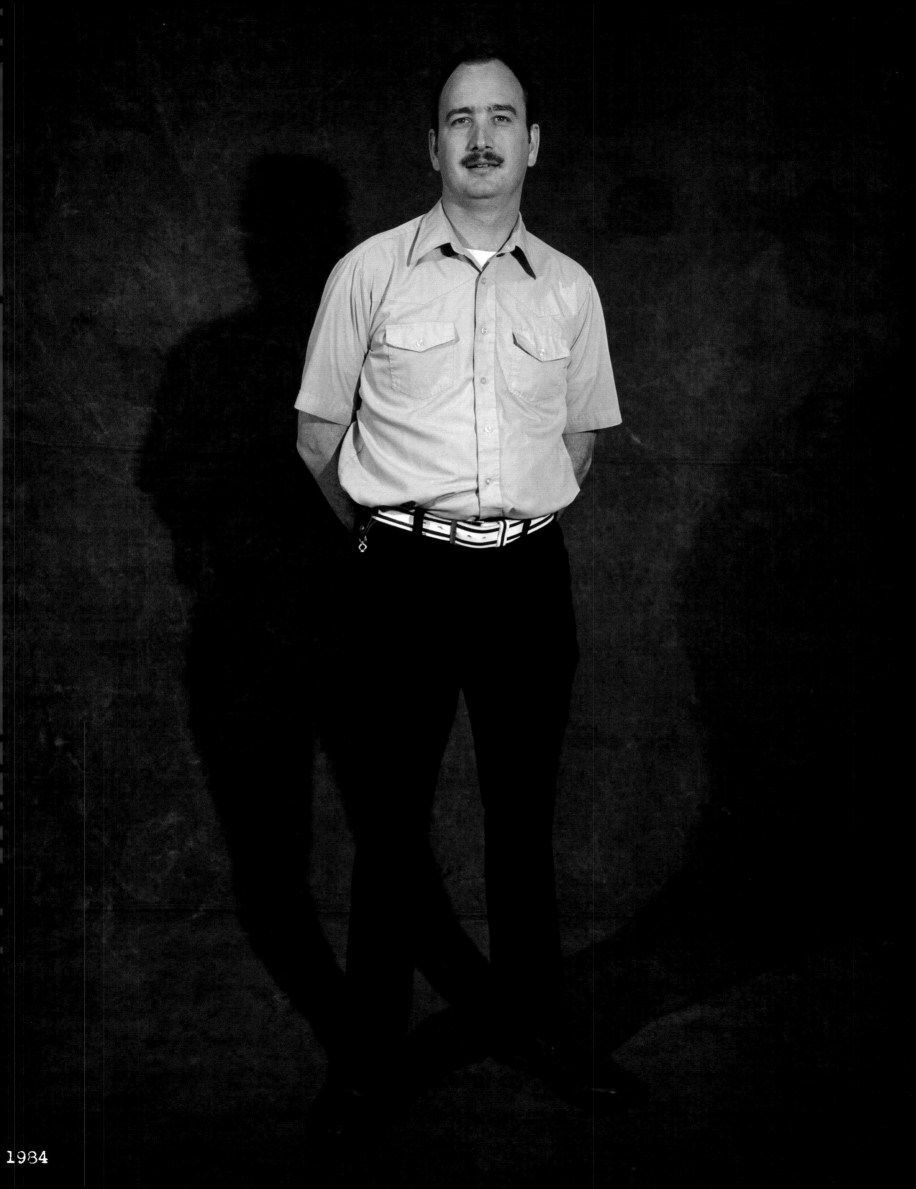

1984

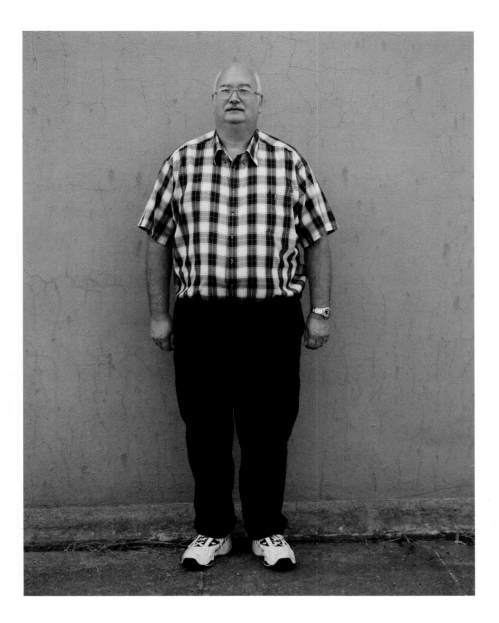

"Through network-marketing sales, I plan to be earning a six-figure income within five years."

BILL REINDL

I MET MY WIFE DOLLY through a personals ad. I said I was a Christian, financially secure, and looking for a committed relationship.

When I was in high school I thought, "Boy, if I could make fifty thousand dollars a year, I could own a home, two cars, and I'd be on easy street." But fifty thousand dollars is nothing today.

In 2003, I had three pulmonary embolisms and I started drinking XanGo. It's mangosteen juice, and it's full of xanthones. Now I sell it. If people drink XanGo for ninety days, they'll see the benefits. I drink four to five ounces a day.

I also sell a fuel additive. You add one ounce for every ten gallons and it'll increase your mileage by ten-to twenty-five percent. A sixteen-ounce bottle retails for thirty dollars.

I sell prepaid legal insurance. It costs seventeen dollars a month.

I sell hearing aids, too. I have the lowest price guarantee within sixty miles.

Through network-marketing sales, I plan to be earning a six-figure income within five years.

BILL REINDL (b.1955)

"I'm single. I learned the computer last January, so now I go to dating sites. I want to go to Colombia or Peru and find a girl and bring her back."

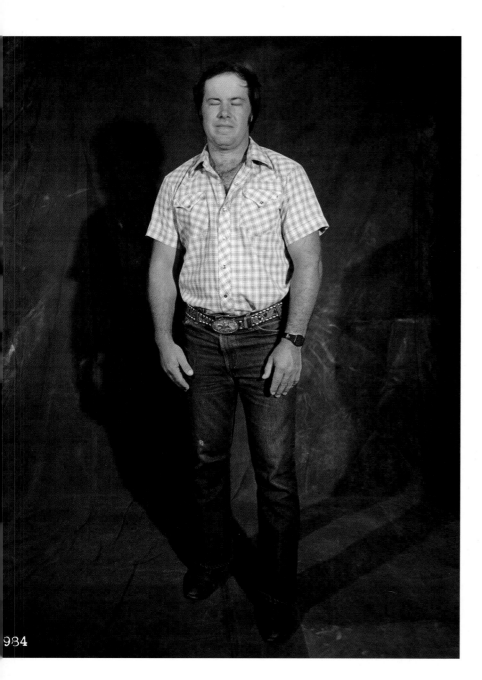

GENE BARNETT, JR.

I GOT A BROKEN NOSE. A guy got me out front of a bar when I was getting into my pickup. I walked around for fifteen years with it broken. A couple of years ago, I started getting plugged up with congestion. I'm thinking that it might have something to do with all the soybean combining I used to do. Even with a cab, you spit out black stuff for days. So I got the nose fixed, and while they were doing it I had a sinus operation, but it didn't help.

I have erratic shakes, like I'm being hit by lightning. I also have neuropathy. I have panic attacks and I have depression. I'm always cold, even though I have this burning feeling that shoots through me.

A couple of years ago, I saw an ad in the newspaper for a free test and the chiropractor said I was burning so hot that I'd blow a fuse.

I'm single. I learned the computer last January, so now I go to dating sites. I want to go to Colombia or Peru and find a girl and bring her back. I wanted to go in June, but I'm cash broke. I'm not very good in Spanish, but I'd be willing to learn. I'd also like to go to the Ukraine. They're real pretty there, but it's expensive to get over there.

I'm not a happy guy. Nothing's fun. The expense of everything turns me off. I'm fifty-two, but I never paid anything into Social Security, so I won't get shit when the time comes.

I drink six or eight beers a night, but I make sure I have them on a full meal. I go to Farmer Nick's, off the Belle Plaine exit. On Fridays he's got an all-you-can-eat seafood special for $6.25.

GENE BARNETT, JR. (b.1955)

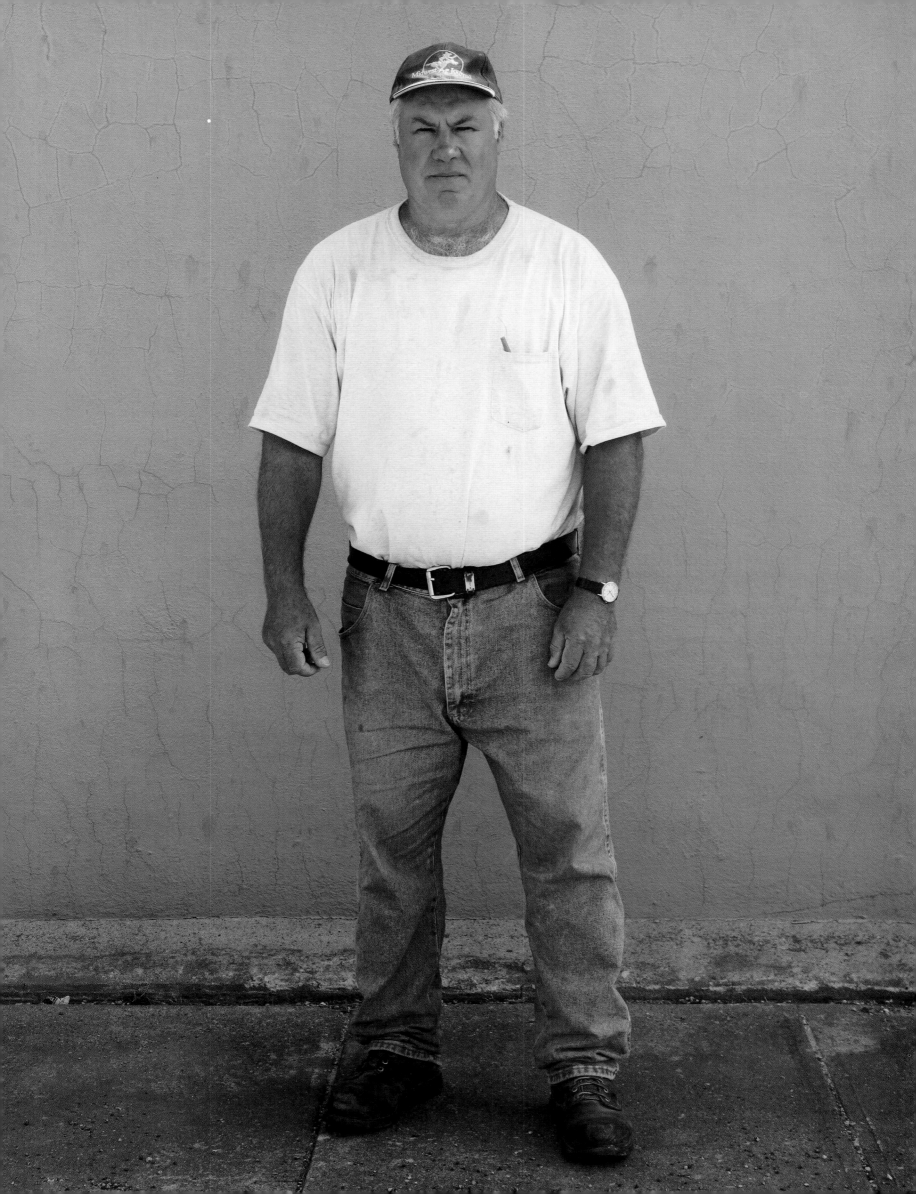

"Eldon Kutcher used to say, 'In a tavern, you believe half of what you see and none of what you hear.'"

—Molly (Kutcher) Swenka

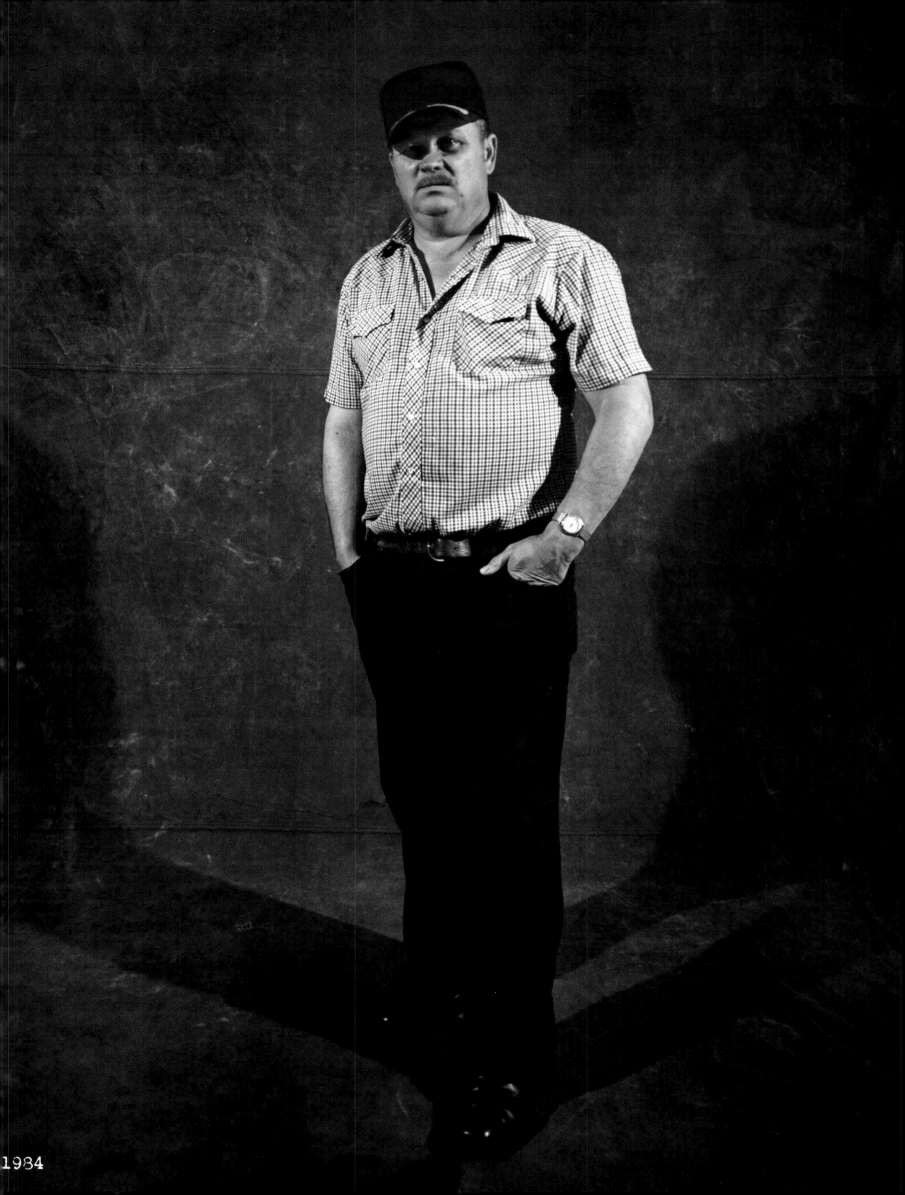

1984

"I boxed in the Navy. I could hold my own in any brawl. It's not something I'm proud of."

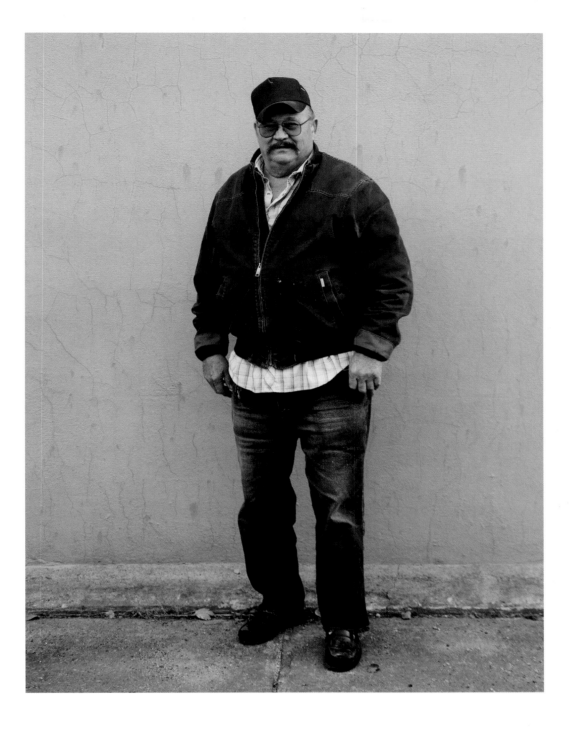

IVAN PORTWOOD

THE THINGS I SAW would set most people into orbit.

I was a gunner on a warship in the Tachen Islands. I seen a pilot miss his landing and get his head sliced off. It rolled right on the deck.

I boxed in the Navy. My hands were too small and my arms too short. I didn't go around looking for trouble, but I sure settled a lot of it. I could hold my own in any brawl. It's not something I'm proud of.

I couldn't wait to get in, and when I got home, I couldn't stand it. I don't know how many times I caught myself on the recruiter's steps, wanting to go back.

My wife and I went to grade school together. We're divorced now. I'd get married again. When you get older, it's nice to have a companion.

IVAN PORTWOOD (b. 1934)

"I didn't know what happened, but I sure felt something. So I took my glove off, shook it, and my fingertip came out."

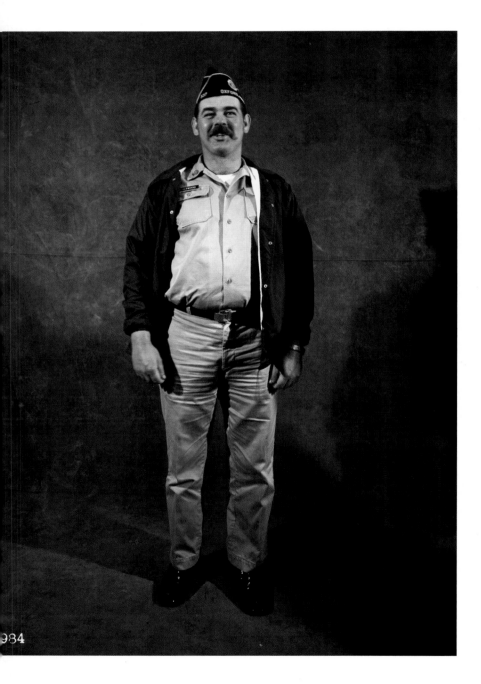

WALT PORTWOOD, JR.

I WAS CHANGING THE BUCKET on my skid loader and I was hurrying. Shouldn't have been hurrying.

I tripped the lever and the bucket fell on my foot. Four hundred pounds. Did that ever sting! I took my boots off and I couldn't wiggle my toes. I spent six hours in the hospital. When the swelling goes down, they're gonna put two steel pins in my left foot.

I rolled a combine once. That was on my right foot.

Another time, I was splitting wood, and it was getting dark. A piece of wood got stuck in between the metal plates. I didn't know what happened, but I sure felt something. So I took my glove off, shook it, and my fingertip came out. They tried to reattach it, but they couldn't. In the winter, the end of that finger gets cold first.

I like farming. I like being my own boss. But we rent the farm out. The guy who rents it probably has five thousand acres with my farm and a couple of others. That's the way it is these days. It's a volume game, like Wal-Mart.

I work for the Street Department in Iowa City filling potholes. I'd much rather be farming than working in town, but I don't have much choice.

I like to hunt when I have the time. I use those turkey callers. Sometimes, they even answer you.

Ivan Portwood's nephew **WALT PORTWOOD, JR.** (b.1949)

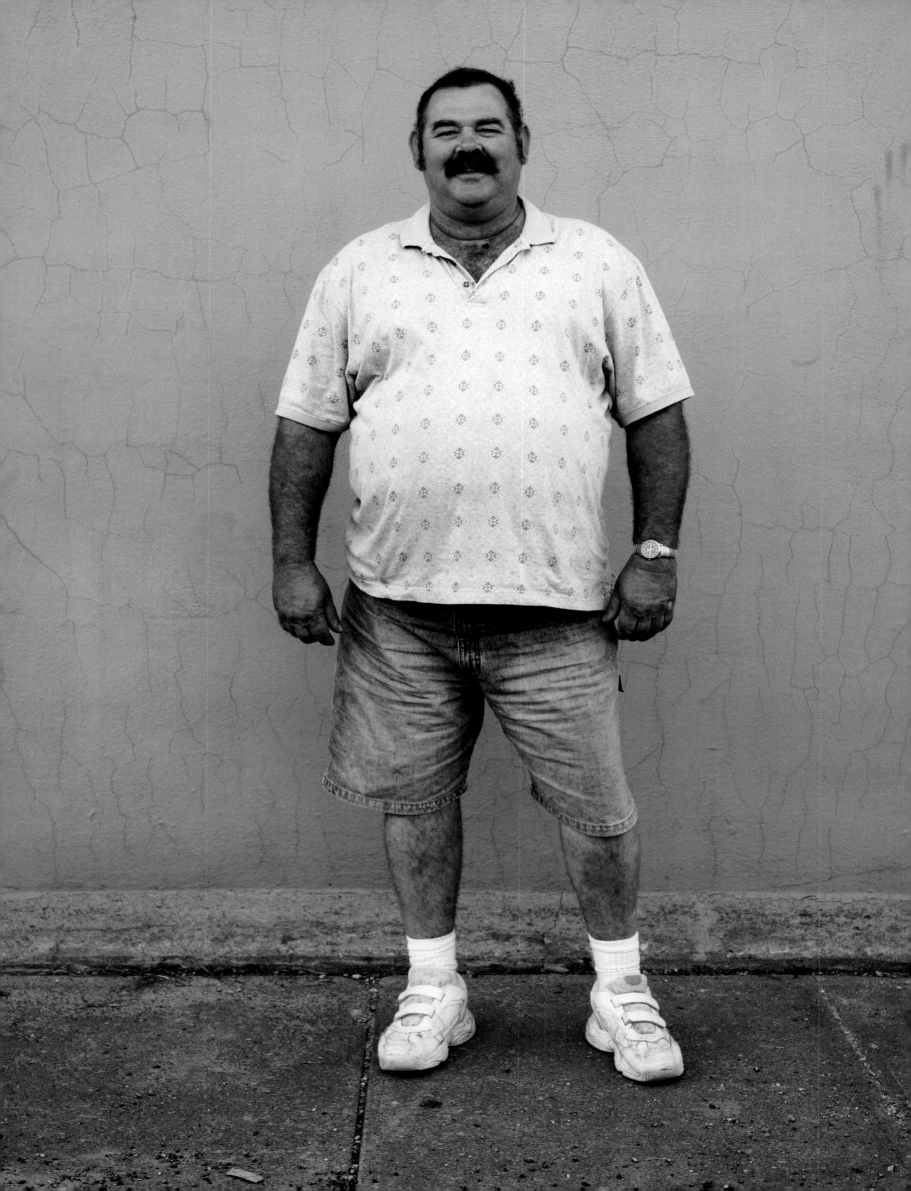

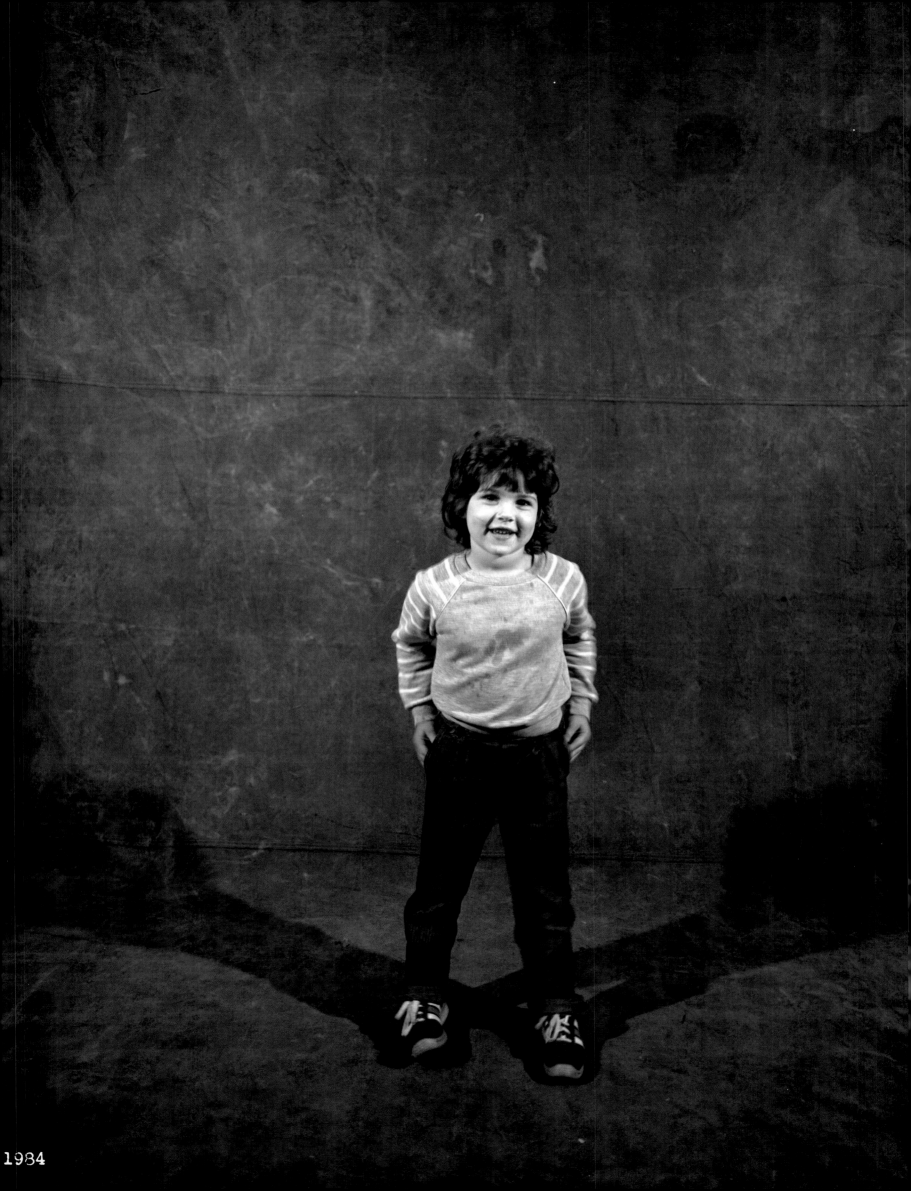

1984

"I totally believe my soulmate is out there, but he's hiding."

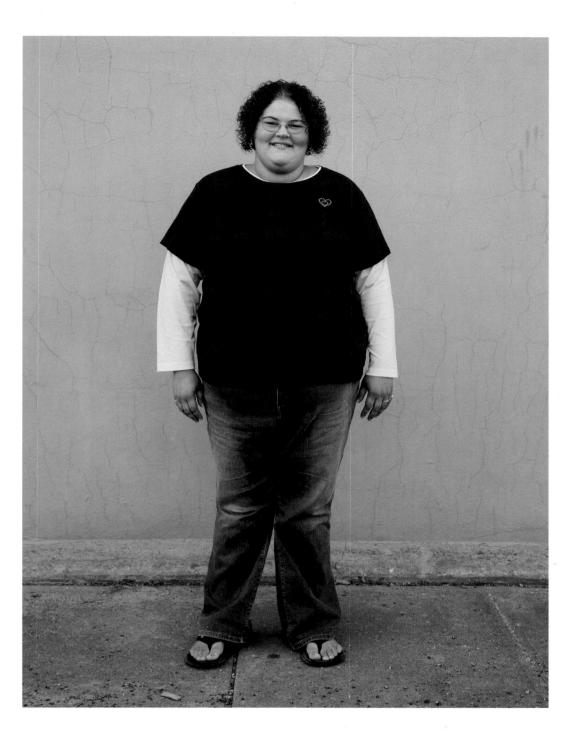

MINDY PORTWOOD

MY FAMILY IS MY WORLD. My brothers, my sister, my parents are my best friends. Growing up, I was a 4-H farm kid. We didn't have a lot of money, but we sure were happy.

I still live at home. I get up at six in the morning, shower, eat Frosted Mini-Wheats or Cheerios. Then I'm off to teach preschool. By the time I get home, I try to catch the last fifteeen minutes of *Days of Our Lives*. I like to read cheesy romance novels at night.

One of my great successes is graduating from college with a teaching degree. My dream job is to teach third-graders, but those jobs are hard to come by.

I believe I was put here to be a wife and a mom. I totally believe my soulmate is out there, but he's hiding. If I hit thirty-five and I'm not married, I'm still going to be a mom. I've had a great life, and the rest of it ought to be just as good.

Walt Portwood, Jr.'s daughter **MINDY PORTWOOD** (b.1979)

"I hope Oxford is my home forever."
—Mindy Portwood

ACKNOWLEDGMENTS

WE WANT TO THANK the generous people of Oxford for allowing their photographs to be taken over a generation's time span and for sharing with us their private, intimate thoughts and reflections.

In many ways, this book is a happy marriage of talents—photography, interviewing, writing, editing, and design. From the beginning, Katrina Fried, Kara Mason, Gregory Wakabayashi, and Lena Tabori at Welcome Books showed an unstinting enthusiasm for the Project, seldom seen in today's profit-driven world of publishing. Each of them helped create a wholly new way of telling stories with photographs and words.

Computer guru Charles Eicher rescued our computers from crashing at all hours of the day and night, streamlined operational elements, and helped resolved complex printing issues.

Curator Amy Worthen spurred us on with her relentless belief in the Project. Amy continues to find nuance in the Project, adding meaning to Oxford residents' photographs and words.

Stephanie Brunia helped with her photographic expertise, and Leigh Ann Randak, curator of the Johnson County Historical Society, assisted us by accessing a treasure trove of Oxford maps and artifacts.

Nan Stillians' early encouragement, gave the Project its first legs.

Poet Gerald Stern showed great support for the Project from its inception. Gerald's artistic integrity has had a profound, guiding influence on both of us.

—PETER FELDSTEIN and STEPHEN G. BLOOM

PHOTOGRAPHER'S NOTE: The 1984 photographs were taken with a 4" x 5" Speed Graphic and printed on Kodak Tri-X sheet film. I used two 1000-watt quartz lights and a tarp borrowed from a local construction company as the backdrop. I processed the film with a developing tank that sat in a tub of water. Every now and then I'd check the temperature of the water, which kept rising in the summer heat, and throw in handfuls ice cubes to cool it down; the resulting prints were very uneven.

When I put the negatives away in 1985, I had no intention of ever using them again, and gave little thought to their storage conditions. When I removed them twenty-two years later, I found some were scratched and terribly dirty. Fixing each image took many hours, from scan to finish.

The current photographs were taken with a 12.8 megapixel Canon 5D, outdoors in natural light, against a blank wall. From the time I made the first exposure in 2006 to the last in 2008, the wall developed signs of stress. Cracks appeared and worsened, the paint faded, and a bad hail storm left marks and streaks that are visible in some of the prints. —P.F.

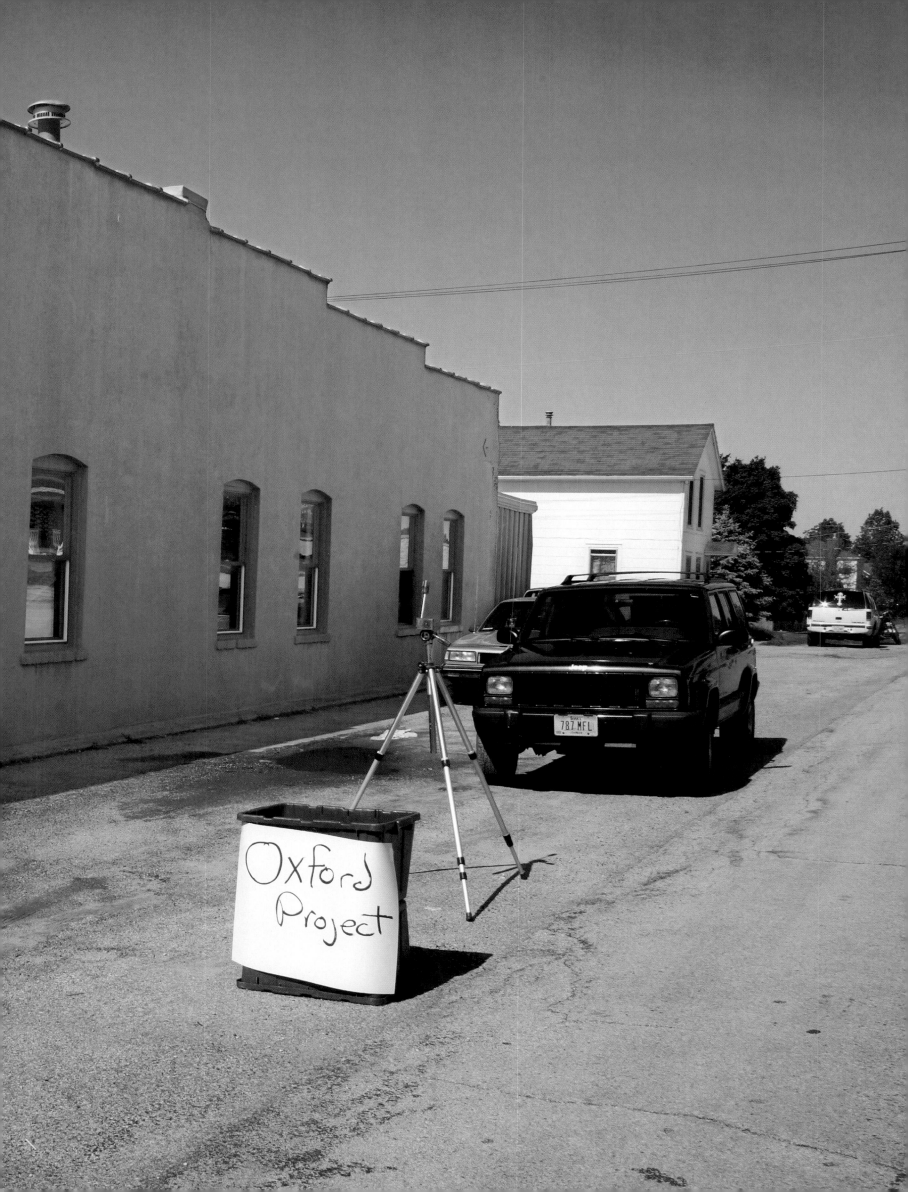

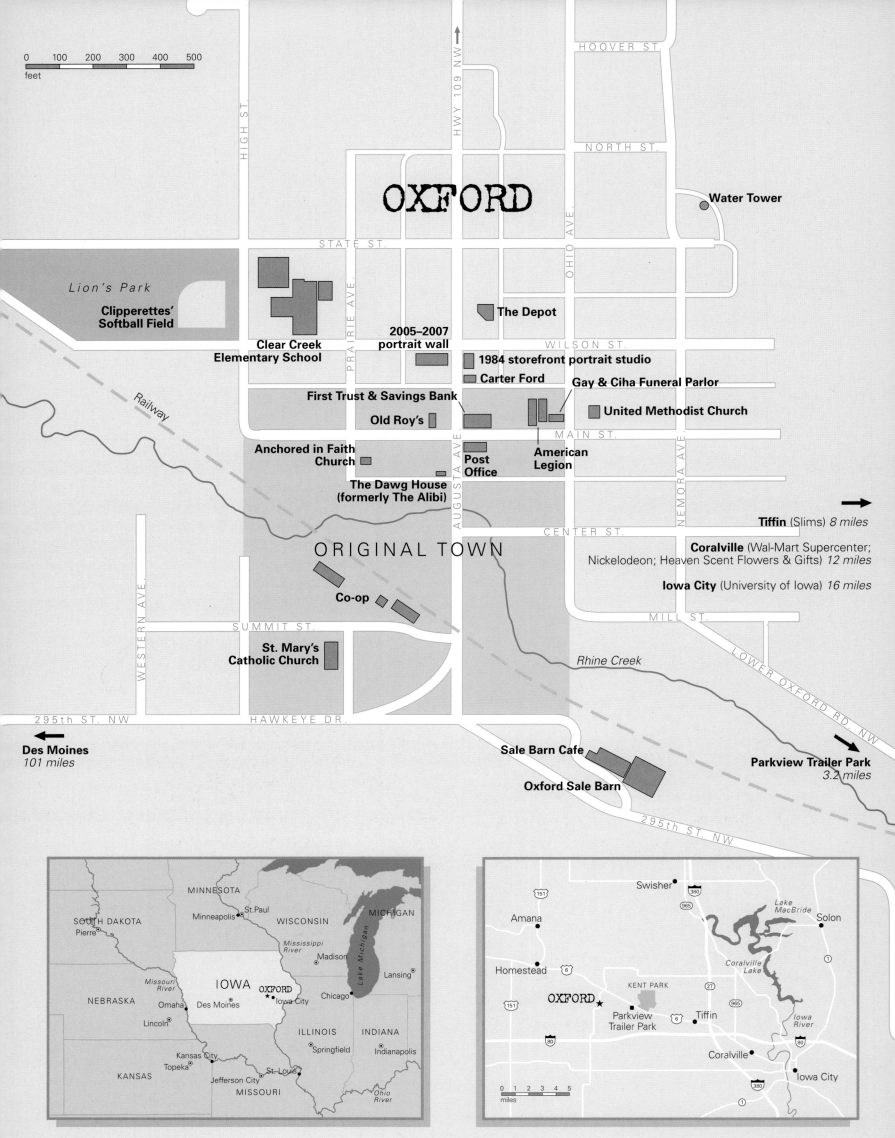

OXFORD

Water Tower

Lion's Park

**Clipperettes'
Softball Field**

**Clear Creek
Elementary School**

**2005–2007
portrait wall**

The Depot

1984 storefront portrait studio

Carter Ford

Gay & Ciha Funeral Parlor

First Trust & Savings Bank

Old Roy's

United Methodist Church

**Anchored in Faith
Church**

**Post
Office**

**American
Legion**

**The Dawg House
(formerly The Alibi)**

Railway

ORIGINAL TOWN

Co-op

Tiffin (Slims) *8 miles*

Coralville (Wal-Mart Supercenter;
Nickelodeon; Heaven Scent Flowers & Gifts) *12 miles*

Iowa City (University of Iowa) *16 miles*

Rhine Creek

**St. Mary's
Catholic Church**

Des Moines
101 miles

Sale Barn Cafe

Oxford Sale Barn

Parkview Trailer Park
3.2 miles

Street labels
HWY 109 NW · HOOVER ST. · NORTH ST. · HIGH ST. · STATE ST. · OHIO AVE. · PRAIRIE AVE. · WILSON ST. · MAIN ST. · AUGUSTA AVE. · NEMORA AVE. · CENTER ST. · MILL ST. · LOWER OXFORD RD. NW · WESTERN AVE. · SUMMIT ST. · 295th ST. NW · HAWKEYE DR. · 295th ST. NW

Scale
0 100 200 300 400 500
feet

Inset map 1 (states)
MINNESOTA · St. Paul · Minneapolis · WISCONSIN · MICHIGAN · SOUTH DAKOTA · Pierre · *Mississippi River* · Madison · *Lake Michigan* · Lansing · NEBRASKA · IOWA · OXFORD · Iowa City · Chicago · *Missouri River* · Omaha · Des Moines · Lincoln · ILLINOIS · INDIANA · KANSAS · Kansas City · Topeka · Springfield · Indianapolis · Jefferson City · St. Louis · *Ohio River* · MISSOURI

Inset map 2 (local)
Swisher · 380 · 151 · 965 · *Lake MacBride* · Solon · Amana · Homestead · 6 · KENT PARK · *Coralville Lake* · 27 · 965 · 1 · OXFORD · Parkview Trailer Park · 151 · 6 · Tiffin · *Iowa River* · 80 · Coralville · Iowa City · 380 · 1

0 1 2 3 4 5
miles

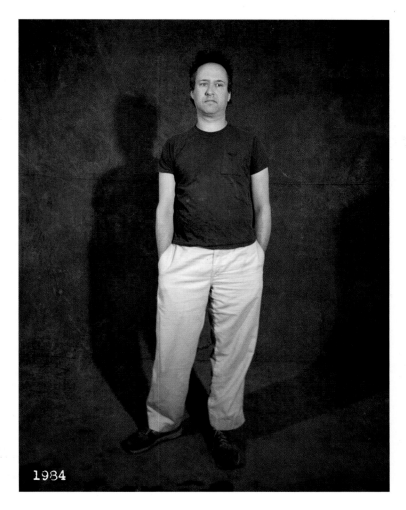

1984

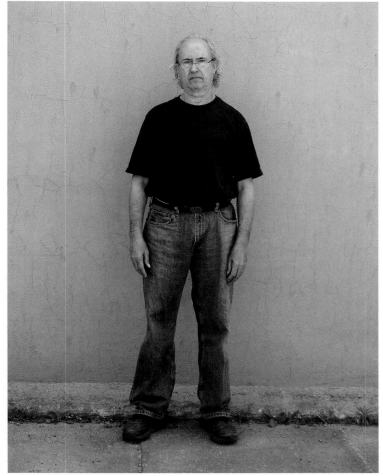

PETER FELDSTEIN

I CAME TO IOWA IN 1960 as a student. After I got my degree in art, I taught in St. Louis, New York, and Boston. Five years later, I came back to teach at the University of Iowa. I needed a studio where I could do my artwork and found two dilapidated storefronts sixteen miles away in a town I had never heard of—Oxford.

For me, Oxford was exotic, mysterious, and strange. It was the first time I had ever lived in a rural community. Even though I was an artist, college professor, and a New York Jew, almost everyone in town welcomed me. As I started fixing up the storefronts, people would poke their heads in and introduce themselves.

The buildings had a lot of bats. Bats have this habit of swooping down on people in the middle of the night, and they used to scare my wife and me to death. I asked Clarence and Margaret Schropp (both in their seventies) for help and they chased the bats out with a tennis racket and a broom. When word got around town, people started calling me Batman.

My neighbors are hard-working people without pretense. They don't put on airs. What you see is what you get.

I've always had this habit of counting things. I've been doing it my whole life. When I was six, my younger brother Don got polio. My parents would leave me with my grandparents on the weekends while they visited Don in the hospital. I slept on the daybed in their bedroom. I remember lying there, watching my grandfather in his long johns smoking his pipe as my grandmother changed into her nightgown. In the glow of his pipe I would count the parts of the furniture that touched the floor. My daybed, my grandmother's dresser, the door, a night table, a floor lamp, the bed, a window, my grandfather's chair. I continued around and around until I fell asleep.

I still count—as I have every day since I was a kid. No matter where I am, counting grounds me. It's part of the reason I started taking photographs of everyone in Oxford. A psychologist once told me there are ways to stop. But after thinking about it, I said, "I don't know what I'd do without it."

ABOVE: **PETER FELDSTEIN** (b. 1942) OPPOSITE: Map of Oxford, Iowa

Published in 2008 by Welcome Books®
An imprint of Welcome Enterprises, Inc.
6 West 18th Street, New York, NY, 10011
(212) 989-3200; fax (212) 989-3205
www.welcomebooks.com

Publisher: Lena Tabori
Editor: Katrina Fried
Associate Editor: Kara Mason
Designer: Gregory Wakabayashi

Designer's Note:
The type is set in Portable Remington from the Vintage Typewriter digital collection and Univers 45 Light, Light Oblique, and Univers 55 Roman. Univers was designed in 1957 by the renowned Swiss type designer Adrian Frutiger. This versatile sans serif was based on the 1896 typeface, Akzidenz-Grotesk, and quickly became a favorite among graphic designers.

COVER: Oxford, Iowa resident Hunter Tandy photographed in 1984 and 2005.
BACK COVER: Various Oxford residents photographed in 1984 and from 2005–2007.
ENDPAPERS: Detail from a map of Oxford Township. Reproduced courtesy of the Johnson County Historical Museum, Coralville, Iowa.

Library of Congress Cataloging-in-Publication Data

Feldstein, Peter.
 The Oxford project / by Peter Feldstein ; text by Stephen Bloom.
 p. cm.
 ISBN 978-1-59962-048-0 (alk. paper)
 1. Oxford (Iowa)--Biography--Portraits. 2. Oxford (Iowa)--Biography--Anecdotes.
 3. Oxford (Iowa)--Social life and customs--Anecdotes. 4. City and town life--Iowa--Oxford--Anecdotes.
 I. Bloom, Stephen G. II. Title.
 F629.O97F45 2008
 977.7′655--dc22

 2008015545

First Edition
10 9 8 7 6 5 4 3 2 1

Printed in Singapore

For further information about *The Oxford Project* please visit online www.welcomebooks.com/theoxfordproject

Additional credit information:
PAGES 14–15: Sources for Oxford statistics: United States Census Bureau (1980 and 2000), Johnson County Registrar of Voters, State Data Center of Iowa
PAGES 158–159: Oxford residents who have died since being photographed in 1984:
Gladys Acord, Louis Acord, Mary Ball, Babe Beard, Ross Beard, Wilma Beard, Dan Brack, Joyce Brack, Richard Brack, Lura O'briant, Dick Ceynar, Tammy Ceynar, Dave Coblentz, Bob Cochran, Murrell Cochran, Jim Collins, Tom Collins, Jeremy Colony, Bob Cook, Lotte Cook, Zella Cotter, Don Crow, Dale Dahnke, Kay Dahnke, Carl Dalton, Pat Downes, Paul Dunn, Annis Dwyer, Russell Ealy, Gladys Edwards, Harold Edwards, Seth Eiman, Burt Falls, Dorothy Falls, Nelle Falls, Claire Flansberg, Thelma Floerchinger, Bill Grabin, Elizabeth Grabin, Mary Grabin, Ken Grauer, Ruth Haman, James Harney, Mary Harney, Keith Heldebrand, Verna Heldebrand, Harry Henkelman, Alberta Hennes, Raphael "Doc" Hennes, Kathryn Holland, Faye Honn, Nel Hoyt, Ethel Hruby, Sally Hummer, Orlo Ives, Adelaide Jiras, Clara Kapfer, Zelda Kapfer, Herb Kawalla, Dennis "Bees" Kennedy, Rachael Kennedy, Earl Kutcher, Mary Ann Kutcher, Roy Kutcher, Mildred Larimer, Loellen Larew, Ellen Linkhart, Slick Mahoney, Katheryn Maske, Jack McDonough, Edith Miick, Genevieve Murphy, Genevieve McDaniel, Mary Novak, W.W. Novak, "Ollie" Olson, Carl Paintin, Don Reynolds, Susan Reynolds, Terry Reynolds, Bob Rohret, Cletus Rohret, Tom Rohret, Bill Rugger, Helen Saxton, Howard Saxton, Don Scheetz, Clarence Schropp, Margaret Schropp, Irene Sedlecek, Mike Sedlacek, Jim Sherlock, Marguerite Sherlock, Wendell Simonson, Donna Slade, Marie Smith, Dick Spratt, Sadie Sprecht, Dale Steckley, Dorothy Steckley, Jerry Stewart, Rita Stockman, Darnell Stoker, Dave Stoker, Bill Stratton, Jerry Stratton, Mary Stratton, Nellie Stratton, Ivan Struzinski, Ed Swenka, Mary Swenka, Marie Svatos, Tom Thompson, Elmer Tomash, Elsie Tomash, Leo Tomas, Stanley "George" Villhauer, Peg Villhauer, Agnes Volk, Jamie Wadilove, Bill Walls Sr., Irene Webster, Stanley Webster, Joe Wilson, Martha Yenter, Orville Yoder, Bud Zimmerman

PETER FELDSTEIN is an artist working at the intersection of photography, drawing, printmaking, and digital imaging. Feldstein's work has been shown in galleries across the country including Chicago, New York, Minneapolis, and Des Moines and has been exhibited at the Walker Art Center (Minneapolis), the Center for Creative Photography (Tucson), and the Rhode Island School of Design. He has been a visiting artist at Dartmouth College and he received an NEA Individual Artist's Grant and two Polaroid Collection Grants. For more than three decades, Feldstein taught photography and digital imaging at the University of Iowa School of Art & Art History. He lives in Oxford, Iowa with his wife, Josephine.

STEPHEN G. BLOOM is the author of *Postville: A Clash of Cultures in Heartland America*, published by Harcourt. *Postville* was named a "Best Book of the Year" by MSNBC, *The Chicago Tribune* and *Chicago Sun-Times*, and received starred reviews in *Publishers Weekly* and *Kirkus Reviews*. Bloom is also the author of *Inside the Writer's Mind*, a collection of his stories and essays, published by Wiley-Blackwell. He has worked as a staff writer for *The Los Angeles Times* and *Dallas Morning News*. His book, *Tears of Mermaids: A Secret History*, a nonfiction detective story about pearls and discovery, will be published by St. Martin's Press in September 2009. Since 1993, Bloom has taught narrative journalism at the University of Iowa. He lives in Iowa City with his wife, Iris, and their son, Michael.

GERALD STERN (Preface) is a poet and essayist. He is the recipient of numerous awards and fellowships, including the National Book Award, The Lamont Prize, a Guggenheim, four NEA awards, and the Ruth Lilly Prize. He has taught at many major universities, including the University of Iowa's Writer's Workshop. Stern lives in Lambertville, New Jersey.

H. Kahler 72 62
Jno Cook 56 72
I. Brant 82
Kahler 48.50
Kahler
River L. Miller 23.65
5 6
20 Edw Haman 63
E. Saxton 7
Chas. C. Oakes 123
Road
H.V. &

Eliza Denson 66
CHI.
39
21
Sam'l L. Brant 90
Louis Miller 40
Wm. Miller
G H Cotter 30
Edward Hanson 120
C. C. Oakes 180
SCH.

J. A. rauer 18
42.27
Wm. Miller 60
Wm. Miller 40
Mary Cotter 50
E. A. Doty 91.50
16
B. G.

C. A. Wagner 125 56
A. P. Rohret 120
Charles C. Oakes 153.30
A. C. Harter 50
I. Cotter 10
L. Saxton 40
UPLAND FARM E 6 Cotter 91
Rohret 240

Christian 170.11
A. P. Rohret 80
Charles
Chas. G. Stratton 80
E. A. Doty 115.50
A. C. Harter 46
J. G. Carmichael 53.34
N B Doty 10.92
W.K. Saxton 20
Saxton 40

Luther
Stratton 80
M.R. Ives 80
John Dolmage 157.99
Oxford
Pat Beecher 40
W. H. Saxton

19
G.
ROCK
20
21

Chas. W. Stratton
M R Ives 80
F.J. McDonough 30
Mary McDonough etal 40
F. J. McDonough 40
E. K. Linkhart 29
M.E. Curry 58.50

Toscow 173.67
OXFORD 1 NO 3
Speers 20
220
Albert Yenter
E. K. Linkhart 120
Wm. H.

Charles G. Stratton 186.52
James Stratton 80
James Stratton 160
H Haefering 38 50
F.J. McDonough 41.50
Wm. H. Clear

30
29
28

Robert Speers 248 60
W. A. Walker 80
OXFORD NO 1
Cronin 160

Edwards 120
Fred Gegenheimer 80
OXFORD NO 1 200
Albert Yenter 160
Jacob Wegmull

T. R. Edwards 80
Cox 90
Oscar F. Glenk 80
Albert Yenter 80
Jacob Wegmull 80

G. W. Clearm